Ireland: Crossroads of Art and Design, 1690–1840

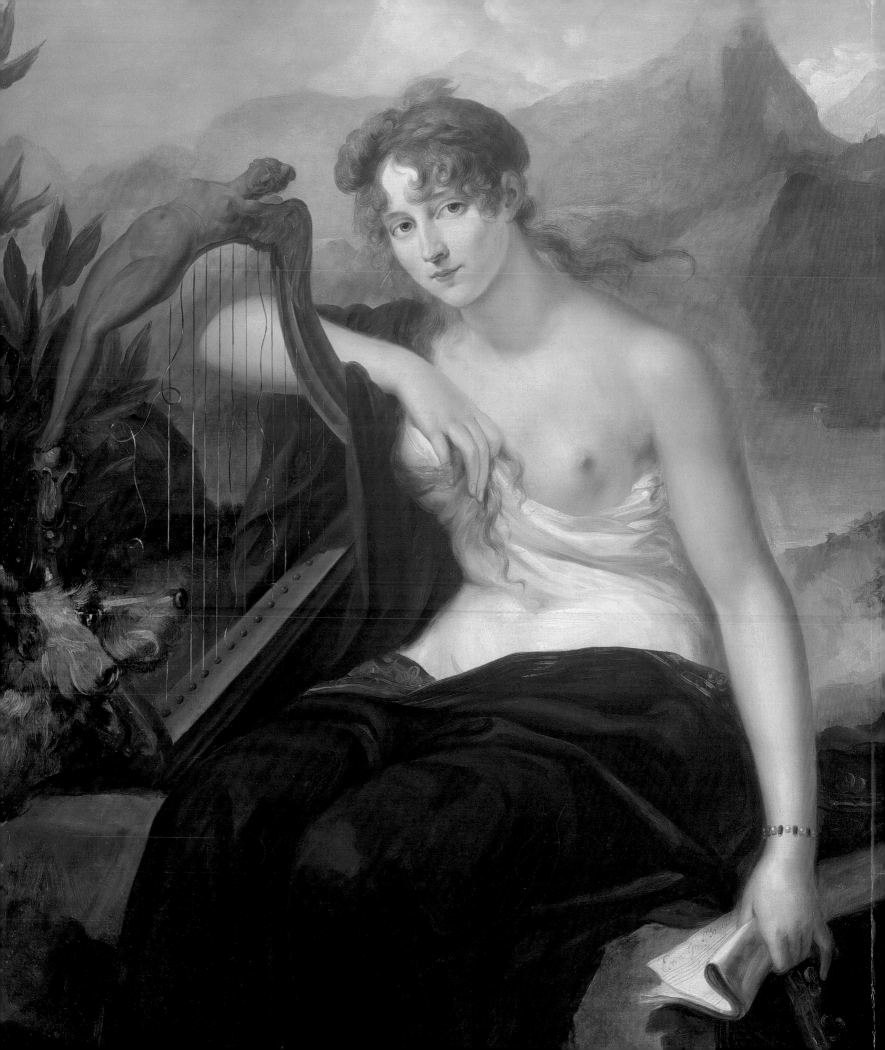

IRELAND

Crossroads of Art and Design, 1690–1840

EDITED BY

William Laffan and Christopher Monkhouse

WITH THE ASSISTANCE OF Leslie Fitzpatrick

WITH CONTRIBUTIONS BY

Toby Barnard, Paul Caffrey, Tom Dunne, Alison FitzGerald, Peter Francis,
Darcy Kuronen, William Laffan, Philip Maddock, Suzanne Folds McCullagh,
Christopher Monkhouse, Kevin V. Mulligan, Finola O'Kane, James Peill,
Brendan Rooney, and Martha Tedeschi

The Art Institute of Chicago

DISTRIBUTED BY

Yale University Press, New Haven and London

For Desmond FitzGerald,
29th Knight of Glin (1937–2011)

Ireland: Crossroads of Art and Design, 1690–1840 was published in conjunction with an exhibition of the same title organized by and presented at the Art Institute of Chicago, March 17–June 7, 2015.

Lead funding has been generously provided by Kay and Fred Krehbiel, Jay Frederick Krehbiel, and the Krehbiel Family Foundation.

Lead Corporate Sponsor

Major support has been provided by Molex, Incorporated; Neville and John Bryan; Caryn and King Harris, The Harris Family Foundation; and the Eloise W. Martin Legacy Fund.

Annual support for Art Institute exhibitions is provided by the Exhibitions Trust: Kenneth and Anne Griffin, Robert M. and Diane v. S. Levy, Thomas and Margot Pritzker, and the Earl and Brenda Shapiro Foundation.

First edition
Printed in Canada

ISBN: 978-0-300-21060-6 (cloth)
ISBN: 978-0-86559-272-8 (paper)

Published by
The Art Institute of Chicago
111 South Michigan Avenue
Chicago, Illinois 60603-6404
www.artic.edu

Distributed by
Yale University Press
302 Temple Street
P.O. Box 209040
New Haven, Connecticut 06520-9040
www.yalebooks.com/art

Produced by the Department of Publishing, the Art Institute of Chicago, Sarah E. Guernsey, Executive Director

Edited by Gregory Nosan and Maia M. Rigas

Production by Joseph Mohan and Lauren Makholm

Photography research by Katie Levi and Lauren Makholm

Proofreading by Leslie Keros

Indexing by Kate Mertes

Unless otherwise noted, photography of works of art is by Chris Gallagher, Robert Lifson, and Jordan Fuller, with postproduction by Jonathan Mathias, Department of Imaging, the Art Institute of Chicago.

Design and typesetting by Joan Sommers, Glue + Paper Workshop, Chicago

Separations by Professional Graphics, Incorporated, Rockford, Illinois

Printing and binding by Friesens Corporation, Altona, Manitoba, Canada

This book was made using paper and materials certified by the Forest Stewardship Council, which ensures responsible forest management.

LIBRARY OF CONGRESS CATALOGING-IN-PUBLICATION DATA

Ireland : crossroads of art and design, 1690–1840 / edited by William Laffan and Christopher Monkhouse ; with the assistance of Leslie Fitzpatrick ; with contributions by Toby Barnard [and 14 others].
 pages cm
 Includes bibliographical references.
 1. Art, Irish—18th century—Exhibitions. 2. Ireland—Civilization—18th century—Exhibitions. I. Laffan, William, editor. II. Monkhouse, Christopher P., editor. III. Art Institute of Chicago.
 N6787.I74 2015
 709.415'09033—dc23
 2015002909

FRONT COVER: John Egan (Irish, active c. 1801–41). Portable Harp, c. 1820. The O'Brien Collection. Cat. 307.

BACK COVER: Samuel Walker (Irish, active 1731–69). Two-Handled Cup and Cover, c. 1761–66. Philadelphia Museum of Art, Gift of an anonymous donor, 2008. Cat. 293.

ENDPAPERS: John Nicklin (Irish, active 1784–1800). Ten Buttons, 1787. The Metropolitan Museum of Art, New York, the Hanna S. Kohn Collection, 1951. Cat. 282. Seven Buttons, 1787. Private collection. Cat. 283.

DETAILS:
FRONTISPIECE: Robert Fagan (Irish, born England, active in Italy, 1761–1816). *Portrait of a Lady as Hibernia*, c. 1801 (detail). Private collection. Cat. 37.

PAGE 4: Henry Kirchhoffer (Irish, c. 1781–1860). *Francis Johnston's Belfry and Gothic Folly in His Garden, Eccles Street, Dublin*, c. 1832 (detail). Private collection. Cat. 74.

PAGE 10: Thomas Roberts (Irish, 1748–1777). *The Sheet of Water at Carton, with the Duke and Duchess of Leinster About to Board a Rowing Boat*, 1775–76 (detail). Private collection. Cat. 109.

PAGE 16: Entrance Hall at Killadoon, County Kildare.

PAGES 36–37: Robert Healy (Irish, 1743–1771). *Tom Conolly of Castletown Hunting with His Friends*, 1769 (detail). Yale Center for British Art, Paul Mellon Collection. Cat. 56.

PAGES 126–27: Probably Mark Fallon (Irish, active c. 1730). Chandelier, c. 1742 or earlier (detail). Winterthur Museum, Bequest of Henry Francis du Pont. Cat. 267.

PAGES 222–23: Francis Wheatley (English, active in Ireland, 1747–1801). *The Salmon Leap, Leixlip*, 1783 (detail). Yale Center for British Art, Paul Mellon Collection. Cat. 135.

CONTENTS

Lead funding has been generously provided by Kay and Fred Krehbiel, Jay Frederick Krehbiel, and the Krehbiel Family Foundation.

Lead Corporate Sponsor

Major support has been provided by Molex, Incorporated; Neville and John Bryan; Caryn and King Harris, The Harris Family Foundation; and the Eloise W. Martin Legacy Fund.

Additional support has been generously contributed by Maureen O'Malley Savaiano, The Buchanan Family Foundation in honor of Katherine H. Buchanan, Pamela and Roger Hull, Patrick and Aimee Butler Foundation, Richard and Ann Carr, Art and Diane Kelly, Maureen and Edward Byron Smith Jr. Family Endowment Fund, Doris and Stanford Marks, Philip and Betsey C. Caldwell Foundation, the Irish Georgian Society, Shawn M. Donnelley and Christopher M. Kelly, The Felicia Fund, Inc., Ellen and Jim O'Connor, the Paul Mellon Centre for Studies in British Art, Ronald and Rose Wanke, Gloria G. Gottlieb, and Steven J. Zick.

Generous support for the catalogue is provided in part by The Richard H. Driehaus Foundation.

Annual support for Art Institute exhibitions is provided by the Exhibitions Trust: Kenneth and Anne Griffin, Robert M. and Diane v. S. Levy, Thomas and Margot Pritzker, and the Earl and Brenda Shapiro Foundation.

The exhibition gala for *Ireland: Crossroads of Art and Design, 1690–1840* is sponsored by R. J. O'Brien & Associates LLC and Patricia and John O'Brien.

Celtic Circle: Neville and John Bryan, Linda and Vincent Buonanno, Peggy and Jack Crowe, Nancy and Steve Crown, Jamee and Marshall Field, Joseph P. Gromacki, Caryn and King Harris, Leslie S. Hindman, Pamela and Roger Hull, Ned Jannotta, Kay and Fred Krehbiel, Jay Frederick Krehbiel, Diane v. S. and Robert M. Levy, Margaret MacLean and Barry MacLean, Ann and Samuel M. Mencoff, Mike and Adele Murphy, Ellen and Jim O'Connor, Kay and Michael O'Halleran, Anne and Chris Reyes, Shirley and Patrick Ryan, Linda and Bob Sullivan, Melinda and Paul Sullivan, Tina and Byron Trott, and Beth and Bruce White.

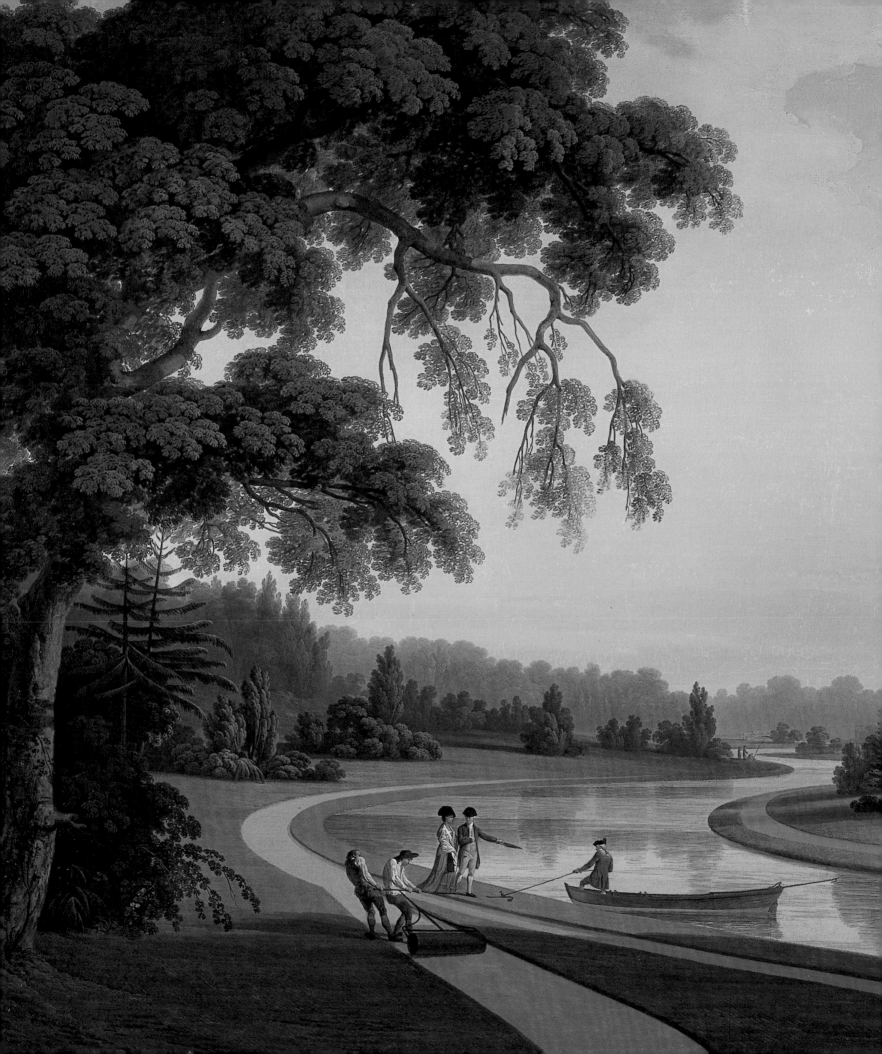

FOREWORD

FROM ITS EARLIEST YEARS, Chicago has been shaped by the tens of thousands of Irish immigrants who came to call it home. The city boasts many important Irish cultural organizations and has elected a dozen mayors of Irish descent. This influence can be glimpsed in the history of the Art Institute itself, whose board of trustees included members of Irish ancestry at a time when this was relatively rare. The museum is thus an especially fitting home for the groundbreaking exhibition *Ireland: Crossroads of Art and Design, 1690–1840*.

In some respects, the show deepens and refines the Art Institute's already substantial engagement with Irish visual culture. The museum hosted *Master European Paintings from the National Gallery of Ireland: Mantegna to Goya* in 1992, which included portraits of Irish sitters though, significantly, no works by Irish artists. *Ireland: Crossroads of Art and Design*, for its part, features works by some of the country's most accomplished artists and seeks to offer a nuanced understanding of their work and its contexts. Encompassing over three hundred objects ranging from paintings, drawings, and prints to furniture, silver, and musical instruments, it is the largest exhibition ever devoted to the arts in Ireland during this period. The project addresses such themes as the ways in which religion, class, and politics shape identity; how the migration of people and objects is determined by political and economic forces; and how patronage influences artistic production.

Like other exhibitions of this scale, *Ireland: Crossroads of Art and Design* was many years in the making. The Art Institute owes special thanks to Christopher Monkhouse, Eloise W. Martin Curator of European Decorative Arts and chair of the Department of European Decorative Arts, who conceived the exhibition and has steadfastly championed it during its development; we also thank Assistant Research Curator and exhibition coordinator Leslie Fitzpatrick. We extend deep gratitude to William Laffan, who collaborated on the exhibition and the catalogue, lending his knowledge and impeccable eye to both.

We gratefully acknowledge the eighty-five individual collectors and institutions that lent works of art to this exhibition. Their enthusiastic participation has been essential to the show's success. Foremost among these lenders and supporters are Kay and Fred Krehbiel and their family, without whose singular generosity the exhibition would not have been possible. The number of American lenders attests to the strong bond between the United States and Ireland, and Americans' attachment to, and enduring interest in, Irish heritage.

While the exhibition afforded us the opportunity to deepen existing relationships, it also allowed us to build new connections with neighboring organizations that support the arts and culture of Ireland. This includes the Chicago Shakespeare Theater as well as the Poetry Foundation, with which the Art Institute cohosted a reading by Nobel Prize–winning poet Seamus Heaney in 2012. We have also forged a longer-distance friendship with the Irish Georgian Society, headquartered in Dublin and led in the United States by Michael Kerrigan. The society has enjoyed strong support over the years from its Chicago chapter and is now returning the favor by dedicating an issue of its annual journal, *Irish Architectural and Decorative Studies*, to the exhibition. In March 2015 *Ireland: Crossroads of Art and Design* will also be celebrated in a symposium to be held at the Art Institute and sponsored by the Irish Georgian Society, the Paul Mellon Centre for Studies in British Art in London, the Philip and Betsey C. Caldwell Foundation, and Christie's, that will further disseminate knowledge of Irish fine and decorative arts. Through these various partnerships, the Art Institute is proud to be at the center of this collaborative network of institutions celebrating Irish artistic achievements.

In 2014 I had the honor of hosting the president of Ireland, Michael D. Higgins, and his wife, Sabina, at the museum. It was a pleasure to share with them some of the exceptional objects from Ireland in the Art Institute's collection, which represent just a small sampling of the works in this exhibition. Many of these ceramics, paintings, textiles, and other fine and decorative artworks left their homeland in the nineteenth and early twentieth centuries, becoming widely dispersed around the world, especially in North America. We now celebrate this artistic diaspora, which has never before been explored on such a scale. It is an honor for the Art Institute to showcase these works of art in Chicago, and thereby increase their national and international visibility, fostering recognition of Ireland's rich artistic legacy.

Douglas Druick
PRESIDENT AND ELOISE W. MARTIN DIRECTOR
THE ART INSTITUTE OF CHICAGO

ACKNOWLEDGMENTS

IRELAND: CROSSROADS OF ART AND DESIGN, 1690–1840 was made possible by the support and hard work of numerous individuals and institutions on both sides of the Atlantic. First conceived in 2007, the exhibition benefited from the enthusiastic encouragement of Douglas Druick, President and Eloise W. Martin Director of the Art Institute of Chicago, and his predecessor James Cuno. Both Douglas and Jim envisioned the project as a way to explore Chicago's deep Irish roots and highlight exceptional objects with Irish histories in the museum's permanent collection. Indeed, the connections between Chicago and Ireland remain strong: we were honored to receive President Michael D. Higgins, his wife, Sabina, and Ambassador to the United States Anne Anderson at the Art Institute in May 2014. In Chicago, we extend our thanks to Consul General Aidan Cronin, his wife, Maedhbh, and Vice Consul Nicholas Michael for their continued support of the exhibition.

Lead funding for *Ireland: Crossroads of Art and Design* has been generously provided by Kay and Fred Krehbiel, Jay Frederick Krehbiel, and the Krehbiel Family Foundation. The lead corporate sponsor is Kerry Group. Major support has been provided by Molex, Incorporated; Neville and John Bryan; Caryn and King Harris, The Harris Family Foundation; and the Eloise W. Martin Legacy Fund. An anonymous foundation provided major funding for publication of the catalogue, and The Richard H. Driehaus Foundation contributed additional support. The lead sponsor of the accompanying symposium is the Irish Georgian Society, along with the Paul Mellon Centre for Studies in British Art, the Philip and Betsey C. Caldwell Foundation, and Christie's.

Additional support has been generously contributed by Maureen O'Malley Savaiano, The Buchanan Family Foundation in honor of Katherine H. Buchanan, Pamela and Roger Hull, Patrick and Aimee Butler Foundation, Richard and Ann Carr, Art and Diane Kelly, Maureen and Edward Byron Smith Jr. Family Endowment Fund, Doris and Stanford Marks, Shawn M. Donnelley and Christopher M. Kelly, The Felicia Fund, Inc., Ellen and Jim O'Connor, Ronald and Rose Wanke, Gloria G. Gottlieb, and Steven J. Zick.

Exhibition gala sponsors R. J. O'Brien & Associates LLC, Patricia and John O'Brien, and the Celtic Circle have been critical to securing funds for the exhibition. The Celtic Circle includes Neville and John Bryan, Linda and Vincent Buonanno, Peggy and Jack Crowe, Nancy and Steve Crown, Jamee and Marshall Field, Joseph P. Gromacki, Caryn and King Harris, Leslie S. Hindman, Pamela and Roger Hull, Ned Jannotta, Kay and Fred Krehbiel, Jay Frederick Krehbiel, Diane v. S. and Robert M. Levy, Margaret MacLean and Barry MacLean, Ann and Samuel M. Mencoff, Mike and Adele Murphy, Ellen and Jim O'Connor, Kay and Michael O'Halleran, Anne and Chris Reyes, Shirley and Patrick Ryan, Linda and Bob Sullivan, Melinda and Paul Sullivan, Tina and Byron Trott, and Beth and Bruce White.

Annual support for Art Institute exhibitions is provided by the Exhibitions Trust: Kenneth and Anne Griffin, Robert M. and Diane v. S. Levy, Thomas and Margot Pritzker, and the Earl and Brenda Shapiro Foundation.

Consummate problem solvers at the Art Institute, John Bryan, Chair of the European Decorative Arts (EDA) Committee, and Martha Tedeschi, Deputy Director for Art and Research, have been a constant source of sage and timely advice, as have Jeanne Ladd, Vice President for Museum Finance, and Julie Getzels, General Counsel and Secretary of the Corporation. The heartfelt support of the entire EDA Committee has been of utmost importance, and we express our gratitude to Jean Armour, Alessandra Branca-Uihlein, Gilda Buchbinder, Linda Buonanno, Francie Comer, Jack Crowe, Lori Gray Faversham, Kathryn Gilbertson, Joseph Gromacki, Caryn Harris, Pamela Hull, Diane Kelly, Jay Krehbiel, Kay Krehbiel, Diane Levy, Doris Marks, John O'Brien, Ellen O'Connor, Edward Byron Smith, Jr., Manfred Steinfeld, Melinda Martin Sullivan, Gayle Tilles, Anne Vogel, and Mary Young. As president of the Antiquarian Society, Meredith Moriarty sits on the EDA Committee. She represents the principal support group for programs and acquisitions in the decorative arts at the Art Institute, and its influence can be seen throughout the exhibition. Vice President for Museum Development Eve Coffee Jeffers and her predecessor Elizabeth Hurley, together with James Allan, Anna Decatur, Alison De Frank,

Stephanie Henderson, George Martin, Jennifer Moran, and Jennifer Oatess, have energetically overseen the fund-raising process with their characteristic professionalism.

Dedicated colleagues from many departments made this catalogue and exhibition possible. First and foremost, we extend our thanks to the members of the Department of European Decorative Arts, who have been essential to the success of this complex undertaking. Above all, Assistant Research Curator and exhibition coordinator Leslie Fitzpatrick has played a vital role. Zahra Bahia, Bill Gross, Lindsay Mican Morgan, Ghenete Zelleke, and particularly Veronika Lorenser have all provided much additional help. Jeffrey Nigro created the interpretive materials, while interns Lauren Cooney and Sneha Vijay Shah and volunteer Camille Grand-Dewyse provided timely research. Outside the department, curators and colleagues, including Sylvain Bellenger, Alison Fisher, Gloria Groom, Suzanne Karr Schmidt, Karen Kice, Suzanne Folds McCullagh, Jane Neet, Zoë Ryan, Jonathan Tavares, Daniel Walker, and Martha Wolff, generously loaned objects and helped secure loans. The present and former staff of the Ryerson and Burnham Libraries, including former Executive Director Jack Perry Brown, former Head of Reader Services Melanie Emerson, Autumn Mather, and Mary Woolever, facilitated our research at every stage.

Executive Director of Publishing Sarah Guernsey oversaw all aspects of the catalogue with her talented team—Stacey Hendricks, Katie Levi, Lauren Makholm, Wilson McBee, Joseph Mohan, Gregory Nosan, Amy Peltz, and Maia Rigas. Her predecessor Robert Sharp guided the publication at its inception. Joan Sommers conceived the striking design. Imaging, led by Lou Meluso, provided beautiful photographs; special thanks go to Chris Gallagher, Jordan Fuller, Robert Lifson, Jonathan Mathias, and P. D. Young. We are grateful to photographers James Fennell and Dara McGrath for the use of their images and graphic designers Jason Ellams and John O'Regan for help in sourcing images.

Executive Director for Exhibitions and Registration Jennifer Draffen and Registrar Darrell Green ably managed relationships and logistics, while Jennifer Paoletti and Megan Rader coordinated the exhibition with aplomb. Chief Operating Officer David Thurm and former Vice President for Exhibitions and Administration Dorothy Schroeder conscientiously oversaw the budget. Objects in the exhibition were expertly assessed and cared for by a team of Art Institute conservators led by Grainger Executive Director of Conservation Frank Zuccari and Chris Conniff-O'Shea that included Rebecca Doll, Christine Fabian, Isaac Facio, Emily Heye, Kelly Keegan, Antoinette Owen, Suzanne Schnepp, Harriet Stratis, Kirk Vuillemot, and Faye Wrubel; Jann Trujillo provided them with indispensable support.

Yau-mu Huang and guest exhibition designer John Vinci developed an insightful installation, while Sara Urizar coordinated various aspects of construction. Vice President for Marketing Gordon Montgomery, Rebecca Baldwin, Nora Gainer, and other team members skillfully brought the exhibition to wide attention. Director of Graphics Jeff Wonderland, Erin Clark, Sal Cruz, Kari McCluskey, and Cassie Tompkins provided labels and signage. Bill Gross and Tom Roach led the installation team, and Bill Caddick and Joe Vatinno and their crew did a superb job of building the installation. In Digital Experience and Access, Michael Neault, Bill Foster, Kevin Lint, Tom Riley, and Will Robertson facilitated the audiovisual components. Jamie Stukenberg of Professional Graphics shot photographs especially for the catalogue, and Andy Talley made custom mounts for various objects. John Molini and Michael Kaysen assisted with the transport of loaned works, and Shannon Riordan from Information Services provided technical support. Russell Collett and Thomas Henkey coordinated security efforts. Museum Education, led by Deputy Director Judith Russi Kirshner, has endeavored to reach diverse audiences through programming provided by Fawn Ring, Allison Muscolino, and David Stark. David coordinated the exhibition's audio guide as well as provided docent training and public lectures. The expertise of Erin Hogan in Interpretation and Communication also shaped the presentation of the exhibition in important ways.

We are extremely grateful to the many private collectors and museums whose generosity in lending their objects attests to their support of the exhibition. In particular, the Yale Center for British Art, led by Amy Meyers, provided loans and helped us secure other critical loans and partial funding for the symposium. We extend our sincerest thanks to Amy and her curators and staff members Cassandra Albinson, Katherine Chabla, Martina Droth, Elisabeth Fairman, Gillian Forrester, Sarah Welcome, and Scott Wilcox. Our thanks also go to the Paul Mellon Centre for Studies in British Art in London, especially director Mark Hallett and former director Brian Allen. Also generous with loans and support were Janne Sirén, Albright-Knox Art Gallery; Adam Carey and Dan Steinke, American College of Surgeons; former director Robert O'Neill, Justine Sundaram, and Kathleen Williams, John J. Burns Library, Boston College; Mirko Zardini, Centre Canadien d'Architecture/Canadian Centre for Architecture; William Hennessey, Chrysler Museum of Art; Aaron Betsky, Cincinnati Art Museum; Ronald L. Hurst, Erik Goldstein, Angelika Kuettner, and Janine Skerry, Colonial Williamsburg Foundation; Caroline Baumann and Sarah Coffin, Cooper Hewitt, Smithsonian Design Museum, Smithsonian Institution; Maxwell Anderson and Kevin Tucker, Dallas Museum of Art; Francis DeCurtis and Joyce

Lee, the Collection of Richard H. Driehaus; Cynthia D'Agosta and Julie Bly DeVere, Filoli: Historic House and Gardens; Michael Witmore and Erin Blake, Folger Shakespeare Library; Marla Berns, Fowler Museum at UCLA; Carl Nold, Nicole Chalfant, and Laura Johnson, Historic New England; Michael Taylor, Hood Museum of Art, Dartmouth College; Kevin Salatino, Huntington Library, Art Collections, and Botanical Gardens; Timothy Potts, J. Paul Getty Museum; Winston Tabb and Earle Havens, John Work Garrett Library, Johns Hopkins University; Eric Lee, Kimbell Art Museum; Margaret K. Powell, Lewis Walpole Library; Pamela Ambrose and Jonathan Canning, Loyola University Museum of Art; Nancy Netzer, Marjorie Howes, Vera Kreilkamp, and Diana Larsen, McMullen Museum, Boston College; Thomas Campbell, Ellenor Alcorn, Elizabeth Bryan, Andrew Caputo, Keith Christiansen, Elizabeth Cleland, Jayson Dobney, George Goldner, Danielle Kisluk-Grosheide, Wolfram Koeppe, Kenneth Moore, Erin Pick, Stuart Pyhrr, Luke Syson, Melinda Watt, and Mary Zuber, Metropolitan Museum of Art; John Smith, Jan Howard, Kate Irvin, Elizabeth Williams, and Jessica Urick, Museum of Art, Rhode Island School of Design; Kaywin Feldman, Eike Schmidt, and Corinne Wegner, Minneapolis Institute of Arts; Malcolm Rogers, Darcy Kuronen, Thomas Michie, Pamela Parmal, and Rebecca Tilles, Museum of Fine Arts, Boston; Gary Tinterow, Museum of Fine Arts, Houston; Earl Powell III and Frank Kelly, National Gallery of Art, Washington, D.C.; Marc Mayer, National Gallery of Canada; Julian Zugazagoitia and Catherine Futter, Nelson-Atkins Museum of Art; David Spadafora and Hjordis Halverson, Newberry Library; Susan Taylor, New Orleans Museum of Art; Hope Alswang, Norton Museum of Art; Timothy Rub, Donna Corbin, and Diane Minnite, Philadelphia Museum of Art; Katherine Howe, Rienzi Collection, Museum of Fine Arts, Houston; Brent Benjamin, Jason Busch, and David Conradsen, Saint Louis Art Museum; Katherine Crawford Luber, Kia Dornan, and Merribell Parsons, San Antonio Museum of Art; James Clifton, Sarah Campbell Blaffer Foundation; Jessica Nicoll, Smith College Museum of Art; Charles Loving and Cheryl Snay, Snite Museum of Art, University of Notre Dame; David Bull, Anita Crider, and John Wilson, Timken Museum of Art; Joseph Rosa, University of Michigan Museum of Art; David Roselle, Wendy Cooper, Linda Eaton, Leslie Grigsby, Tom Savage, Matthew Thurlow, and Ann Wagner, Winterthur Museum; Jock Reynolds and John Stuart Gordon, Yale University Art Gallery; and William Purvis and Susan Thompson, Yale University Collection of Musical Instruments.

The exhibition, which builds on a remarkable efflorescence of research on Irish art and architecture over the last two decades, has enjoyed the support of Ireland's scholarly community. We are most grateful to the distinguished experts who have contributed to the catalogue. It was truly an international team: Toby Barnard, Paul Caffrey, Tom Dunne, Alison FitzGerald, Peter Francis, Darcy Kuronen, Philip Maddock, Suzanne Folds McCullagh, Kevin V. Mulligan, Finola O'Kane, James Peill, Brendan Rooney, and Martha Tedeschi. We must also acknowledge the pioneering work of Anne Crookshank and Desmond FitzGerald, 29th Knight of Glin, on Irish painting; Maurice Craig and Edward McParland on architecture; and Mairead Dunlevy on textiles. For their help on all manner of issues concerning the exhibition and catalogue, we are grateful to them and others, including Angela Alexander, Christine Casey, Nicola Figgis, Peter Harbison, Eileen and John Harris, Magda and Rolf Loeber, Conor Lucey, Anna Moran, Peter Murray, Caroline Pegum, and David Skinner.

From the beginning of the project we have collaborated closely with the Irish Georgian Society, whose journal *Irish Architectural and Decorative Studies* has been at the forefront of research into the material world of Ireland. We thank Penny and Desmond Guinness; Louise, Patrick, and Celeste Guinness; Donough Cahill; David Fleming; Emmeline Henderson; Doreen McNamara; Robert O'Byrne; and Letitia Pollard. The Irish Georgian Society in America has also been immensely supportive, especially Michael Kerrigan and Maribeth Welsh. The project has received assistance from the staff at the Irish Architectural Archive in Dublin; we thank David Griffin, Colum O'Riordan, Simon Lincoln, and Eve McAulay. At the Office of Public Works we acknowledge the assistance of Mary Heffernan and Rose Anne White. At the National Library of Ireland we thank Honora Faul and Finola Ross; at the National Trust, Frances Bailey, Alastair Laing, Mark Purcell, and Christopher Rowell; and at the Victoria and Albert Museum, Elizabeth Bisley, Leela Meinertas, Tessa Murdoch, and Michael Snodin.

We are grateful to many individuals and institutions for their gracious hospitality during our research trips in Ireland and England. We thank the staff of Ballyfin Demesne; Desmond Barry; the Earl and Countess of Belmore; Julius Bryant; William Burlington; Sally and Charles Clements; Isabel and Alec Cobbe; Sir David Davies; Minister for Diaspora Affairs Jimmy Deenihan; Dermot Dix; Olda, Catherine, Nesta, and Honor FitzGerald; Marianne and Michael Gorman; Jeannie Hobhouse; Tim Knox; Todd Longstaffe-Gowan; Lord and Lady Magan; Conor Mallaghan; Eamon McEneaney; the Earl and Countess of Meath; Carmel and Martin Naughton; John O'Connell; Valerie and Thomas Pakenham; John Redmill; Jim Reynolds; Helen and Michael Roden; the Earl and Countess of Rosse; MaryAnne Stevens; and Audrey Whitty. We must single out Hubert Fitzell, Eileen Kirby, Nora Landers, Glen McCarthy, and Liz McCarthy for especially warm thanks.

In the course of researching and documenting objects in North America, the following individuals, in addition to the directors and curators from the lending institutions mentioned above, have provided help beyond measure: Richard-Raymond Alasko, Henry Beckwith, Devon Bruce and Yvonne Derrig, Linda and Vincent Buonanno, Sandy and Peter Butler, Desirée Caldwell, John Carpenter, Peggy Carr, Liz Carroll, Jay Clarke, Margaret Conrads, Kim Coventry, Caroline Craycraft, Alan Darr, Nancy Druckman, Lise Dubé-Scherr, Diana Edwards, Marty Fahey, Sheila ffolliott, Paula Fogarty, Donald and Grace Friary, Tom Gleason, Thomas Gray, Charlotte Hanes, Fenella and Morrison Heckscher, Father Thomas Hurley, Mike Jarvie, Laura-Caroline Johnson, Nancy Joyce, James Kenny, Maria Labhard, Dwight Lanmon, Colles and John Larkin, Roseann Finnegan LeFevour, Sandie Lockhart, Niamh and Philip Maddock, Johanna McBrien, DeCourcy McIntosh, Kieran McLoughlin, Pauline Metcalf, Nancy Novit, Patricia and John O'Brien, Tom O'Gorman, Elizabeth Pochoda, Megan Reddicks, Julian Sands, Maureen O'Malley Savaiano, Arlene and Bill Schwind, Earle Shettleworth, Thomas Sinsteden, Peter Spang, Laura and Seth Sprague, Melinda and Paul Sullivan, Marjorie and Louis Susman, Christa Thurman, Gayle and Glenn Tilles, Evelyn Tompkins, Ian Wardropper, Ruth and David Waterbury, and Alice and Peter Westervelt.

Given the exhibition's focus on tracing the histories of objects dispersed from Ireland, we have relied heavily on the goodwill and assistance of many gallerists and art dealers. Our deep thanks go to Ronald Bourgeault, Eamonn de Búrca, Rachel and Ben Elwes, Justin Evershed-Martin, Sarah and Christopher Foley, Deborah Gage, Jeremy Garfield-Davies, Tracy Gill and Simeon Lagodich, Sir Robert and Lady Goff, Térèse and James Gorry, Titi Halle, Anne and James Hepworth, Mary and

Alan Hobart, Angela Howard, Chris and the late Paul Johnston, Josephine Kelliher, Robin Kern, Patricia and Martin Levy, Lowell Libson, Tim Martin, James McConnaughy, Allen Miller, Martin Mortimer, Henry Neville, Tim Osborne, Chantal O'Sullivan, Colin Rafferty, Eric Shrubsole, Elle Shushan, Anthony Verschoyle, and Wynyard Wilkinson. We are also grateful to Steven Zick and Nicholas White at Christie's, to Arabella Bishop at Sotheby's and to Max Deliss, John Hardy, Liam Fitzpatrick, and Ronan Teevan.

A name that appears throughout this catalogue is that of Desmond FitzGerald, 29th Knight of Glin. He had long dreamed of organizing this exhibition in America, and he put his full support behind the Art Institute of Chicago when we made the decision to realize his vision. Between 2007 and his death in 2011, the Knight freely shared his research and ideas, even hosting us for a weeklong stay at his home, Glin Castle. The exhibition was at the forefront of his mind right up to the time of his death. In the Knight's memory, Sir John Richardson has had his eighteen Thomas Frye mezzotints specially conserved. Indeed, the Knight enjoyed an incredibly large and diverse circle of fiercely loyal friends, all of whom have contributed in some way to this project. It is our hope that *Ireland: Crossroads of Art and Design* will form part of his lasting legacy.

William Laffan
Christopher Monkhouse

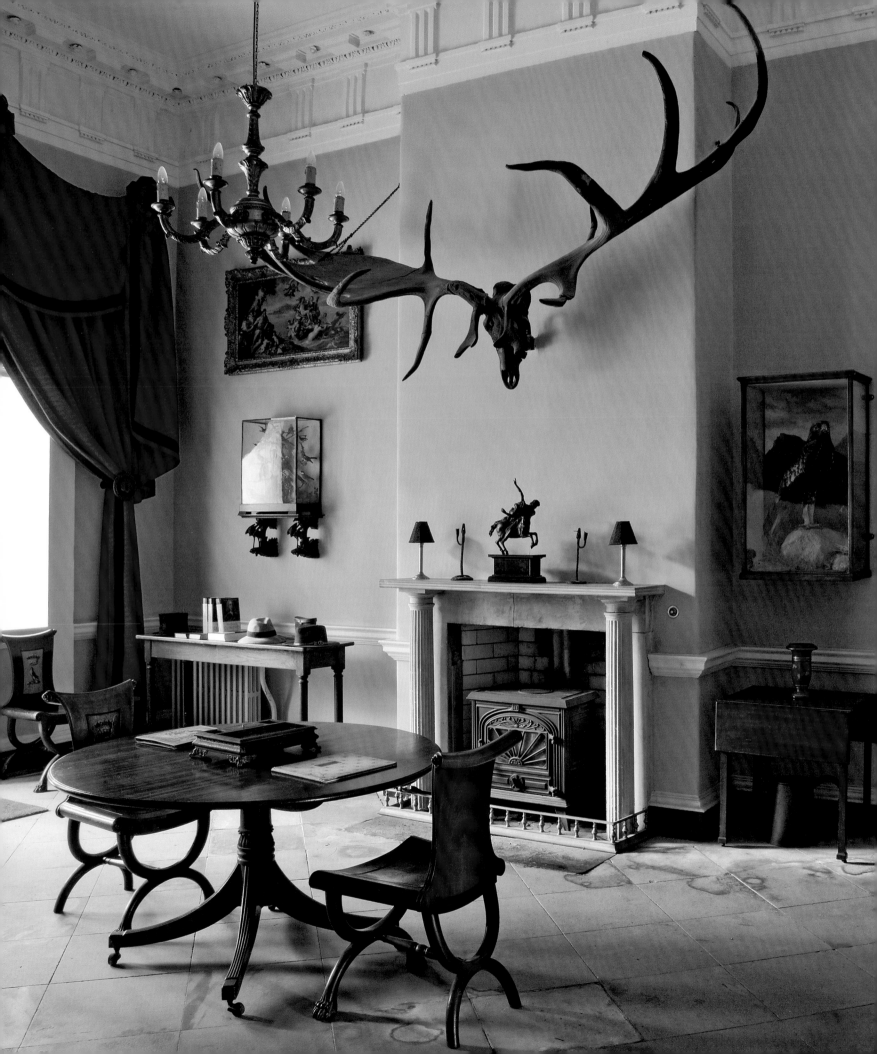

PREFACE

THE EXHIBITION AND CATALOGUE *Ireland: Crossroads of Art and Design, 1690–1840* celebrate connections among art, artists, patrons, and collectors that cross the boundaries of nations and media. The stories behind the works included here, and their movement from collection to collection, illustrate themes of identity, emigration, politics, and patronage.

The exhibition was conceived with a Chicago audience in mind, and one curatorial goal was to identify potential loans from public and private collections within the orbit of the Windy City. The Art Institute of Chicago's own important Irish holdings served as an impetus for the exhibition. The Snite Museum of Art at the University of Notre Dame in nearby South Bend, Indiana, as well as the Loyola University Museum of Art, the Newberry Library, and the American College of Surgeons, all in Chicago, have lent important objects with an Irish provenance.

While the inclusion of the American College of Surgeons may at first seem surprising, its loan has in fact become the natural starting point for introducing the exhibition. Dominating the entrance to the galleries are the skull and antlers of an extinct deer popularly known as the Giant Irish Elk (*Megaloceros giganteus*) (SEE CAT. 143, P. 237). The set serves as a symbolic welcome to visitors, evoking the eighteenth-century Irish tradition of mounting elk antlers in the entrance hall of a country house to suggest a family's long-held connection to the land.

The antlers also have the distinction of being the oldest object in the exhibition.

Spanning ten feet, they likely date to the close of the Ice Age, about eleven thousand years ago. At one time *Megaloceros giganteus* roamed much of Europe, northern Africa, Siberia, and China, but the vast majority of its remains have been found in Ireland buried in beds of marl, which preserved them. Subsequent layers of sediment became peat bogs, and estate workers harvesting the peat for heating fuel frequently discovered elk skeletons buried below. In the nineteenth century, these were excavated for their value as scientific specimens and antiquarian relics, and the first known example of a Giant Irish Elk skull and antlers crossing the Irish Sea to England occurred during the reign of Elizabeth I (1558–1603). Nearly a century later, Charles II received a pair of antlers, valuing "them so highly for their prodigious largeness" that he installed them in the Horn Gallery at Hampton Court.[1]

The skull and antlers in the exhibition highlight the deep, vital connection between Chicago and Ireland. Shortly after the American College of Surgeons established its headquarters here in 1913, the organization developed a particularly warm friendship with its equivalent in Dublin, the Royal College of Surgeons in Ireland. On the strength of those ties, and with the knowledge that the college in Chicago already had "a large number of very interesting heads of big game of the North American continent" on display, the Royal College presented it with the set in 1921. The skull and antlers had been discovered about nine miles southeast of Dublin in Ballybetagh

Bog, most likely by William Williams, a natural history preparator who earned a living from the sale of archaeological specimens.[2] The Royal College had purchased a skull and antlers as early as 1836 for its own museum in Dublin for the not-inconsiderable sum of £50. The 1921 gift truly expressed the deep bond existing between the two organizations.[3]

Through the ebb and flow of objects across the Irish Sea, Ireland became an international crossroads for art and design during the period from 1690 to 1840. The subsequent migration of objects, including these antlers, across the Atlantic Ocean has enabled us to include works in the exhibition from throughout the United States and Canada. These objects, through the history of their production and ever-changing ownership, truly place Ireland on a world stage.

Christopher Monkhouse
CHAIR AND ELOISE W. MARTIN CURATOR
DEPARTMENT OF EUROPEAN DECORATIVE ARTS
THE ART INSTITUTE OF CHICAGO

NOTES

1 Gould 1977, p. 80; see also Crookshank and Glin 1994, pp. 33–34.

2 As the site had been superficially explored in the 1840s, it warranted a second visit in 1876. Williams published his findings in Williams 1881. It seems highly likely he served as the source for the Royal College's 1921 gift. On the gift, see Royal College of Surgeons in Ireland, minutes book, November 18, 1920; January 20, 1921; and February 3, 1921. Also see Royal College of Surgeons in Ireland, copy letter book, 1921–24, pp. 5, 19, Mercer Library, Royal College of Surgeons in Ireland, Dublin.

3 Cameron 1916, p. 329.

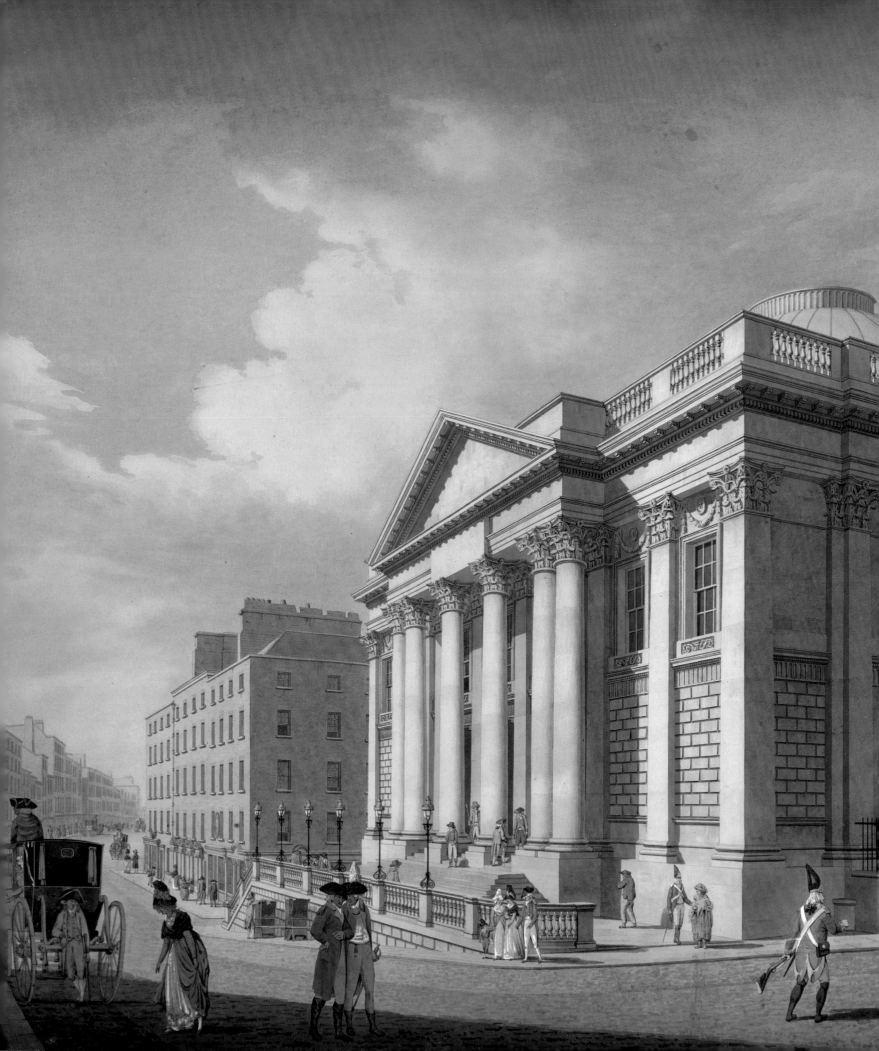

Colonial Ireland: Artistic Crossroads

WILLIAM LAFFAN

FOR SIX MONTHS IN 1893, two rival villages on the shore of Lake Michigan introduced visitors to the World's Columbian Exposition in Chicago to "the quaint charms of rural Ireland": a two-thirds reproduction of Blarney Castle with a piece of the Blarney Stone, an entrance copied from Cormac's Chapel on the Rock of Cashel, and a series of faux-Irish cottages formed a backdrop to demonstrations of an imagined Irish material culture with "lads and lasses . . . plying the needle, loom wheel, or carving tools"—all of them, one commentator noted, "actual Irish."[1] The villages on the Midway drew more than half a million visitors, and their portrayal of Ireland has shaped the American view of the country ever since, reinforcing "stereotyped visions of Ireland as a backward peasant society," nostalgic for its early Christian renaissance more than a millennium earlier.[2] This exhibition of fine and decorative arts from 1690 to 1840 offers a rather different picture. It explores the arts in Ireland from the Battle of the Boyne, which resulted in victory for the English, or Protestant, interest—what would become known a century later as the Protestant

Ascendancy—to the eve of the Great Famine that saw a million starve and two million emigrate. In exploring the Irish material world over a century and a half, with an emphasis on Dublin rather than the more usual rural focus, it becomes apparent that the very specific circumstances of colonial Ireland made it a place of artistic fusion, occasional brilliance, and, perhaps surprisingly, cosmopolitan sophistication.

Acknowledging that any single display can only offer a partial overview of a nation's arts or material culture, this project takes its place alongside a series of recent American exhibitions that combine to offer a more complex and multifaceted picture of Ireland than the 1893 exposition's presentation allowed. The utilitarian furniture, humble utensils, and implements of the rural poor— and their depiction in art—was the subject of *Rural Ireland: The Inside Story*, held in 2012 at the McMullen Museum, Boston College. The following year, *Nobility and Newcomers in Renaissance Ireland*, at the Folger Shakespeare Library in Washington, D.C., illuminated the period immediately before our exhibition begins, exploring how the different waves of invaders from England fought—and cooperated—with one another and with the native Irish. It shared our exhibition's thesis that

Ireland can only be understood as a "truly international place" and a "melting pot of cultures," a place of "creativity amid great turmoil and destruction."[3] In 1992 the Smart Museum of Art at the University of Chicago explored the period immediately after our exhibition ends in *Imagining an Irish Past: The Celtic Revival, 1840–1940*.

Twentieth-century painting and contemporary Irish art have also been showcased comprehensively in North America, notably in *When Time Began to Rant and Rave: Figurative Painting from Twentieth-Century Ireland* at the Berkeley Art Museum (1998) and *Irish Art Now: From the Poetic to the Political* (1999–2000).[4] In the catalogue to the exhibition *Irish Art Now*, which visited Boston and Chicago in 1999, Fintan O'Toole made much the same point about the country in the late twentieth century as the Folger exhibition had for the seventeenth: that "contested places can become imaginative spaces."[5] Acknowledging these insightful exhibitions, and, more specifically, building on the fruits of a flourishing of new scholarship on the arts of Georgian Ireland published in the last two decades, this exhibition aims to fill the gap identified some years ago by Desmond FitzGerald, Knight of Glin, and James Peill, who called for "a major exhibition on Ireland's decorative arts of the eighteenth

James Malton. *Dublin, Royal Exchange*, 1795 (detail). Cat. 85 (see p. 231).

century" that would "give an overview of the shared patrimony with England and the continent and show the high level of craftsmanship achieved in Ireland at that time."[6]

Much ink has been spilled debating the question of Ireland's precise constitutional position vis-à-vis England, in particular, the question of whether Ireland was a colony.[7] Not quite is the best answer; it had, after all, its own parliament for most of the period covered by the exhibition, although even after legislative independence was won in 1782, the power of the exclusively Protestant parliament was to a large extent illusory, and the executive in Dublin Castle led by the lord lieutenant—a position that after 1710 was exclusively occupied by an Englishman—held the real power. Certainly it was not a colony in the same sense that the thirteen settlements on the Eastern Seaboard of North America were. At the same time, however, it seems that a colonial mindset prevailed, at least for some. Jonathan Swift, for instance, wrote that British ministers "look down upon this kingdom as if it had been one of their colonies of outcasts in America."[8] Later in the century, Charles Lucas claimed that the Irish had been treated by English settlers "as the Spanish used the Mexicans, or as inhumanely as the English now treat their slaves in America."[9] Nor was this merely the rhetoric of aggrieved Protestant patriots. John Gwynn, the English architect and planner, could write twenty years later in 1766 in connection with the foundation of the Dublin Society Drawing Schools, "Should we not be displeased, as a Nation, to be ranked, by Foreigners, after one of our own Colonies."[10] If, as James Kelly writes, "Ireland's political relationship with Britain was every bit as colonial as that of the American colonies," an important psychological difference that exacerbated the colonial mentalité was that in Ireland, the new English settlers and their descendants lived cheek by jowl with the displaced Catholic majority, who, deprived of civic rights and religious

freedoms, were felt by many within the Protestant interest to be, by definition, hostile, ridden with superstition, and plotting to regain ancestral lands.[11]

The recent and sometimes seemingly precarious nature of their settlement (with "multitudes of ignorant and barbarous Enemies, ready to overwhelm" it, as an eminent divine put it) imparted to the Protestant Irish a frontier mindset born of uncertainty of status and ambiguity of identity.[12] Exquisite refinement lived side by side with rough-hewn rusticity, urban squalor, and not-infrequent brutality; whimsy and caprice combined with steely resolution and "a certain savagery of mind."[13] Calculating self-interest, patriotism, and religious belief coalesced in the doctrine of "improvement," in effect the desire to make Ireland more like England: prosperous, Protestant, hardworking, and Anglophone. Yet even at the end of our period in 1840 about half of Ireland's population, then at its high of over eight million in the period preceding the Great Famine of the mid-nineteenth century, still spoke Irish as their mother tongue, and conversions to the established church had been paltry.[14]

Colonial insecurity could take different forms. On the one hand, it led to a cringing deference to the mother country. When Dublin's Royal Exchange (SEE P. 18) was being planned and an architectural competition arranged, the *Freeman's Journal* noted that the desirability of English architects submitting was "too obvious to be insisted on."[15] The newspaper went further when the first three premiums were awarded to English architects, noting how their designs had led the Irish architects who had seen them "out of darkness into marvelous light." On the other hand, there was a distinct feeling that Dublin could, and should, outdo England in architectural scale and splendor: "the architecture of Parliament, of tax gathering (Gandon's Custom House), of education (Trinity College), of justice (the Four Courts),

outshone . . . anything that London could show in related genres."[16] The showy extravagance of the Parliament House, however, does not in itself speak of nationhood; instead, "like the self-conscious pretentiousness" of the government buildings unveiled at Stormont outside Belfast in 1932, it demonstrated that Ireland's status was "not international but colonial" and that there was a "determination to compensate" for this unpalatable truth.[17]

Building, landscaping, and the arts in general were crucial components of the colonial experiment. In his *Reflections and Resolutions Proper for the Gentlemen of Ireland* (1738), Samuel Madden, having offered his views on improving the banking system, noted a further area in need of reform "to make our people more industrious"—the encouragement "by proper premiums [of] those politer arts which are . . . strangers to our country, I mean sculpture, painting and architecture."[18] Madden's motivations for this were various: "to employ and enrich our people," to act as a "spur on their industry," and to "improve our taste and adorn our country." Art is here given a role in Madden's civilizing—or, put another way, colonizing—purpose. This colonial (Madden would have said "improving") intent is clear throughout his work. Among the "resolutions" the book offers, alongside well-intentioned ideas on promoting the linen industry, is to "bring over our Countrymen from the delusions and ignorance which they are kept in by the Popish Priests, as the greatest cause of their misery." The conflicts and contradictions within colonial nationalism are all too apparent: it is resolved both "to use no sort of Clothes and Furniture which are not manufactured in Ireland" and "never to hurt the trade or interests of Great Britain"—a difficult circle to square. For Madden, art had a crucial place in both civilizing Ireland and improving her economy. The promotion of painting and sculpture, he argued, "would create infinite business for our artists and

amusement and delight for our gentry." The arts could act as a barometer of the wider project to make Ireland English and Protestant, "as they have . . . been considered by all civilized nations as the greatest elegancies and ornaments of every country, so that utter neglect of them, which prevails in Ireland, will ever be a proof against us of barbarism and Gothic ignorance, until we shake it off."

Focusing on the "elegancies and ornaments" that Madden and his fellow improvers promoted—the products, for example, of the World's End Pottery, which the Dublin Society supported financially—the exhibition reflects the distinct confessional bias in the consumption of material goods. But, when they could, the majority Catholic population also aspired to membership in the consumer society, and they too commissioned and created works of art. The furniture and utensils of the Catholic Irish, in Dublin at least, often differed little from those of their conforming peers, though distinct religious typologies and iconographies were developed, evident in chalices, devotional prints sold at fairs, or the "penal" crosses bought by pilgrims, moving in their expressionist simplicity (SEE FIGS. 1–2 AND P. 75, FIG. 18).[19] A portrait of a Gaelic warlord (SEE P. 42, FIG. 4) or a Catholic bishop (SEE P. 55, FIG. 22) serves as a reminder that the well connected of all faiths could avail themselves of the services of artists, while several of the leading painters of the period, notably James Barry and James Forrester, were Catholic. Surviving traces of the material culture of the urban and rural poor before the mid-nineteenth century are, however, exiguous in the extreme, though their appearance and usage can occasionally be re-created from other sources; *Three Papist Criminals Going to Execution* (FIG. 3) shows, for example, the consolatory power of religious artifacts. This haunting image comes from Hugh Douglas Hamilton's *Cries of Dublin* of 1760 (CAT. 50), which is invaluable for its unmediated

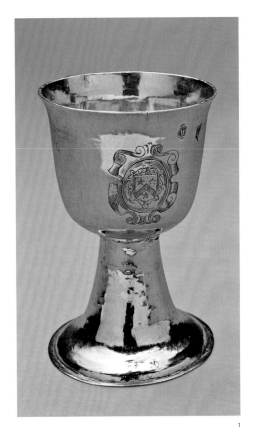

1

portrayal of the urban underclass, offering an unusually vivid evocation of the bleakness of existence for those at the very bottom of Ireland's social order.[20] Elsewhere in Hamilton's album, the world of goods at its most basic level is shown as a variety of artifacts is used, traded, or repaired: bellows, brogues, hearses, musical instruments, newspapers, secondhand wigs and clothes. What Hamilton occasionally makes apparent is how sometimes more than just the bare necessities of life were available to—or could at least be coveted by—the humble.[21] In another drawing, a young girl, perhaps a lady's maid, tries out a pair of scissors from among the baubles offered by a chapman, or peddler (FIG. 4).[22]

Hamilton was a prize-winning pupil of the Dublin Society Schools, which were set up as part of the concerted effort in the 1740s by Madden and other improvers to better the state of the kingdom's artistic production and, hence, its manners. Hamilton went from

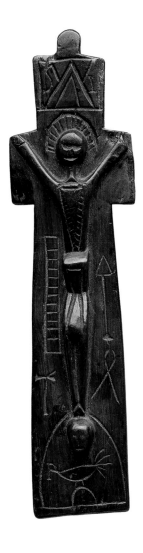

2

Fig. 1
Andrew Gregory. Traveling Chalice, 1680/81. Private collection by arrangement with S. J. Shrubsole, New York. Cat. 269.

Fig. 2
Crucifix, 1776. Snite Museum of Art, University of Notre Dame, Gift of Rev. James S. Savage. Cat. 316.

3

4

relatively humble beginnings—his father was a wig maker—to success in London and Rome. Although one of his masterly portraits hangs in the National Gallery of Art in Washington, D.C., Irish artists, with only a few exceptions, tend to be little known outside Ireland. When the exhibition *Master European Paintings from the National Gallery of Ireland: Mantegna to Goya* traveled to North American museums including the Art Institute of Chicago in 1992, "many puzzled viewers asked where the Irish artists were."[23] This exhibition addresses this lacuna with works by Hamilton; by the incomparable Thomas Roberts; by Nathaniel Hone, who challenged Sir Joshua Reynolds's authority in the Royal Academy; by James Barry, the "Great History Painter" who influenced both Jean-Auguste-Dominique Ingres and Eugène Delacroix; and by many other artists unfamiliar to most, among them Susannah Drury, Jonathan Fisher, Thomas Frye, Robert Healy, James Latham, and Stephen Slaughter. But the exhibition also acknowledges the inherent difficulty in singling out the *Irish* component of the material world of an island colonized by its nearest neighbor, with porous borders, a government that actively encouraged the settlement of Protestant craftsmen from Continental Europe, and patrons who often preferred the work of nonnative artists.

There was no homogenous Irish culture, not even a homogenous Protestant culture. Not all Protestants were rich, nor indeed were all Protestants Anglican; nonconforming Presbyterians in the north and Quakers throughout the country were equally excluded from power and defined their own material cultures and distinct architectural typologies. Following recent scholarship, the exhibition presents the arts of colonial Ireland as a complex amalgam of homegrown, English, and Continental influences that combined to form the paradox of what Toby Barnard describes as a "distinctive and derivative" culture.[24]

Figs. 3–4
Hugh Douglas Hamilton. Left, *Three Papist Criminals Going to Execution*; right, *Hard Ware*, from *The Cries of Dublin*, 1760. Private collection. Cat. 50.

Fig. 5
The Long Gallery, Castletown, County Kildare, c. 1935. Country Life Picture Gallery.

Fig. 6
Meindert Hobbema. *A Wooded Landscape*, 1663. National Gallery of Art, Washington, D.C., Andrew W. Mellon Collection, 1937.1.61. Cat. 59.

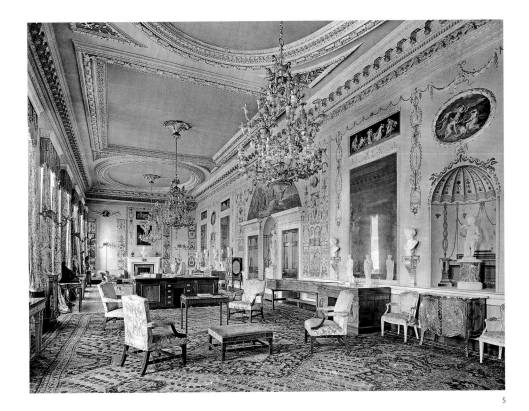

5

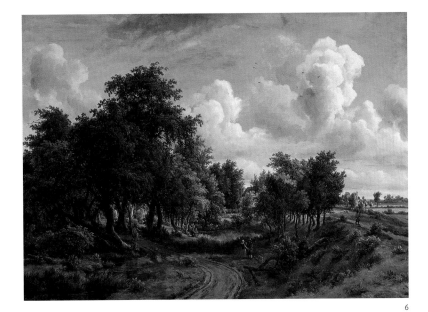

6

These seemingly contradictory characteristics reflect the conflicting impulses that regulated the consumption of luxuries in Ireland: the desire to support local industry and take pride in indigenous manufactories and the lure of the imported, exotic, or just metropolitan. The principle of patriotic consumption—the "Buy Irish" card—was articulated by Jonathan

Swift in a pamphlet published in the summer of 1720, *A Proposal for the Universal Use of Irish Manufacture in Cloaths and Furniture of Houses etc., Utterly Rejecting and Renouncing Everything Wearable That Comes from England.* Two years later, in July 1722, Sir John Perceval expressed the same aspiration rather more poetically, hoping that Castletown, the great Palladian

mansion in County Kildare then under construction, should become "the epitome of the kingdom" and be built exclusively from Irish marble, metal, and wood.[25] It is rather telling, however, that in the end Castletown was something of a hybrid. Built to designs by the Italian Alessandro Galilei but completed by the Irish architect Sir Edward Lovett Pearce, it was furnished in the next generation by the Dublin cabinetmakers Richard Cranfield and Cooper Walker but given additional elegance with cabinets by the French *ébéniste* Pierre Langlois, polychromatic chandeliers of Murano glass, and Pompeian *grotteschi* (SEE FIG. 5).[26]

Another complex mix of sources and craftsmen can be seen in the decoration of Ballyfin, County Laois, in the 1820s. There, Cork-born Richard Morrison and his son William Vitruvius combined the Empire style of Percier and Fontaine—specifically, their work at the Royal Palace of Aranjuez outside Madrid—with Moorish designs inspired by the pavement in the Lion Court of the Alhambra in Granada.[27] Ballyfin itself was furnished with Italian chimneypieces, sculpture by artists such as Johann Gottfried Schadow, and furnishings purchased in Italy through the agent Gaspare Gabrielli, a Rome-based artist who had worked extensively in Ireland. Personal links such as this enabled Sir Charles Coote, the builder of Ballyfin, to acquire works of art from Paris or Italy without the need to leave Ireland. Closer to home, Matthew Pilkington, a sometime friend of Swift's, helped Archbishop Charles Cobbe and his son Thomas put together a splendid collection of Old Masters for Newbridge near Dublin, including Meindert Hobbema's masterpiece *A Wooded Landscape* (FIG. 6), while also compiling the first biographical dictionary of artists' lives in English.[28]

A similar amalgam of influences was Joseph Leeson's Russborough, on which, as one contemporary noted, "artificers from most parts of Europe" were employed.[29]

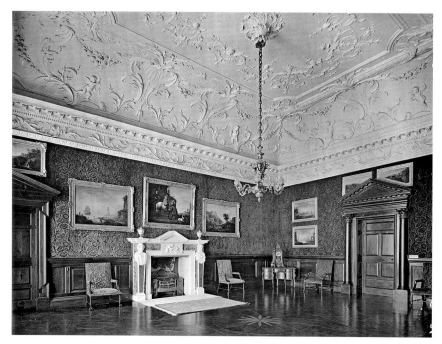

7

Fig. 7
The Saloon at Russborough, County Wicklow, with a set of mahogany armchairs commissioned by the first Earl of Milltown (see p. 103, fig. 7). Country Life Picture Library.

Fig. 8
Venus Genetrix, 2nd century A.D. The J. Paul Getty Museum, Villa Collection, Malibu, California, Gift of Barbara and Lawrence Fleischman. Cat. 315.

Fig. 9
George Wickes. Epergne and Stand, 1742/43. Courtesy of the Colonial Williamsburg Foundation. Cat. 295.

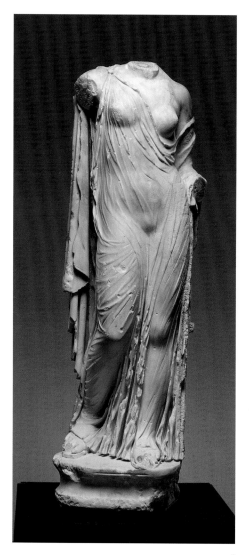

8

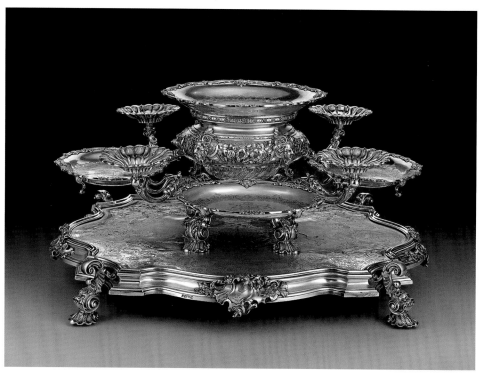

9

Fig. 10
Giovanni Battista Cipriani. *Four Studies for Statues of Apollo, Venus, Bacchus, and Ceres for the Marino Casino, Clontarf, County Dublin*, 1760. Private collection. Cat. 25.

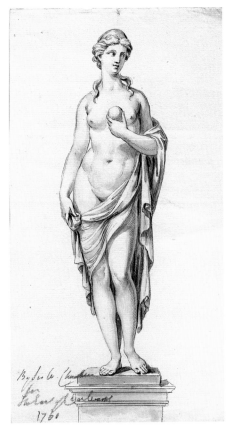

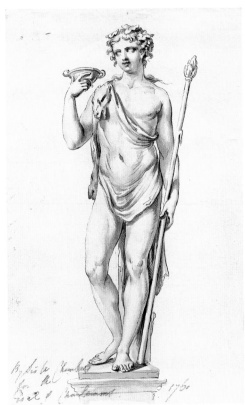

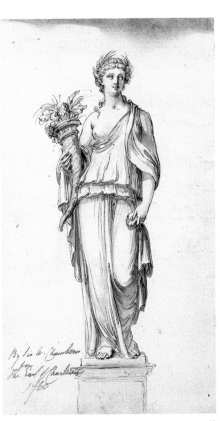

Russborough was designed by Richard Castle, an émigré architect of Jewish origin (with the possible help of Francis Bindon from County Clare) in a Palladian style originating in the Veneto; its interior stucco, among its greatest glories, was in large part executed by the Ticinese (Italian Swiss) Lafranchini brothers; its saloon (SEE FIG. 7), hung with Genoese velvet, housed a great collection of mostly Italian paintings bought on two grand tours in addition to Classical sculpture both ancient and more recent (SEE FIG. 8). Much of its silver was supplied at huge expense by George Wickes of London, including a centerpiece now in the collection of the Colonial Williamsburg Foundation (FIG. 9). In telling contradistinction to Perceval's desire for the symbolic use of Irish oak at Castletown, at Russborough mahogany from San Domingo was extensively deployed.

If there is a sense at Ballyfin and Russborough of the ostentatious spending of a recently acquired fortune, Leeson's sometime companion in Rome, James Caulfeild, Lord Charlemont, was a much more sophisticated patron and collector. But his case, too, illustrates the internationalism of much Irish architecture and decorative art. He conceived his temple to the arts, the Marino Casino (SEE P. 107, FIG. 15), during his grand tour, on which he measured the Acropolis and surveyed the villas of Palladio. It was designed by Sir William Chambers—an architect of Scottish Swedish ancestry who had traveled in China—with the involvement of the Anglo-Dutch sculptor Simon Vierpyl, and with statues designed by the London-based Italian Giovanni Battista Cipriani (SEE FIG. 10). All had met in Rome.[30] Charlemont was among the most enlightened Irish patrons of the period. In London he was friendly with William Hogarth, commissioning from him a painting of a subject, and at a price, of the artist's own choosing: *The Lady's Last Stake* of 1759 (FIG. 11).[31] In Rome he was a

10

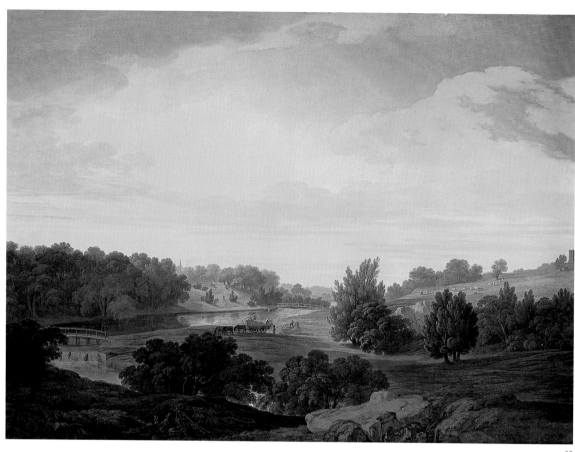

20

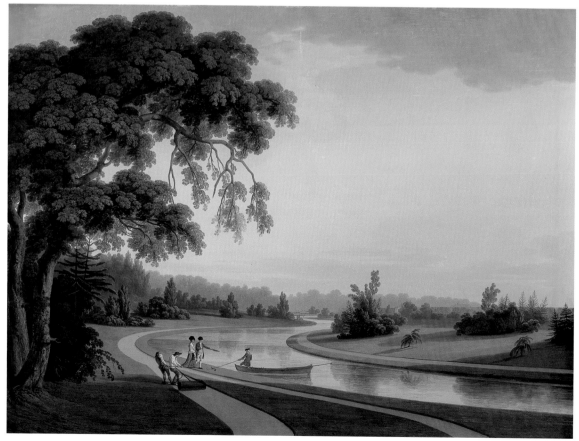

21

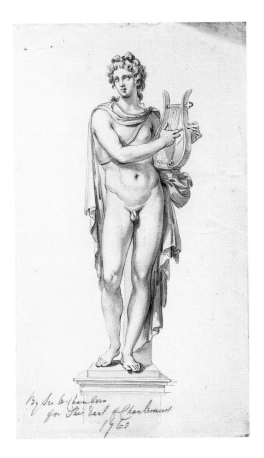

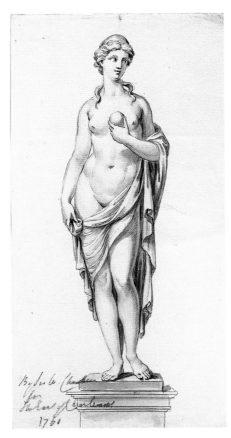

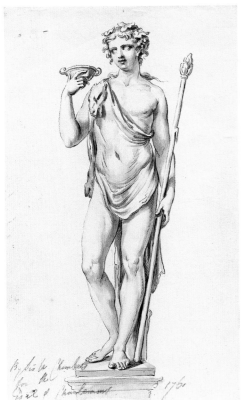

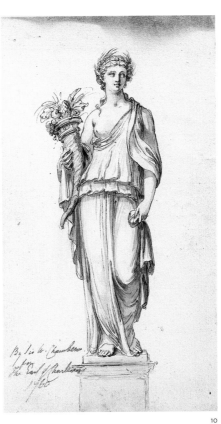

Russborough was designed by Richard Castle, an émigré architect of Jewish origin (with the possible help of Francis Bindon from County Clare) in a Palladian style originating in the Veneto; its interior stucco, among its greatest glories, was in large part executed by the Ticinese (Italian Swiss) Lafranchini brothers; its saloon (SEE FIG. 7), hung with Genoese velvet, housed a great collection of mostly Italian paintings bought on two grand tours in addition to Classical sculpture both ancient and more recent (SEE FIG. 8). Much of its silver was supplied at huge expense by George Wickes of London, including a centerpiece now in the collection of the Colonial Williamsburg Foundation (FIG. 9). In telling contradistinction to Perceval's desire for the symbolic use of Irish oak at Castletown, at Russborough mahogany from San Domingo was extensively deployed.

If there is a sense at Ballyfin and Russborough of the ostentatious spending of a recently acquired fortune, Leeson's sometime companion in Rome, James Caulfeild, Lord Charlemont, was a much more sophisticated patron and collector. But his case, too, illustrates the internationalism of much Irish architecture and decorative art. He conceived his temple to the arts, the Marino Casino (SEE P. 107, FIG. 15), during his grand tour, on which he measured the Acropolis and surveyed the villas of Palladio. It was designed by Sir William Chambers—an architect of Scottish Swedish ancestry who had traveled in China—with the involvement of the Anglo-Dutch sculptor Simon Vierpyl, and with statues designed by the London-based Italian Giovanni Battista Cipriani (SEE FIG. 10). All had met in Rome.[30] Charlemont was among the most enlightened Irish patrons of the period. In London he was friendly with William Hogarth, commissioning from him a painting of a subject, and at a price, of the artist's own choosing: *The Lady's Last Stake* of 1759 (FIG. 11).[31] In Rome he was a

10

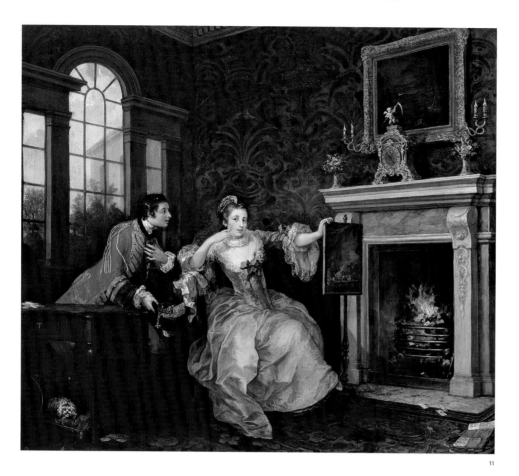

11

supporter of Giovanni Battista Piranesi (until they fell out spectacularly, and the Irish peer's name was effaced from the frontispiece of the second edition of *Le antichità romane* [SEE FIGS. 12–13]).[32]

While Charlemont promoted international Neoclassicism in Ireland ("to make what Greece, what Rome, can boast of, ours"), he was not immune to the charms of the East and was one of a hundred or so Irish patrons to commission an armorial dinner or tea service from China (SEE FIG. 14).[33] The chain of the Order of Saint Patrick on a piece of Qianlong porcelain is a telling sign of the incipient globalization in the production and distribution of luxury goods. Another cross-fertilization of Ireland and the East, here mediated through French Rococo, is a silver dish ring (a particularly Irish form) made by Charles Townsend in Dublin in 1772 with faux-Chinese decoration (FIG. 15).[34] As in England and France, the taste for chinoiserie permeated many of the applied

arts and is exemplified by the imitation of Chinese designs on Dublin delftware (see Peter Francis's ceramics essay in this catalogue); by rooms decorated with imported Chinese paper at Westport, County Mayo (c. 1780–90) and Caledon, County Tyrone (c. 1820–30); and less visibly (though, for this very reason, showing just how pervasive *le goût chinois* had become) in the use of Chinese fretwork patterns on the service staircases of Dublin townhouses.[35] Charlemont had traveled in the eastern Mediterranean, and he commissioned an Egyptian room from the Swiss architect Johann Heinrich Müntz to house a collection of antiquities (SEE FIG. 16). Another family of great Irish travelers, the Belmores of Castle Coole, County Fermanagh, also acquired Egyptian treasures, notably the large stone bark of Queen Mutemwia, mother of Amenhotep III, now in the British Museum, London; John FitzGibbon, 2nd Earl of Clare, who served as governor of Bombay and subsequently Bengal, brought

Fig. 11
William Hogarth. *The Lady's Last Stake*, 1759. Collection of Albright–Knox Art Gallery, Buffalo, New York, Gift of Seymour H. Knox., Jr., 1945. Cat. 60.

Fig. 12
Giovanni Battista Piranesi. Frontispiece to *Le antichità romane*, 1st edition, vol. 1, 1756. The John Work Garrett Library, Johns Hopkins University, Fowler Collection. Cat. 178.

Fig. 13
Giovanni Battista Piranesi. Frontispiece to *Le antichità romane*, 2nd edition, vol. 1, 1757. Vincent and Linda Buonanno. Cat. 179.

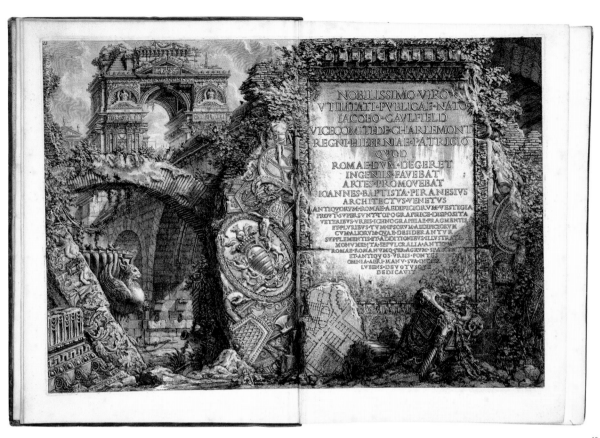

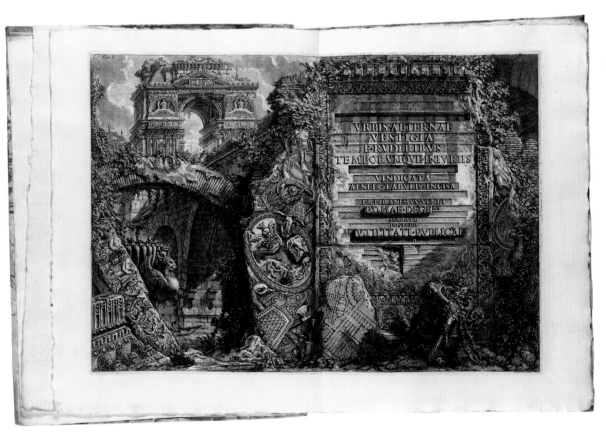

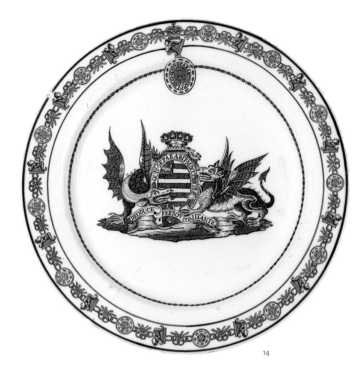

14

15

Fig. 14
Dinner Plate with the Arms of James
Caulfeild, 1st Earl of Charlemont, and
Insignia of the Order of Saint Patrick,
c. 1785. Private collection. Cat. 215.

Fig. 15
Charles Townsend. Dish Ring, 1772.
The Art Institute of Chicago, Kay and
Frederick Krehbiel, Joseph P. Gromacki,
Jenner and Block, the Avrum Gray
Family Fund, 2011.1169. Cat. 287.

home to Limerick a trove of Asian artifacts.[36] Objects from the East could do more than satisfy acquisitive desire or supply a decorative flourish. In a portrait by John Michael Wright (SEE P. 42, FIG. 4), the Japanese armor at Sir Neil O'Neill's feet was most likely included in response to reports of the persecution of Jesuit missionaries in Japan. O'Neill presents himself as a defender of his faith with "the arms of its persecutors lying like a trophy at his feet."[37]

For those on both sides of the confessional divide, travel in Europe inspired purchases of luxury goods. In about 1745, a member of the MacElligott family from County Kerry who had fought for James II at the Boyne and served in the armies of France and Austria commissioned armorial porcelain from the Meissen factory near Dresden.[38] Six years later, another émigré Catholic, Lawrence Carew of Cádiz, presented an elaborate Baroque silver candlestick and a reliquary crucifix to Saint Patrick's Church in his hometown of Waterford.[39] Later in the century, William FitzGerald, Marquis of Kildare, toured the Meissen manufactory when on his grand tour but demurred when it came to purchase, writing to his mother with characteristic common sense, "It is immensely dear, or otherwise I should have been tempted"; even for the heir to a dukedom, price was key in purchasing decisions. Writing from Paris six years later, however, he informed his mother that he had succumbed to the charms of Meissen's great French rivals: "I have ruin'd myself with a sett of Seve China—it is beautiful."[40] Related to the FitzGeralds by marriage, though several degrees below them in the social pecking order, Charles Tisdall, a squire from Meath, shopped extensively in Paris in the 1740s, recording expenditures on a post chaise, a gold-headed cane, a gold repeating watch, and a suite of furniture in "red velvit embroidered with gold."[41] Like his relations, though, he also patronized the Dublin silversmith Robert Calderwood and bought more workday furniture locally near Kells.

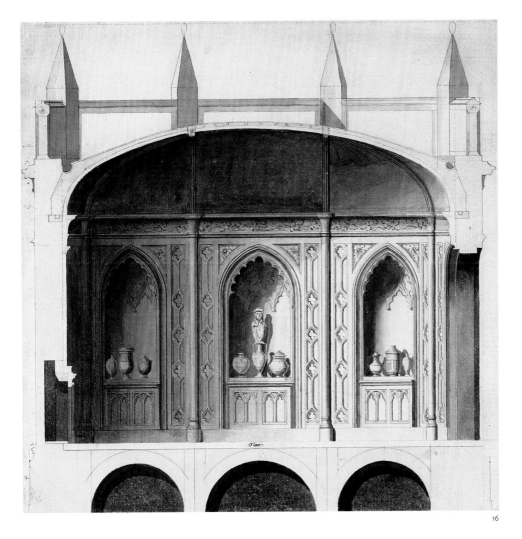

16

Fig. 16
Johann Heinrich Müntz. *Dublin: Marino House, Design for an . . . Egiptian Room*, 1762. Courtesy of the Lewis Walpole Library, Yale University. Cat. 91.

Collecting by grandees had a direct impact on artists back in Ireland. Both Charlemont and Leeson owned works by Claude Lorrain, as did the ducal Leinsters, who acquired *Coast Scene with Europa and the Bull* (FIG. 17) through the second duke's marriage to Emilia Olivia St George. This great Claude painting, his "most sophisticated composition of the early 1630s," was recorded in 1795 as hanging in the James Wyatt–designed picture gallery at Leinster House in Dublin and later in the saloon at Carton (SEE P. 50, FIG. 16).[42] Charlemont and the Leesons were known for the easy access they granted to their collections, especially to artists, and they and the Leinsters were active patrons of the Dublin group of landscape painters, notably George Barret and Thomas Roberts. These artists formed a distinctive and highly accomplished body of work, taking inspiration from great masters such as Claude and Hobbema, from the Irish landscape, and possibly, too, from a precocious adaptation of plein air painting.[43] Canvases by Barret and Roberts hung in Leinster House alongside the Claude, as well as works by Peter Paul Rubens and Rembrandt van Rijn, and at Russborough side by side with a Nicolas Poussin. Roberts's set of views of the grounds of Carton, unfinished at his premature death in 1777, is one of the supreme achievements of Irish landscape painting, a field in which, as was recognized at the time, Ireland excelled (FIGS. 18–21).[44] Nor was it just magnates like Kildare or connoisseurs such as Charlemont who owned good pictures. Visiting Castle Oliver in County Limerick, the English agricultural improver Arthur Young noted a group of five fine paintings by Sebastiano Ricci, including *The Continence of Scipio* (FIG. 22). These took their place alongside the elegant house and park with its picturesque cascade, glen, and hermitage to demonstrate that the proprietor was an improving gentleman.[45]

Increasingly as the eighteenth century passed, those at a less elevated social level than Leeson or Charlemont could sample Continental and Eastern goods, especially in the entrepôt of Dublin, and some of the middling sort were just as avid as the great in their pursuit of the novel. In January 1753, Richard Murphy's shop at the corner of Eustace Street offered "French gold and silver t[h]reads," "Dresden handkerchiefs and ruffles," and Indian pictures and tea boards.[46] Five years later, a rival emporium nearby on Bachelor's Quay noted its recent importation of "rare old Japan jars," "Dutch chimney tiles," and "a variety of Chelsea figures."[47] When in 1763 "the entire household furniture" of Francis Pierpoint Burton's home on Sackville Street was offered for sale, it included India chintz curtains, Turkish and Wilton carpets, and "a

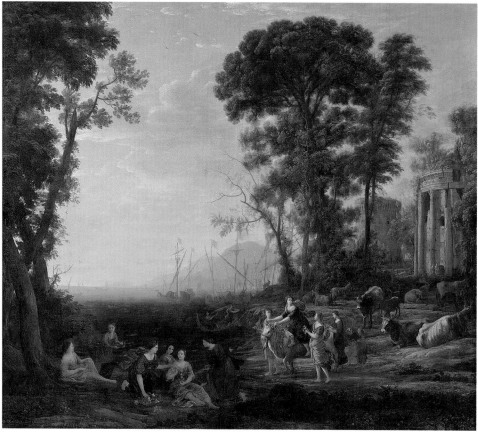

17

Fig. 17
Claude Lorrain. *Coast Scene with Europa and the Bull*, 1634. Kimbell Art Museum, Fort Worth. Cat. 80.

Fig. 18
Thomas Roberts. *The Bridge in the Park at Carton with Workmen Landing Logs from a Boat*, 1775–76. Private collection. Cat. 108.

Fig. 19
Thomas Roberts. *A View in the Park at Carton with the Ivory Bridge in the Foreground*, 1775–76. Private collection. Cat. 110.

fine set of French gilt wine glasses."[48] Nearby on Abbey Street, Mary Bijar, "just arrived from London," opened "an Indian ware-house" where she sold Chinese wallpapers as well as "Indian silks . . . painted Indian calicoes, India dressing boxes . . . tea chests . . . a variety of Indian fans . . . and . . . Turkish coffee."[49] Among the attractions of a house being sold in 1724 "near the barracks of Dublin" were "Indian pictures" and a hall "inlade with Italian marble."[50] Indeed, it is arguable that, in terms of commodities available for purchase, Dublin of the 1750s was a far more cosmopolitan place than in the 1950s.

As well as a flow of works of art into Ireland, there was fluid movement of craftsmen from Europe who came to work for short periods, or to settle and spend entire careers, bringing with them new ideas, skills, and techniques. Huguenots comprised 22 percent of the free brothers of the Goldsmith's Company of Dublin—a disproportionate number, as this émigré French Protestant community made up only about 3.5 percent of the city's population—and they were also instrumental in developing the silk industry.[51] John Odasha, one of the earliest pioneers of Irish glassmaking, was an Italian from Holland, while John Rocque, a French cartographer, produced a pioneering map of Dublin (P. 71, FIG. 13) and beautifully executed estate surveys on which he employed the budding talents of Hugh Douglas Hamilton (P. 99, FIG. 2; SEE ALSO CAT. 114, P. 233). Hamilton and a whole generation of Irish artists were trained in the French tradition at the Dublin Society Schools, whose founding master, Robert West, was a pupil of Carle Vanloo.[52] French Rococo prints circulated widely, and French books were avidly consumed.[53] In 1768 James Reilly could exhibit

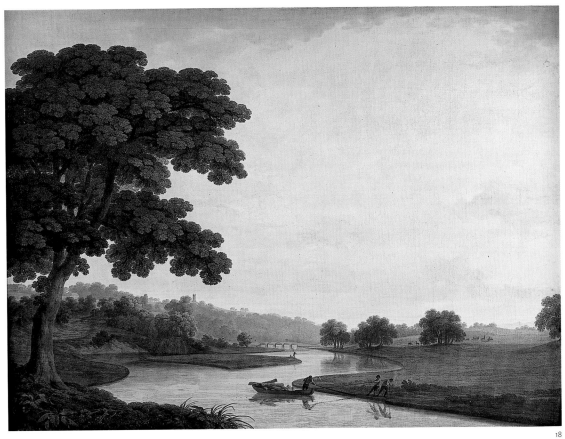

18

19

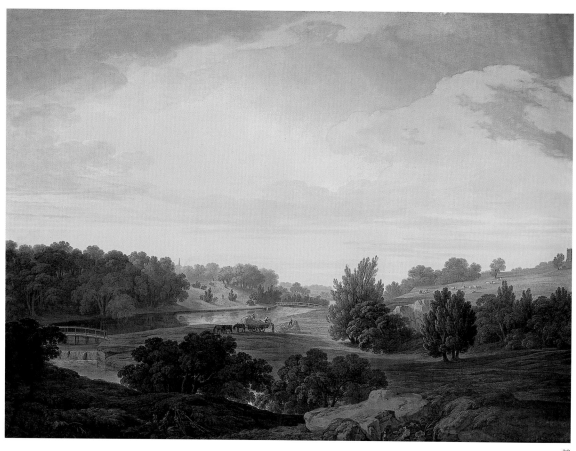

20

21

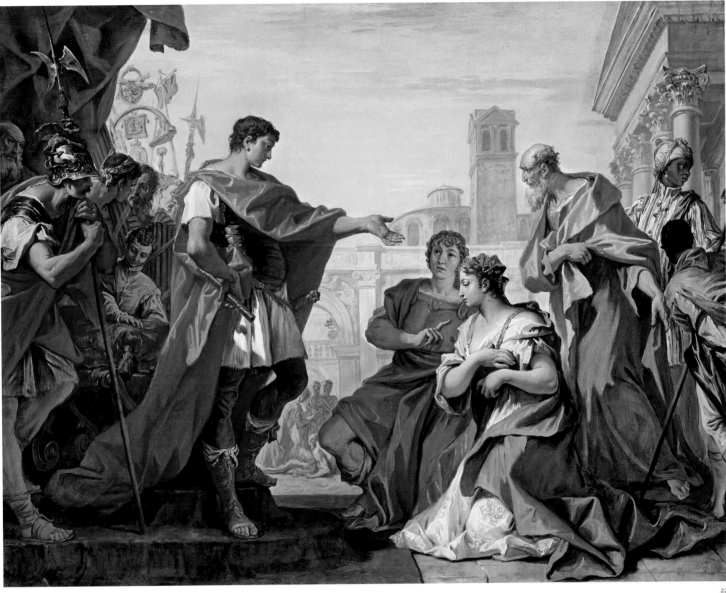

22

Fig. 20
Thomas Roberts. *A View in the Park at Carton with Haymakers,* 1776. Private collection. Cat. 111.

Fig. 21
Thomas Roberts. *The Sheet of Water at Carton, with the Duke and Duchess of Leinster About to Board a Rowing Boat,* 1775–76. Private collection. Cat. 109.

Fig. 22
Sebastiano Ricci. *The Continence of Scipio,* c. 1706. The Art Institute of Chicago, Preston O. Morton Memorial Fund, 1970.106. Cat. 101.

a history painting in Dublin on the subject of Belisarius and note in the catalogue, without feeling the need for an explanatory gloss, that it was "From [Jean-François] Marmontel."[54] A year earlier, Peter Shee, who worked at the World's End ceramics manufactory, exhibited a *Shepherdess Bathing* from a design by the still-living François Boucher.[55] The French artist was also a popular source for Dublin stucco-work, while a mirror from the famed workshop of Francis and John Booker is decorated with a frieze taken from the *Livre d'ornements* (1734) by Juste-Aurèle Meissonnier.[56] If the influence of French Rococo prevailed from about this date,

a little earlier, in the decades after William of Orange's 1690 victory at the Battle of the Boyne, a distinct Dutch inflection can be detected in Irish architecture, landscape design, and sculpture; the "Dutch Billy" townhouse, for instance, was ubiquitous, and its introduction actually anticipated its namesake's landing at Carrickfergus.[57] William van der Hagen pioneered landscape painting in Ireland from the 1720s to the 1740s, and in his commission to take prospects of Derry and the Boyne for tapestries decorating the House of Lords, one Dutch William commemorated the deeds of another.

33

The one national influence that, before about 1840, was stubbornly resistant to incorporation into the decorative arts of Protestant Ireland was the native Gaelic tradition. Civility was equated with Englishness, and for most of the period, the material cultures of English and Gaelic Ireland did not cross-fertilize. Antiquarians such as William Burton Conyngham commissioned drawings of early Christian and pre-Christian antiquities, and artists in his circle, including Thomas Roberts, made fruitful use of round towers and pre-Reformation ecclesiastical remains.[58] But this was unusual and in no way indicated a sympathy for the political plight of the native Irish; Conyngham, though friendly with the Catholic antiquarian Charles O'Conor of Belangare, was opposed to Catholic emancipation. The one great exception to this general rule, the appropriation of the Irish harp as a symbol, is discussed in Tom Dunne's essay in this catalogue.

The flow of artisans into Ireland was not all one way, and Irish artists were equally mobile and sometimes successful. Among the Irish painters who spent most of their careers in London was Charles Jervas, from County Offaly, the principal painter to Kings George I and George II; George Barret, born in the Liberties area of Dublin, was a founding member of the Royal Academy, of which Dublin-born Sir Martin Archer Shee rose to be president. Nor was it just painters who found success abroad. Samuel Cardy, a Dublin carpenter, was responsible for Saint Michael's Church (and probably the State House) in Charleston, South Carolina; the stuccodore Richard Tharp oversaw the plasterwork at Mount Vernon; and the White House was built to designs by James Hoban, a Catholic from Callan, County Kilkenny.[59] The first presidential portrait, a miniature of George Washington (1789; National Portrait Gallery, Washington, D.C.) was painted by John

Ramage, an American loyalist (and bigamist) from Dublin, while one of his classmates at the Dublin Society Schools, John James Barralet, produced elegant watercolors of Philadelphia's streetscape (1807; Dunlap House) and the symbolically charged *America Welcoming Irish Immigrants Ashore* (c. 1796; Winterthur Museum).[60] The Dublin-born merchant-decorator Plunkett Fleeson ran a highly diversified business in Philadelphia from the late 1730s until the American Revolution, supplying furniture, textiles, and wallpapers, while the leading wallpaper maker in prerevolutionary Bordeaux was another Irishman, Edward Duras.[61] Despite commercial restrictions placed on Irish trade, there was a lively exchange of goods between Ireland and North America, with Irish glass and linen being exported to the colonies.

The migration of artists, motifs, and objects was, of course, not unusual at this date, and Ireland formed an integral part of the British Atlantic world even as it maintained other, older, often Catholic, links to Continental Europe—to the wine and brandy trade of Bordeaux, the armies of Spain, and the Colleges of Paris, Prague, and Salamanca.[62] However, these multiple connections have sometimes been overlooked at the expense of a deeply entrenched habit of viewing Ireland's Georgian art and architecture solely, or primarily, in relation to England. This has led the appreciation and historiography of Protestant Ireland's material world to travel a curious arc shaped by half-truths and conflicting expediencies. When Russborough, Joseph Leeson's treasure-house in County Wicklow, was offered to the newly independent Irish state in 1929, it was rejected on the grounds that "Georgian is not an Irish style of architecture . . . [and] there seems no point in an Irish Government preserving as a national monument a building not distinctly Irish."[63] By suggesting that Ireland's architectural heritage was to be

sought in "structures of pre-Christian antiquity at Newgrange, round towers, churches at Glendalough, the Rock of Cashel," the new state symbolically disassociated itself from the architecture and artifacts of the more recent past in order to mark a clear break with the previous polity. In time there was a reaction to this one-dimensional view of Ireland's heritage—and then an overreaction. When in 1940 the archive of drawings by Michael Stapleton, the great Neoclassical stuccodore, was acquired for the National Library of Ireland, the hope was expressed that they "should finally abolish the myth of foreign craftsmanship that has grown about this period"; the Lafranchini brothers were to be written out of history.[64] If in a more sophisticated form, this position has become the orthodoxy and was best expressed by Desmond FitzGerald, Knight of Glin: "Even if the upper classes were considered 'foreign,' the craftsmen and the builders were Irishmen. The naïve assumption that these houses are to be seen as merely memorials to outdated colonialism should be resisted because they are in fact treasure houses of Irish skill."[65] However, claiming the architecture and decorative arts of the period as uniquely Irish—the work of Irish hands—is as wrong, or as half-true, as the earlier total denial of the Irishness of Irish Georgian architecture.[66] Such black-and-white assessments also serve to preclude a more nuanced understanding of complex issues of patronage—of how, for example, the Catholic Stapletons were employed in the twin redoubts of the Protestant establishment, Dublin Castle and Trinity College, and at the end of the eighteenth century could become major property owners in Dublin in a way impossible for their coreligionists at its beginning.[67]

All of these views of the Irishness of Irish culture in the long eighteenth century reflect the times that shaped them, as, no doubt, do the views expressed here. It was

as understandable for the Knight of Glin in the 1980s to stress the Irishness of Georgian architecture in his valiant attempts to save from destruction buildings he loved as it was—though to some this is less palatable—for the revolutionary generation to want to build anew on different foundations. As often, it took an outsider to bring fresh perspective. When Mario Praz, the great historian of Neoclassicism and interior decoration, visited Ireland, he saw beyond the British-Irish duality, perceiving in "the Georgian quarters of Dublin" their pan-European sources of inspiration: "Staircases and ceilings adorned with white rococo plasterwork, and with classical plasterwork in soft colours, white or pale green or light tawny brown . . . Venetian plasterwork, Pompeian plasterwork, the tombs of Via Latina, the palace of Split, the Mediterranean world shines out even here."[68] The study of the stuccoed interior, "arguably the apogee of visual culture" in Georgian Ireland, has continued to provide a model of how the migration of artisans and motifs from Europe to Ireland should be investigated. It shows that, as Conor Lucey has stated, "our shared design history" links "Como with Dublin, and Munich with Amsterdam," and that colonial Ireland was an excitingly dynamic artistic crossroads.[69]

NOTES

1 N. Harris 1992, p. 93.

2 N. Harris 1992, p. 99.

3 Herron and Kane 2013, p. ix.

4 Steward 1998; McGonagle, O'Toole, and Levin 1999.

5 O'Toole, "Ireland," in McGonagle, O'Toole, and Levin 1999, p. 25.

6 Glin and Peill 2007, p. xx.

7 See, for example, McDonough 2005; Howe 2008.

8 Quoted in J. Kelly 1991, p. 10.

9 C. Lucas 1751, quoted in S. Murphy 1993, p. 87. The contrary view, though emphasizing nomenclature rather than dissecting where real power lay, was articulated by William Molyneux in 1698: "Do not the Kings of England bear the *Stile of Ireland* amongst the rest of their Kingdoms? Is this agreeable to the nature of a *Colony*? Do they use the Title of Kings of *Virginia, New England* or *Mary-land*?" Molyneux 1698, p. 148.

10 Gwynn 1749, p. 35.

11 J. Kelly 2007, p. 364.

12 Haydon 2013, p. 94.

13 R. Foster 1988, p. 176.

14 F. Lyons 1979, p. 8. For improvement, see Barnard 2008.

15 *Freeman's Journal*, August 3–16, 1768.

16 McParland 1991–92, p. 210.

17 R. Foster 1988, p. 174.

18 Madden 1738, pp. 218–19.

19 A. Lucas 1953. In general, see McDonnell 1995 and Ó Floinn 2011.

20 Laffan 2003b, p. 152.

21 Laffan 2003b, pp. 166–67.

22 Laffan 2003b, pp. 156–57.

23 Dalsimer and Kreilkamp 2000, p. 12.

24 Barnard 1995, p. 160.

25 Glin and Peill 2007, p. 66.

26 Glin and Peill 2007, pp. 122–25; Mayes 2011, pp. 232–34, 56–65.

27 Mulligan 2011, p. 54; Hurley 2009; Harbison 2012, pp. 106–11.

28 Laing 2001.

29 Chetwood 1746, p. 246.

30 Laffan and Mulligan 2013.

31 Quoted in Egerton 2001, p. 92.

32 Minor 2006.

33 Contemporary anonymous poem quoted in C. O'Connor 1999, p. viii; Howard 1986.

34 McDonnell 1997, p. 85.

35 Skinner 2014, pp. 58–75; Lucey 2006.

36 Barnard 2005, p. 72; Marson 2007; FitzGibbon 1976.

37 Stevenson and Thomson 1982, p. 90.

38 McDowell and Morley-Fletcher 1997, pp. 102–04.

39 McEneaney and Ryan 2004, pp. 158–61.

40 E. FitzGerald 2000, p. 133; William FitzGerald, 2nd Duke of Leinster to Emily, Dowager Countess of Leinster, National Library of Ireland, MS 617, FitzGerald Correspondence, vol. 3 (1774–90), letter 144, June 14, 1775; quoted in Lucey 2011, p. 171.

41 Rogan 2014, pp. 18–19, 25, 26.

42 Kitson 1973, p. 775; Malton 1792–99; Griffin and Pegum 2000, pp. 49–50.

43 Laffan 2007.

44 Laffan and Rooney 2014b.

45 A. Young 1970, vol. 1, p. 494.

46 *Pue's Occurrences*, January 6–9, 1753.

47 *Pue's Occurrences*, June 12–16, 1759.

48 *Pue's Occurrences*, April 23–26, 1763.

49 *Faulkner's Dublin Journal*, November 25–28, 1749.

50 *Dublin Intelligence*, July 28, 1724.

51 Cunningham 2009; Dunlevy 2011, pp. 35, 58–60. In general, see Caldicott, Gough, and Pittion 1987.

52 Turpin 1990.

53 McDonnell 1994; Kennedy and Sheridan 1999.

54 Breeze 1985, p. 23.

55 Breeze 1985, p. 26.

56 McDonnell 1994.

57 Loeber 1970.

58 Harbison 2012; Laffan and Rooney 2009, pp. 110–33.

59 Severens 1990; Lucey 2007, p. 35, with further literature cited.

60 The class of 1763 at the Dublin Society Schools was particularly gifted and also included John Butts, Jonathan Fisher, Robert Hunter, and Thomas Roberts. See Willemson 2000, pp. 110–11.

61 Skinner 2014, pp. 82–93.

62 Among the rich literature on Ireland in a European context, see L. Cullen 2000b; T. O'Connor 2001; Parmentier 2005; T. O'Connor and Lyons 2006; Downey and MacLennan 2008. For Ireland in an American and Atlantic context, consult Canny 1988; Bric 1996; Hoffman and Mason 2000.

63 See Laffan and Mulligan 2014, pp. 228–30.

64 The sixteenth Annual Report of the Friends of the National Collections of Ireland, 1950; see Lucey 2007, p. 94, n. 2.

65 Glin 1988, p. 28.

66 See, too, though largely for an earlier period, Rowan 1997.

67 Lucey 2007.

68 Praz 1969.

69 Conor Lucey in the introduction to the exemplary Casey and Lucey 2012, pp. 21, 23.

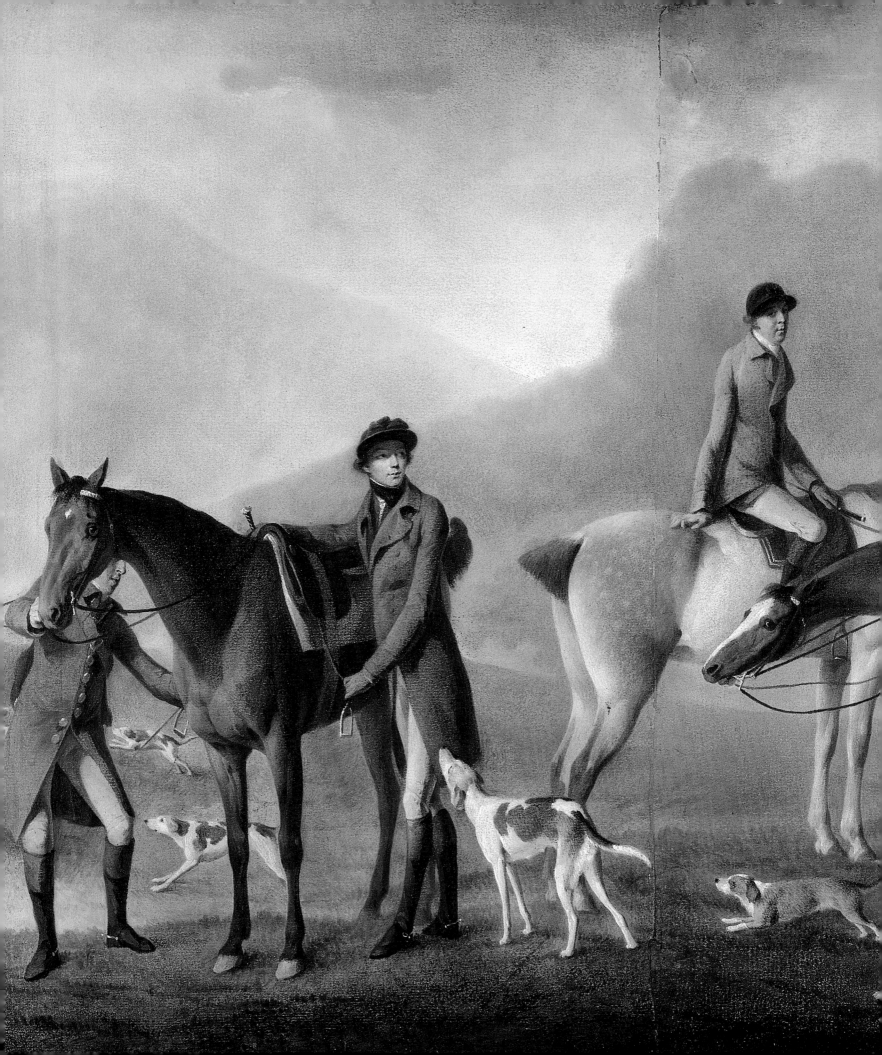

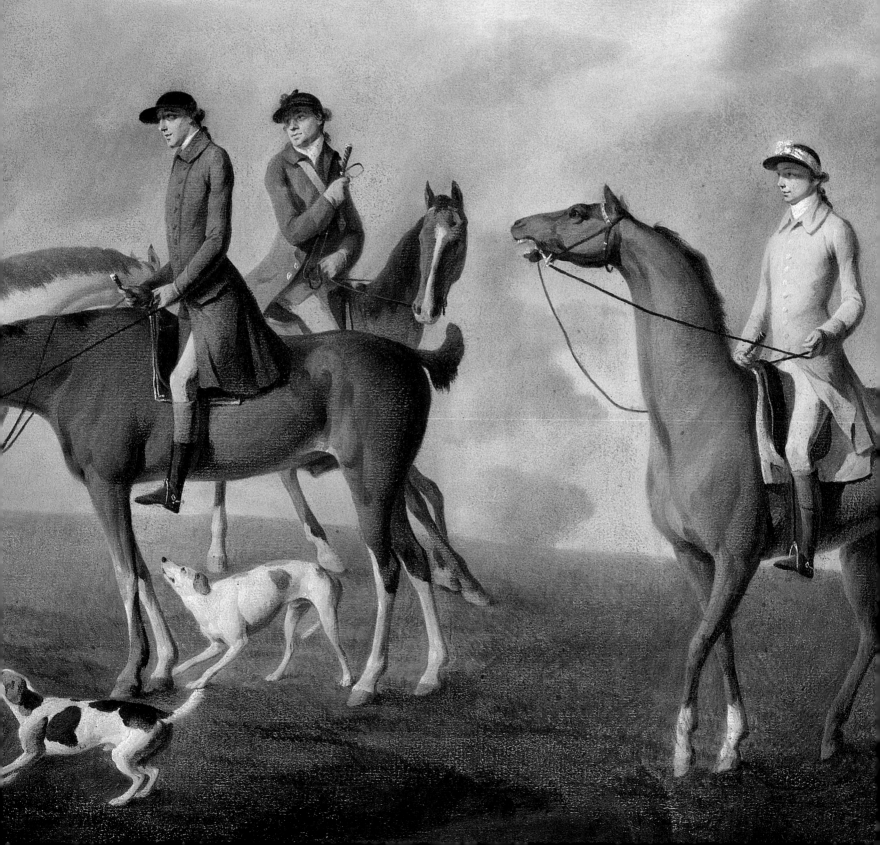

PART ONE

PEOPLE AND PLACES

Portraits and Pantheons

WILLIAM LAFFAN

IN 1600, DURING THE NINE YEARS' WAR, the English lord deputy Baron Mountjoy was campaigning through the midland territory of the O'Mores when he noted with amusement that in one of the Irish rebel's houses a picture of Queen Elizabeth I was matched by an image of her great enemy—and brother-in-law—King Philip II of Spain; having it both ways has long been an Irish characteristic.[1] The episode is telling, though, for while the specific circumstances of colonial Ireland certainly made portraiture a contested arena in which decisions as to who was painted—and by whom—often signified much more than personal or aesthetic preference, things were not always quite as they seemed. If by the twentieth century the display of portraits of individuals (Queen Elizabeth II, the pope, and even John F. Kennedy) could be used as a shorthand signifier of political or religious allegiance, the use of portraiture in the long eighteenth century had more complex and sometimes unexpected resonances. A certain ambiguity, irony, or paradox, exacerbated at times of political uncertainty, characterizes much Irish portrait making, which can be defined broadly as taking the image of a recognizable individual,

Nathaniel Hone. *Self-Portrait*, c. 1747 (detail). Cat. 64 (see p. 59, fig. 29).

primarily—though not exclusively—through commissioned paintings executed in oil on canvas. For one thing, the motivations of artist and sitter were not always aligned. Hugh Douglas Hamilton could write to his friend the sculptor Antonio Canova about his fears of imminent rebellion ("the people here are full of revenge") and paint the "definitive image" of Lord Edward FitzGerald, a young aristocratic leader of the rebels (1796/98; National Gallery of Ireland, Dublin).[2] If the political is inescapable in much Irish portraiture—the assertion of status, power, and loyalty (or otherwise)—the personal must not be forgotten, and more innocent emotions and sensitivities are also at work: the enjoyment of good looks, fashion, and dressing up; pleasure taken in marriage and progeny; and the commemoration of the dead.

Two centuries after Mountjoy's troops stormed the homestead of the equivocating rebel, the choice of whom to commemorate had moved on from a binary alternative of foreign monarchs. In March 1796 Wolfe Tone was in Paris, garnering support for his plans to lead a French army to Ireland; while there, he visited the church of Saint Genevieve, which was being converted into the Panthéon, dedicated to the great men of the revolutionary years—and precursors such as Voltaire

and Jean-Jacques Rousseau—who were to be buried there. Himself intoxicated with the revolutionary spirit that would lead to his violent death two years later, Tone fully approved of the idea lying behind the Panthéon, commending it as "sacred to every thing that is sublime, illustrious and patriotic" and continuing, "If we have a republic in Ireland, we must build a Pantheon."[3] However, he was not unaware of the problems inherent in the task and cautioned, "We must not, like the French, be in too great a hurry to people it." Of course, Tone, being Tone, could not resist making a few suggestions as to who should be included, but these only underline the almost inevitable paradox that tends to result from such an exercise in an Irish context. While Rory O'Moore, leader of the 1641 Rebellion and kinsman of Mountjoy's rebel, was a not-unexpected choice, Tone's other three candidates held political views very different from his own and from one another. William Molyneux, philosopher and author of *The Case of Ireland's Being Bound by Acts of Parliament in England, Stated* (1698), was a moderate Protestant patriot; Jonathan Swift was a Tory; and Charles Lucas advocated municipal reform rather than the overthrow of the state. Indeed, this trio has been grouped together for sharing an ideology that was fundamentally *unlike*

Tone's in wanting to preserve some link with England and that "conceded full rights only to the Protestant and indeed Church of Ireland section of the population."[4] Nevertheless, Tone adjudged all his candidates "good Irishmen."

The idea of an Irish pantheon, if only conceptual—and the problem of who to put in it—reemerged in different guises throughout the period. Half a century later, Charles Gavan Duffy, leader of the Young Ireland movement, bemoaned the fact that, with the exception of the much-reproduced statue of Daniel O'Connell by Peter Turnerelli, there was "seldom a bust of an Irishman to be seen in an Irish house."[5] Duffy tells the story of a friend who visited Giacomo Nanetti's statuary business in Dublin's Church Lane to purchase some busts for his library and was offered an array of English and Scottish writers—Lord Byron, John Milton, Walter Scott, and William Shakespeare—"but not a single Irishman." He enquired after images of Irish luminaries such as Edmund Burke (SEE FIG. 1) and Lord Edward FitzGerald, but to no avail, and decried the fact that the Duke of Wellington (SEE FIG. 2), "the genius of military despotism," represented Ireland "in Mr. Nanetti's collection." Happily, however, "our friend discovered a head of [Henry] Grattan [SEE FIG. 3] on a high shelf and a bust of Thomas Moore under a bench: and when he had purchased both, he left the collection . . . without one Irishman."

Of course, the issue was one of politics as much as nationality or even religion. Both Catholics (Moore) and Protestants (Grattan) were admissible to this Young Ireland pantheon, and even Burke's and Lord Edward's diametrically divergent political stances on the topical (and not unimportant) subject of revolution could be reconciled, but Duffy's friend could not countenance the presence of the Dublin-born Wellington, who was simply not a "good Irishman." Rather tellingly, Duffy absolved the sculptors of Ireland from responsibility for this seeming bias: "Do we blame the

artist for this? Not in the least—it is the fault of the public." Blaming the public for not liking what it is meant to like is always problematic, and turning Lord Edward and Shakespeare into mutually incompatible alternatives is mischievous: Lord Edward plotted rebellion in the Irish Shakespeare Gallery in Dublin's Exchequer Street overlooked by Henry Fuseli's bloodcurdling scene from *Macbeth* (P. 74, FIG. 17), while, as his journal attests, Tone loved to quote from the bard.[6] It is clear, nonetheless, that demand for busts of, say, Wellington

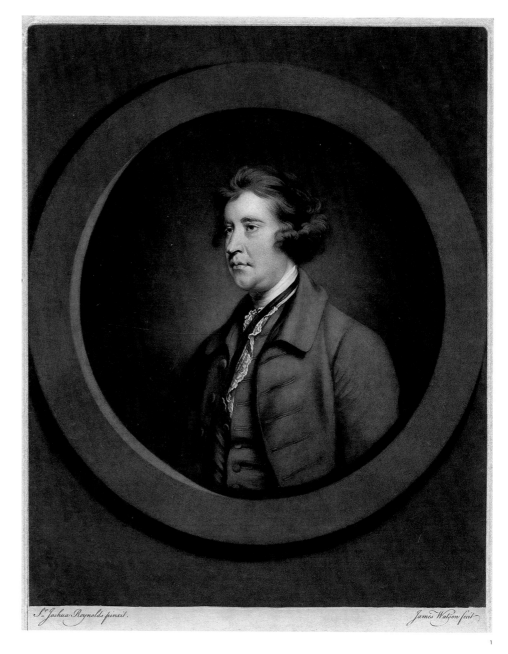

St. Joshua Reynolds pinxit. James Watson fecit

Fig. 1
James Watson, after Sir Joshua Reynolds. *Edmund Burke*, 1770. Yale Center for British Art, Paul Mellon Fund. Cat. 131.

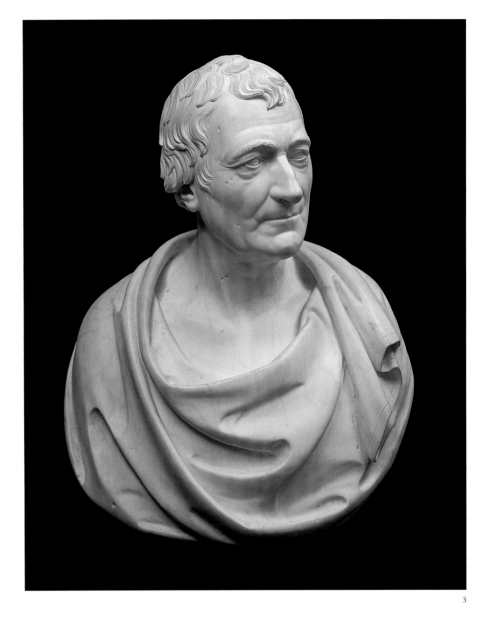

3

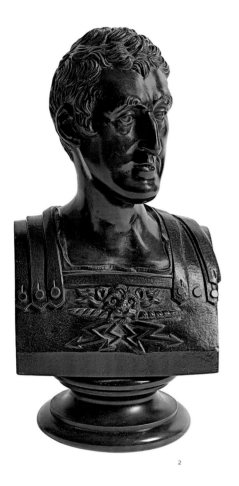

2

Fig. 2
Lawrence Gahagan. *Arthur Wellesley,
Duke of Wellington*, 1811. Dr. and Mrs.
Leo Ackerman. Cat. 312.

Fig. 3
Peter Turnerelli. *Henry Grattan*, 1820.
Private collection. Cat. 314.

reflected a British—an imperial—as well as an
Irish, identity. Nor was this just a development
that occurred only in the period following
the Act of Union in 1800 that united Ireland
and Great Britain. A century earlier, a further
snapshot of whose image was in favor among
Dublin's Protestant print-buying public can be
found in the contents of Michael Ford's shop
on Cork Hill, where that unholy triumvirate of
Oliver Cromwell, William of Orange, and the
Duke of Cumberland competed for space with
less contentious figures including the famed
circumnavigator George, Lord Anson; the cel-
ebrated Irish beauty Elizabeth Gunning; David

Garrick (SEE P. 152 AND P. 157, FIG. 7); and
Emily, Countess of Kildare (CAT. 88, P. 232).[7]

A further tension within portraiture cen-
tered not on the subject but on the artist. The
clash between the desire to support the home-
grown and the lure of the imported, or exotic,
recurs time and again in contemporary discus-
sions about purchasing and commissioning. As
noted in the introduction, this issue was cen-
tral to newspaper coverage of the architectural
competition in the late 1760s for the Royal
Exchange, when the superiority of English
architects was taken as self-evident. A direct
parallel can be found in the field of portraiture,

where the issue crystallized around who should be awarded the prestigious commissions from Dublin's Corporation to hang in the Mansion House, home to the lord mayor. In 1766 the corporation commissioned Sir Joshua Reynolds to paint the outgoing lord lieutenant, Hugh Percy, 2nd Earl of Northumberland, but three years later picked Thomas Hickey, a pupil of the Dublin Society Schools, to paint his successor, George, Lord Townshend.[8] However, some continued to doubt the ability of native artists. The choice in 1780 to commission a portrait of the current lord lieutenant, John Hobart, 2nd Earl of Buckinghamshire, but to insist on a native artist, was attacked in the *Hibernian Journal* as counterproductive, small-minded, and inspired by "blind Partiality and Ignorance," especially "when there is not at *this* Time in Ireland a *Native* who can draw a Portrait in *Oil* fit to grace the Temple of Cloacina"—in other words, a lavatory.[9] The writer suggested instead that Ireland should import talent and follow the example of England, which a century earlier could itself hardly boast a native artistic school of its own: "Neither, Holbein, Van-dyck, nor Kneller, were Natives of England, and yet they were called English Painters." Dublin's aldermen, he continued, "should not be the scare-crows to frighten the fine Arts from settling in this country, but follow the Example of their discerning and sensible neighbours, who though they possess a *Reynolds* and a *West*, gave equal countenance to the merits of a Kauffmann [*sic*] and a Cypriani [*sic*]." Concern as to the nationality of the artist mirrors that of the sitter. As Duffy concluded in the passage quoted above, "If we do not learn to love and cherish the memory of our illustrious countrymen" by, he implies, purchasing portraits of them, "we will have no more illustrious countrymen to love." Some felt exactly the same about patronizing Irish artists: if they were not encouraged, they would not exist. Others, however, were attracted to portrait painters precisely *because*

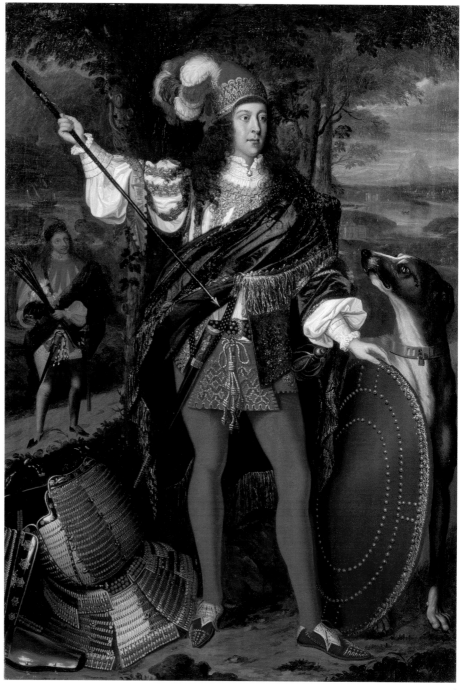

4

they were based in London, Paris, or Rome and, almost by definition, better. On this occasion Dublin won out, and the "conspicuous failure" of Buckinghamshire's term in office was commemorated with a portrait by the Irish artist Robert Hunter.[10]

Painted exactly a century earlier in 1680, an overtly political portrait (FIG. 4) marks the beginning of the period covered by this exhibition. It depicts Sir Neil O'Neill, a young Ulster baronet, whose family (unlike other branches of the O'Neills) enjoyed royal favor after the Restoration. It was painted by John Michael Wright, one of the most international artists of the period, who was born in London, trained in Edinburgh, spent a decade in Rome, worked as an antiquary for the Archduke of Austria in Flanders, and painted Charles II.

As a Catholic, Wright fled to Ireland when the so-called Popish Plot led to his coreligionists being excluded from London. In Ireland he enjoyed extensive patronage, largely from recusant clients led by Richard Talbot, 1st Earl of Tyrconnell, whose daughters he painted (1679; National Gallery of Ireland, Dublin).[11] Here O'Neill, Tyrconnell's nephew, chose to portray himself in archaistic and deliberately programmatic Gaelic costume.[12] The inescapable political import of this was recognized by a near-contemporary writer, who described it as an image of "an Irish Tory in his country dress," highlighting the politically provocative nature of the portrait in the Ireland of the 1680s.[13] The word *Tory* still bore its original potency, deriving from the Irish *tóraidhe*, a "robber" or "highwayman." The wearing of Irish dress at Dublin Castle had specifically been banned under the administration of Thomas Wentworth, 1st Earl of Strafford, forty years before, and to the Protestant and English interest, O'Neill's manner of presentation would have conjured up the image of a rapparee, one of the Catholic irregular soldiers who terrorized large parts of the country.[14]

As is often the case with Wright, the picture is densely allusive. Mention has been made in the introduction of the symbolically charged Japanese armor at Sir Neil's feet, but references to the Western tradition of portrait painting are also present. The pose of sitter and dog relates to works by Titian such as his *Emperor Charles V with a Hound* (1533; Museo del Prado, Madrid), but there is also a more specific political allusion. Strafford, on being appointed Ireland's lord deputy by Charles I, was painted by Sir Anthony van Dyck clad in armor beside a noticeably docile Irish wolfhound (FIG. 5). The imagery was unmistakable: "The pacified and planted Ireland was firmly under the crown and [Wentworth] would take up the sword to civilize the island should its inhabitants prefer to bark rather

than to heel."[15] O'Neill, who draws his weapon, keeps an alert and bright-eyed wolfhound, and dresses in the garb that Strafford had banned from Dublin Castle, offers a powerful image of resistance. The Irish wolfhound would bark again, though this would prove fatal to its owner. At the Battle of the Boyne ten years later, O'Neill fought with notable valor before he was wounded and carried from the battlefield, dying at age thirty-two.

The victory of William of Orange at the Boyne spelled the final end for any lingering hopes of a Catholic—let alone Gaelic—Ireland, ushering in a long period of comparative peace. For most of the long eighteenth century, the four Hanoverian King Georges ruled Ireland through a viceroy in Dublin Castle. Royal portraiture, which had long served as a conspicuous indicator of loyalty (as, for example, in the stucco portraits of Elizabeth and Edward VI at Ormonde Castle, Carrick-on-Suir), became more and more prevalent and was a fundamental, though not uncontested, component of Irish iconography. Indeed, public sculpture on the streets of Dublin was limited almost exclusively to English kings or, as the *Nation* put it in 1843, not even *English* English kings: "We now have statues to William the Dutchman, to the four Georges—all either German by birth or German by feeling . . . while not a single statue of the many celebrated Irishmen whom their country should honour adorns a street or square of our beautiful metropolis."[16] While Grinling Gibbons's equestrian statue of King William on College Green was the city's most prominent symbolic site of loyal ceremonial and occasional dissent, George I stood (for a while at least) on Essex Bridge, and from 1758 a not-very-satisfactory equestrian statue of George II by Jan (John) van Nost the Younger marked the central point of Saint Stephen's Green. The corporation trumpeted the award of this commission to a Dublin-based artist as adding to the "honour and reputation of the city"—though only after

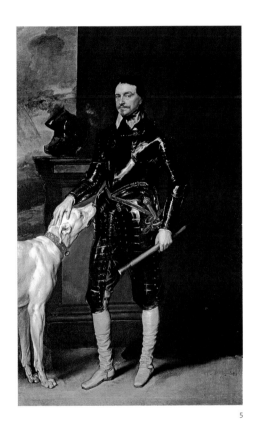

5

Fig. 4
John Michael Wright. *Portrait of Sir Neil O'Neill, 2nd Baronet of Killyleagh*, 1680. Private collection. Cat. 140.

Fig. 5
Sir Anthony van Dyck (Flemish, 1599–1641). *Thomas Wentworth, 1st Earl of Strafford (1593–1641)*, c. 1633. Oil on canvas; 229.9 × 149.2 cm (87¾ × 58¾ in.). Private collection.

Louis-François Roubilliac, their preferred, London-based choice, proved too expensive.[17]

Royal portraiture has often caused problems in Ireland, though not always the expected ones. On the one hand, the statue of George II was among those that the United Irishmen planned to decapitate in 1798; on the other, when the Catholic Committee, of which Wolfe Tone was secretary, dissolved itself after the disappointment of the only partial relief measures in 1793, it voted that £2,000 of its remaining funds go to a statue of George III.[18] Another statue of George II stood outside Weavers' Hall in the Coombe, while the king was also on display within the building in a fine tapestry woven by Jan (John) van Beaver (FIG. 6).[19] Van Beaver took this likeness from an engraving after a 1716 portrait by Sir Godfrey Kneller; the frame, which the weavers themselves commissioned, is of Irish manufacture and probably by John Houghton (the tasseled ropes are an Irish trademark).[20] There is some irony that this strange amalgam of a portrait—by a Flemish weaver, after a German-born painter, of a German-speaking English king—is a peculiarly Irish object.

For most of the period covered by the exhibition, Dublin could support the studios of two or three able portrait painters such as John Michael Wright in the 1680s or James Latham fifty years later as well as a small group of cheaper, less talented alternatives. Artists of varying abilities, including Strickland Lowry, John Ryan (SEE FIG. 7 AND FIG. 22 BELOW), and Robert Woodburn catered to provincial demand in Ulster, Galway, and Waterford, respectively, while itinerant face painters filled in the gaps. Admittedly, it was often the case that the most talented Irish portraitists in each generation—Nathaniel Hone, Charles Jervas, or Sir Martin Archer Shee, for example—made their careers in London, where there was far greater scope for patronage, though Hugh Douglas Hamilton, after years in London and Italy, settled back in Dublin to enjoy a fruitful

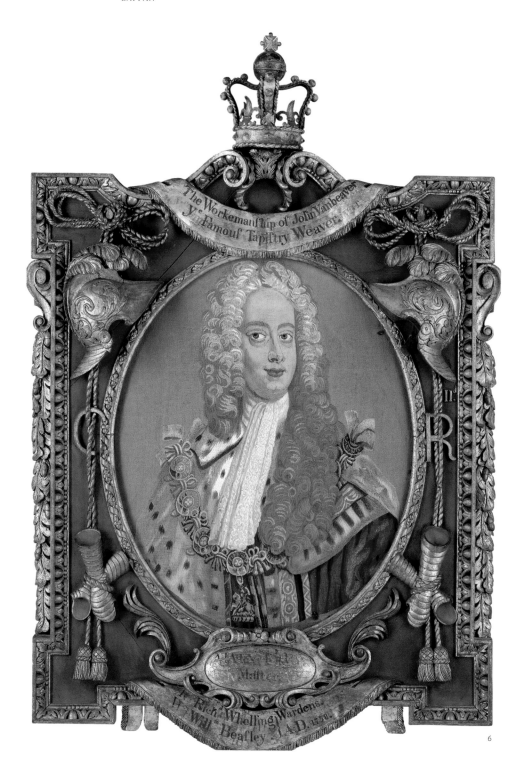

Fig. 6
Workshop of Robert Baillie, woven by Jan (John) van Beaver, frame probably John Houghton. *Portrait of George II*, 1733/34, frame 1738. The Metropolitan Museum of Art, New York, Gift of Irwin Untermyer, 1964. Cat. 317.

Fig. 7
John Ryan. *Anne Bingham, Wife of Christopher St George of Tyrone*, c. 1785. Peter Clayton Mark. Cat. 117.

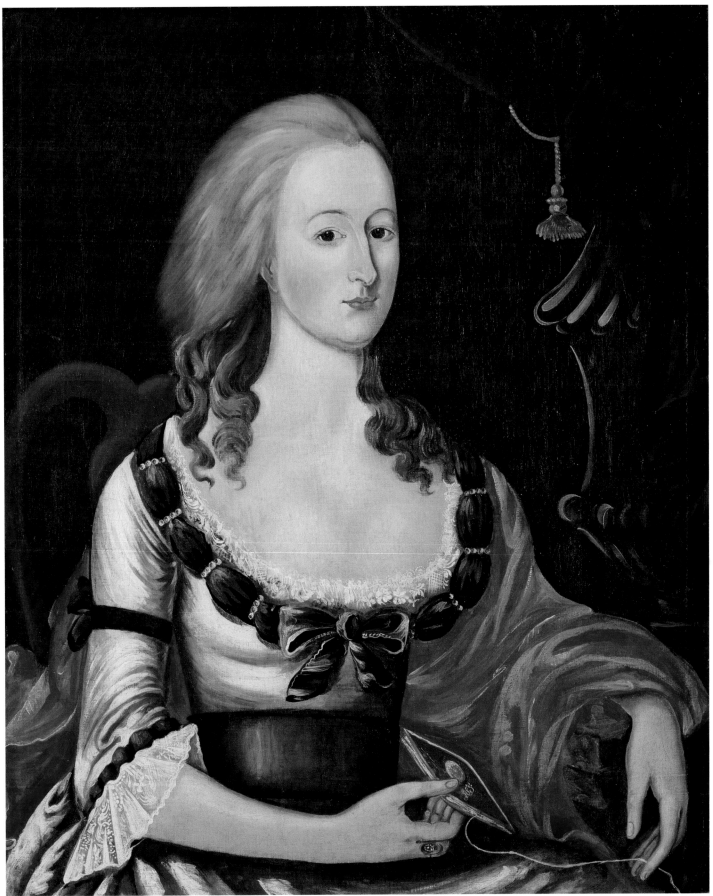

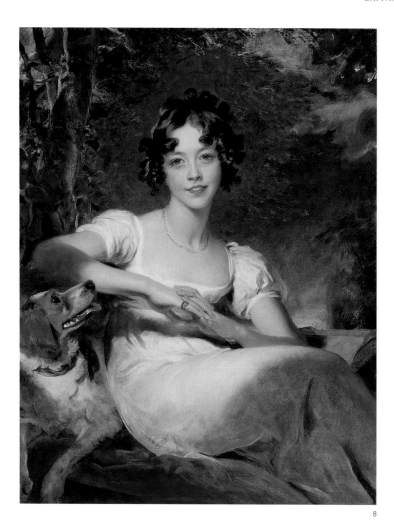

8

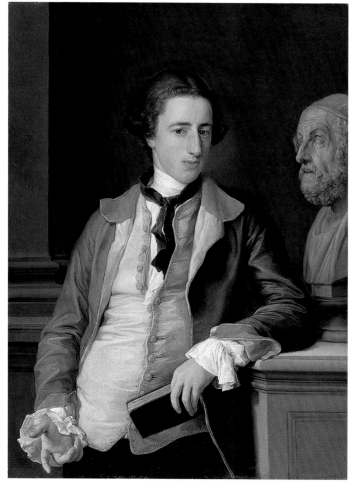

9

late period. Reciprocally, leading portrait painters of English, Continental, or North American origins, such as Angelica Kauffman, Stephen Slaughter, Gilbert Stuart, and Francis Wheatley had productive spells in Dublin. The flow was two-way across the Atlantic as well, with Henrietta de Beaulieu Dering Johnston, an artist of French Huguenot extraction, moving in 1708 to Charleston, South Carolina (SEE P. 148, FIG. 1).

The richest or most cosmopolitan sitters, such as Lady Maria Conyngham and Robert Clements, were painted by Sir Joshua Reynolds and Sir Thomas Lawrence in London (SEE FIG. 8) or Pompeo Batoni in Rome (SEE FIG. 9). Travel was an opportunity, and an excuse, for a portrait. In the 1770s, the mother of Patrick Lattin, a Catholic squire from Kildare, urged him to have his likeness taken as soon as he

settled on the Continent, and he was painted by a German in Paris and also when in Turin.[21] The Cork glassmaker, lumber merchant, and patron Cooper Penrose, a not wholly observant Quaker, was unusual in gaining a sitting with Jacques-Louis David (FIG. 10) when he visited Paris during the Peace of Amiens, which allowed travel on the Continent for the first time in years; prior to this, whether for patriotic reasons or faute de mieux, he had commissioned portraits from Irish artists including Charles Forrest, Robert Hunter, and Thomas Pope-Stevens.[22] Occasionally friendship as much as fashion determined commissions, as was the case with William Hogarth and James Caulfeild, 1st Earl of Charlemont (SEE FIG. 11).[23] There was an active flow not just of artists but also of paintings across the Irish Sea. Wheatley sent his twin portraits of the Catholic Swiney

Fig. 8
Sir Thomas Lawrence. *Lady Maria Conyngham*, c. 1824–25. The Metropolitan Museum of Art, New York, Gift of Jessie Woolworth Donahue, 1955. Cat. 77.

Fig. 9
Pompeo Batoni. *Robert Clements, Later 1st Earl of Leitrim*, 1754. Hood Museum of Art, Dartmouth College, Hanover, purchased though a gift from Barbara Dau Southwell, Class of 1978, in honor of Robert Dance, Class of 1977, a gift of William R. Acquavella, and the Florence and Lansing Porter Moore 1937 Fund. Cat. 13.

Fig. 10
Jacques-Louis David. *Cooper Penrose*, 1802. Timken Museum of Art, The Putnam Foundation Collection, San Diego. Cat. 30.

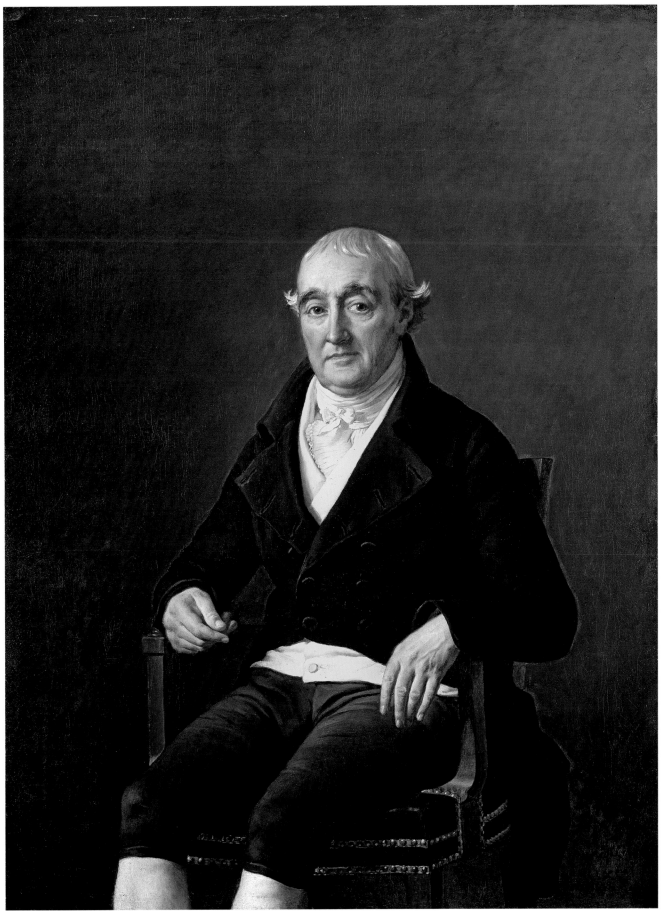

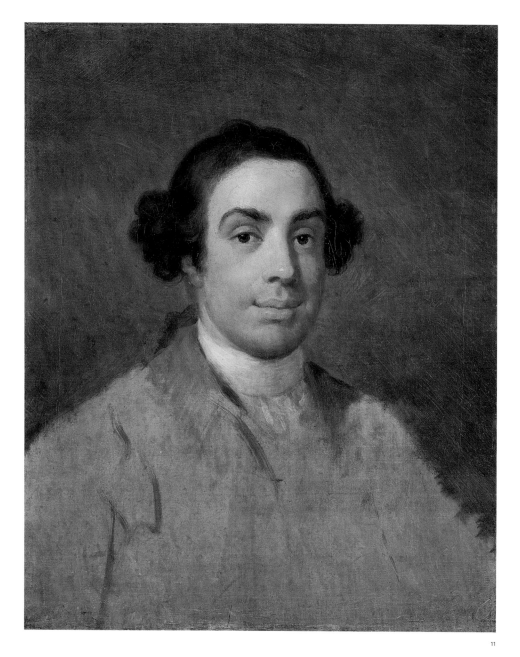

11

the family of the first and second Dukes of Ormonde patronizing a wide array of international talent including Michael Dahl, Hans Hysing, Sir Godfrey Kneller, Sir Peter Lely, and John Michael Wright.[24] Images of the ducal Ormondes—the closest that Ireland came to a royal family in the late seventeenth and early eighteenth centuries—were disseminated widely through prints and other commemorative media such as a tin-glazed earthenware charger with a stylized portrait of the second duke (SEE FIG. 15). Only the grandest of Irish houses had a separate picture gallery, and elsewhere portraits tended to be gathered in dining rooms. Institutional patronage made up a significant proportion of commissions for portraiture, with Dublin Corporation, the Royal Hospital Kilmainham, Saint Patrick's College in Maynooth, Trinity College, and the various guild halls putting together collections of mayors, monarchs, prelates, and other worthies to create minipantheons of academic complacency, municipal pride, and orthodox loyalty. For instance, portraits of John Foster, speaker of the House of Commons until the Union, were commissioned by the Bank of Ireland, Dublin Corporation, and the Dublin Society, though Gilbert Stuart's portrait of the speaker (P. 73, FIG. 15) and those of his daughter with a cousin (P. 196, FIG. 3) and of Foster's friend William Burton Conyngham (SEE P. 104, FIG. 9) were private commissions.[25]

Individuals commissioned portraits to mark important milestones, notably marriages (especially advantageous ones), election to parliament, and elevation to or within the peerage; they were given both to political supporters and loved ones. Swift, for example, treasured portraits given him by the second Duke of Ormonde and his wife, while figures as different as John FitzGibbon, 1st Earl of Clare, and Oliver Goldsmith circulated engravings of themselves to friends.[26] As treasured heirlooms, portraits were often entailed or singled out as bequests in wills. Joseph Leeson,

Fig. 11
William Hogarth. *James Caulfeild, 1st Earl of Charlemont*, 1759/64. Smith College Museum of Art, Gift of Mr. and Mrs. R. Keith Kane (Amanda Stewart Bryan, Class of 1927). Cat. 61.

brothers (FIGS. 12–13) from Dublin to London for exhibition at the Royal Academy, and Charlemont's commissions from Hogarth went in the opposite direction, while his portrait by Batoni (P. 107, FIG. 13) had a longer and more hazardous trip from Rome.

Despite Irish customers taking much of their business elsewhere, portraiture was still the most frequently practiced genre in Ireland. From the seventeenth century onward, the great hall of Kilkenny Castle was densely hung with portraits (SEE FIG. 14), with

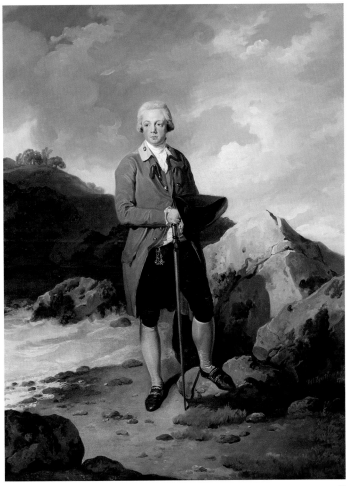

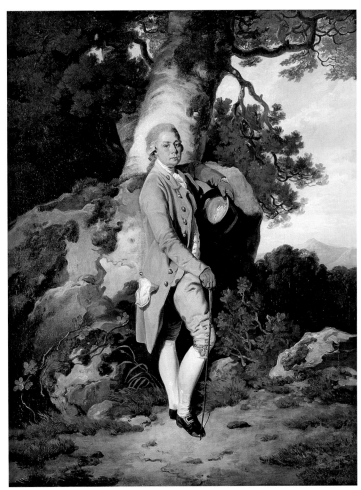

12

13

Fig. 12
Francis Wheatley. *Portrait of Michael Swiney of Woodbrook, County Dublin, Standing on the Seashore*, 1783. Private collection. Cat. 134.

Fig. 13
Francis Wheatley. *Portrait of John Swiney of Mountjoy Square, Dublin, Standing at the Edge of a Wood*, 1783. Private collection. Cat. 133.

Fig. 14
Robert French (Irish, 1841–1917). Picture Gallery, Kilkenny Castle, County Kilkenny, 1865/1914. Glass negative; 31 × 25 cm (12¹³⁄₁₆ × 9⁷⁄₈ in.). The Lawrence Photograph Collection, National Library of Ireland.

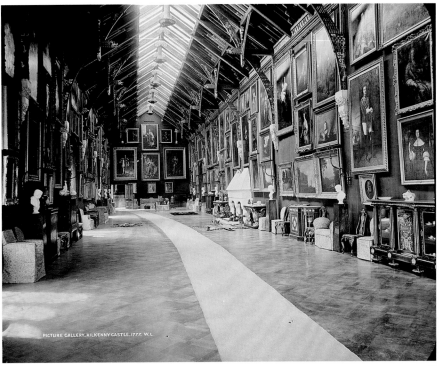

14

15

16

Fig. 15
Lambeth, England. Charger, c. 1690–
1700. Neville and John Bryan. Cat. 207.

Fig. 16
The Saloon at Carton, County Kildare,
c. 1935. Country Life Picture Library.

1st Earl of Milltown, always conscious of his obscure origins, had retrospective portraits of his parents painted to bolster his ancestry.[27] More endearingly, he kept small caricatured portraits of friends made on the grand tour in his study for private delectation.[28] His own portraits by Batoni and Anthony Lee were treasured and displayed in the public rooms at Russborough for a century after his death. Similarly at Carton, Reynolds's portrait of the second Duke of Leinster hung above the chimneypiece of the saloon until quite recently (SEE FIG. 16). If this gave pride of place to patriarchal lineage, the role of English wives was acknowledged on either side of the door to the library with Allan Ramsay's portrait of Emily, the duke's mother, flanked by Willem Wissing's image of an earlier countess of Kildare,

Lady Elizabeth Jones (FIG. 17; ALSO FIG. 16, AT LEFT).[29] Horace Walpole, however, noted that the more usual fate of family portraits as the generations passed was to be sent to the attic or to auction; such a sale takes place on stage in Richard Brinsley Sheridan's *School for Scandal* (1777).[30]

While an image of Oliver Plunkett, a Catholic archbishop and victim of the Popish Plot (1681; National Portrait Gallery, London), is a highly charged icon of martyrdom and sainthood, motivations for the commissioning and use of portraiture were often less elevated.[31] Family tradition records that Robert Fagan's titillating *Portrait of a Lady as Hibernia* (P. 122, FIG. 4) depicts Margaret Simpson, mistress of one of the viscounts Dillon, while the Belfast artist Joseph Wilson painted a companion of

the Marquis of Downshire "in various attitudes, dressed and naked."[32] At the other end of the spectrum, Wilson captured Volunteer officers preening in their uniforms and the "literati of Belfast" assembled at the Adelphi Club (FIG. 18); in this rare group portrait of 1783, prints or drawings on the walls show how portraiture could make absent friends present. Wilson was himself a member of the club, which was at the center of several overlapping networks that linked Freemasonry, the theater, and the Volunteer movement, and he included a self-portrait on the right of the composition.[33] Portraiture, like Masonry and participation in the Volunteer militias, gave sitters a chance to dress up and strike a pose, as Sir Neil O'Neill does with noticeable swagger. If the Countess of Kildare asked Wissing to portray her as a

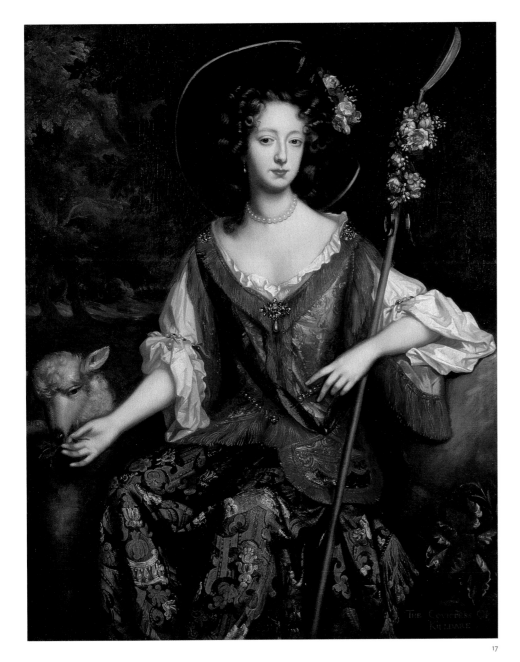

17

Fig. 17

Fig. 17
Willem Wissing. *Elizabeth Jones,
Countess of Kildare*, c. 1684. Yale Center
for British Art, Paul Mellon Fund.
Cat. 137.

joseph, richly laced with gold, and a whip in her hand. Sophie was to be a shepherdess, with as many sheep as the painter could put in for nothing."[34] Here and elsewhere, portraiture served to flatter the vain—indeed, this was one of its primary functions. This was doubly the case when artist and sitter were one and the same, and the revelation of what Walpole described as Charles Jervas's "presumption" and "self love" is what makes his self-portrait (FIG. 20) such a splendidly—if unconsciously—perceptive image of self-satisfaction.[35]

Oil on canvas was far from the only medium available in the busy Dublin marketplace. Those trained at the Dublin Society Schools produced distinctive portraits in pastel and charcoal, while several Irish artists excelled at scraping mezzotints and painting miniatures (see the essays by Suzanne Folds McCullagh, Martha Tedeschi, and Paul Caffrey in this catalogue). Natives and visitors such as Lawrence Gahagan (SEE FIG. 2 ABOVE), John Hogan, and Jan (John) van Nost the Younger supplied the market for portrait sculpture. A bust by Van Nost, whose family was originally from Flanders, of the banker David La Touche II (FIG. 21)—himself of Huguenot origins and a patron of Antonio Canova in Rome—highlights the incipient cosmopolitanism of mercantile patronage as the eighteenth century drew to a close.[36] Less orthodox media were also explored. In 1785, for instance, Richard Bull promoted "likenesses in hair," while a few years later the Cabinet of Royal Waxworks was advertised on College Green.[37] Another sort of pantheon to have emerged from revolutionary France, it comprised a "highly admired and superb assemblage of the faithful portraits in wax, large as life, of the Royal and most celebrated personages of the age," including the Prince of Orange and the czar and czarina of Russia; celebrity has always been a draw.[38] In June 1740, meanwhile, Nathaniel Bermingham advertised his cut-paper portraits and stressed the remarkable

demure and innocent shepherdess guarding her flock, her contemporary, the Countess of Meath, identified herself quite differently. Sir Peter Lely depicts her holding an arrow, which links her to Diana, but positions it in a way that knowingly subverts the goddess's association with chastity (FIG. 19). Oliver Goldsmith parodied this taste for allegorical trappings in *The Vicar of Wakefield* (1766), when the Primrose family commissioned a "large historical family piece": "Olivia would be drawn as an Amazon, sitting upon a bank of flowers, drest in a green

51

18

19

20

Fig. 18
Joseph Wilson. *The Adelphi Club,
Belfast,* 1783. Private collection. Cat. 136.

Fig. 19
Sir Peter Lely. *The Countess of Meath,*
c. 1674. National Gallery of Canada,
Ottawa Purchase, 1929. Cat. 78.

Fig. 20
Charles Jervas. *Self-Portrait,* c. 1725.
Private collection. Cat. 71.

verisimilitude he was able to achieve: "Those who have seen them have expressed their surprise to see such strong likenesses done in this manner."[39] Time and again, "likeness" is seen as the key to a successful portrait. At his print shop and lottery office on Capel Street, Isaac Colles offered profile miniatures and noted that if he did not achieve "a striking likeness," he demanded no payment.[40]

At the opposite end of the market, James FitzGerald, 1st Duke of Leinster, judged Sir Allan Ramsay superior to Sir Joshua Reynolds, as he could recognize the portraits of acquaintances when he visited the former's studio but not when calling on the latter; he himself had been painted by both artists.[41] Just before setting off on his final voyage to Ireland with a paltry French invading force, Wolfe Tone commissioned a chalk portrait of himself for his wife knowing that the failure of the mission

and his own death were almost inevitable. Under the circumstances, likeness was all important, and Tone agonized over the artist's success: "It is not very like, but it seems to me a sort of a likeness; however you will judge for yourself."[42] Although Matthew Pilkington, a friend of Swift, drew a distinction between "the skill to trace some faint resemblance of the face" and the work of the more psychologically penetrating artist who could lay bare "the secret soul," most customers were more than satisfied if their features were recognizably recorded.[43] The variety of media that artists exploited to achieve the perfect likeness was directly related to the multiplicity of motivations and occasions for commemorating a face. Thus, miniature portraits recorded love or loss; oversized oils on canvas, especially in elaborately carved frames, usually denoted achievement of one sort or another; and

features transferred onto ceramics or textiles often had political, and typically partisan, import.

The Penal Laws, which prevented Catholics from voting for or sitting in parliament, among many other restrictions both draconian and petty, did not extend to a ban on commissioning portraiture. However, Catholics' relative impoverishment and their desire to keep as low a profile as possible meant that the vast majority of portraits painted in Ireland in the eighteenth century and beyond were of members of the established church. As Bishop Ryan of Wexford put it as late as 1812, the Protestants "appear more numerous than they really are because they have power and can make a show."[44] There were, of course, exceptions. If after the Battle of the Boyne a large-scale portrait of an Irish Catholic like Sir Neil O'Neill was almost unthinkable for at least a century, senior Catholic churchmen were occasionally painted, although their activities were officially severely curtailed. In about 1740 James Latham, who also depicted several Anglican bishops including the great philosopher Bishop George Berkeley (SEE P. 154, FIG. 1), sympathetically portrayed Christopher Butler, archbishop of Cashel, in full episcopal robes (University College, Dublin), though the latter's kinship with the powerful Butler family of Kilkenny Castle no doubt smoothed a path to the commission.[45] In the west of Ireland some forty years later, John Ryan presented an image of Catholic learning and piety in his portrait of Laurence Nihell, bishop of Kilfenora and Kilmacduagh (FIG. 22), surrounded by volumes by Augustine, Eusebius, and Josephus as well as his own writings.[46] But if it was possible for a Catholic bishop to be openly painted, images such as this are still distinguished above all by their rarity. Indeed, it was not until well into the nineteenth century that the newfound confidence—and financial resources—of the emancipated church were reflected in

triumphalist portraits such as John Hogan's statue of James Doyle, bishop of Kildare and Leighlin, for Carlow Cathedral (1839) and Nicholas Crowley's *Taking the Veil*, which shows Archbishop Murray receiving a postulant (1846; Saint Vincent's Hospital, Dublin).[47]

The bias toward Protestant sitters is skewed dramatically by the individual case of Daniel O'Connell, the Catholic emancipationist and crusader for the repeal of the Act of Union, whose image was the most widely circulated portrait in nineteenth-century Ireland. Some ten thousand plaster copies of Peter Turnerelli's bust of O'Connell were cast and, as quoted above, Charles Gavan Duffy noted their ubiquity. O'Connell was the only Catholic to whom a statue was erected in Dublin in the course of the century, and his features decorate everything from plates and figurines to engravings, medals, and handkerchiefs (SEE FIG. 23).[48] It is not surprising that as a great manipulator of public opinion, he should have been adept at manufacturing and controlling his image. In a portrait by Joseph Haverty of about 1836, which hangs in London's Reform Club among the great and good of nineteenth-century Liberal Britain, he poses as a Gaelic chieftain, wearing a great cloak with green sash and accompanied—in a telling echo of *Sir Neil O'Neill*—by his faithful wolfhound.[49] While this image reflects at once O'Connell's vanity and his defiant Irish identity, several of portraiture's other purposes, uses, and associations can be illustrated by his remarkable career. Portraits, and specifically portrayals of great men, have long been extolled for their inspirational power—a "spur to glory," as Samuel Madden put it—and the young O'Connell enjoyed perusing the illustrated press for images of the leading figures of the day. "I was always an ambitious fellow," he recalled years later, "and I often used to say to myself, 'I wonder will *my* visage ever appear in the *Dublin Magazine*,' I knew at the time of no greater notoriety."[50] Some years later, as his political

21

Fig. 21
Jan (John) van Nost the Younger. *David La Touche II*, 3rd quarter of the 18th century. The Huntington Library, Art Collections, and Botanical Gardens. Cat. 313.

Fig. 22
John Ryan. *Laurence Nihell, Bishop of Kilfenora and Kilmacduagh*, c. 1790. Private collection. Cat. 118.

Fig. 23
Daniel O'Connell, c. 1870. Private collection. Cat. 211.

22

23

career was taking off, he caught a glance of a copy in a Dublin shop window that included his own portrait. He had made it: "Here are my boyish dreams of glory realised."

O'Connell continued to use portraits of himself and others as part of his political campaigns and cult of personality (the two were inextricably linked). In an echo of the ambivalent Elizabethan rebels discussed at the outset of this essay, in Dundalk in 1843 at one of his "monster meetings," portraits of Queen Victoria—O'Connell had a particular fondness for the young queen—and her husband, Prince

Albert, surmounted triumphal arches flanking a central one dedicated to O'Connell.[51] This serves to highlight the contradictory complexity of much Irish political iconography, of an Irish pantheon. In the year of repeal, O'Connell was appropriating images of an English queen and German prince in his attempt to wrench Ireland from the Union; a later generation of Irish nationalists would expend considerable effort and ingenuity in removing traces of Victoria and Albert from the streets of Dublin. However, portraiture also had a very different, private significance for O'Connell.

For Christmas 1800, he promised his fiancée a miniature portrait of himself with a lock of his hair, while a few years later the couple's eldest child, Maurice, liked to kiss the picture of his often-absent father every morning, addressing it as "Dan."[52] Of course, this reminds us that not all Irish portraiture is political, and the same father-son bond is reflected in tender images of their children by Matthew William Peters (SEE FIG. 24), Sir Martin Archer Shee (SEE FIG. 25), and Nathaniel Hone (SEE P. 140, FIG. 2).

A different combination of the personal and political, of parental and conjugal love,

of commemoration and memory, is neatly
illustrated by another figure whose absence
Duffy's friend lamented in Nanetti's shop:
Lord Edward FitzGerald, coconspirator of
Wolfe Tone. On May 23, 1798, the very day
that O'Connell was called to the Dublin bar,
FitzGerald—son of the first Duke of Leinster
and one of the leaders of the United Irishmen
conspiracy—was arrested; he was wounded
resisting capture and died, very conveniently
for the authorities, in early June. A much-loved
figure, the dashing FitzGerald was greatly
admired even by O'Connell, who deeply disap-
proved of the rebellion that was launched
a few days after his arrest. FitzGerald had
been painted several times when alive, but
after his death there was a surge in demand
for images of the martyr, and posthumous
portraits proliferated. Within days his aunt
wrote to his brother Henry to arrange the
distribution of versions of Hugh Douglas
Hamilton's portrait: "There are two pictures
of him, one for your mother and the other for
you."[53] Portraiture served to console. Horace
Hone had painted FitzGerald in 1795 and 1797
and continued to produce miniature images
of him posthumously (p. 160).[54] The very act of
grouping them suggests their role as relics of
the beloved dead. Lord Edward's manner of
self-presentation speaks eloquently of political
commitment: his clothes and shortly cropped
hair are very much in the style of the French
revolutionaries. A Dublin audience, particu-
larly in the heightened atmosphere of the
1790s, would have been well attuned to reading
these indicators of loyalty: when FitzGerald's
beloved sister Lucy (also keenly *engagée*) wore
her "hair turn'd close up" at a ball, she noted
that it was "reckon'd democratic, and [I] was
not danced with."[55] In three of the miniatures,
Lord Edward wears a red neckerchief, a further
indicator of his allegiance to French revolu-
tionary principles; in the other, it was replaced
with a white one as a gesture of taste and
sensitivity after his sanguinary end.[56]

24

Fig. 24
Matthew William Peters. *Portrait of John
William Peters, the Artist's Son*, 1802.
Private collection. Cat. 98.

Fig. 25
Sir Martin Archer Shee. *William Archer
Shee, the Artist's Son*, c. 1820. Chrysler
Museum of Art, Norfolk, Gift of Walter
P. Chrysler, Jr. Cat. 120.

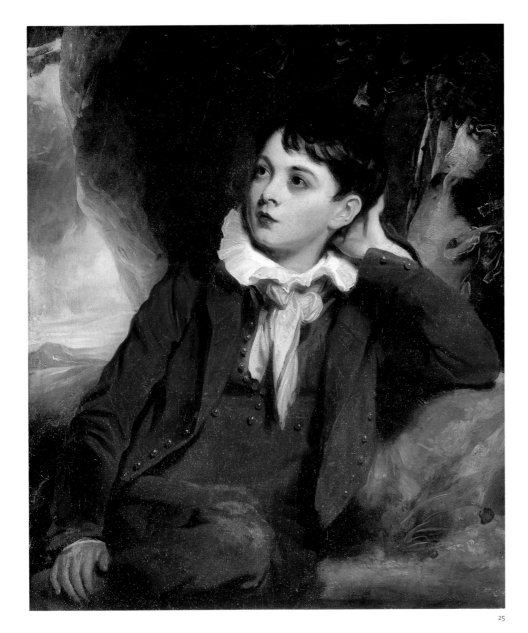

25

a horse, a groom, and a dog, all belonging to Lord Edward's younger brother.[59] The image and its title rather jar. The picture sympathetically portrays the handsome servant at center standing with dignity and poise. The title, by contrast, gives priority to the named horse rather than the starkly anonymous man, who is listed merely as one of the possessions of his six-year-old owner.

From antiquity onward, portraiture has served to commemorate not just a nation's statesmen but also its writers, philosophers, and, if less frequently, artists. Authors such as Swift appeared in Tone's imaginary Irish pantheon, and a bust of Thomas Moore was for sale in Nanetti's shop. The library at Trinity College, another pantheon of literary, philosophical, and scientific achievement, included busts of Cicero, Demosthenes, and Homer as well as Shakespeare and Milton. An Irish flavor was added through busts of the scientist Robert Boyle and the philosopher James Ussher, which were joined in 1749 by Roubilliac's portrait of Swift. Meanwhile, a circulating pantheon of writers was created by the growing market for prints, which was a comparatively cheap way to preserve the features of Ireland's great writers; Swift again was much in demand (SEE FIG. 27) as were Edmund Burke, Oliver Goldsmith, and Sheridan (SEE FIG. 28). As artists have always done, Irish painters portrayed themselves and their colleagues: Nathaniel Hone in particular recorded his own features on many occasions (SEE FIG. 29), while Thomas Frye (P. 156, FIG. 5), Charles Jervas (FIG. 20), and Alexander Pope (P. 151, FIG. 8) produced striking images of themselves in mezzotint, oil, and pastel, respectively. Quite different is the suave Neoclassical elegance of Adam Buck's portrait of himself and his family (FIG. 30), in which he balanced his interest in the art of the past with an evident love of kin; indeed, the two combine in the herm commemorating a deceased child, and the painting's juxtaposition of

If Reynolds's image of FitzGerald's brother, the second Duke of Leinster, took pride of place in Carton's saloon (SEE FIG. 16 ABOVE), FitzGerald's portrait by Hamilton assumed a talismanic significance for the family. In the 1930s, the American wife of the seventh duke recalled that, even then, the work hung in the house, and that Nesta, daughter of the fourth duke, "'nearly genuflected in front of it."[57] Also hanging for many years at Carton is perhaps the most striking image of an outsider in Georgian Ireland, Thomas Roberts's depiction of an elegantly attired East Indian servant

holding a horse (FIG. 26). Ironically, until very recently this was thought to represent Tony Small, a loyal servant who had saved Lord Edward's life at the Battle of Eutaw Springs during the American Revolutionary War—an occasion on which FitzGerald was fighting for the Crown *against* the cause of liberty.[58] However, instead of depicting Small, who was of African descent, it can be identified as a work Roberts exhibited at the Society of Artists in Ireland in 1772, *Bold Sir William (a Barb), an Indian Servant and French Dog in the Possession of Sir Gerald FitzGerald*, showing

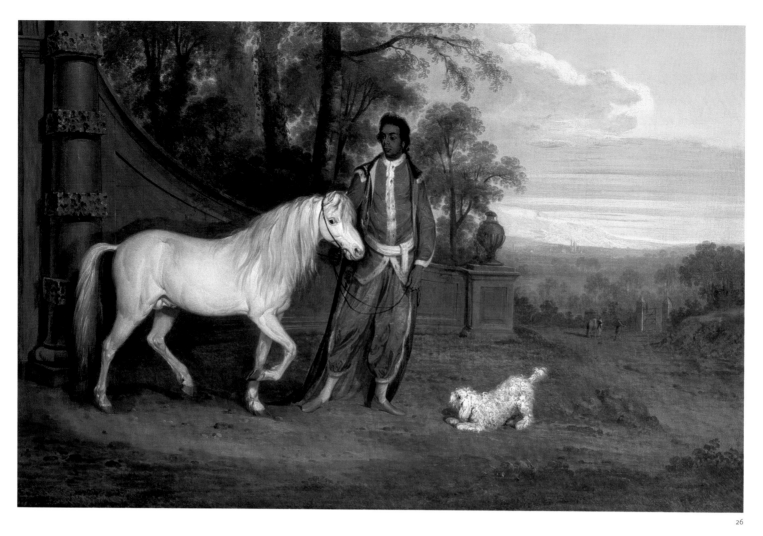

26

Fig. 26
Thomas Roberts. *Bold Sir William (a Barb), an Indian Servant and French Dog in the Possession of Sir Gerald FitzGerald,* 1772. Private collection. Cat. 105.

flesh and marble is poignant.[60] Also apparent, though, is an enjoyment of fashion, as the artist presents himself as a dandified Regency buck. If less so than writers, artists themselves were public figures, and a demand existed for their portraits. Among Gilbert Stuart's first sitters in Dublin was the artist Jonathan Fisher, who was also drawn in pastel by Hugh Douglas Hamilton (FIG. 31).[61]

Ireland has continued to celebrate its literary achievements rather more actively than its occasional artistic triumphs. Perhaps the multiple and complex factors that determined how art, and especially portraiture, was commissioned partly account for this. The recurring question of who would be commemorated, and by whom, continually asserted itself. For some, the beau ideal of an Irish portrait aimed to match a patriotic (and usually nationalist) Irish sitter with a native artist. For others, such as the author of the article in the *Hibernian Journal* quoted above, an English artist painting an English peer was the most appropriate image for the Mansion House, home of Dublin's mayors. Given these conflicting desiderata, it is inevitable that ironies abound: the most gloriously defiant image of Gaelic Ireland, the portrait of Sir Neil O'Neill, was painted by an Englishman, while the most "conspicuous" item in a display of portraits of "great Irishmen" at the Chicago World's Columbian Exposition in 1893 was a colossal statue by the Irish artist Albert Bruce-Joy of English prime minister William Gladstone.[62] But then there are always problems with the creation of a pantheon. Tone noted how, already in 1796, the remains of two of the revolution's illustrious dead, Honoré

Fig. 27
Andrew Miller, after Francis Bindon.
The Rev'd Jonathan Swift D. D., Dean of Saint Patrick's Dublin, 1743. Yale Center for British Art, Paul Mellon Collection. Cat. 90.

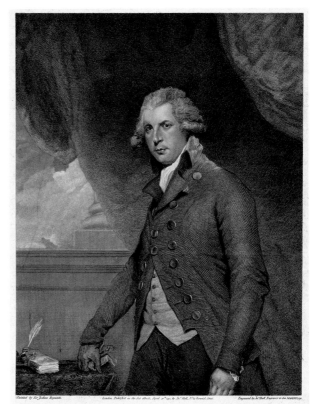

28

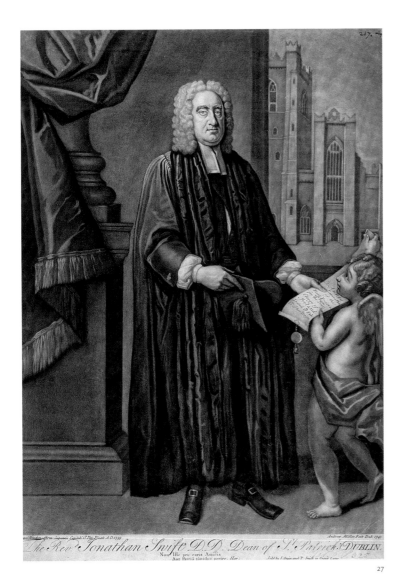

27

Fig. 28
John Hall, after Sir Joshua Reynolds.
Richard Brinsley Sheridan, Esq., 1791.
Private collection. Cat. 49.

Fig. 29
Nathaniel Hone. *Self-Portrait*, c. 1747.
Private collection. Cat. 64.

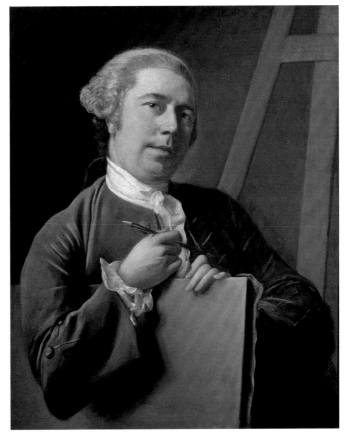

29

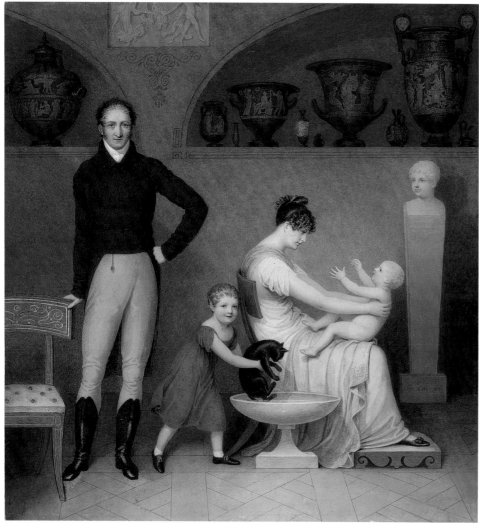

Fig. 30
Adam Buck. *The Artist and His Family*,
1813. Yale Center for British Art, Paul
Mellon Collection. Cat. 21.

Fig. 31
Hugh Douglas Hamilton. *Jonathan
Fisher*, c. 1777. Private collection. Cat. 52.

Gabriel, comte de Mirabeau, and even the republican martyr Jean-Paul Marat, had been removed from their crypts in the Panthéon for reburial elsewhere as their posthumous reputations plummeted. A similar readjustment was made after the outbreak of revolution in 1798, when the jittery authorities of Trinity College removed a portrait of Henry Grattan from its hall and put up an image of Edmund Burke, who, half a century later, was to be given good Irishman status by the *Nation*.[63] But at Trinity he was twinned not with Lord Edward FitzGerald but with the feared Lord Chancellor John FitzGibbon, 1st Earl of Clare. When making this selection, Burke's *Reflections on the Revolution in France* (1790) no doubt weighed heavier on the worthy dons' minds

than his reflections on the sublime, which he had begun as a student there many years before; depending on context, an individual's features could have more than one symbolic resonance. There is, of course, a further irony that, instead of hanging more portraits of English monarchs to affirm its loyalty in troubled times, Trinity—bastion of the English and Protestant interest—displayed images of two men of Irish and Catholic stock, if not confession. But Irish portraiture seems to throw up these incongruities: while almost seventy years elapsed between the laying of the foundation stone of Wolfe Tone's monument in Dublin and the 1971 erection of his statue by Edward Delaney on Saint Stephen's Green, it took only four years for his coreligionists to blow it up.[64]

The busts of O'Connell and Grattan that Duffy's friend singled out were created by that unlikely sounding Belfastman, Peter Turnerelli.[65] Perhaps—especially in the context of this exhibition, which highlights the many Continental influences on Irish art—it is not inappropriate to seek an Irish pantheon in the statuary shop of Giacomo Nanetti, another Italian immigrant. Paradoxically, the commercial impartiality that led Nanetti to stock busts of the Duke of Wellington and Thomas Moore did not result in any more confused couplings than Tone's heated musings about Jonathan Swift and Rory O'Moore, or indeed the conjunction of Queen Elizabeth and King Philip of Spain. Ireland has a long and complex tradition of appropriating external influence,

and it is rather fitting that Nanetti's son, Joseph Patrick, was to become lord mayor of Dublin and a member of parliament for College Green (James Joyce referred to him in *Ulysses* as a model, of sorts, of cultural assimilation). Come to think about it, an Italian in the Mansion House solves all sorts of problems.

NOTES

1 With thanks to Toby Barnard, Tom Dunne, and Kevin V. Mulligan. R. Foster 1988, p. 42. For the uses of portraiture in Ireland, see P. Murray 2010, pp. 151–87; F. Cullen 2004; Laffan 2001c. See also Fenlon 2012 and further literature by Dr. Jane Fenlon cited therein.

2 Hugh Douglas Hamilton to Antonio Canova, September 30, 1800. See F. Cullen 2000a; F. Cullen 1984, p. 175.

3 Wolfe Tone, March 7, 1796; Moody, McDowell, and Woods 1998–2007, vol. 2, p. 102.

4 S. Murphy 1993, p. 102.

5 *Nation* 1844, pp. 122–23. See Barrett 1975, pp. 405–06; F. Cullen 2004, p. 147.

6 Tillyard 1997, p. 242.

7 Glin and Laffan 2006; Strickland 1913, vol. 1, pp. 370–72.

8 Clark 1999; in general, Clark 2006.

9 *Hibernian Journal*, January 21–24, 1780; quoted in Powell 2004, p. 126.

10 Malcomson 2011, p. 57; Crookshank 1989–90, p. 180.

11 For an illustration of this portrait, see Stevenson and Thomson 1982, pp. 86–87, cat. 33.

12 Stevenson and Thomson 1982, p. 90. The nearest comparison to the costume can be found in John Derricke's 1581 *Image of Irelande*, in which a Gaelic chieftain is shown with a similar conical feathered hat, fringed cloak, and tights.

13 Buckeridge 1706, p. 479.

14 The portrait exists in three versions: the present work and two life-size portraits located in Tate Britain and Dunrobin Castle, Scotland. See Fenlon and Laffan 2010.

15 Herron and Kane 2103, p. 98.

16 *Nation*, May 27, 1843, p. 523. See Usher 2012, pp. 96–128.

17 Usher 2012, p. 124.

18 Powell 2004, p. 141.

19 Standen 1985, vol. 2, p. 731, with further bibliography. The tapestry was a donation (in 1734) from Van Beaver himself, who had come to Ireland from Flanders and worked on *The Valiant Defence of Londonderry* and *The Glorious Battle and Victory of the Boyne*, tapestries commissioned from Robert Baillie for the House of Lords, where they remain today.

20 Glin and Peill 2007, pp. 76–77.

21 Barnard 2005, pp. 69–70.

22 P. Murray 2008.

23 Egerton 2001.

24 Fenlon 2001, p. 13.

25 Malcomson 2011, p. 358; Barratt and Miles 2004, pp. 83–90, 97–99.

26 McMinn 2005, p. 168; Kavanagh 1997, p. 200; D. Alexander 1973, p. 79.

27 Laffan and Mulligan 2014, pp. 12, 16.

28 Laffan and Mulligan 2014, p. 101. These were executed by Sir Joshua Reynolds in Rome.

29 It is tempting to see Emily's hand in this juxtaposition; her sister, Caroline Fox, certainly oversaw the hanging of the family portraits at Holland House in London and wrote to Emily about it. See Retford 2006, pp. 322–23; A. FitzGerald 2014, pp. 118–27. See also an album dated 1891 of photographs of Carton taken by T. H. Riley of 24 Grafton Street, Dublin, which was sold at Neal Auction House, New Orleans, February 8–9, 2014, lot 1054. For Willem Wissing's portrait, see MacLeod and Alexander 2002, pp. 204–05.

30 Horace Walpole, *Anecdotes of Painting in England* (1788; repr., J. Murray, 1872), p. 324. The sale takes place in act 4, scene 1 of *The School for Scandal*.

31 For this portrait of Plunkett, which is attributed to Garret Morphey, see F. Cullen 2004, pp. 46–48.

32 M. Lyons 1995, p. 175.

33 Benn 1877, p. 444, n. 1; Laffan 2006, pp. 125–27.

34 Friedman 1966, vol. 4, pp. 82. See Stafford 2004, pp. 149–50.

35 Walpole 1872 (note 30), p. 323. For Jervas, see Pegum 2010.

36 Benedetti 1998.

37 *Volunteers Journal*, June 6, 1785.

38 *Hibernian Journal*, January 10, 1791. In the 1760s Patrick Cunningham had pioneered small portraits modeled in colored wax; Casey 1995b.

39 *Dublin Newsletter*, June 3–7, 1740.

40 *Hibernian Journal*, September 11–14, 1778.

41 B. FitzGerald 1949–57, vol. 1, p. 133.

42 Elliott 2012, p. 371.

43 Matthew Pilkington, *Poems on Several Occasions* (1730), quoted in Barnard 2004, p. 151.

44 Quoted in Whelan 1995, p. 37.

45 McDonnell 1995, pp. 16–22; for the portrait of Latham, see p. 16, fig. 13.

46 Mitchell 1974–75.

47 For Hogan's statue of Doyle, see P. Murphy 2010, pp. 62–64, fig. 75; for Crowley's painting of Murray, see McDonnell 1995, pp. 20–22, fig. 19.

48 See O'Ferrall 1994.

49 For Haverty's portrait of O'Connell, see O'Ferrall 1994, p. 98.

50 Madden 1739, p. 49; Daunt 1848, vol. 1, p. 101.

51. Geoghan 2010, p. 147.

52. Geoghan 2008, pp. 96, 105.

53. Quoted in Moore 1831, vol. 2, p. 149. For Hamilton's portrait of Lord Edward FitzGerald, see F. Cullen 2004, p. 158, fig. 101.

54. Hone's images relate in some way, not yet fully understood, to a series of portraits of the sitter by Hugh Douglas Hamilton; Caffrey 2000, p. 99; Hodge 2008, pp. 94–95. See also the discussion in F. Cullen 2004, pp. 176–79.

55. Tillyard 1997, p. 221.

56. Caffrey 2000, p. 99; Tillyard 1997, p. 218.

57. Quoted in Dooley 2014, p. 221.

58. See, for example, Tillyard 1997, pp. 64–66.

59. See Breeze 1985, p. 25, and the discussion in Laffan and Rooney 2009, pp. 161–66. As Small did not arrive in Ireland until some years after Thomas Roberts's death in 1777, this identification necessitated a further error and an attribution of the painting to the artist's younger brother, Thomas Sautelle.

60. Jenkins 1988.

61. For the Stuart portrait of Jonathan Fisher, see Barratt and Miles 2004, p. 76; for the Hugh Douglas Hamilton, see Laffan and Rooney 2014a.

62. F. Cullen 2012, p. 137.

63. See Crookshank and Webb 1990, pp. 53, 61; F. Cullen 2000b, p. 194.

64. Delaney 2009, pp. 172–98.

65. See Gilmartin 1967.

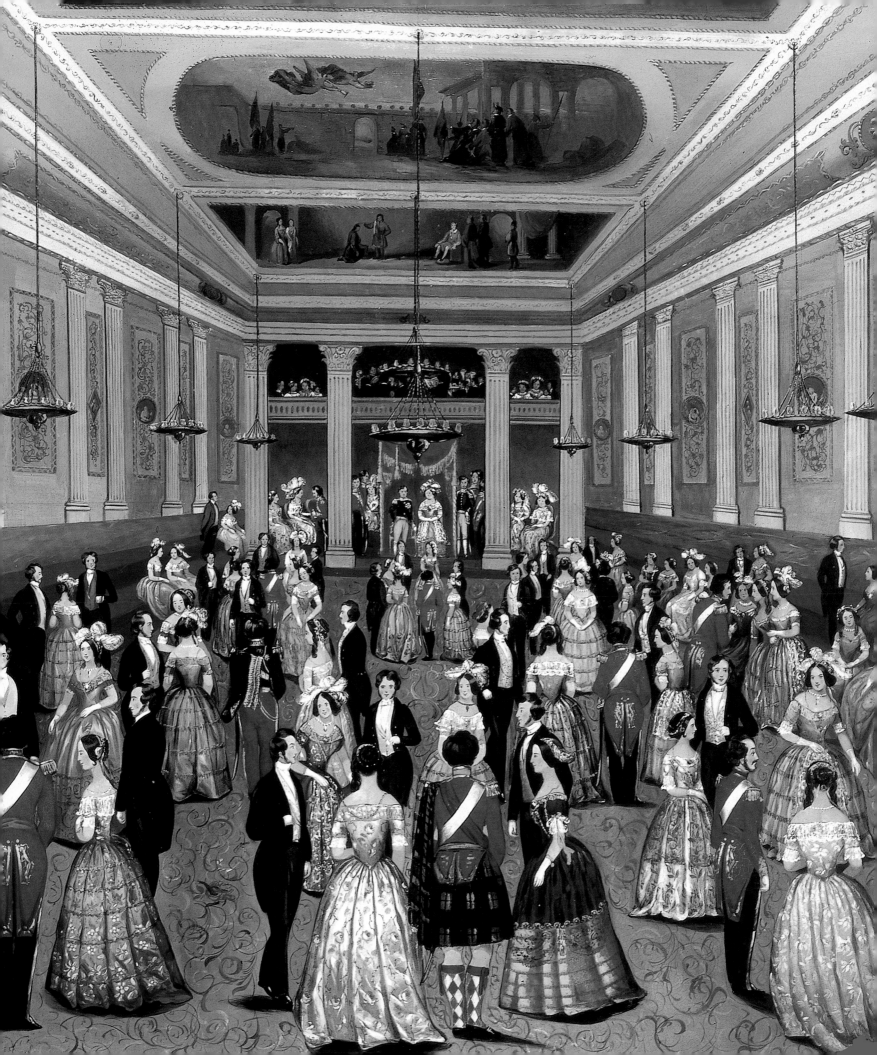

Dublin: Capital of Ireland, Second City of the British Empire

TOBY BARNARD

DUBLIN MADE A CONVENIENT headquarters for successive invaders of Ireland. First, in the ninth century, came the Danes; the Normans arrived from England and Wales three centuries later. The settlement, located on the east coast, was readily accessible by sea and conveniently situated to serve as the capital of the English kingdom of Ireland. By the seventeenth century, the place had acquired some of the attributes of a European capital (SEE FIG. 1). It accommodated the English king's representative, usually given the title lord lieutenant, who resided in Dublin Castle for part of every second year. It was the seat of a parliament that met every two years from 1703 until its abolition in 1800; law courts; a rapidly expanding bureaucracy and tax-gathering apparatus; a university; and prestigious religious and educational establishments that published scholarly books of the highest quality. Theaters opened, and booksellers and printers, such as the Trinity College Printing

House (SEE FIG. 2), multiplied, as did voluntary associations and commercial entertainments. Not just members of the propertied elites and professionals, but also the middling sorts (craft workers, shopkeepers, and traders) came together in clubs, guilds, Masonic lodges, and the groups that ran Church of Ireland and Catholic parishes and nonconformist meeting houses. The work and pleasures of these many organizations added to the demand for material accessories. Members embellished the buildings and rooms where they met, acquired uniforms and regalia, and employed furnishings and utensils for their ritualized convivialities. Slowly rising incomes paid for these efforts.

Dublin did not monopolize such activities, but its great population ensured that it enjoyed the largest share. Provincial towns, especially those around the coast, served as commercial and administrative centers.[1] In time they, too, promoted new styles of living. Dublin's preeminence as dictator of fashion was assisted by its role as the busiest port in Ireland. Moreover, goods shipped in—exotic woods, silk yarn, sugar—were made into salable commodities close to the quays where

they had been unloaded. Given these favorable conditions, it was not surprising that Dublin grew in size to become, by some distance, the most substantial city in Ireland. Indeed, within the empire of the later Stuarts and Hanoverians, it was second only to London. Its population increased from an estimated 45,000 in 1685 to 92,000 in 1725, then 140,000 at George III's accession in 1760. In 1798 it was thought to total 182,000, in 1821 224,000, and in 1841 254,000.[2]

Size endowed the city with an attractive power that tempted more to settle, either temporarily or permanently. It was a place in which it was supposed jobs were to be found, reputations and fortunes made, marriage partners located, health mended, the latest styles seen, and shopping done. Under these pressures, Dublin expanded physically along both the north and south banks of the River Liffey, which had to be spanned by more bridges. Fresh developments catered to the demand for accommodation both prestigious and utilitarian; districts came into vogue that were promoted by speculators and investors and decked out in smart architectural dress. Town houses arranged in terraces and

F. J. Davis. *The State Ballroom, Saint Patrick's Hall, Dublin Castle,* mid-19th century (detail). Cat. 31 (see p. 68, fig. 8).

1

squares were only occasionally interspersed with palazzi owned by rich peers. Care was devoted to furnishing such residences and to organizing the entertainments staged in them, and they set a standard of living and display that was much copied. Owners and tenants of these Dublin lodgings frequently spent much of their lives in the Irish provinces. They returned to their country homes with objects and ideas that they passed on to neighbors and relations whose horizons were more constricted. For those who lacked any opportunity to sample for themselves the cornucopia of material delights spilling through the Dublin streets, there were always newspaper advertisements. Provincial artificers and entrepreneurs, avid for more business, rapidly copied articles for sale in the city; occasionally, they improved upon them with wares such as the elegant decanter produced by the Waterloo Glasshouse Company in Cork (FIG. 3).

Dublin had a dynamism that expressed itself in its appearance and its cultures, and which was felt with varying intensity across the whole island. Furthermore, thanks to its strategic location on the Irish Sea, the city enjoyed close connections with Bristol, Chester, Greenock, Liverpool, Milford, Minehead, and Whitehaven. For some along the western seaboard of Britain—for example,

in North Wales—it was easier to take a ship to shop in Dublin than to trek to London.

Despite its vibrancy and aspirations to cultural independence, Dublin, like Ireland itself, had to acknowledge elements of subordination. There were irksome economic, legal, and practical dependencies on England and London. Tax regimes favored English goods and discriminated against the Irish-made. Much that happened in Dublin, including the manners in which houses and their accoutrements were designed, was mediated through England. From outsiders' perspectives, Ireland and Dublin were remote and peripheral, awkward of access from London and southeastern England, the pivot of English government. Nor were there the same incentives for travelers to venture west as those that impelled them into the Low Countries, down the Rhine and Danube or to Paris, and then over the Alps into Italy. Any notion that there was an enviable, rich Irish culture to be pillaged was slow to develop, even among proud natives. A rarefied taste for what were thought to be authentic Celtic artifacts and designs gradually influenced contemporary artificers, but not powerfully until the mid-nineteenth century.

Inhabitants of Ireland filched and sometimes even pirated from London notions of

2

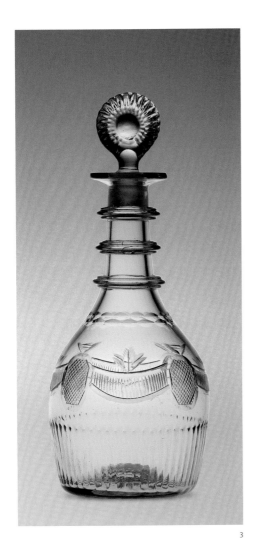

3

Fig. 1
Francis Place. *View of Dublin from the North*, c. 1699. Museum of Art, Rhode Island School of Design, Providence, Anonymous gift 71.153.26. Cat. 99.

Fig. 2
Edited by John Hawkey, printed by Trinity College, E Typographia Academiae. Frontispiece to *Terentius*, 1745. Philip and Niamh Maddock. Cat. 157.

Fig. 3
Waterloo Glasshouse Company. Decanter, c. 1820. Private collection. Cat. 247.

correct decor, dress, and furnishings. However, their enslavement to metropolitan rules was not total. In succession, the English embrace of Baroque, Rococo, Neoclassical, and Romantic styles reflected a veneration and belated adoption of ideas originating in Continental Europe. The Irish, too, could go directly to the same sources, eliminating any humiliating debt to Britain. By the late seventeenth century, travelers from Ireland were following the same itineraries as their English, Scottish, and Welsh counterparts. George Berkeley, a cleric from Trinity College soon to become a bishop (SEE P. 154, FIG. 1), proved an intrepid explorer of Italy during the 1710s. In the next generation, James Caulfeild, 1st Earl of Charlemont, traveled with his Irish companions into the Near East. Irish visitors to Rome could commission the same artists—painters such as Anton Raphael Mengs and Pompeo Batoni, and sculptors including Christopher Hewetson—as their non-Irish contemporaries; they chose from the same booty and had *pietra dura* cabinets and tabletops, antique statuary and sarcophagi crated up for shipment back home (SEE P. 24, FIG. 8). In Rome they also found a colony of Irish sojourners such as artists Hewetson, James Durno, Robert Fagan, Hugh Douglas Hamilton, and Henry Tresham, who stayed for much of their careers.[3] These presences eased the diffusion into Ireland of objects and values that spoke of a Europe-wide veneration for Classical antiquities and their modern revival.

However, affluent grand tourists were not necessarily the most important conduits through which the material cultures of Hanoverian Ireland were diversified. Nor indeed was Italy always the most powerful influence over what was admired, bought, and copied. Although Ireland's distance from the cultural heart of Europe was a drawback, it was accessible to maritime trade. By the later seventeenth century, existing traffic across the seas was extended as more Irish left their homeland for foreign ports. Penalties against Catholics, following their military defeats of the 1640s and 1689–91, swelled the exodus. To European destinations were added ones in the Americas and Asia. Merchants in Ireland of all religions had long maintained factors and correspondents around the Atlantic littoral and beyond: Bordeaux, Cádiz, Jamaica, Ostend, Philadelphia, Rouen, and Seville. Thanks to these linkages, customers in Ireland found it relatively easy to acquire the luxuries, novelties, and staples they craved.

English laws required that most of these commodities be supplied by way of Britain, not directly into Ireland. Such prohibitions added to the attractions of smuggling. In addition, they ignored geographical realities. The island of Ireland could deal directly with European ports and, increasingly, with those beyond. Vessels returning from the East and West Indies sailed close to the country's southern seaboard; piracy, storms, and clandestine trade brought ashore exotic contraband such as porcelains and vivid calicoes, chintzes, and silks.

These forces combined to turn seventeenth- and eighteenth-century Dublin into a lively entrepôt. Seagoing vessels sailed into the heart of the city, berthing and unloading at wharves located beside warehouses, offices such as the customhouse, and private homes. Dublin Bay itself, commanding the open and unpredictable sea, was visible from many locations in and around the city and came to be valued as a prospect from houses and gardens. As sea bathing was promoted as healthy, the fashionable acquired villas beside the shore.

Institutions set the standard for striking and modern building. The state, for instance, founded the Royal Hospital Kilmainham on an elevated site to the west of the city (SEE FIG. 4). Intended for war veterans, it was an Irish equivalent of the Royal Hospital Chelsea and a riposte to Louis XIV's Invalides in Paris.

Its architect, Sir William Robinson, captured here in a portrait by Sir Godfrey Kneller (FIG. 5), served (and apparently defrauded) the administration in a variety of capacities. In an era before architecture became a profession for which formal or standardized training was available, gifted amateurs enjoyed exciting opportunities to design and build. Robinson was followed by Thomas Burgh, son of a Church of Ireland bishop, who applied his forte in fortifications to the planning and construction of a massive, almost barrack-like library for Trinity College. In scale rather than in sophistication of plan and detail, it embodied the primacy of the recently established Protestant interest at its intellectual center. Soon Burgh's efforts were surpassed by those of another from the Protestant elite, Sir Edward Lovett Pearce, the son of a general. The younger Pearce traveled to Italy and studied at firsthand the works of the classical masters, notably Andrea Palladio. He benefited too from kinship with the English architect Sir John Vanbrugh. Pearce—like Robinson and Burgh before him, an Irish MP—was entrusted with the design of the new Parliament House that was to be erected in a conspicuous site opposite Trinity College, as seen in James Malton's 1797 watercolor, with Parliament on the left and Trinity College on the right (FIG. 6).

In comparison, although the official residence of the royal deputy in Ireland at Dublin Castle underwent campaigns of renovation and enlargement, it remained ramshackle and inconvenient despite its idealized appearance in Malton's 1792 view (FIG. 7). Occupants of the lord lieutenancy concentrated their efforts on redecorating and embellishing the state apartments, which was more easily achieved. Woven tapestries, lushly upholstered chairs of state, and murals most readily achieved sumptuous effects and provided settings for elaborate entertainments. The apogee was reached under Lionel Sackville, 1st Duke of

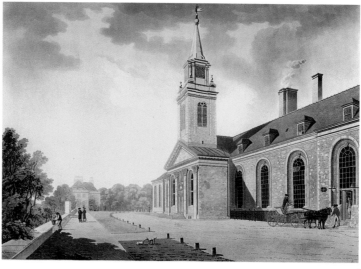

4

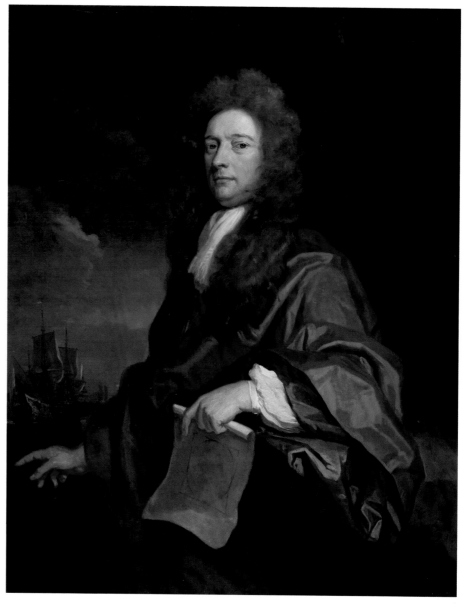

5

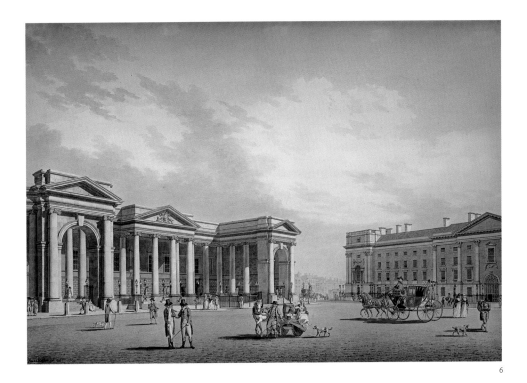

6

Fig. 4
James Malton. *Old Soldiers Hospital, Kilmainham, Dublin*, published February 1794. The Art Institute of Chicago, gift of Mrs. Isaac K. Friedman, 1932.1244.9. Cat. 84.

Fig. 5
Sir Godfrey Kneller. *William Robinson, Later Sir William Robinson, Knight*, 1693. The Huntington Library, Art Collections, and Botanical Gardens, Gift of Beatrix Farrand. Cat. 75.

Fig. 6
James Malton. *Parliament House, Dublin*, 1797. The Huntington Library, Art Collections, and Botanical Gardens. Cat. 87.

Dorset, who had two tours of duty in the 1730s and 1750s. Although he imported some of the props for viceregal ceremonies, Dorset patronized local artificers and suppliers. A service of earthenware embellished with his own ducal coronet (not his royal master's heraldry; SEE P. 182, FIG. 2) shows the lavishness of Dorset's arrangements. Even so, lords lieutenant were constrained by tight budgets and stayed only for relatively brief periods; the objects they commissioned have often, but not always, proved evanescent. F. J. Davis, thought to be a decorator at Dublin Castle in the mid-nineteenth century, recorded a state ball in Saint Patrick's Hall around 1845, in which guests danced under newly installed gaslights and scenes relating to Saint Patrick by Vincenzo Valdrè (SEE FIG. 8 AND P. 62).

The lords lieutenant had a modest, old-fashioned country retreat at Chapelizod that was easily reached from Dublin; this, however, was soon eclipsed by the palazzi of local notables. Most conspicuous by the end of the 1720s was Castletown, the seat of William Conolly, speaker of the House of Commons and the leading politician of his generation.

This was soon joined by nearby Carton, which signaled the reemergence of the venerable Anglo-Norman dynasty of the FitzGeralds. The FitzGeralds, like other ascendancy families such as the Wingfields (Lords Powerscourt), also owned stately town houses in Dublin. Such assets made them—and those like them—into alternative and potentially rival leaders of Dublin society with whom the transient lords lieutenant found it hard to compete successfully.

Nevertheless, an economy of ceremonies punctuated the life of the castle. Much of it followed the routines of the English court, which by George III's reign was noted more for its domesticity than its magnificence. Distinctive Irish elements were introduced, with annual thanksgivings for the Protestants' deliverance from the Catholics' supposed conspiracy on October 23, 1641, and from Catholic domination by the arrival of William III in 1688. Not until 1783 was an Irish order of chivalry instituted. The Order of Saint Patrick aimed belatedly to supply political and cultural cement to the landowning elite in the way that the Order of the Garter and Knights of the Thistle had in England and Scotland, respectively. Gilbert Stuart painted the Marquess of Waterford wearing a star of the Order of Saint Patrick (FIG. 9; SEE ALSO FIG. 10). Fresh renovations in the Cathedral of Saint Patrick and the castle accommodated these modern patrician rituals.

Calculated to eclipse viceregal efforts and proving generally more durable were commissions from the parliament, the university, the established Protestant Church of Ireland, and the law courts. Unlike the lords lieutenant, the personnel and the institutions they staffed were deeply grounded in Ireland and seemed to better justify architectural and artistic display. The standard was set by the Irish Parliament. Dissatisfied with a succession of modest billets, the members hired Pearce to design a noble new building. The architect brought his understanding of Classicism

to the commission, and the result outdid
in sophisticated modernity the parliament
houses of Westminster and Edinburgh; it was
further enhanced by James Gandon later in
the century (SEE FIG. 11). The building faced
onto College Green, on which an equestrian
statue of William III was raised on a massive
plinth. From the 1760s, the Parliament House
was answered by the symmetrical Classical
blocks of Trinity College. Like its neighbor,
it was a Protestant monopoly and could be
regarded as the seminary and intellectual hub
of the Protestant Ascendancy. The estab-
lished church had inherited the two medieval
cathedrals, Christ Church and Saint Patrick's,
but directed most of its spending on par-
ish churches, building new ones to serve the
growing population and replace decrepit
facilities. The law courts had been obliged to
sit in a number of makeshift locations that
were deemed unworthy and, in some cases,
positively dangerous when floors collapsed.
Eventually, the legal quarter was moved to the
north side of the Liffey, where buildings appro-
priate to the majesty of the law—notably, an
English import—were erected. The Irish artist
James Hore recorded Gandon's Four Courts in
about 1837 (FIG. 12).

In a comparable manner, the seat of the
revenue commissioners, originally by the
congested riverside, was removed nearer the
seaward end of the Liffey. Gandon's Customs
House, completed in 1791, attested to the
importance of trade to Dublin and the larger
Irish economy, as well as to the self-promo-
tion of the commissioners. These grandiose
projects reflected a local pride, sometimes
with a decided patriotic tang and occasion-
ally in a way that masked Irish irritation
with the patronage and slights coming from
England. Meanwhile, individual owners of
urban properties grasped opportunities to
profit as demand for housing grew. Dublin's
city government tried to systematize some of
the piecemeal development and set standards

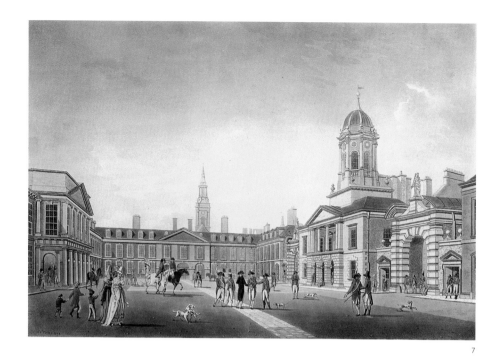

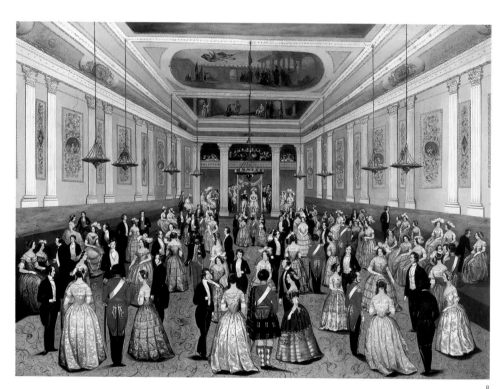

Fig. 7
James Malton. *Great Courtyard, Dublin Castle*, published July 1792. The Art Institute of Chicago, gift of Mrs. Isaac K. Friedman, 1932.1244.5. Cat. 82.

Fig. 8
F. J. Davis. *The State Ballroom, Saint Patrick's Hall, Dublin Castle*, mid-19th century. The Irish Art Collection of Brian P. Burns. Cat. 31.

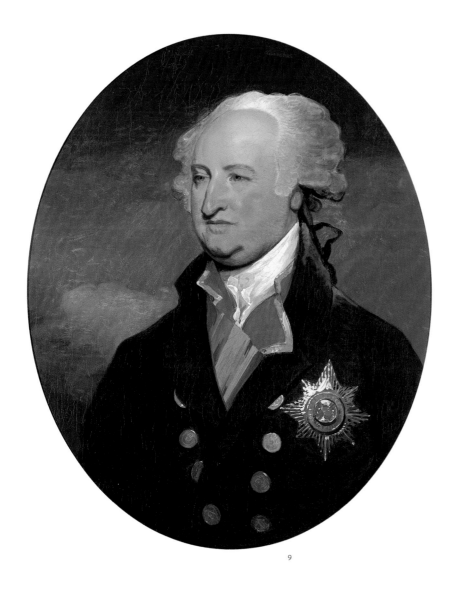

9

10

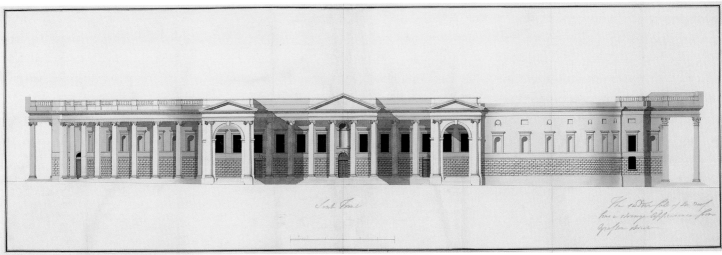

11

Fig. 9
Gilbert Stuart. *The Marquess of Waterford*, c. 1787–92. Snite Museum of Art, University of Notre Dame, Acquired with funds provided by the Lawrence and Alfred Fox Foundation and Edward and Ann Abrams. Cat. 124.

Fig. 10
Rundell, Bridge and Rundell. Star of the Order of Saint Patrick, c. 1815. Private collection. Cat. 285.

Fig. 11
Office of James Gandon. *Parliament Building, South Front*, c. 1800. Collection Centre Canadien d'Architecture/ Canadian Centre for Architecture, Montréal, DR1983:0452. Cat. 46.

for materials and styles in the areas it owned. Beginning in 1664, Saint Stephen's Green was developed with a large central enclosure planted with trees and crossed by walks and rides. Private enterprise created pleasure grounds modeled after those in London and Paris, regulating entry through admission charges. A more rigorous attempt to sweep away the antiquated, unsafe, and unsavory occurred with the creation of a Wide Streets Commission. Informed by knowledge and admiration of planned towns outside Ireland, the commissioners aspired to make Dublin more regular and commodious during the 1780s.

The cartographer John Rocque, who had completed surveys of Paris and London in 1746, mapped these enlargements and offered a detailed survey at the midpoint of the eighteenth century (SEE FIG. 13). Artists also recorded notable additions and picturesque survivals. Sometimes patrons paid them to do so; sometimes they were responding to their own visual fancies. In the thriving city, the talents of craft workers, designers, painters, and surveyors were much in demand; their work is explored in part 2 of this catalogue. Even so, there were regular complaints that native prowess was insufficiently appreciated; so much so that the ambitious had to emigrate to seek work and recognition. The corollary of this objection was that the exotic, foreign, and unfamiliar were of interest at the expense of the home-produced.

Such a situation was not unique to Dublin and Ireland, yet it posed a conundrum for patrons and consumers. In choosing between various goods, they had to weigh cost, durability, quality, and utility alike. A quest for novelty and a wish to be abreast, or indeed ahead, of fashion frequently came into play. In general, the latest and most desirable objects originated outside Ireland and often away from Britain. Competing with the wish to be seen as a cynosure of style, however, was the gathering

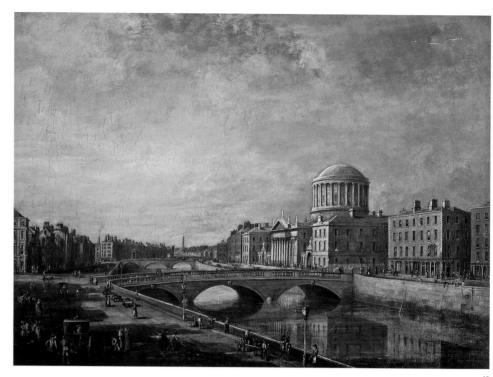

12

strength of patriotism. Purely financial arguments decried the draining of money to non-Irish producers and suppliers; in addition, the devaluation and ridicule of Ireland and all its works riled locals. In answer, they stuck ostentatiously to native-made wares and sought to improve their look and quality.

Dublin possessed boisterous, earthy, ribald qualities that, depending on one's attitude and experience, either charmed or horrified. As in any large and rapidly growing city, problems of deprivation, disorder, and heavy mortality abounded. The population shared unequally in the prosperity and vitality that gave rise to architectural and artistic achievements. Bit by bit, however, the refinements of so-called polite living were diffused among professionals, the middling sorts, and even the working poor. Furthermore, those whose livelihoods depended on catering to and servicing the well-to-do and would-be respectable could partake of the improved standards of living.

We can develop a sense of this broader consumerism through inventories of possessions recorded at death, through records of

purchasing, and through the proliferation of articles that each had a maker and retailers to stock and sell them. Yet there were anxieties about the fragility of this development. Spending might suddenly be checked by bad weather or traffic interrupted by foreign wars; by decreased sale prices of agricultural goods and increased rents for land; or by a rise in the cost of staples, which left less money to spare for nonessentials. Throughout the eighteenth century, commentators regularly worried about the financial and moral damage of preferring imported fashions to indigenous ones. Efforts to check this preference, other than exhortation and protectionism through higher import duties, brought attempts to improve the competitiveness of Irish-made products. There were determined moves to ensure that Irish ceramics, furniture, glass, and silver in particular matched or surpassed foreign rivals in appearance, durability, price, and utility. Many of these efforts involved copying and ideally anticipating the fashions set in London, Paris, and Rome. While many producers were emulating and varying prototypes that were

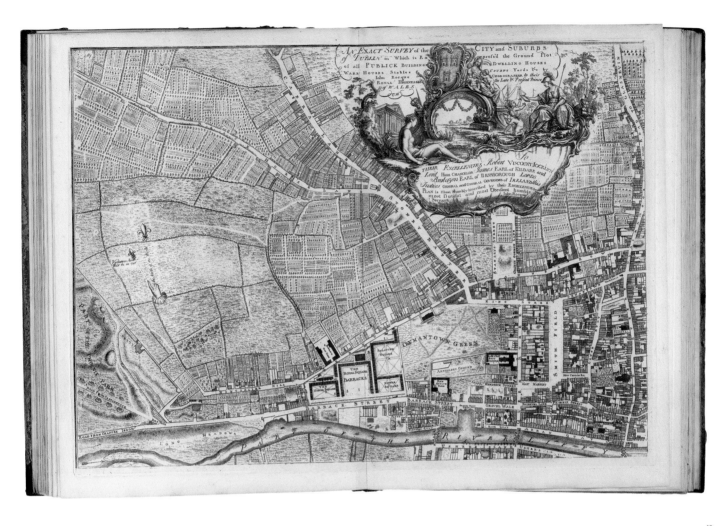

Fig. 12
James Hore. *The Four Courts, Dublin, from the Quay*, c. 1837. The Irish Art Collection of Brian P. Burns. Cat. 69.

Fig. 13
John Rocque. *An Exact Survey of the City and Suburbs of Dublin*, 1757. Yale Center for British Art, Paul Mellon Collection. Cat. 180.

not original to Ireland, some of the variants themselves came to be recognized and valued as typically Irish (SEE FIG. 14).

Worry over the precariousness of Dublin's grandeur was heightened when, in the wake of the unsuccessful but destructive uprising of 1798, a legislative union of Ireland and Great Britain was enacted. In 1800 Ireland lost its parliament. Ultimate decisions about policies had long been made in London, but the removal of one of the most tangible features of Ireland's status as a kingdom entitled to govern itself dealt a psychological and practical blow. Just how much the cultural, economic, and political life and morale of Dublin—and Ireland—suffered is a matter of dispute. A lord lieutenant continued to reside periodically in

Dublin Castle and preside over state occasions. Dublin remained the administrative, ecclesiastical, educational, legal, and medical hub of the island. Much traffic passed through its port, although, unlike Belfast, it never developed into a major manufacturing center.

Long before the formal Act of Union in 1800, there had been recriminations that if they were to make their reputations and fortunes, ambitious Irish were obliged to emigrate, typically to London but also to Continental Europe or North America. Only outside Ireland, it was argued, did there exist wealthy and appreciative patrons and rewards. Gilbert Stuart returned to America even though he portrayed Speaker John Foster (FIG. 15) and Lord Chancellor John FitzGibbon,

1st Earl of Clare (1789; Cleveland Museum of Art), two giants of the Dublin parliament during its final phase. James Barry, despairing of making a career in Ireland, settled in London, where he executed a series of paintings for the Adelphi Rooms of the Royal Society of Arts and was involved in an unrealized scheme to decorate Saint Paul's Cathedral. The sculptor Christopher Hewetson, as we have seen, established himself permanently in Rome, where his commissions ranged from likenesses of the pope and cardinals to the provost of Trinity College, Richard Baldwin, and the earl bishop of Derry, Frederick Hervey. To his younger rival Antonio Canova, Hewetson was "Mr Cristoforo Irlandese."[4] Thomas Frye, meanwhile, played a pivotal part in the founding of the Bow Porcelain Factory (SEE FIG. 16) in London and pioneered mezzotint portraits while continuing his work as a painter.

Even remembering these examples, it would be unduly pessimistic to contend that it was impossible for anyone born in Ireland to thrive at home as an artist, designer, or writer. Word of mouth, connections, and sheer ability brought profitable work to some whose careers were spent entirely in Ireland, sometimes even in provincial towns. By the 1760s and 1770s, freelance artists were advertising in Cork and Belfast, taking commissions for miniatures and silhouettes and giving lessons to aspiring amateurs.[5] In 1777 it was announced that a gentleman had just arrived in Belfast who executed striking profiles in miniature for two shillings and sixpence each; he combined this skill with that of repairing and whitening teeth.[6] Common among artists and skilled craft workers was an itinerant life. Trained sometimes in London or Italy, they used whatever openings and introductions appeared, and those might oblige a peripatetic existence divided between Britain and Ireland. Moreover, the knowledge that Dublin was populous and prosperous enticed foreigners such as the architects Richard Castle, Davis Ducart,

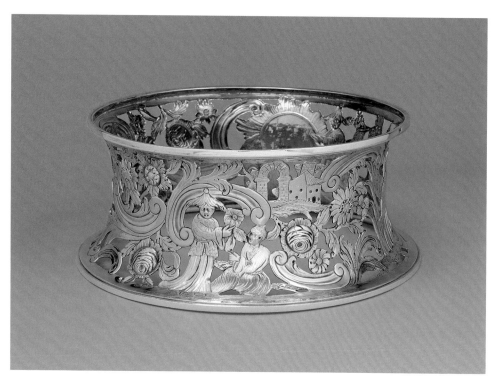

14

and James Gandon, and the expert Swiss stuccodores Paolo and Filippo Lafranchini to relocate there. In some cases, private individuals including Robert Molesworth, 1st Viscount Molesworth, and Lord Charlemont invited favored architects such as Alessandro Galilei and Sir William Chambers to work for them.

The several routes by which artisans and artists emerged in eighteenth-century Ireland go far to explain the hybrid nature of what they made. Many sprang from indigenous traditions in the crafts; the lucky, having exhibited potential, were helped to perfect their skills in the drawing and design schools set up by the Dublin Society or through subsidized training outside Ireland. In particular, the Dublin Society sent hopeful youths on scholarships to Rome. Other students traveled within Ireland, where they viewed the country's increasing selection of buildings and objects, or to Britain and Continental Europe, encountering idioms and ideas that they might later apply to their work.

Inhabitants of Ireland were sensitive about what they regarded as the habitual

denigration of themselves and their country. At best they were described as primitive, less flatteringly as provincial, or, with the Hanoverians' empire swelling, as colonials little different from those in Asia and America. To counter such affronts, the Irish made strenuous attempts to assert their country's ancient and advanced culture, emphasizing its history as an early stronghold of Christianity that retained relics of its status as an island of saints and scholars. In addition, Irish patriots called attention to native innovations in the arts, institutional improvements, and manufactures. The iconic role of Jonathan Swift (SEE P. 59, FIG. 27), who resided mainly (if reluctantly) in his Dublin deanery of Saint Patrick's from 1713 to 1745, offset the embarrassing flights to England of Edmund Burke (SEE P. 40, FIG. 1) and Richard Brinsley Sheridan (SEE P. 59, FIG. 28).

The increasing numbers of artisans and craft workers recorded in Dublin suggested brisk demand for their wares on the part of residents and visitors. This eagerness to buy revealed a belief that such possessions were

15

necessary not just to live, but to live creditably. Yet the bulk of what survives from the eighteenth century was of relatively high monetary value, meaning that its preservation mattered. Cheaper replicas and substitutes of what the rich wore and displayed in their homes proliferated but have seldom survived. Journeymen painters recorded the likenesses of provincials, and the hopeful or desperate among them quit Dublin—and even England—to seek new customers in towns such as Armagh and Belfast. To make their works more readily affordable, they painted only the head and shoulders rather than three-quarter or full-length portraits. For their part, reproductive engravings and etchings had long been promoted as a means for consumers to decorate their walls economically and also gain access to notable paintings held in private or overseas collections. Tapestries and textile hangings, always the preserve of a tiny elite, were falling from fashion by the eighteenth century. Sober wooden paneling had to suffice for many, but a taste for lush plasterwork spread among the fashion-conscious both in Dublin and the provinces. Even so, its presence did not always obviate the wish to enliven walls with painted or printed images. So far as the latter were concerned, the Irish tended to acquire works that had been made either in Continental Europe or London. Acknowledged Old Masters were in demand, but so too were moderns such as William Hogarth with his series *The Rake's Progress* (1732–33). James Woodmason's Dublin Shakespeare gallery on Exchequer Street— an attempt to re-create the success of John Boydell's similar venture in London—included works by Irish artists such as Matthew William Peters but also their London-based peers, notably Henry Fuseli's *Macbeth Consulting the Vision of the Armed Head* (FIG. 17). Scenes of land and sea battles in which Irish had fought often alongside Britons (and sometimes against them) reminded viewers of Ireland's place in the larger British Empire and in

Fig. 14
Robert Calderwood. Dish Ring, c. 1760.
Collection of Melinda and Paul Sullivan.
Cat. 266.

Fig. 15
Gilbert Stuart. *John Foster*, 1790–91.
Nelson-Atkins Museum of Art, Kansas City, Missouri (Purchase: William Rockhill Nelson Trust) 30-20. Cat. 126.

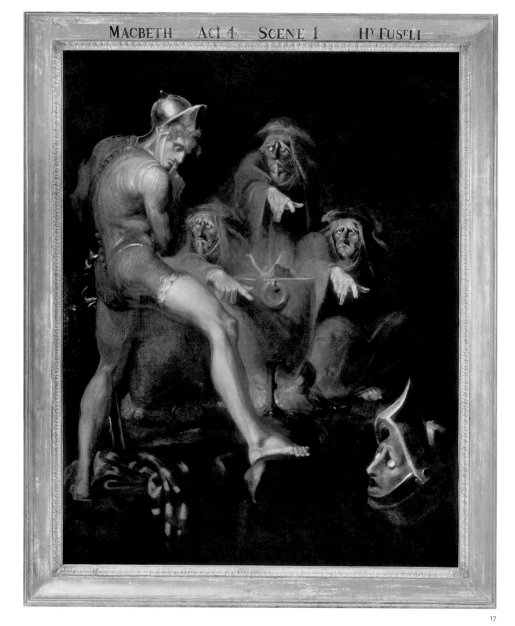

MACBETH ACT 4 SCENE 1 H⁷ FUSELI

16

17

international conflicts. Others merely catered to curiosity, as the range of places portrayed included modern and antique marvels such as the new London Bridge, Saint Paul's, the ruins of Rome, and the freshly uncovered Pompeii and Herculaneum, extending beyond them to the South Seas, which were being charted by James Cook and Joseph Banks.[7]

Artists also enlarged their choice of pictorial subjects to embrace Irish locations. Marvels that excited awe and speculation, such as the basalt formation at the Giant's Causeway in County Antrim (SEE P. 85, FIG. 9) or the lakes

and mountains around Killarney in County Kerry (SEE P. 84, FIG. 8), were recorded and reproduced in prints. A surging sense of patriotism further fostered interest and appreciation of these local splendors. Thomas Roberts and Jonathan Fisher painted Irish views; in his engravings, James Malton celebrated the public buildings and impressive prospects of the capital, the majority of which were of very recent construction. With a few exceptions, it is hard to know whether buyers consciously chose secular rather than sacred topics, or Irish rather than British or foreign scenes. Pinning up

an engraving could have a purpose other than a simple desire for ornament. It was a way of proclaiming one's religious or moral conviction, admiration for a hero, or interest in campaigns and victories in which the Irish were directly or vicariously involved.

There were groups, however, who abstained from decorative exuberance for other than financial reasons. Austere Protestants led by Presbyterians and Quakers condemned imagery as distracting from the word of God. The ban affected not just churches and chapels, but homes as well. The

18

domestic interiors of the Catholic majority, though, are harder to reconstruct. Owing to circumspection, legal restrictions, and poverty, in their churches they could rarely aspire to the architectural and decorative magnificence that characterized the Counter-Reformation across the rest of Catholic Europe. In Ireland these straitened conditions generally did not alter until Catholic Emancipation in 1829. Before then, donors and benefactors, sometimes living outside the country, gave precious objects—holy statues, liturgical silver, paintings, and vestments—to religious institutions associated with their kindred (SEE FIG. 18).[8] Devotional aids, including engravings of Jesus Christ, the Virgin Mary, and saints, are known to have been shipped into Ireland in large quantities. In time they were produced in Ireland itself. Intended for the edification of the laity and of low price, the images may have brightened otherwise grim rooms.

Different denominational groups may have encouraged members to favor or eschew particular kinds of goods. Such preferences were sometimes accentuated by geography. Presbyterians, who were strongest in the northeast, received both ideas and artifacts from Scotland, where many of their forebears had originated and with which they retained close ties. Quakers maintained links with London, northwest England, and North America. Catholics exploited and enlarged their multiple connections with coreligionists in Europe. In the marketplace, however, the secular predominated. Given the requisite cash or credit, edifying moralities, drolleries, lubricious caricatures, and ribald satires could be sampled by Catholic, conformist, and dissenter alike. Similarly, consumers could choose between what was made locally or by top producers in Dublin, and between what merely aped the wares of Britain, Continental Europe, and beyond or had been actually imported. Confronted with this bewildering variety, shopping became a pleasure and a puzzle.

Wholesalers and retailers competed for business with increasing ferocity and ingenuity. Josiah Wedgwood, the innovative Staffordshire potter, and Matthew Boulton, the entrepreneurial Birmingham silversmith, sought to tap into what they thought was an underexploited and potentially lucrative Irish market centered on Dublin. Within the capital, and gradually in the larger towns, shops began to specialize in what they sold and paid greater attention to advertising and to the look of their premises. Even so, the material cultures of Ireland resisted homogenization.

NOTES

1 These coastal towns include Belfast, Cork, Derry, Galway, Kinsale, Limerick, Sligo, Waterford, and Wexford; inland exceptions were Armagh and Kilkenny.

2 Dickson 1989, p. 180. For studies of Dublin in the long eighteenth century, see Craig 1952; Maxwell 1956; Casey 2005a; O'Brien and O'Kane 2008; Casey 2010; Dickson 2014.

3 Figgis 1986.

4 Honour 1959, p. 244.

5 *Belfast Newsletter*, August 18, 1758, and October 14, 1766.

6 *Belfast Newsletter*, February 21–25, 1777.

7 *Belfast Newsletter*, August 5, 1766. An Armagh stockist advertised in 1775 the "newest mezzotints" and "royal views" that he had lately imported; *Belfast Newsletter*, September 22–26, 1775.

8 W. Burke 1907, p. 330.

Ireland: A New Geographical Pastime?

FINOLA O'KANE

IRELAND, LIKE ALL ISLANDS, makes a grand figure. Its physique is easily conceived in the mind's eye, with rivers leading from the flat midlands, through the hills and mountains that ring the coastline, to city-ports. Early views of Ireland were drawn with military precision and a wide-angle strategic eye (SEE P. 64, FIG. 1) until the prospect, color, and foliage of eighteenth-century landscape painting invaded their spare-line composition. Blessed with both a river valley and the great embrace of a bay, Dublin views caught the River Liffey as it wound its way from Wicklow's uplands, through the demesnes and villa gardens ranged along its banks, to reach the sea. Nymphs played and bathed in Francis Wheatley's view of the Leixlip Salmon Leap (FIG. 1), the river cascading around them down to the city's stone quays. Topographical accuracy persisted, and Joseph Tudor placed Dublin carefully between the Phoenix Park's military fort and the Royal Hospital Kilmainham, echoing a distant pairing of the Hill of Howth and the Killiney Obelisk in blue

Andrew Nicholl. *A View from Carlingford, County Louth, to Rostrevor, Beyond a Bank of Wild Flowers* (detail), c. 1835. Private collection. Cat. 93 (see p. 94, fig. 25).

(FIG. 2). Growing both in eminence and number, Dublin's distinguished public buildings were studded, jewellike, into a set of views by James Malton at the century's close (SEE P. 66, FIG. 4, AND P. 68, FIG. 7).

Dublin, as a city on an open bay, embraces the sea with more physical and visual abandon than Cork, which sits on an almost enclosed harbor. There, merchant princes chose to build their villas along a high northern ridge to allow for great, plunging views of town, ships, and sea. Filtered through landscape paintings and prints to reach eventually a serving tray (FIG. 3), Cork's landscapes, as Arthur Young put it, "opened to view in noble reaches of a magnitude that fills the eye and the imagination: a whole country of a character truly magnificent."[1] Young, Ireland's most analytical tour guide, also described the Cork estuary's compositional balance of foreground and middle ground, shifting screens of trees and the pinpoint placement of houses, in his 1780 *Tour in Ireland*, based on his travels there in 1776–79 (CAT. 183). Rowing into the belly of the harbor, where it appeared "landlocked on every side with high lands," he delighted in the "chearful circumstances of lively commerce," with the harbor's narrow neck concealing the rude

sea.[2] Young later chided the Loire River in his *Travels in France* for being "boasted as the most beautiful in Europe" yet exhibiting "such a breadth of shoals and sands as to be almost subversive of beauty"; similarly, as Samuel Frederick Brocas's view (FIG. 4) indicates, the flat, wide sheen of the River Shannon may have lost Limerick's setting some status even as it encouraged a close depiction of her urban form.[3] In contrast, both Dublin Bay and Cork Harbor had all the attributes of a great Irish eighteenth-century landscape: water, compositional balance, and a constantly changing view.

Estates, or demesnes, were necessary for the landscape garden. Only large areas of land under the control and gaze of an aesthetically inclined individual could evolve into the mid-eighteenth-century landscape garden. Such creations were profoundly influenced by the theories of Lancelot "Capability" Brown, with swirling routes and plastic plantings that allowed the best views to structure the composition. Such a multiple framing of views was harder to achieve in a geometric layout, where avenues and axes limited the design to a precise set of angles; the oblique, eccentric, and loose composition of the mid-eighteenth-century landscape garden could

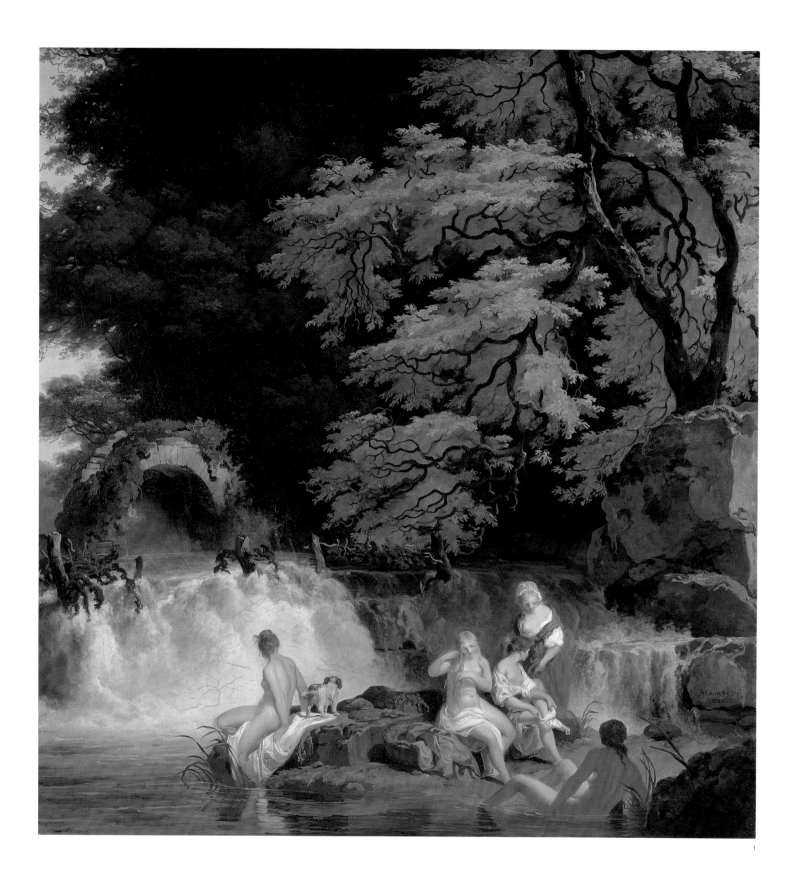

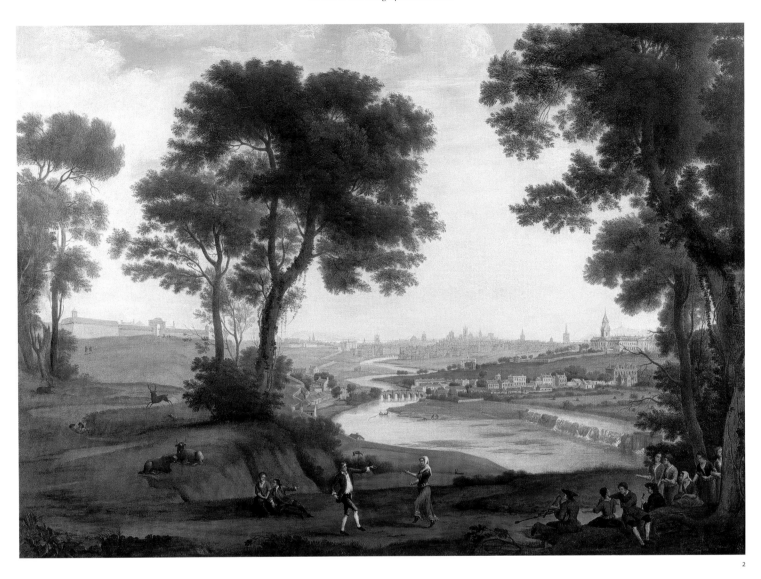

2

Fig. 1
Francis Wheatley. *The Salmon Leap,
Leixlip*, 1783. Yale Center for British Art,
Paul Mellon Collection. Cat. 135.

Fig. 2
Joseph Tudor. *A View of Dublin from
Chapelizod*, c. 1750. Private collection.
Cat. 129.

catch all of them.[4] With, as the landscape
theorist Thomas Whately put it, "the great-
est composition of water" being "in part a
lake and in part a river," the rolling drumlin
geology of Lough Erne, County Fermanagh,
collapsed both river and lake into an infinity of
islands.[5] Thomas Roberts's two pendant views
of Lough Erne are ascetic studies of superla-
tive landscape form—pure explorations of
contour, mass, and position (FIGS. 5–6). With
one vista composed from the demesne of his
patron Samuel Molyneux Madden and the
other from the opposing lands of Sir Ralph
Gore, this landscape of give-and-take, borrow
and benefit is one of considerable aesthetic
consensus, with all participants united in their

desire to create a balanced and harmonious
prospect. Here, the harsh divisions between
demesne and tenanted land, so sharply cut
by high stone walls elsewhere in Ireland, are
folded unseen into rolling waves of lake, fields,
and hills. A view to be enjoyed from a chair
while shaded by a parasol, the Erne land-
scapes also announced the new popularity of
painting en plein air, with Roberts sometimes
depicting himself.[6] As William Laffan and
Brendan Rooney described it, the "unorthodox
nature" of these pendant views transgressed
the bounds of estate portraiture in a way that
"was both unprecedented in an Irish context
and practically unknown in British art."[7] When
an estate portrait broke convention by being

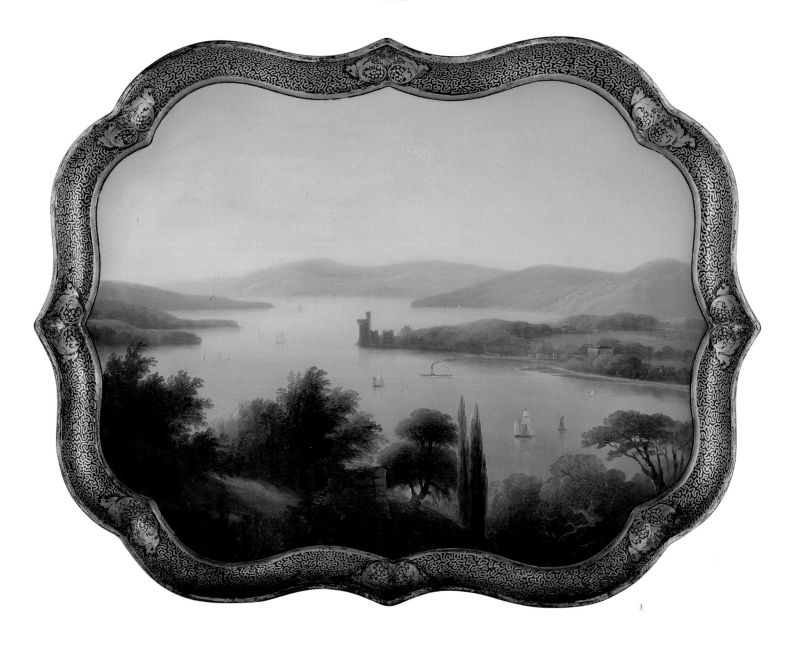

3

painted from within a neighbor's property, it gave the patron, in Joseph Addison's words, a new "kind of Property in everything he sees" without the necessity of possession.[8]

The landscape garden and the picturesque tour evolved as vectors of landscape experience. Composed from a preferred direction, their follies, inscriptions, plantings, rides, and walks promoted an ideal route. Winding out of demesne and into Ireland's growing network of roads, the picturesque tour also evolved a hierarchy of views, and this designed route inspired many landscape paintings.[9] The

progression is particularly evident in the work of Jonathan Fisher, an able landscape painter and early advocate of engraved views and the much wider public they could seduce. Books of such views, especially Fisher's *Picturesque Tour of Killarney* (1789) and *Scenery of Ireland* (1795), threaded these separate landscapes into published routes, establishing a hierarchy of Irish landscapes, tours, sites, and towns. Almost a development of the pendant view, Fisher's *Picturesque Tour of Killarney* proposed a value for landscape paintings as stages in a route, a carefully managed suite of real sites

Fig. 3
B. Walton & Company. Tray with Scene of Cork Harbor, 1840/44. Private collection. Cat. 241.

Fig. 4
Samuel Frederick Brocas. *A View of Limerick*, 1820/30. Private collection. Cat. 17.

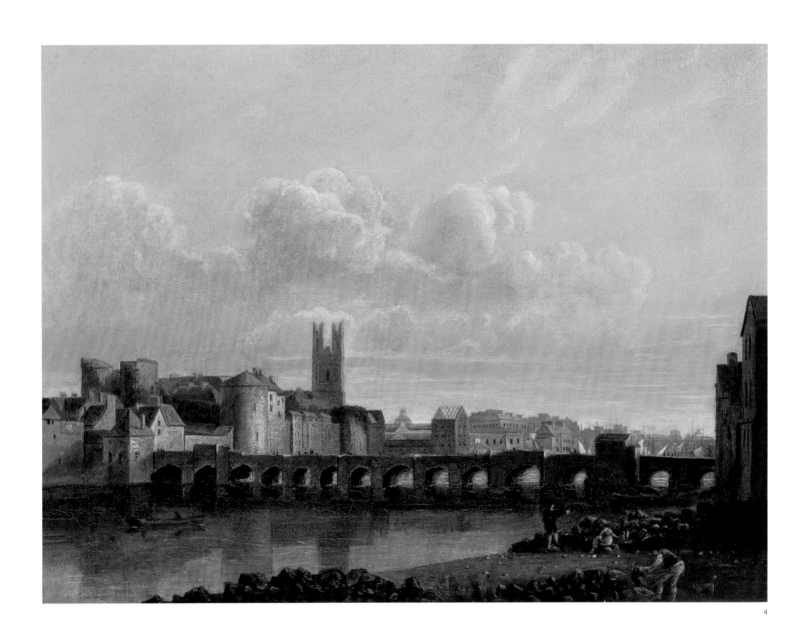

4

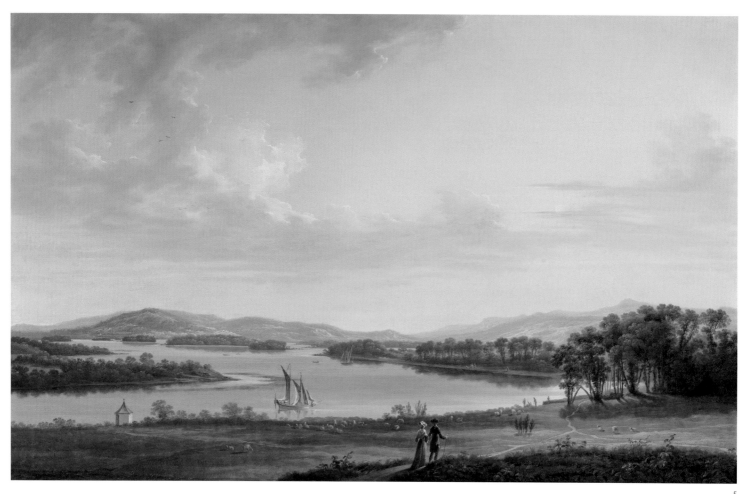

5

and their images that harnessed all to the tourist's experience. Advancing Killarney as the ultimate destination in Ireland, Fisher also drew a plan of his views so that visitors began from the right place and took the optimum route in a clockwise direction (FIG. 7). Traveling along the road from Castleisland and "approaching the lake in this direction after traversing dreary wastes," they arrived "at a spot where the first appearance of a long-wished for object present[ed] itself," when the eye naturally felt "relieved, and often conceive[ed] a partiality" for that view.[10] Placing the point of view exactly where the gap between Killarney's Glena and Turk Mountains made a long, expansive view of the Upper Lake and its distant mountains possible (SEE FIG. 8), Fisher explained how a position further away from Killarney would have disturbed the painting's balance by enlarging

its foreground. William Gilpin was convinced of Killarney's ascendancy: while he dismissed the Giant's Causeway as an interesting novelty (SEE FIG. 9), the Lake of Killarney attracted his attention.[11] The causeway, with its octagonal basalt columns, had achieved the mid-eighteenth-century's ambition for the arts and sciences to "become acquainted" and "extreme good friends."[12] Yet this very integration, once Edmund Burke had fractured landscape aesthetics into the separate realms of the sublime and the beautiful, made it less attractive as a landscape. Other well-worn sites needed both nymphs and myths to ply their wares by the 1780s (SEE FIG. 1 ABOVE).

Unlike his Lough Erne paintings, Roberts's pendant views, *An Extensive Lake Landscape with Figures Loading a Cart* and *A Wooded River Landscape with a Ruined Abbey and a Travelling Family Resting* (FIGS. 10–11), painted

for Lord Lieutenant Simon, 1st Earl Harcourt, are picturesque compositions structured by ruin and route. Foreshadowing Sir Uvedale Price's 1794 preference for subjects "strongly contrasted" in "their two characters," Roberts offers an abbey "built in some sequestered spot, and surrounded by woods" and a castle with a "commanding, or at least an uncommanded situation."[13] Ruins, and the reasons for their ruined state, had complex overtones in Ireland, where the dissolution of the monasteries in the 1530s was not regarded as a universal good. Both the figures unloading cargo from a boat onto a cart and the small, distant silhouette of a second ruined castle suggest a route from ruin to ruin by river. The antiquary Daniel Grose praised picturesque scenes that "multiply as you proceed up the stream," structuring his antiquities by route rather than any archaeological analysis.[14] Yet unlike Roberts's

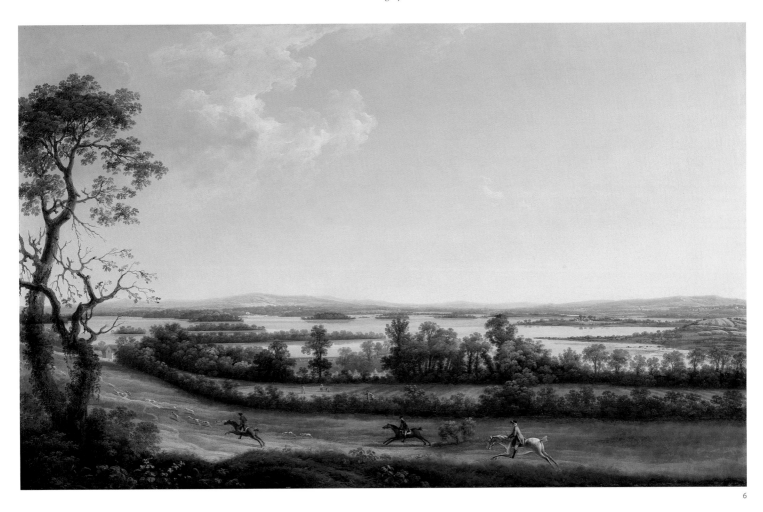

6

Fig. 5
Thomas Roberts. *Knock Ninney and
Lough Erne from Bellisle, County
Fermanagh, Ireland*, 1771. Yale Center
for British Art, Paul Mellon Collection.
Cat. 104.

Fig. 6
Thomas Roberts. *Lough Erne from
Knock Ninney, with Bellisle in the
Distance, County Fermanagh, Ireland*,
1771. Yale Center for British Art, Paul
Mellon Collection. Cat. 103.

Fig. 7
Jonathan Fisher (Irish, 1735–1809).
Map of the Lakes of Killarney, from A
Picturesque Tour of Killarney, London,
1789. National Library of Ireland, JLB
7411.

7

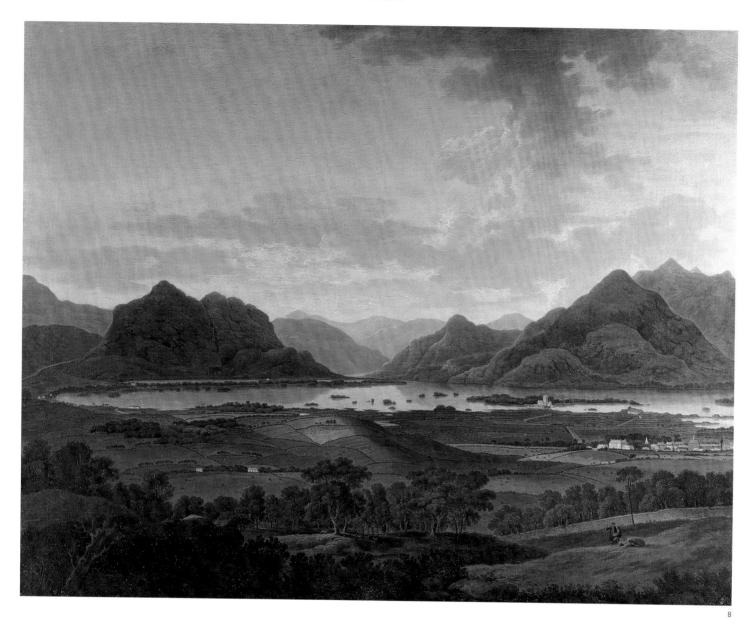

8

Lough Erne landscapes, which smoothly conceal Ireland's "inherent social, political and confessional tensions, which occasionally erupted into violence," these views are less silent if not exactly direct.[15] The unknown locations, together with the directional drive of the roads, gives both an archetypal momentum, and while Roberts included bucolic haymakers in the fields of County Fermanagh, the barefoot family resting by the roadside appear as reluctant transients of Ireland (SEE FIG. 11). The elite pastimes of hunting on horseback and traveling by carriage, together with the elevated viewpoints often used to depict them, have no place in these landscapes of road and ruin. Nor are these roads distinguished public improvements: Alexander Pope's poetic enjoinder to "'bid public ways extend,'" which was used to promote James Paine's design for a stone bridge across the River Foyle (SEE FIG. 12), is difficult to apply to these well-worn tracks of earth.[16] Roberts's choices of working and walking figures lead the viewer to perceive spatial relationships from a lower level and at a more ruminative pace. As the tourist gaze dropped and slowed, other issues came into focus, particularly those relating to local people's lives and relationships. In Agostino

Fig. 8
Jonathan Fisher. *A View of the Lakes of Killarney from the Park of Kenmare House*, c. 1768. Private collection. Cat. 41.

Fig. 9
François Vivares, after Susanna Drury. Top, *The East Prospect of the Giant's Causeway in the County of Antrim in the Kingdom of Ireland*; bottom, *The West Prospect of the Giant's Causeway in the County of Antrim in the Kingdom of Ireland*, published May 1, 1777. Rolf and Magda Loeber. Cat. 130.

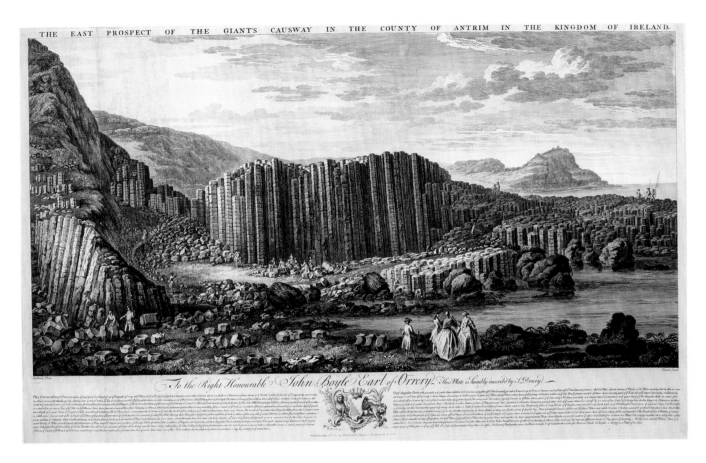

To the Right Honourable John Boyle Earl of Orrery, This Plate is humbly inscribed by S. Drury

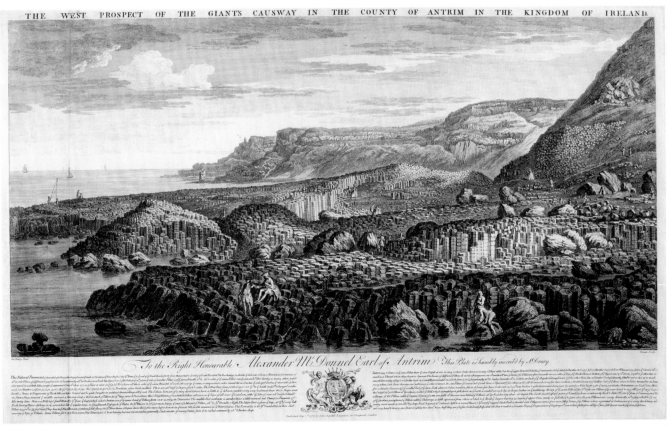

To the Right Honourable Alexander McDonnel Earl of Antrim, This Plate is humbly inscribed by M. Drury

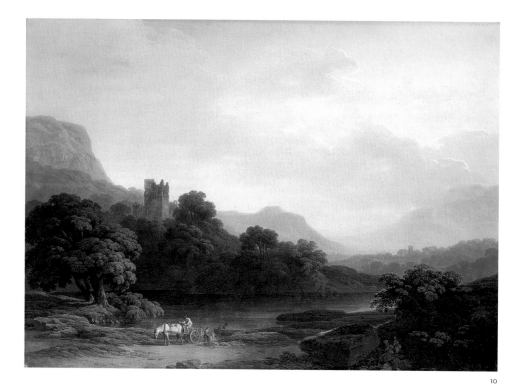

10

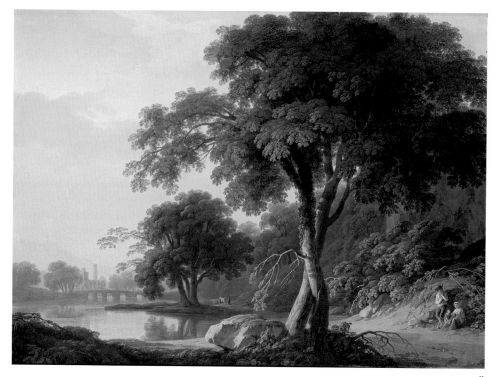

11

Fig. 10

Thomas Roberts. *An Extensive Lake Landscape with Figures Loading a Cart,* c. 1773. Private collection. Cat. 107.

Fig. 11

Thomas Roberts. *A Wooded River Landscape with a Ruined Abbey and a Travelling Family Resting,* c. 1773. Private collection. Cat. 106.

Aglio's view of Lord Kenmare's cottage–cum–banqueting house in Killarney (FIG. 13), the walkers meet the gaze of the hooded natives. As pedestrian travel became the more authentic way to experience both nature and society, the rugged became ever more significant, with the picturesque eye eventually ranging, in William Gilpin's words, "with supreme delight among the sweet vales of Switzerland."[17]

Edmund Burke wrote admiringly of George Barret as a "wonderful observer of the accidents of nature," recalling how the artist did "not even look at the pictures of any of the great masters, either Italian or Dutch," when depicting native landscapes.[18] Wicklow, which provided Dublin with a nearby mountain range and where Barret painted many of his most accomplished landscapes, is a likely inspiration for Burke's seminal *Theory of the Sublime and Beautiful* (1751).[19] Unlike Ireland's other tours, which were typically structured around a group of lakes (Killarney, Lough Erne) or along a river (the Blackwater, Boyne, Lee, or Liffey), the experience of Wicklow was difficult for any artist to translate into a route. Topographically a fortress until the construction of a spinal military road in the early 1800s, there was no way through it—only around it. County Wicklow's broad palette of landscapes included such gardens as Mount Kennedy (SEE P. 110, FIG. 20), which was renowned for having no level ground at all but was, according to Young, "tossed about in a variety of hill and dale."[20] Powerscourt demesne had rolling lawns to the north and a great prospect of Sugar Loaf Mountain to the south (SEE P. 112, FIG. 22) with the hanging rocks of the Dargle Valley and a great waterfall in its outer reaches (SEE FIG. 14). Complex sites of picturesque pilgrimage and pleasure such as Glendalough led visitors to the even more thrilling sublime upland landscapes of the Devil's Glen and Glen Malour.

The more popular the view, the more likely its transfer to a useful object such as a china plate or a tray. The artist Paul Sandby

described Catherine the Great's commission of a Wedgwood creamware dinner service (1773) painted with "views of all the noblemen and gentlemen's seats, and of every delightful spot throughout the kingdom" as a "useful undertaking calculated to improve the taste and polish the manners of her subjects, without corrupting their hearts."[21] His book of views, *The Virtuosi's Museum*, was intended to ensure "the direction of this national taste to the most innocent and refined amusements."[22] As Sandby implied, visual depictions could accomplish more by stealth than more literary endeavors, which could not avoid comment on such difficult and contentious subjects as politics, religion, native behavior, and relative poverty. Catherine the Great's Wedgwood service proved influential, as seen in the Derby dessert service of Irish landscapes and demesnes (FIG. 15).[23]

If many images finessed rude politics into polite visual theory, others were still potentially inflammatory. The condition of Irish cabins, and by extension their occupants, was a matter of constant concern for tourists in eighteenth- and nineteenth-century Ireland. Young's illustration *An Irish Cabbin* (FIG. 16) followed the Powerscourt Waterfall as one of only two in *A Tour of Ireland*.[24] The dwelling's rudimentary construction, absent chimney, lines of potato lazy beds, and tiny size brought uncomfortable truths to bear upon the scene. Emily, Duchess of Leinster, also invoked the cabin, and not the cottage, when summarizing the essential differences between Irish and English landscape:

You can't imagine anything more like the country of England than it is all round us here [near Stradbally, County Laois]; shady lanes with oak trees in the hedges, a river just under the windows, fields and meadows with paths thro' them, no stone walls, no miserable looking cabins near it—in short, this spot is vastly pretty.[25]

Demesne landscapes contained great houses, churches, follies, ruins, stables, barns,

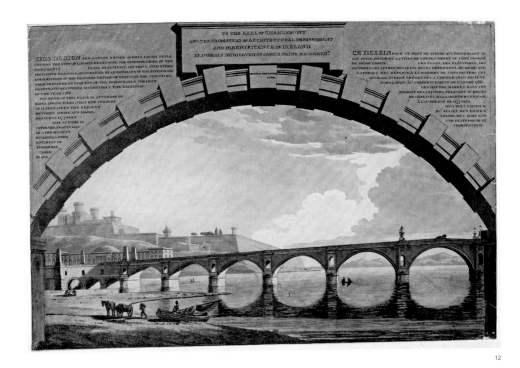

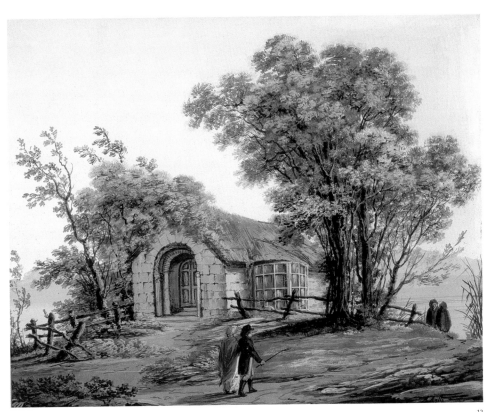

Fig. 12
James Paine. *Proposed Bridge across the River Foyle, County Derry (Unexecuted)*, published Jan. 1, 1793. Rolf and Magda Loeber. Cat. 95.

Fig. 13
Agostino Aglio. *The Abbey on Inisfallen Island, Killarney, County Kerry*, c. 1812. Private collection. Cat. 4.

and occasionally cottages of the orné variety. Roberts's cottages, unlike that in Young's frontispiece, all have smoking chimneys, while those that tend toward cabins are silent as to both location and owner. This painterly act of omission may have originated in the patron's act of commission: views of cabins to illustrate Ireland were distinctly undesirable. The Derby dessert service, which showed a generic "Irish scene," carefully excluded such problematic landscape features.

By the late eighteenth century, the elite practice of landscape tourism had become a calculated performance that required some design and effort. In 1775 William, Earl of Shelburne, "stumbl'd upon a great company of fine Ladys" close to Killarney and was obliged to take his "part. . . . to talk to them in a complimentary stile . . . while they pass'd the day one moment in ecstacy at the beauty of the Lake, and another in despair at the Flies which tormented them."[26] Structured into a suite of staged practices, elite tourism was soon accompanied by such fashionable accessories as the Claude glass and other commodities of leisure. A rare Irish example is the silver, rosewood, and steel traveling set made by Abraham Tuppy in Dublin in 1786/87 (FIG. 17).[27] Aspects of performance also became evident in the practice of painting, when added to every gentlewoman's baggage of accomplishments. Amateur watercolors slowly saturated the landscape experience.

Just as artists were painting real landscapes repetitively from the best viewpoints, theater professionals were repeatedly incorporating staged landscapes into the plots, sets, and titles of their plays. The literary historian Christopher Morash writes that in 1770 Thomas Ryder, manager of Dublin's Smock Alley Theatre, commissioned John O'Keeffe to adapt *Harlequin in Waterford* (1767) "to a northern setting"; it became "*Harlequin in Derry*, complete with scenery showing the north of Ireland."[28] *The Giant's Causeway; or, A*

Trip to the Dargle, also by O'Keeffe, "featured a giant capable of flying from the Antrim coast to the Wicklow mountains, thus providing occasion for an elegant View of the Giant's Causeway, the Dargle, and the Waterfall of Powerscourt." Such plotlines facilitated a tour of Irish sites, and the audience's memory of their own landscape experience manipulated the drama. *Faulkner's Irish Journal* advertised the opening of *The Elopement; or, A Trip to the Dargle (Entirely New)*" in December 1779.[29] The play's scenery apparently "surpass[ed] any thing exhibited in the kingdom," and the *Journal* reassured prospective theatergoers that the sets were not reused but "entirely new, painted by Messrs. Bamford, Whitmore, and Jolly" with "the machinery by Hamilton."[30] Such confusion as to whether the scenery or the play itself was new was compounded by an earlier pantomime also called *A Trip to the Dargil*, which was performed at the Smock Alley Theatre in 1762; Emily, Duchess of Leinster, found the play itself "mighty ill executed" but praised the stage set of the waterfall as "the prettiest thing . . . much beyond that at the Opera, and so like that at

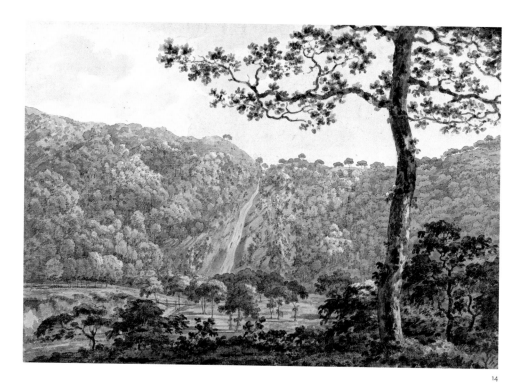

14

Fig. 14
William Pars. *The Falls at Powerscourt,* c. 1771. Yale Center for British Art, Paul Mellon Collection. Cat. 96.

Fig. 15
Derby Porcelain Factory. Partial Dessert Service Depicting Irish Landscapes and Demesnes, c. 1795. Private collection. Cat. 204.

Fig. 16
Arthur Young. *An Irish Cabbin,* from *A Tour in Ireland,* 1780 edition, vol. 1. Philip and Niamh Maddock. Cat. 183.

Fig. 17
Abraham Tuppy. Traveling Set, 1786/87. San Antonio Museum of Art, Bequest of John V. Rowan, Jr. Cat. 289.

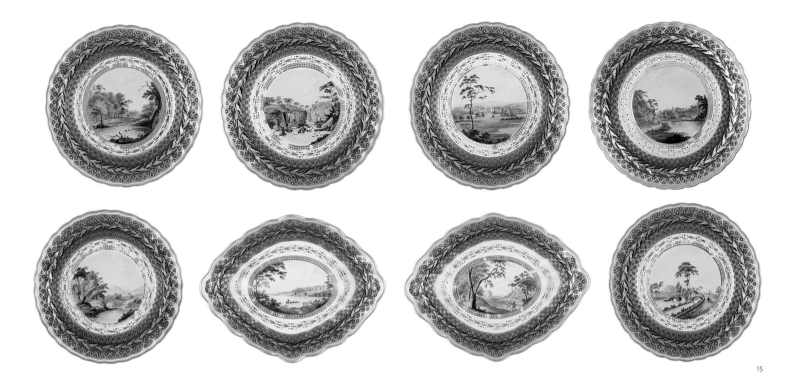

15

An Irish Cabbin.

16

17

18

Powerscourt, that you actually fancy yourself in the very place."[31] Reworked and overlapping scripts and titles suggest that for some viewers, the site was the thing, not the text, and *Faulkner's* even listed the play's views as part of the entertainment.[32] Moving from Dublin Bay through the Drumcondra demesne of Fortick's Grove, *The Elopement; or, A Trip to the Dargle* then crossed the city limits at Ballybough Bridge before entering a tall house in Capel Street. It reached Powerscourt and the Dargle Valley via a country village with a cabin on fire. Whately had recommended the use of small buildings to dramatize

the landscape and wrote of how they were "entitled to be considered as characters."[33] This inflammatory, staged image of a small burning cabin would continue to haunt the Irish landscape into the future.

Thomas Roberts's younger brother, Thomas Sautelle Roberts, was responsible for an exhibition of watercolor landscape views "chiefly executed for his excellency the Lord Lieutenant"—in this case, Philip Yorke, 3rd Earl of Hardwicke—that opened in Dublin's old Parliament House in January 1802.[34] According to the *Freeman's Journal*, the paintings were "principally taken in the County

Fig. 18
Thomas Sautelle Roberts. *Stormy Landscape with Anglers*, c. 1820. Private collection. Cat. 112.

Fig. 19
Thomas Sautelle Roberts (Irish, 1760–1826). *The Military Roads, County of Wicklow*, 1804. Colored aquatint; 40 × 55 cm (15¾ × 21⅝ in.). The British Library Board.

Fig. 20
J. B. Harraden, after Salvator Rosa. *A View near the Devil's Glen, Ireland.* The British Library Board.

THE MILITARY ROADS, COUNTY of WICKLOW.

The Roads and Aurora Camp, appear in the Middle ground — in the Fore ground the Lord Lieutenant and Suit—with the Soldiery and Peasantry employed in blasting, and removeing the huge rocks, so numerous in this romantic Country.

19

A VIEW NEAR DEVILS GLEN. IRELAND.

20

of Wicklow, including the Gold, Copper, and Lead Mines," with the "most interesting Views taken from the new Military Roads and close Scenes of the Dargle"; twelve were proposed as prints "to accompany a Tour through that romantic country."[35] The military road, whose principal arm ran south from Rathfarnham in County Dublin into the heartland of the Wicklow Mountains, was built in response to the United Irishmen's Rebellion of 1798. The historian Thomas Bartlett has described how the rebel leaders "General" Holt and Michael Dwyer "remained at large in the mountains and valleys of Wicklow" from 1798 to 1803, "frustrating all attempts to capture them." It was only "when the army developed a comprehensive counter-guerilla policy—construction of a military road, a programme of barrack-building, billeting of troops on private houses and imprisonment of likely harbourers—that Dwyer's days were numbered."[36] Thomas Sautelle Roberts's watercolors made sure that it was Lord Hardwicke, and not a local mountain rebel, who stood astride the waterfall. Thrilling views of the Dargle (similar to another view he would paint [FIG. 18]) were hung beside those that actively reversed the rebel position, thereby appropriating Wicklow's Romantic landscape from the rebel cause (SEE FIG. 19). Acting as an able witness to such ideological maneuvers, the caption of the latter work describes a "Fore ground" of "the Lord Lieutenant and Suit—with the Soldiery and Peasantry employed in blasting, and removing the huge roacks, so numerous in this romantic Country." With such counter-revolutionary views actively undermining the picturesque, other exhibited views such as *An Irish Hut* and *A Rebel Retreat in the Devil's Glen; General Holt Is Represented As Appointing His Evening Guards* suggest a more ambiguous tone.[37] Although many are now lost, the visual parry of such images is evoked by *A View near the Devil's Glen, Ireland* (FIG. 20), an engraving

DARRYNANE ABBEY.
The Residence of Daniel O'Connell, Esq.r M.P.

21

of hidden caves and rock outcrops with strangely Grecian warriors standing guard.

Eight days after the opening of Thomas Sautelle Roberts's exhibition in the old Parliament House, the play *The Wicklow Gold Mines* debuted at the Theatre Royal, again by "'command of his Excellency the Lord Lieutenant and Countess of Hardwicke."[38] Morash explains that the drama was first performed in 1795, "the same year in which the United Irishmen became a secret society," and featured "a range of stock Irish characters" but also introduced "a new figure: a violent member of a secret society who is on the side of good, the native Redmond O'Hanlon."[39] With

O'Hanlon positioned in upland Wicklow, his foil was the grouse hunter and Dubliner Squire Donnybrook, who tries to marry his daughter Helen to the owner of a Wicklow goldmine, the suggestively American Mr. Franklin.[40] O'Hanlon and the local people prevent a miscarriage of justice when they bundle Felix, an accused man, into a secret tunnel that leads from a chapel to an abbey ruin so that he can escape over the mountains.

Mountains too close to cities develop strange interstitial outcrops where the viewpoint of the villa intersects with that of the rebel, and the aristocrat walking along a high terrace begins to see with the accuracy of a

Fig. 21
Robert Havell, Sr., and Robert Havell, Jr., after John Fogarty. *Derrynane Abbey, the Residence of Daniel O'Connell, Esquire, M.P.*, c. 1833. Private collection. Cat. 55.

Fig. 22
James Arthur O'Connor. *A View of Irishtown from Sandymount*, 1823. Private collection. Cat. 94.

Fig. 23
Henry Kirchhoffer. *Francis Johnston's Belfry and Gothic Folly in His Garden, Eccles Street, Dublin*, c. 1832. Private collection. Cat. 74.

22

23

sniper. Geographically unstable, the play's dialectic between rebel and landlord, mountain and city, eastern seaboard and western wilderness, continued to define native and foreign landscapes in Ireland. The association of national and revolutionary identity with romantic mountain strongholds and the western horizon was not easily dislodged. In 1800, for example, Arthur O'Connor, a United Irishman, published *Letters from the Mountains; Being a Series of Letters from an Old Man (Called Montanus) in the Country to a Young Man in Dublin*, an homage to Jean-Jacques Rousseau's letters of the same name, which were written to Geneva from an alpine mountain.[41] The lure of the west was captured in a view of Derrynane Abbey (FIG. 21), Daniel O'Connell's estate in County Kerry, where a waterfall rushes down a mountain that is scaled by an impossibly steep road. Above the house, caught tight in the snare of its gardens' perspectival grids, the small island abbey draws the eye toward Ireland's pathway to America, watery yet infinite. Reversing this western momentum, James Arthur O'Connor painted the strand of Irishtown near Donnybrook in 1823 (FIG. 22). Placed on the far eastern edge of the flat Fitzwilliam estate, a small timber bathing hut anchors the long stone ramparts that protect Sandymount from Dublin Bay's notorious storms, while ships from the east glide along Dublin's South Wall. As the city's prospects contracted over the nineteenth century, Henry Kirchhoffer compressed the Gothic vista into a view from the back window of an Eccles Street town house (FIG. 23). In reality two mews buildings attached to the distinguished architect Francis Johnston's own conjoined houses, the pasteboard Gothic follies are both urbanized and domesticated. No Wicklow Abbey of romantic mountain and tunnel these, more an architect politely practicing in his garden.

A didactic board game entitled *The Cottage of Content, or Right Road and Wrong*

Ways (1795) recalls the manner in which many landscape gardens—those of the Italian Renaissance or the eighteenth-century Stourhead in Wiltshire, for instance—incorporated routes of moral happiness and abject dissolution.[42] Cartographic board games also used routes to both educate and moralize. They were produced from the mid-eighteenth-century onward and played, according to the cartographic board game historian Adrian Seville, with a "top-like spinner known as a totum" in place of dice, which held unfortunate gambling connotations.[43] The educational publisher William Darton, Jr., published *Walker's Tour through Ireland: A New Geographical Pastime*, in 1812 (FIG. 24).[44] It followed Darton's 1809 *Walker's Tour through England and Wales*; he later published board games of Scotland, Europe, and the world.[45] *Walker's Tour through Ireland* begins with an introduction to the country's history and geography, and its course starts in Dublin; *Tour through England and Wales*, however, has no introduction and sets off abruptly from Maidstone, Kent. As a branch of the English journey, Wales did not fare well: it was summarized as "but a poor place" and featured no overnight stops; this was not necessarily a slight, though, as no night was spent in Bath despite its surpassing "every town in England for splendor and elegance of buildings." Touring Ireland, in contrast, was a much more leisured pastime, requiring many more overnight stops and considerably more political comment. Looping back on itself and with sudden veering midland detours, the board game had little of Arthur Young's directional drive. Although Killarney was "remarkable for its picturesque beauties," Lough Erne and Wicklow scarcely featured, while time spent in Cork was primarily for attentively considering "the advantages to nations and individuals by the governments of the world living on terms of peace with each other." Demesnes, great houses, and the men who owned them drove

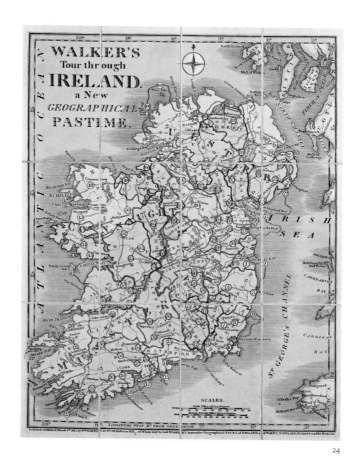

24

25

Fig. 24
Published by William Darton, Jr.
Walker's Tour through Ireland: A New Geographical Pastime, published March 9, 1812. Rolf and Magda Loeber. Cat. 29.

Fig. 25
Andrew Nicholl. *A View from Carlingford, County Louth, to Rostrevor, Beyond a Bank of Wild Flowers*, c. 1835. Private collection. Cat. 93.

some of the selection criteria, with the three turns in Waterford spent viewing the "noble mansions and plantations belonging to the Marquis."[46] A stop in Kildare was the chance result of a spin of the totum, and the rules of the game insisted that players do the following:

Here make a stop for four turns, not to see the cruel and disgraceful practice of horse-racing, but to consider how much the late Union of both kingdoms is likely to promote the general happiness of the whole British empire, and to render the inhabitants one vast brotherhood, endeared by the most friendly offices and the mutual ties of interest.

Touring was a carefully constructed experience by the end of the eighteenth century, with demesnes, landscapes, roads, tourist landscapes, and towns forming stages in a mobile, multisensory experience. Conceptions of a country, nation, and people could be derived and influenced by these carefully constructed routes and the views they promoted. As landscapes of improvement diminished in attraction over the long eighteenth century, those of a more picturesque and Romantic character increased. For the more anthropological and sensationalist tourist of the nineteenth century, the western seaboard's exotic Gaelic customs and disquieting poverty gave it a voyeuristic appeal. Slowly both Connacht and Connemara were included in Ireland's canon of picturesque sites, with visits to Clare Island, County Mayo, "to see the poor pilgrims." In 1840 the husband-and-wife team of *Hall's Ireland* toured Connemara from "Maam to Clifden and then to Leenane via Renvyle," but their tourist's gaze was affected by "witnessing scenes of appalling want, that deducted largely from the enjoyment we received."[47] Some artists dropped the angle of view by hiding in the botanical details of wildflowers (SEE FIG. 25), while others, such as Francis Richardson and George Petrie, began to paint the Irish cabin with some of Young's cold analysis while heightening the atmosphere for emotional effect. Players

won *Walker's Tour through England and Wales* by abruptly reaching London, of which no description was required, by way of Hertford. They won W*alker's Tour through Ireland* by landing exactly on "the celebrated Giant's Causeway," both "bold and romantic," after having passed the ruins of Dunluce Castle standing on "a precipice jutting over the sea." Choosing the causeway as an ending asserted the Irish landscape's persistent imaginative power and the role of geographical pastimes in keeping it sharply in view.

NOTES

1 A. Young 1970, p. 320.

2 A. Young, 1970, p. 317.

3 A. Young 1906, p. 74.

4 See O'Kane 2004a, chap. 3.

5 Whately 1770, p. 55.

6 See Laffan 2007.

7 Laffan and Rooney 2009, p. 73.

8 Joseph Addison, *Spectator* 411 (1712), p. 171.

9 See O'Kane 2013, chap. 3.

10 Fisher 1795, pp. 11–12.

11 Gilpin 1794, p. 43.

12 Gwynn 1749, p. 55.

13 Price [1794] 1842, pp. 366–67.

14 Stalley 1991.

15 Laffan and Rooney 2009, p. 79; chapter 3 discusses Roberts's Lough Erne views.

16 Paine's print (fig. 12) is inscribed *To the Earl of Charlemont and the promoters of architectural improvement and magnificence in Ireland is humbly dedicated by James Paine R.A.B. Archt. "Bid Public Ways Extend"— Alexander Pope.*

17 Gilpin 1794, p. 43.

18 Fryer 1809, vol. 2, pp. 86–89.

19 See Crookshank and Glin 2002, p. 135.

20 A. Young 1970, vol. 1, p. 94.

21 Sandby 1778, preface.

22 Sandby 1778, preface.

23 The titles of the Derby plates illustrated in figure 15 are the following: top row, left to right, *Bessborough, in the County of Kilkenny Ireland,* seat of the Earl of Bessborough, view engraved by Thomas Milton after William Ashford; *The Dargle in the County of Wicklow, Ireland,* near seat of Lord Viscount Powerscourt, view engraved by Thomas Milton after J. J. Barralet; *Brockley Park, in the Queens County, Ireland,* seat of the Earl of Roden, designed by David Ducart "a gentleman of Italy," view engraved by Thomas Milton after William

Pars; and *Beau-park, in the County of Meath, Ireland,* seat of Charles Zambart, Esq., view by Thomas Milton after Thomas Roberts. Bottom row, left to right, *View in Ireland; Bally Finn, in the Queens County,* seat of the Hon. William Wellesley Pole, view engraved by Thomas Milton after William Ashford; *Mount Kennedy, in the County of Wicklow,* seat of the Right Hon. General Robert Cuningham, view engraved by Thomas Milton after William Ashford; and *Lucan House, in the County of Dublin,* seat of the Right Hon. Agmondisham Vesey, view engraved by Thomas Milton after J. J. Barralet.

24 A. Young 1970; the print appears as the frontispiece to volume 2.

25 Emily Kildare to James Kildare, May 9, 1759, B. Fitzgerald 1949–57, vol. 1, p. 76.

26 Petty-Fitzmaurice 1937, p. 67.

27 See Andrews 1989.

28 Morash 2002, p. 72: "Three years later O'Keeffe continued in the newly popular mode of virtual tourism with a piece for the Cork Theatre Royal entitled *Tony Lumpkin's Ramble Thro' Cork.*"

29 *Faulkner's Dublin Journal,* December 14–16, 1779, Greene 2011, vol. 3, p. 1874.

30 Greene 2011, vol. 3, p. 1874.

31 Greene 2011, vol. 3, p. 1874. Emily Kildare to James Kildare, December 16, 1762, B. Fitzgerald 1949–57, p. 156.

32 *Faulkner's Dublin Journal,* December 14–16, 1779; Greene 2011, vol. 3, p. 1874.

33 Whately 1770, p. 93.

34 *Freeman's Journal,* January 18, 1802, http://archive .irishnewsarchive.com.

35 *Freeman's Journal,* January 19, 1802, http://archive .irishnewsarchive.com.

36 Bartlett 1994, p. 389.

37 Strickland 1913.

38 *Freeman's Journal,* January 21, 1802, http://archive .irishnewsarchive.com.

39 Morash 2002, p. 74.

40 O'Keeffe 1814.

41 A. O'Connor 1800, p. 28.

42 William Spooner, *The Cottage of Content, or Right Road and Wrong Ways,* 1795, board game, Victoria and Albert Museum, London, E1785-1954.

43 Seville 2010.

44 John Walker, *Walker's Tour through Ireland: A New Geographical Pastime* (William Darton, Jr., 1812). See B. Smith and Vining 2003, p. 265.

45 John Walker, *Walker's Tour through England and Wales: A New Pastime* (W. and T. Darton, 1809).

46 Walker, *Walker's Tour through England and Wales.*

47 S. Hall 1984, vol. 2, p. 416.

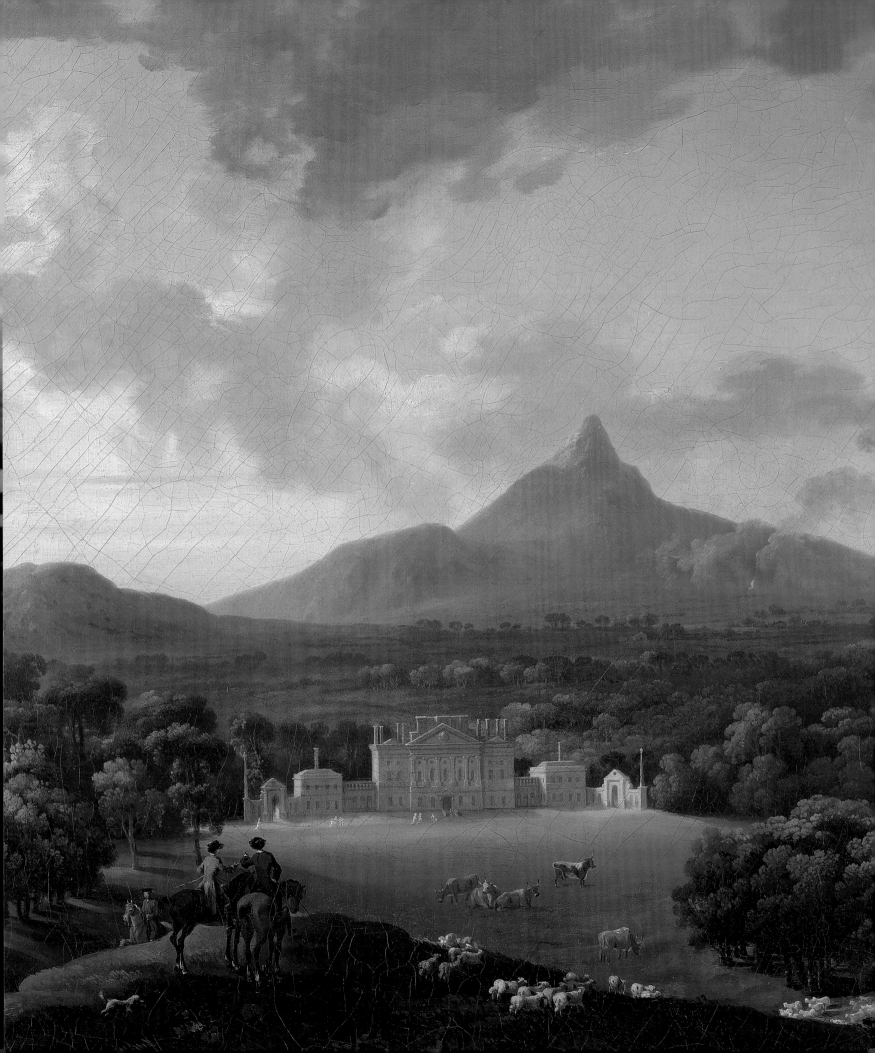

The Realm of the Irish Country House

KEVIN V. MULLIGAN

BUILT FOR RETIRING PROVINCIAL squires and colonels, hubristic aristocrats, lordly clerics, opportunistic politicos, or aspiring self-made men—whether motivated by ambition, duty, or both—country houses and their demesnes epitomized the possession of power and prestige in an age when land constituted the primary source of wealth. Like its European counterparts, the Irish country house of the long eighteenth century functioned on numerous levels. Whether land was owned time out of mind, earned by service, or bought, the country house helped to validate a landowner's rights of possession and fulfill his moral and political responsibilities. It was also a key aspect of "improvement," a concept that was tied to material and moral advancement and that shaped attitudes among the ruling class. The country house represented a commitment to order, asserting a civilizing authority within the wider community, with its appearances and operations upheld by barely visible servants and menials. As well as affirming legitimacy, it satisfied the desire to secure dynastic succession as the house became a metaphor for bloodline and, thus conceived, constituted a worthy patrimony to root and

bind the family, ensuring its dignity and continued prosperity. Such aspects are overlaid by architectural and artistic attributes so that the Irish country house, with its contents and the designed landscape that enveloped it, represents a complex physical embodiment of the lives and culture of the social elite.

In the early seventeenth century, the recipients of landed estates in Ireland were compelled to build in order to demonstrate their commitment to plantation settlements and secure the stability of local government. Surprisingly, the widespread devastation to buildings during rebellion and civil war (1641–53) did not deter investment in new architectural adventures, and while anxiety continued to be justified, building activity actually accelerated as the restoration of the monarchy in 1660 brought an extended interlude of peace and growing prosperity. This was evident enough that Henry Hyde, 2nd Earl of Clarendon, who served as lord lieutenant from 1685 to 1686, observed signs of progress in "many buildings raised for beauty, as well as use, orderly and regular plantations of trees and fences and enclosures throughout the kingdom."[1]

A spate of country house building gradually reestablished a colonial imprint on the landscape, imparting a sense of order and

civility to an otherwise unsettled and underdeveloped territory. Such activity created demands for new skills, and immigrant craftsmen were encouraged to settle.[2] This helped to advance construction technologies and spread the Classical principles of architecture as workers moved between projects.[3] Before 1690 greater architectural sophistication had become most obvious in the adoption of double-pile plans and the appearance of pedimented breakfronts with carved timber eaves, characteristics that conformed to the Dutch-inspired Classicism then popular in England.[4] In Ireland, however, facades remained predominantly plain, without columns or pilasters, and the explicit use of Classical orders only emerged on domestic buildings in the early decades of the eighteenth century.[5] Houses began to share many formal architectural and domestic characteristics, evidence that aesthetic considerations were now increasingly important, supplanting the unattractive features necessitated by defensive concerns.[6]

The staircase at Eyrecourt, County Galway (FIG. 1), which provided a stately ascent from the hall to the *piano nobile*, is carved from oak with ebullient foliage and hideous masks; it preserves a glimpse of the splendors created in a late-seventeenth-century

George Barret. *Powerscourt, County Wicklow*, 1760/62 (detail). Cat. 9 (see p. 112, fig. 22).

provincial interior and reveals the artistic supremacy of the woodcarver in the decoration of early Classical architecture in Ireland.[7] Unfortunately, the dearth of extant buildings means that our impressions of late-seventeenth-century interiors largely rely on contemporary inventories that indicate the quality of works furnishing some of the more aristocratic houses. The most princely of these are associated with the dukes of Ormonde, whose inventories list furnishings of great richness: silver; paintings; coverings of brocatelle, damask, mohair, and velvet; gilt-leather hangings; carved giltwood chairs; and silvered and japanned tables and cabinets. Especially evocative is a ten-branched "Christall schambiliere" recorded in the drawing room at Kilkenny Castle.[8] The most impressive element of the family collections was the twenty-nine sets of tapestries recorded in an inventory of 1675. Amounting to 144 pieces, this represented an unparalleled assemblage worthy of Ireland's (then) only duke, with many acquired from Belgium, including Francis Cleyn's prized series *The Great Horses*, which was designed for the Mortlake Tapestry Works and reproduced in those at Lambeth.[9] The same subject was commissioned from Lambeth by Sir Edward Brabazon of Kilruddery, 2nd Earl of Meath (SEE P. 195, FIG. 2).[10]

Architectural achievements were almost completely effaced by the War of the Two Kings (1689–91) fought between the supporters of the Catholic King James II and those of Protestant Prince William of Orange. Economic recovery was sluggish, and lingering uncertainty over some estates, reduced revenues and debts, and anxieties over security effectively disabled substantial investments in country houses. Momentum returned only after the accession of George I in 1715, a year in which Jacobite aspirations were further suppressed, bolstering the confidence of the Protestant interest.[11] Even so, the country lost its potentially greatest architectural patron

1

when the second Duke of Ormonde, despite having performed heroically for William at the Battle of the Boyne in 1690, sided with the Stuart cause and was forced to abandon Ireland for a life of exile. The most significant architectural developments in these early decades were associated with Ireland's richest commoner, William Conolly, who at Castletown in County Kildare set a new standard for architectural aspiration.[12] In 1729 he presided over the decision to build the new Parliament House in Dublin (SEE P. 67, FIG. 6). By ensuring that the design was entrusted to Sir Edward Lovett Pearce, an architect of extraordinary talent who had also worked at Castletown, Conolly helped bring Irish architecture briefly to the point of brilliance.[13]

Although the confiscations that followed the Williamite victory radically transformed landownership to the benefit of opportunists like Conolly, many old English nobility of the Pale—the area surrounding Dublin that had for centuries been under the direct control

of the English Crown—managed to retain or recover their estates after 1690. Families like the Talbots of Malahide, the St. Lawrences of Howth, and the Plunketts of Dunsany and Killeen preferred to maintain and enhance their ancient seats. Sentiment seems to have made Sir Donat O'Brien reluctant to eschew the old in his remodeling of Dromoland, County Clare; the result was such that, after his death in 1717, the incomplete works were left in a "very terrible condition."[14] Rudeness matched sentiment, so that when in 1716 William King, archbishop of Dublin, proclaimed Ireland "backward in Architecture" he singled out for opprobrium the beneficiaries of confiscated estates: "Generally a parcel of ruff soldiers, that had so little taste of fine building, that it was their principle to pull down the best they found standing, and wanting everything, they were for taking up with anything, that wou'd cover them from the rain."[15]

Those who failed to build on their estates risked appearing no better than those they

2

Fig. 1
The Staircase at Eyrecourt Castle, c. 1670s, View from the First Landing. Detroit Institute of Arts, gift of the William Randolph Hearst Foundation and the Hearst Foundation, Inc., 58.259.

Fig. 2
Hugh Douglas Hamilton. Frontispiece to John Rocque, *A Survey of Kilkea, One of the Manors of the Right Hon. James, Earl of Kildare*, 1760. Private collection. Cat. 115.

had come to colonize, or, worse yet, as though they might be corrupted into the same uncivil habits as their predecessors.[16] At Castle Leslie in County Monaghan, Elizabeth Leslie worked hard to combat her husband's preference for Dublin and lack of interest in the family seat, writing to his nephew and heir in 1720 that she had made him "the handsomest house in the three countyes . . . the finest in the outside, and the most conveniency within."[17] Childless herself, she attached the hope that he might "think of getting a good wife, that your father's family may not sink."

To accommodate his family's resurgence and provide an appropriate backdrop for their foremost position within the Irish peerage, Robert FitzGerald, 19th Earl of Kildare,

purchased Carton in 1738; this allowed him to exchange his medieval castle at Kilkea, in the south of County Kildare, for a more fitting seat that was at once closer to the capital and more modern, having already been remodeled in the Classical style in the late seventeenth century. While Carton stood on ancient FitzGerald lands, Kilkea continued to be proudly maintained as an integral part of the family's ancient patrimony and was included in John Rocque's sumptuous eight-volume survey of their sixty-eight-thousand-acre estate.[18] The volume on Kilkea has the richest frontispiece (FIG. 2), which features the fictive triumphal arch that Hugh Douglas Hamilton composed in 1760, a few years before he encountered such architecture directly in Rome.[19]

The impulse to build radiated out into the surrounding landscape also. Although the ambition for formal Baroque schemes in Ireland is now largely evident only on paper, before the end of the seventeeth century, examples of such gardens had become commonplace in schemes that were integral to the architectural ensemble of the country house and its ancillary buildings. Late-seventeeth- and early-eighteenth-century plans for Stillorgan, County Dublin, and Barbavilla, County Westmeath—as well as those for Carton and Dromoland—strove for and created an effect that was truly heroic.[20] Sometimes patrons spent more, or at least more often, on the landscape than on the house; this is understandable given the complex geometry of their Dutch- and French-inspired gardens, which featured both compartments and vistas, and comprised axial avenues, canals, flower gardens, ponds, and wildernesses.

At Breckdenstown, his relatively modest demesne in north Dublin, Robert Molesworth amused himself with what he called the "diversions of my grounds and gardens" and was fond of trumpeting their merits.[21] By 1719 he boasted of having "much the finest canal near completed in the Kings dominions" despite complaining of the want of "proper workmen & instruments for the execution of my designs, this kingdom affording none good." Similar achievements on a more moderate scale were evident at Garryhundon, County Carlow, where a visitor in 1709 found "a very pretty new improved garden of grass, greens, gravel . . . a large bason and fountain in the middle of the garden and a noble canal at the end of it."[22] Here in 1734 Sir Richard Butler aspired to enhance the demesne even further by commissioning the provincial English architect William Halfpenny, who produced a design for an imposing house whose garden front was expressed in the style of Sir John Vanbrugh (FIG. 3).[23]

3

The Irish country house landscape is most commonly referred to as the demesne. The term, which evolved from the administrative structure of the medieval manor, possesses a lordly connotation that helped to emphasize the landowner's presence on his estates and endorse his authority. Integral to the functions of the house, the demesne defined the boundaries of a private domain; although subject to considerable aesthetic considerations, it was utilitarian, a farm with gardens where improved husbandry and agricultural practices could be pursued or where aristocratic or gentlemanly sporting activities indulged. Such leisure pursuits, so central to ideals of image, also provided material for sporting portraits. Examples include Stephen Slaughter's representation of Windham Quin of Adare Manor in County Limerick (FIG. 4) as well as still lifes incorporating trophies of the hunt, like those by Irish artist Charles Collins (SEE FIG. 5).

Equally of service to art and leisure was the special relationship between the horse and the country house. The animal's association with status and power was perfectly acknowledged in the bold proclamation Sir Edward O'Brien displayed on his stables at Dromoland: *In equus patrum virius* (The strength of a nation is in its horses).[24] As well

Fig. 3
William Halfpenny. *The Garden Front of Garrahundon [Garryhundon] House, County Carlow*, 1734. Private collection. Cat. 48.

Fig. 4
Stephen Slaughter. *Windham Quin of Adare, County Limerick, Ireland*, c. 1745. Yale Center for British Art, Paul Mellon Collection. Cat. 121.

Fig. 5
Charles Collins. *Still Life with Game*, 1741. Private collection. Cat. 26.

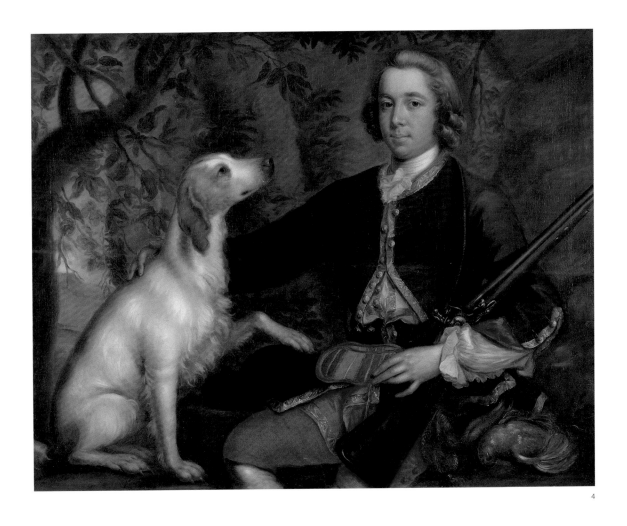

4

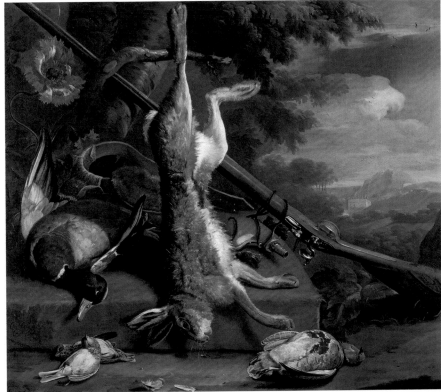

5

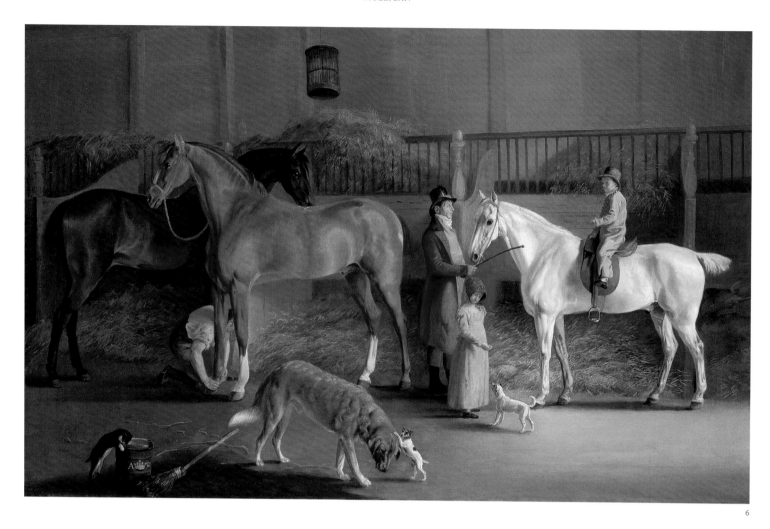

6

as providing power and transport, horses were bred for sport, and their accommodation represents an integral part of the architectural ensemble of the country house. This is certainly the case with Carton, where the interior of the stables is known from a painting by George Nairn (FIG. 6). At times it took on a more princely dimension: at Castletown and a succession of grand houses designed by Richard Castle, the vaulted stables were supported on Classical columns and accommodated in one of two pavilions in an expanded Palladian layout.[25]

The Palladian formula established at Carton in the seventeenth century, and first expressed with a palatial quality at Castletown, endured in the work of Castle, who served as Pearce's assistant on the Dublin Parliament House.[26] The attraction of this as a model for aspiring patrons was demonstrated in 1739 by a visitor to Hazelwood, near Sligo, a Palladian house designed by Castle and begun in 1731; his travelogue included a description so that it might "drop some useful hints in the way of gentlemen who have a spirit for building."[27] One of Castle's major contributions was his use of the saloon as the principal room of state. At Castletown the long gallery formed the great room and, following seventeenth-century precedent, was located on the *piano nobile* beside the great staircase, as at Eyrecourt. In Castle's larger houses, the saloon became the great room, given a formal, axial relationship with the entrance hall, where its centrality within the plan could be developed as the architectural climax of the interior.[28] The saloon's importance was typically reflected in its size and an elaborate treatment

Fig. 6
George Nairn. *The Interior of the Stables at Carton, County Kildare: A Liveried Groom, Lord Charles William FitzGerald, and His Sister, Lady Jane Seymour FitzGerald,* c. 1825. Anne and Bernard Gray. Cat. 92.

Fig. 7
George II Armchairs, c. 1750. Mahogany with modern upholstery; each 109 × 74 cm (43 × 29 in.). Private collection.

Fig. 8
Possibly John Houghton and John Kelly. Side Table, 1760/70. Private collection. Cat. 228.

7

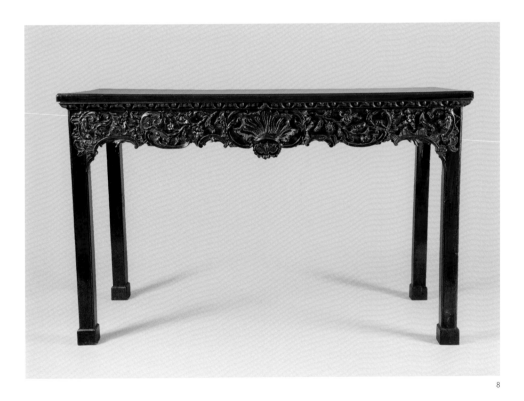

8

that, at Russborough in County Wicklow, featured coved ceilings, aedicular doorcases, a richly carved chimneypiece, walls hung with expensive textiles, and the best pictures and furniture, including a large set of seat furniture commissioned in Dublin by Joseph Leeson (FIG. 7; SEE ALSO P. 24, FIG. 7). The room's sense of importance was typically enhanced by the austere treatment of the entrance hall, as expressed in the preference for the Doric order in the decoration, the display of sculpture, and even, beginning in the 1730s, the use of hard hall chairs, the shaped backs of which display heraldic devices (SEE P. 219, FIG. 7, AND CAT. 226, p. 249).[29]

Castle was loyal to craftsmen "of his own acquaintance" who included the highly skilled Dublin woodcarvers John Kelly and John Houghton, who are responsible for much fine mid-Georgian furniture and architectural carving, including a table that was very likely supplied to the Reverend Francis Hewson of Ennismore, County Kerry (FIG. 8). The men also worked in stone and were employed at Carton to carve the coat of arms in the pediment.[30] Another of the architect's close associates was David Sheehan, a monumental sculptor who specialized in chimneypieces and to whom are attributed many of the distinctive Baroque examples found in Castle's houses. Alongside these Irish craftsmen were the migrant stuccodores Paolo and Filippo Lafranchini from the Swiss village of Bironico, north of Lugano, whose names were first recorded in England in 1731 when they were employed by James Gibbs.[31] Castle was likely responsible for their arrival in Ireland later in the decade, where their first documented work was at Carton. Here, the bold figurative compositions that ornament the saloon still stand as one of the greatest moments in the decoration of the Irish country house interior (SEE P. 50, FIG. 16).[32]

Given Castle's dominance, it is unsurprising that English architects had little or no

direct involvement in the early development of country house architecture in Ireland, and while there is evidence that architects such as Hugh May were consulted, few ever visited.[33] Before the middle of the century, the only prominent figure to enjoy a substantial commission in Ireland was Gibbs, who designed Newbridge, near Dublin, for Charles Cobbe in 1747. Ultimately, however, it was Gibbs's *Book of Architecture* (1728) that was to be most influential on Irish architecture even into the succeeding centuries.[34]

The country house library contributed to the spread of the Classical vocabulary among patrons who gradually became more connoisseurial in their architectural interests, elevating the subject to a liberal art that "any aspirant to true civility should burnish."[35] Indeed, architecture became not just a moral and social obligation but also a gentlemanly occupation to be pursued as one of the pleasures of country life. As a corollary, scholarly and aristocratic texts dominated in private libraries, led by Vitruvius, Palladio, and Vignola in their various editions.[36] Gentlemen architects including Francis Bindon and Wogan Brown possessed comprehensive collections, and it is not surprising that, as the leading country house architect, Castle had subscribed to Colen Campbell's *Vitruvius Britannicus* (1725). The book's popularity with Irish patrons accorded well with their embrace of a Palladian aesthetic. In 1742 Charles Tisdall, owner of a small estate in County Meath, obtained from a Dublin bookseller copies of Campbell's *Vitruvius* and Ware's translation of Palladio's *Four Books of Architecture*, perhaps to familiarize himself with fashionable tastes just before he engaged Castle to design his modest house.[37] As one would expect, true connoisseurship was clearly demonstrated by the architectural books in the libraries of James Caulfeild, 1st Earl of Charlemont, and the antiquarian William Burton Conyngham of Slane Castle, County Meath (FIG. 9).[38]

9

Fig. 9
Gilbert Stuart. *William Burton Conyngham*, c. 1785. Norton Museum of Art, Bequest of R. H. Norton, 53.189. Cat. 123.

Fig. 10
Rev. John Payne. *Twelve Designs of Country-Houses*, no. 9, 1757. Yale Center for British Art, Paul Mellon Collection. Cat. 177.

Fig. 11
Sir Richard Morrison. *Design for a Gate-Way or Entrance to a Park, &c.* From *Useful and Ornamental Designs in Architecture*, 1793. Private collection. Cat. 176.

10

The first contribution by an Irish architect, John Aheron's *General Treatise of Architecture in Five Books* (1754), demonstrates the importance of aristocratic patronage to the development of architectural tastes outside the capital.[39] Begun in 1741 and prepared in meticulously detailed manuscripts, Aheron's treatise owed its existence to the encouragement of Sir Edward O'Brien of Dromoland, who, the author explained, "gave rise to my ambition and desire for the study of architecture."[40] The contemporary endeavors of another provincial, the self-confessed "lover of architecture" Samuel Chearnley, are represented in an equally rare manuscript, *Miscelanea Structura Curiosa*, conceived in the mid-1740s and only recently brought to light.[41] Both works offer insight into the creative ambience of the country house library in the mid-eighteenth century.[42]

In 1754 the Dublin printer George Faulkner, inspired by *Vitruvius Britannicus*, proposed a *Vitruvius Hibernicus* with engravings "drawn either from the buildings themselves, or the original designs of the architect."[43] Unfortunately, this "aristocratic work," which would allow the buildings of Ireland to "vie with other nations" instead of lying "in obscurity and oblivion," never materialized, but it is clear that the country had by then accrued

enough buildings to encourage the contemplation of such a lavish publication.[44] Craftsmen, however, depended on more modest texts, pocketbooks such as Halfpenny's *Practical Architecture* (1724), Francis Price's *British Carpenter* (1733), and William Salmon's *Palladio Londinensis* (1734), whose plates provided the familiar Georgian vocabulary of Palladian "surface trimmings" encountered on innumerable provincial houses and public buildings throughout the country.[45] Also drawing inspiration from these texts was the Reverend John Payne, rector of a rural parish in County Meath and author of *Twelve Designs of Country-Houses* (FIG. 10). This treatise, popular among his gentry neighbors, followed the practical approach and encouragement offered by the Dublin Society, which in 1745 held a competition for designs of "houses from two to eight rooms on a floor" at which Castle advised on the merits of the submissions.[46]

In fact, Castle's dominance of the profession had the effect of undermining Irish architecture; this was evident after his death, when patrons disdained native talent because, as one critic put it, they believed "that no native of this kingdom, can equal a foreigner in the point of taste or judgement."[47] The failure in 1760 of the Cork architect John Morrison to publish

what was evidently an ambitious book promising "regular designs" was almost certainly foredoomed by its provincialism. Many years later, in 1793, Morrison's son Richard would publish his own treatise, *Useful and Ornamental Designs in Architecture* (FIG. 11). That this was a work of limited importance hardly mattered (although it did reach Philadelphia), because by then the aspiring architect had already begun his ascent to the top of his profession.[48] The younger Morrison enjoyed an ancestry in architecture, education at the Dublin Society Drawing Schools, and, through his studies with James Gandon, exposure to the Neoclassical orthodoxy of Sir William Chambers; later, he gained the benefits of a son, William Vitruvius Morrison, who made the grand tour. Constantly employed "by people of fortune and taste," he merited the praise of the English architect Thomas Hopper, who wrote in 1839, "I should be puzzled to find amongst the practisers of Architecture in England any name that I could place equal to that of Morrison."[49] With Richard Morrison, Irish country house architecture had finally come of age.

Encounters with European art and architecture on the grand tour greatly influenced the progression of Irish taste, informing and inspiring artists and stirring the fancies and ambitions of patrons. For Francis Bindon, who visited Padua in 1716, travel contributed to his recognition "as one of the best Painters and Architects this Nation has ever produced."[50] For Pearce, exploring the Veneto in 1724 allowed him to compare Palladio's texts with the buildings themselves and gave him the confidence to explore an independent interpretation of Palladian ideas, impressively achieved a few years later with the villa of Bellamont Forest in Cavan.[51] Patrons undoubtedly gained most from the grand tour. Once in Italy, travelers shared common experiences. They were encouraged in Rome "to study a little Architecture"—an "elegant and useful acquirement soon learnt as far as will be useful."[52] The discoveries of

treasures can be seen in Henry Tresham's watercolor *An Archaeological Excavation in Italy* (FIG. 12), and the active trade in antiquities and pictures encouraged competition in the pursuit of trophies to bring home. Purse strings—wittingly or otherwise—were readily loosened for a panoply of artists: portraitists who could perfectly capture the connoisseur's poise and swagger or copyists who had perfected the techniques of the great masters. Greedily acquired spoils were shipped home by virtuosi to be displayed as marks of sophistication and refinement.[53]

Joseph Leeson's motivation for his travels was entirely self-serving.[54] Rich and desperate to cast off his background in trade, he hastily acquired an estate in Wicklow, initiated the building of Russborough, and embarked on a spending spree to acquire a collection of paintings and sculptures to fill it (SEE P. 24, FIG. 8). Through the experience, he perhaps hoped to cultivate the manners and refinement that would facilitate his entry to the peerage.[55] He eventually achieved that goal in 1756, culminating with an earldom in 1763. While Leeson's ambition might undermine his standing as a connoisseur, his ability as a collector—whether as a well-financed consumer or a seeker of the best advice—still stands.[56] Lord Charlemont (SEE FIG. 13), who enjoyed a seven-year sojourn on the Continent, was a more pioneering grand tourist; to a fellow Italophile, he was among the "few who have made so great and universal use of their travels."[57] In fact, there is much about Charlemont that is atypical. On his return to Ireland, he chose to build not on his ancestral estates in Armagh but near the sea close to Dublin, where he could create his own Elysium and satisfy his patriotic ideals. Like a true connoisseur, Charlemont demonstrated that he had seen something of the world and bore his cosmopolitanism with an ease that universally endeared him to his peers, acquaintances, and the many artists he commissioned. In his tastes he was both catholic and discriminating.

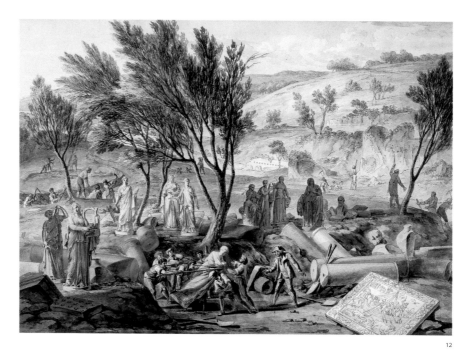

12

Having admired Palladio's Villa Rotonda in Vicenza so much that he entertained a fancy "to build it again in Ireland," he was happy instead to indulge himself—and William Chambers's exacting Classicism—by constructing the Casino, a rather expensive and impractical temple to architectural purity (SEE FIGS. 14–15).[58] Charlemont had befriended the architect in Rome and patronized him extensively, but he was not bound by Chambers's purism.[59] He was also loyal to the wider circle of artists, among them Giovanni Battista Cipriani (SEE P. 25, FIG. 10), Simon Vierpyl, and Joseph Wilton, whom he had also met in Rome, and earned the fruits of their collaborative skills.[60]

Charlemont's contemporary, Sir Thomas Taylor, 1st Earl of Bective, was Robert Adam's principal patron in Ireland yet appears never to have suffered the passions of a connoisseur.[61] There is no evidence that he ever undertook a grand tour or desired to. While he did not possess Leeson's riches—neither, for that matter, did Charlemont—the complexities associated with the evolution of the designs for Headfort, his house in County Meath, suggest that Taylor merely wished to conform to fashionable tastes. The building was a protracted affair, and its commencement

Fig. 12
Henry Tresham. *An Archaeological Excavation in Italy*, c. 1785. Private collection. Cat. 128.

Fig. 13
Pompeo Batoni. *James Caulfeild, 4th Viscount Charlemont (Later 1st Earl of Charlemont)*, 1753–56. Yale Center for British Art, Paul Mellon Collection. Cat. 12.

Fig. 14
Sir William Chambers. *Designs for Two Chimneypieces in Lord Viscount Charlemont's Casino at Marino, Dublin*, c. 1758–59. The Metropolitan Museum of Art, New York, The Elisha Whittelsey Collection, The Elisha Whittelsey Fund, 1953. Cat. 24.

Fig. 15
Sir William Chambers. *Design of His Lordship's Casino at Marino*, from *A Treatise on Civil Architecture*, 1759. The Art Institute of Chicago, Ryerson and Burnham Libraries. Cat. 174.

13

14

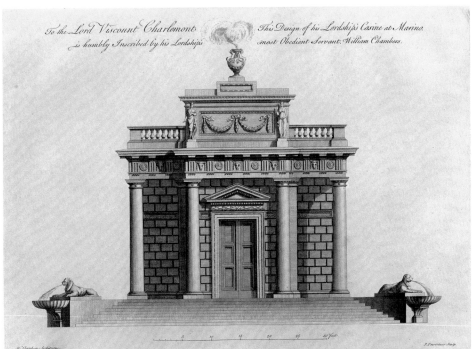

15

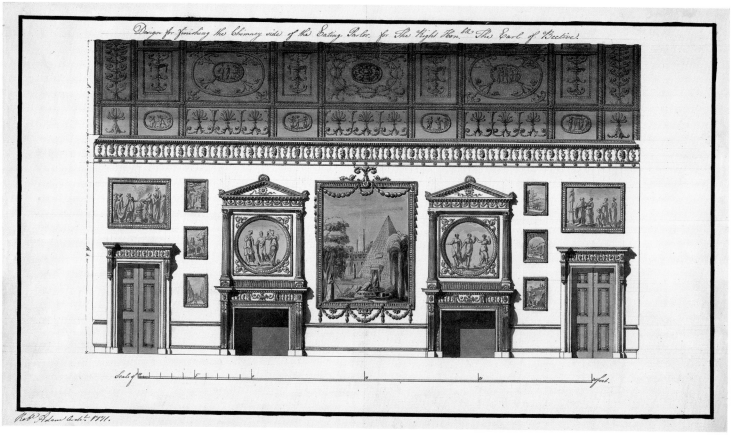

Design for finishing the Chimney side of the Eating Parlor, for The Right Hon.ble The Earl of Bective.

Rob.t Adam Archt. 1771.

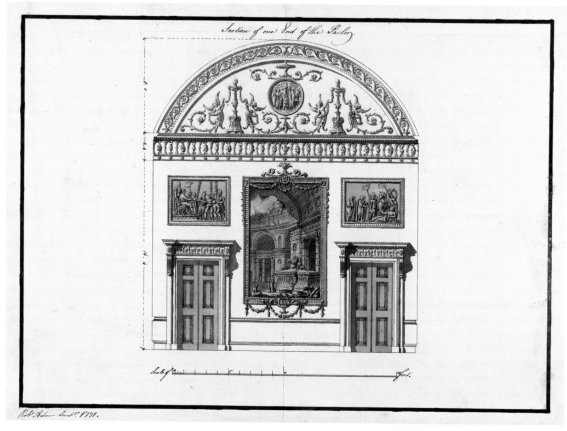

Section of one End of the Parlor.

Rob.t Adam Archt. 1771.

18

19

Fig. 16
Robert Adam. *Headfort House, Ireland: Elevation of the Eating Parlour*, 1771. Yale Center for British Art, Paul Mellon Collection. Cat. 2.

Fig. 17
Robert Adam. *Headfort House, Ireland: Section of One End of the Parlour*, 1771. Yale Center for British Art, Paul Mellon Collection. Cat. 3.

Fig. 18
Pompeo Batoni. *Thomas Taylor, Viscount Headfort*, 1782. Sarah Campbell Blaffer Foundation, Houston. Cat. 15.

Fig. 19
Pompeo Batoni. *Mary Quin Taylor, Viscountess Headfort, Holding Her Daughter, Mary*, 1782. Sarah Campbell Blaffer Foundation, Houston. Cat. 14.

after years of procrastination was eventually accelerated by Taylor's elevation to the peerage in 1760.[62] As Viscount Headfort's new building rose over the next decade, so too did he: he was granted an earldom in 1766, soon after contemplating the radical alteration of his works to designs obtained from Chambers. The new Lord Bective, however, endured with his old-fashioned double-pile plan by George Semple, which resulted in a monumentally dour edifice.[63] Presumably finding that the work he had undertaken represented a poor figure for his noble status—Headfort was "more like a college or an infirmary," according to one critic—Bective employed Adam to decorate the interiors two years after the main structure was completed.[64] His vacillation between Chambers and Adam suggests the sort of difficulties less discerning patrons faced in attempting to achieve the most fashionable result.[65] However, Bective procrastinated again and ultimately

economized on Adam's commission for a series of rooms that included an ambitious eating parlor or great room.[66] Having rejected the architect's proposed segmental vault (SEE FIGS. 16–17), he took four years to decide on a plainer, cheaper, coved space. Thus the evolution and decoration of Headfort suggests a patron who, without a grand tour experience, had little real appreciation of the antique Roman world that Adam was so inspired by and was at pains to celebrate in his characteristic, richly embroidered low-relief grotesques. In fact, as if determined to gain the benefits of the grand tour entirely by vicarious means, Bective was content to have works from other grand tour collections copied for Headfort.[67] The earl's son made amends of a sort in 1782, when he visited Rome with his wife, Mary, and had Pompeo Batoni paint full-length portraits (FIGS. 18–19) that were installed as pendants in the eating parlor.[68]

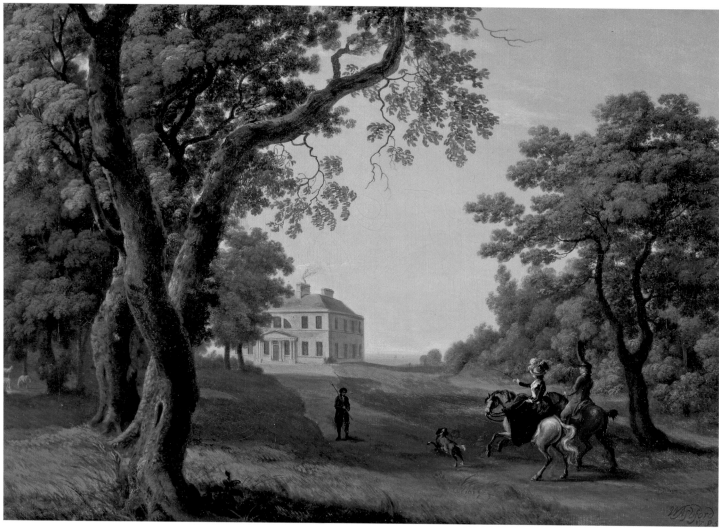

20

By the end of the eighteenth century, formal landscapes were openly criticized for imposing "unsuitable ornaments" upon "the simple garb of nature."[69] The taste for a freer, poetic style of gardening gradually removed or subsumed vestiges of earlier schemes, reordering the landscape in a manner that was closer to nature—or at least an idealized interpretation of nature inspired by the classicized landscapes of painter Claude Lorrain, whose popularity was stimulated by the grand tour. Jonathan Swift, his close friend Patrick Delany, and his wife, the redoubtable Mary Delany, were among the most active Irish exponents of this approach, expounding in their own horticultural pursuits the idea that "all nature was a garden." Dangan Demesne in County Meath,

the family seat of the Duke of Wellington, was developed by Richard Wesley, 1st Lord Mornington, as a perfect Arcadian landscape in accordance with the principles of Lancelot "Capability" Brown.[70] Wesley's cousins at Ballyfin were also early exponents of the natural style, which was well suited to the County Laois topography. Here they erased traces of an older formal landscape, achieving an artful informality by creating broad vistas of undulating, open meadows and random tree clumps in which the house was approached by meandering avenues and reflected in a serpentine lake. Their success attracted the admiration of Emily, Countess of Kildare, who in 1759 found Ballyfin the "most delightful place . . . much beyond any I have seen in Ireland."[71]

Pride in landscaping achievements inspired patrons to have their demesnes represented—and most likely perfected—in topographical views that were displayed prominently inside their houses.[72] By the 1770s the execution of such picturesque views was dominated by competing artists Thomas Roberts and William Ashford, who enjoyed a sophisticated, mainly aristocratic patronage. Before his untimely death in 1778, the extremely precocious Roberts "brought the art of Irish demesne painting to its peak" with works that included his last, a series of wonderfully ethereal views in the demesne at Carton (PP. 31–32, FIGS. 18–21) including an idyllic sheet of water inspired by Ballyfin.[73] Ashford, first president of the Royal Hibernian Academy, continued to specialize in

21

Fig. 20
William Ashford. *Mount Kennedy, County Wicklow, Ireland,* 1785. Yale Center for British Art, Paul Mellon Collection. Cat. 7.

Fig. 21
William Ashford. *Belan House, County Kildare,* c. 1780. University of Michigan Museum of Art, Ann Arbor, Gift of Booth Newspapers, Inc., in memory of George Gough Booth and Ralph Harmon Booth. Cat. 6.

demesne views including impressive canvases of Mount Kennedy, County Wicklow (SEE FIG. 20), and Lord Aldborough's seat at Belan, County Kildare (SEE FIG. 21), as well as a more modest series of views of the lake at Ballyfin painted in the 1780s.[74]

The Arcadian country house landscape promoted an awareness of the inherent beauty in nature and encouraged patrons to see it celebrated in art. George Barret, an early beneficiary of the Dublin Society Schools and a skillful copyist of Classical landscapes, is understood to have been encouraged by Edmund Burke to achieve a greater authenticity in his art by looking directly to nature and exploiting its scenic potential. To achieve this, Burke introduced him to the demesne

of Powerscourt (FIG. 22), which included the romantically wild Dargle Valley with its celebrated waterfall (SEE P. 88, FIG. 14). This setting provided the perfect embodiment of a sublime natural landscape, and Barret used it to develop his craft and even enjoyed extensive patronage from the owner, the second Lord Powerscourt.[75]

Landscape design and painting each contributed to the rediscovery of Ireland's topography and its antiquarian culture. Growing interest in the ancient Irish past was partly fed by excavated curiosities: when ditching or turf cutting on landed estates yielded elk antlers (SEE P. 16), as it frequently did, or early Christian treasures, the discoveries were usually presented to the big house.

23

Fig. 22
George Barret. *Powerscourt, County Wicklow*, 1760/62. Yale Center for British Art, Paul Mellon Collection. Cat. 9.

Fig. 23
Catherine Maria Bury, Countess of Charleville. *Charleville Forest, County Offaly*, 1812/20. Rolf and Magda Loeber. Cat. 23.

Depending on the interest of the landowner, these might be displayed with a measure of local pride to match the relics possessed by some of Ireland's ancient families such as the Kavanaghs of Borris and the O'Conors of Clonalis, and many of these collections eventually found their way into Irish or British institutional collections.[76]

In an era when the strictures of Classicism dominated design, the typical Irish Georgian house, regardless of scale, was composed of symmetrical facades, most commonly with a restrained expression limited to carefully chosen, well-balanced details. In this way, it could convey both good aesthetic judgment and a sense of intellectual accomplishment while symbolizing the rational mind and the desire for order that was consistent with political stability and social contentment.

Interest in the picturesque, antiquarian curiosity, and the desire to evoke an ancient past all helped to rehabilitate the Gothic as an acceptable style so that, by the end of the eighteenth century, architects had evolved the skills to accommodate the competing tastes of their patrons. Although the chaotic structures of the medieval past spoke most immediately of conquest and discontent, those who upheld this architectural patrimony against the tides of fashion—sometimes out of economic necessity—appreciated the mark of ancient dignity these buildings conferred on their family. Evolving tastes would eventually make them Romantic and picturesque, attracting others to emulate Gothic architecture consciously, whether to obscure arriviste origins or to evoke a more ancient lineage, as was the case with the Charleville family (SEE FIG. 23).

The expression of feminine identity in the country house landscape was perhaps strongest in the taste for picturesque scenes in which the cottage orné and other rustic

24

H. French del. *Heywood Queen's Co.*

25

Fig. 24
Mary Delany. *Six Flower "Mosaicks,"* after 1771. Private collection. Cat. 32.

Fig. 25
Helena Sarah Trench, later Lady Domvile. *Heywood Estate, Queen's County: Twenty-Five Views of Cottages and Gate Houses,* 1815. Rolf and Magda Loeber. Cat. 182.

garden buildings played a key part.[77] At Mary Delany's cottage at Delville near Dublin, "a sweeter spot on earth was never found," and in such heavenly bowers, gardening and creative female recreation such as "paper mosaicks," shellwork, and fancywork could be enjoyed (SEE FIG. 24).[78] The picturesque aesthetic became a favorite subject in women's sketchbooks, which they filled with romantic ruins and pretty cottages in attractive landscapes.[79] Some women considered their ability to draw as more than just a polite accomplishment and applied it to practical ends. They developed and adapted existing architectural ideas to benevolent building projects such as estate housing and schools, for which women typically assumed responsibility. As the moral conscience of the estate system, women often effected a strong counterbalance to

male indulgence in sporting pursuits, rakish behavior, extravagant building projects, and art collections. For example, in about 1815 Lady Helena Domvile issued a book of borrowed designs for estate buildings on her family estate, Heywood, Queen's County, now County Laois (FIG. 25).[80]

Most country houses and their demesnes shared common characteristics and served the same purpose: to integrate architecture and environment, artfully conceived into a fitting backdrop against which the theater of life might be played out. Furnishings and possessions typically transcended mere utility. Whether they are represented in custom-made goods adorned with heraldic emblems that affirm family honor and prestige, or grand tour spoils collected in response to fashion and to complement architectural ambitions, these

things ultimately expressed manners and refinement, maintained social standing, and provided all the comforts and rewards of a privileged life.

NOTES

1 Quoted in Loeber 1973, p. 5.

2 The immigration of craftsmen is likely to have been promoted by the passing of "An act to encourage protestant settlers in Ireland" in 1662, and an influx is clearly suggested by the growth of craft guilds in suceeding years. Glin and Peill 2007, p. 23.

3 The documentary evidence for this becomes greatest in the early Georgian period as illustrated in 1711, when Sir John Perceval was advised by the steward of his estate in Cork that he knew "two or three . . . that have Bueilt several Good houses" in Clare and Limerick and who "performed very wel." Loeber 1973, pp. 27, 35; Barnard 2004, pp. 44–50; Loeber and Hurley 2012, pp. 206–07.

4 As, for example, in the architecture of Sir Roger Pratt and Hugh May; see Worsley 1995, pp. 21–43. A double-pile plan consisted of a rectangular block two rooms deep, with the rooms sometimes separated by a passage.

5 The examples of post-Restoration houses that help affirm Clarendon's overall impression of a changing architectural landscape include Burton House in Cork; Eyrecourt in Galway; Killruddery, County Wicklow; and Carton in Kildare. In 1665 Dunmore, in Kilkenny, was given a "frontispiece of pillars," while Blessington House in Wicklow, built a decade later, used freestanding columns in an open loggia extending across the ground floor. Glin and Peill 2007, p. 24; Breffny 1988a.

6 Loeber 1973, pp. 29–32; O'Kane 2004a, pp. 90–94.

7 O'Connell and Loeber 1988. The staircase has survived the destruction of the house; exported to California by William Randoph Hearst in the 1920s, it is today in storage at the Detroit Institute of Arts. Another, more refined example of the same period, recycled from elsewhere, formerly existed at Desart Court in Kilkenny. The best surviving staircase of this period is the balustered example in yew wood at Birr Castle, County Offaly. Glin and Peill 2007, pp. 23–31.

8 Glin and Peill 2007, 24–25.

9 Fenlon 2010.

10 Marillier 1927.

11 In the provinces, architectural ambition was demonstrated in the Corinthian frontispiece conceived for Dromoland in Clare (c. 1714) and the application of pilasters and pedimented windows at Castle Durrow in Laois (1715 onward). Barnard 2004, pp. 46–47, 53; O'Kane 2004b.

12 In response to Conolly's decision to build Castletown, Sir John Perceval wrote to George Berkeley, "I am glad for the honour of my Country that Mr Conolly has undertaken so magnificent a pyle of building." August 5, 1722, British Library, London, add. MS 47,029, f. 129; McParland 2001, p. 187.

13 McParland 2001, pp. 207–11.

14 Loeber and Hurley 2012, p. 203. With part of the old castle "half pulled down" and the remainder "ill joined" to the new, O'Brien's widow attempted to complete the house with the assistance of Thomas Burgh; O'Kane 2004b.

15 Archbishop William King to Lord Molesworth, August 3, 1716, quoted in Judge 1986, p. 63.

16 Barnard 2004, p. 57.

17 Shirley 1879, pp. 147–78.

18 The survey took six years to complete, culminating in the Kilkea volume; see Hamilton 2005; Horner 1971; Crookshank and Glin 1994, pp. 66–67; Hodge 2001.

19 Hamilton 2005; see also Laffan 2003b, pp. 17–18.

20 Horner 1975; Glin and Malins 1976, pp. 5–28; O'Kane 2004b; Barnard 2004, p. 207.

21 Glin and Malins 1976, p. 16.

22 Samuel Molyneux, quoted in Glin and Malins 1976, p. 13.

23 Ibid.

24 P. McCarthy 2008b, p. 28.

25 This obsession with equestrian pursuits did not extend to everyone; in 1775 Lord Russborough, for example, was pleased to stay at Castletown only because he would avoid Tom Conolly's hunting comrades. B. FitzGerald 1949–57, vol. 3, pp. 140, 168; Laffan and Mulligan 2014, pp. 108–09.

26 Pearce's ambitious but unexecuted remodeling of Stillorgan Park seems to confirm his collaboration with Castle on the magnificent Summerhill House in Meath, which even in 1753 was recognized for its expressions of "the Vanburgh style." McVeagh 1995, p. 141.

27 Rev. W. Henry, "Hints towards a natural, typographical [sic] history of the Counties Sligo, Donegal, Fermanagh and Lough Erne," National Archive, Dublin, MS 2533, pp. 374, 464–65. Castle was the son of an English-born Jewish merchant settled in Dresden; experienced in engineering and skilled at drawing, he had been brought to Ireland purposely to design a country house in Fermanagh in 1728; see Calderón and Dechant 2010. Following Pearce's unqualified recommendation of his talents that year, issued to his fellow members of parliament "who may have occasion of such a person," Castle monopolized country house design until his death in 1751. National Library of Ireland, MS D20, 209, quoted in Glin 1964, p. 32.

28 The form and position of the oval saloon at Ballyhaise (1730s) in Cavan, with which Pearce and Castle were both likely involved, is among the earliest and most intriguing examples. See Mulligan 2013, pp. 22, 165–70; and Worsley 1995, pp. 74–75.

29 Cornforth 2004, p. 36.

30 Michael Ledwidge to William Smyth, incomplete letter (c. 1738), National Library of Ireland, Barbavilla Papers, MS 41,588/2.

31 See Curran 1967, pp. 27–41; Breffny 1988b; McDonnell 1991, pp. 1–11, 22–24; McDonnell 2010; McDonnell 2011; Casey 2012a; Casey 2012b.

32 The Lafranchinis' skills at drafting and modeling, combined with a resourcefulness in exploiting Italian and French engravings for their compositions, elevated Irish stucco decoration to the highest ranks in Europe and fostered the skills of native artisans.

33 Loeber 1981, pp. 70–71. For William Kent and Richard Boyle, 3rd Earl of Burlington, for instance, see Barnard 2004, p. 40.

34 Cobbe and Friedman 2005. Gibbs also supplied designs for a substantial house to Alexander Stewart of Mount Stewart, though it is unclear if this was ever intended for Ireland; see Casement 2010. The impact of Gibbs's book was apparent soon after its appearance: the design of Castle Dobbs, County Antrim (1730), and Palliser House, Rathfarnham, Dublin, were both inspired by "A House for a Gentleman in Essex," plate 64 of Book of Architecture.

35 Demand even contributed opportunity for employment, as suggested by one gentleman amateur who remarked, "If I improve myself in drawing, I could find suffcent business concerning building." Barnard 2004, pp. 46, 56.

36 Casey 1988.

37 Meath County Library, copy of the account book of Charles Tisdall, 1740–51.

38 Both owned numerous editions of Vitruvius's text, spanning 1556 to 1771, with Charlemont owning as many as six. Casey 1988.

39 Casey 1995a, pp. 65–80, 135.

40 Casey 1995a, p. 135, n. 2.

41 Casey 1990–91; Laffan 2005; Barnard 2004, p. 53.

42 Chearnley dreamed up a fantastic paper architecture rich with designs for garden buildings inspired by the European Reniassance tradition; although largely impractical, they affirmed the importance of garden architecture to demesne landscapes. Casey 2005b.

43 Casey 1990, p. 44.

44 Casey 1990, pp. 44–45.

45 Casey has noted from American collections the popularity of the handbooks by Price and Salmon, indicating the importance of these works for colonial carpenters and builders also. Casey 1988; Craig 1976, p. 40.

46 Casey 1995a, p. 71; see also Casey 2005b, pp. 44–45, n. 4.

47 Identified as the poet Henry Brook, who had promoted John Aheron as "superior, [or] at least equal to any foreign architect." Casey 1995a, pp. 78–79.

48 McParland, Rowan, and Rowan 1989, p. 2.

49 McParland, Rowan, and Rowan 1989, pp. 1–11.

50 Ingamells 1997, pp. 91, 750.

51 Mulligan 2013, pp. 179–84.

52 Ingamells 1997, p. li.

53 A more provincial instance of an aspiring virtuoso is the case of Walter Lawrence of Bellevue in Galway,

whose grandiose decorative aspirations were
ultimately realized by the local artist John Ryan (SEE
CATS. 117–18). See Hyland and Kelly 1998, p. 64; Glin,
Griffin, and Robinson 1988, p. 74; Ingamells 1997, p. 590;
*Lawrence Papers 1826–1930, a Descriptive List prepared
by Galway County Council Archives*, 34-5, GP/1/86; 82-3,
GP/293-4.

54 Leeson undertook two tours, the first in 1744 and the
second in 1750. Ingamells 1997, pp. 484, 593–94.

55 Laffan and Mulligan 2014, pp. 85–125.

56 Some early recognition was given to the achieve-
ment at Russborough by the Countess of Kildare, who
visited in 1759 and declared the house "really fine and
the furniture magnificent." B. FitzGerald 1949–57, vol. 1,
pp. 76–77.

57 Ingamells 1997, p. 197.

58 McParland 2001, p. 207.

59 Charlemont felt sufficiently free to indulge a fancy for
French Rococo in the interiors of the Dublin town-
house that Chambers designed for him in 1763. O'Reilly
1993; McParland 2001, p. 207.

60 Laffan and Mulligan 2013.

61 For more on Taylor's ancestors and their estates, see
University College Dublin, Rowley Papers, S6/26/13-15.

62 Taylor's father, Thomas, had obtained plans from
Castle before the architect's death in 1751. Taylor died
in 1757, and by the time his son embarked on building
a year later, Castle's plans were considered too old-
fashioned; one of his schemes was inscribed by an
anonymous hand as "a damn bad one." What followed
could not claim any superiority. Griffin 1998; J. Harris
1973; Casey and Rowan 1993, pp. 313–17.

63 In 1789 the Duke of Rutland famously disdained
Headfort as "a long and tasteless range of building."
J. Harris 1973.

64 J. Harris 1973.

65 In 1765 Adam decorated two rooms in the Dublin
townhouse of Bective's father-in-law, Hercules Rowley;
Taylor reused one of these designs in the saloon at
Headfort, presumably as an economy; Harris 1973.

66 Further economies, though not unusual, can be
detected at Headfort in the reuse of a Kilkenny marble
chimneypiece and a Gibbsian doorcase, most likely
recycled from the Dublin townhouse in Smithfield that
had been designed by Richard Castle. Griffin 1998.

67 In 1766 Bective wrote to Lord Milltown at Russborough
seeking advice about suitable landscapes to have
copied, and there is evidence that at least six works
at Headfort derived in this way from the Milltown
collection, including examples by Vernet and Lacroix.
Bective also commissioned views of Rome from
George Barret that were based on the published works
of Piranesi. O' Boyle 2010, p. 43; Finegan 2006.

68 Ingamells 1997, p. 481. In 1802, after earning a hand-
some bounty and a marquessate by voting for the
Act of Union, Lord Headfort toyed with the idea of
transforming the stern Classical facades of his father's
house into a Gothic extravaganza with the help of

architect Francis Johnston. Irish Architectural Archive,
Murray Collection, nos. 879–85.

69 Glin and Malins 1976, p. 5.

70 With its groves, temples, statues, hills crowned by
obelisks, and lake with elaborate mock fortifications,
Dangan Demesne was described by Richard Pococke
in 1753 as "altogether the most beautiful thing I ever
saw." McVeagh 1995, p. 141.

71 In writing these comments to her husband, Lady
Kildare also added that the lake at Ballyfin was "like
what I fancy ours will be." B. FitzGerald 1949–57, vol. 1,
p. 76. See Mulligan 2011, pp. 193–207.

72 The earliest examples were bird's-eye views, including
the early Georgian landscapes at Mount Ievers in Clare
and, formerly, at Stradbally in Laois. Among the depic-
tions of formal landscapes conceived in a Dutch man-
ner are 1730s paintings of Carton and Howth Castle.
While elements of the landscape at Howth remain,
how far the artist was encouraged to apply the fictive
and illusory to these representations remains unclear.
Crookshank and Glin 2002, pp. 67–69.

73 The set was completed by William Ashford. Laffan
and Rooney 2009, pp. 270–303; Laffan 2011, pp. 68–72,
74–88; Figgis and Rooney 2001, pp. 28–39, 406–14.

74 Laffan and Mulligan 2010.

75 Figgis and Rooney 2001, pp. 40–59; Laffan 2011,
pp. 56–61.

76 G. Murray 2012, pp. 31–32.

77 Thorpe 2013.

78 Hayden 1980, p. 103. The pictures illustrated in figure
24 represent the following: top left, *Pelargonium ×
hortorum*; top middle, *Caesalpinia pulcherrima*; top
right, *Echium plantagineum*; bottom left, *Pelargonium
scabrum*; bottom middle, species of *Verbascum*; and
bottom right, species of *Geranium*. We are grateful to
the scientists and researchers of the Chicago Botanic
Garden for their identification of these flowering
plants.

79 Thorpe 2013, p. 26.

80 And as a corollary, as if to atone for the indulgences
of his predecessors, Charles Cobbe was satisfied that
the sale of his Meindert Hobbema (SEE P. 23, FIG. 6)
from the walls of Newbridge House to fund improved
housing for tenants on the Wicklow estate was mor-
ally justified, its application to such a worthy cause
presenting "a better picture to the Christian eye."
McParland 1985, p. 91; Thorpe 2013, pp. 43–49, 50. Lady
Domvile issued another book around 1840, *Designs for
Cottages*, relating to estate buildings at her husband's
country house, Santry Court, Santry, County Dublin.

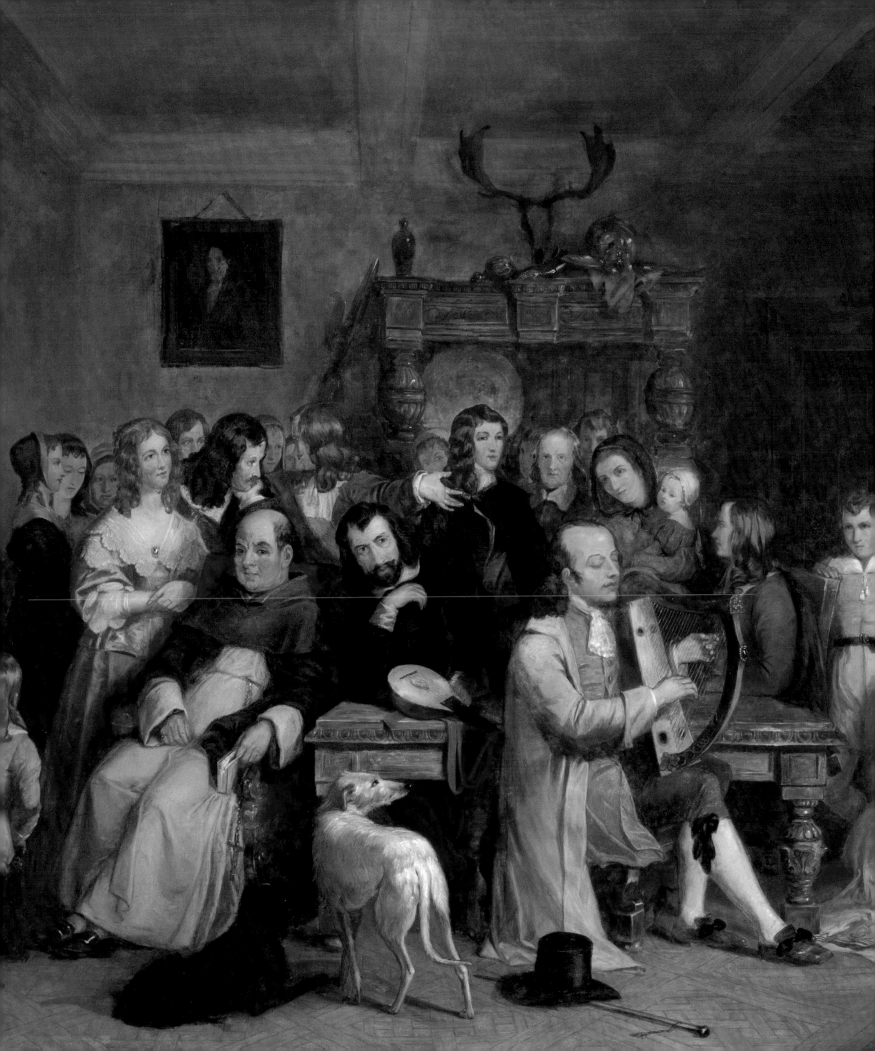

Ireland's "Wild Harp": A Contested Symbol

TOM DUNNE

A POWERFUL SYMBOL, the harp has been deployed across the Irish political spectrum for centuries, gaining its meaning from its users and surroundings. While it has represented the country on the British royal standard since the early seventeenth century, for instance, it was also appropriated by opponents of British rule from the middle of that century and became the official emblem of the Irish state and many of its agencies in 1922.[1] This unique role may have its origin in the fact that, beginning in the late twelfth century, harp music was the only aspect of Gaelic society that colonialist writers praised.[2] As the Gaelic threat receded and the Romantic cult of sensibility developed in the early eighteenth century, some of the ruling elite began to take a wider interest in the Gaelic past; this found a particular focus in the remarkable popularity of the blind poet, composer, and harpist Turlough Carolan (or O'Carolan; 1660–1738).[3] Growing up in remote County Roscommon, Carolan attracted the patronage of leading Gaelic families and bilingual, relatively wealthy Protestants, ensuring his welcome through both music and praise poems celebrating

weddings and funerals. Thanks to the strong metropolitan connections of his main patrons, Carolan gained national fame as a composer who inflected the Gaelic repertoire with the new vogue for Italian music and even had some of his compositions published in his lifetime. What made him a truly iconic figure, however, was the Romantic cult of the bard inspired by literary works such as Thomas Gray's *The Bard, a Pindaric Ode* (1757) and James Macpherson's *Fragments of Ancient Poetry* (1760). The latter purported to be a translation of Gaelic poems recovered in the Scottish Highlands, some of them written by the third-century bard Ossian, who soon captured the northern European imagination. In 1760 Oliver Goldsmith introduced Carolan to the British public as the product of a remote, backward country, a man whose value was mainly in offering a way of understanding "the ancient manners of our own [British] ancestors."[4] Carolan, he explained, was "the last and greatest of the bards." In the 1770s, the antiquarians Joseph Cooper Walker and Thomas Campbell added a Classical gloss to this primitivist view, comparing Carolan to Orpheus and Homer.[5]

It is perhaps surprising, given their literary vogue, that neither Ossian nor Carolan featured significantly in Irish art. The only known

contemporary likeness of the latter (FIG. 1) was possibly taken by Francis Bindon, a friend and painter of Jonathan Swift who also had connections to the musician. The small oil is an awkwardly executed half-length portrait of Carolan playing a small harp.[6] While engraved and published several times, it fails to convey the romantic image of Carolan then prevalent. There was to be no other painting of him until James Christopher Timbrell's *Carolan, the Irish Bard* (P. 118 AND FIG. 6 BELOW), exhibited at the Royal Academy in 1844. This too, as we will see, lacked Ossianic romance, being rather a Victorian version of Carolan that appealed to a new sensibility.

The cult of the bard was, as cultural historian Joep Leerssen put it, part of the wider "cultural transfer" of elements of the Gaelic world to the "new English-speaking civic and urban environment," not least in the development of a patriotic Anglo-Irish identity.[7] In the Irish Parliament of the 1770s, the "Patriot" opposition to the British-run Dublin Castle administration came to identify with the harp, especially in its protest against the stalling of reform and the war against the American colonies. This resistance led to the formation of local Volunteer Corps, which outdid each other in elaborate uniforms and regimental regalia, many featuring the harp, usually

James Christopher Timbrell. *Carolan the Irish Bard*, c. 1844 (detail). Cat. 127 (see p. 124, fig. 6).

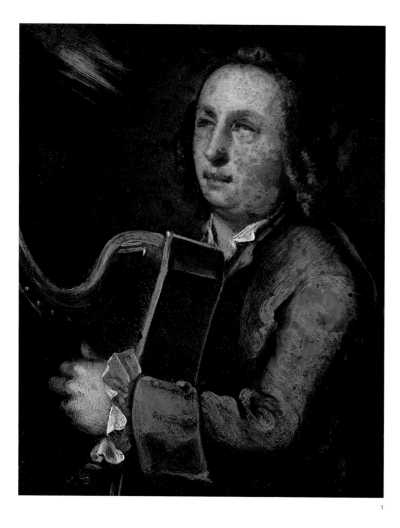

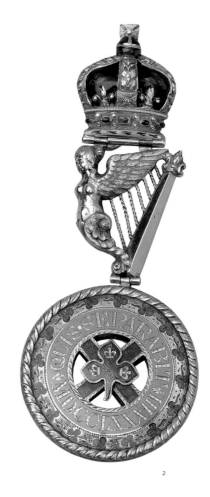

surmounted by the crown, as in the royal arms, but sometimes without it. Part of the administration's response was to inaugurate a new chivalric order in 1783, the Order of Saint Patrick. Leading Irish peers were inducted, including many who had been prominent in the Volunteer movement. The group's elaborate insignia, worn by the lord lieutenant as head, included a pendant with the crest featuring the cross of Saint Patrick, shamrocks, and the motto *Quis separabit* (Who will separate us?) hanging from a crowned harp (SEE FIG. 2).[8] This renewed attempt to identify the harp with the state may have had some success among the aristocracy, and it certainly further popularized the idea of this symbol as a key Irish emblem. Increasingly it appeared on luxury goods, especially glass, ceramics, and silver, as in Samuel Walker's harp-handled cup,

which incorporates silver from the Great Seal of Ireland from the reign of George II (FIG. 3). In their fine mahogany wine cooler, the Dublin cabinetmakers Mack, Williams and Gibton (P. 173, FIG. 9) even incorporated the crowned harp and crest of the order.

But many in the target audience were not won over. In a 1785 Volunteer pamphlet, William Drennan, using the Swiftian nom de plume "an Irish Helot," called for reform and the addition of "new strings to the Irish harp."[9] Six years later, a new and more radical reform movement, the United Irishmen, adopted the winged maiden harp of the Order of Saint Patrick but replaced the crown with the revolutionary cap of liberty and the motto "It is new strung and shall be heard." Given its largely Protestant leadership, the Gaelic emphasis of the United Irishmen was

Fig. 1
Attributed to Francis Bindon (Irish, 1690–1765). *Portrait of Turlough Carolan*, c. 1720. Oil on copper; 20 × 17 cm (7⅞ × 6¹¹⁄₁₆ in.). National Gallery of Ireland, Purchased, 1956.

Fig. 2
Badge of the Grand Master of the Order of Saint Patrick, c. 1850. Private collection. Cat. 302.

Fig. 3
Samuel Walker. Two-Handled Cup and Cover, c. 1761–66. Philadelphia Museum of Art, Gift of an anonymous donor, 2008. Cat. 293.

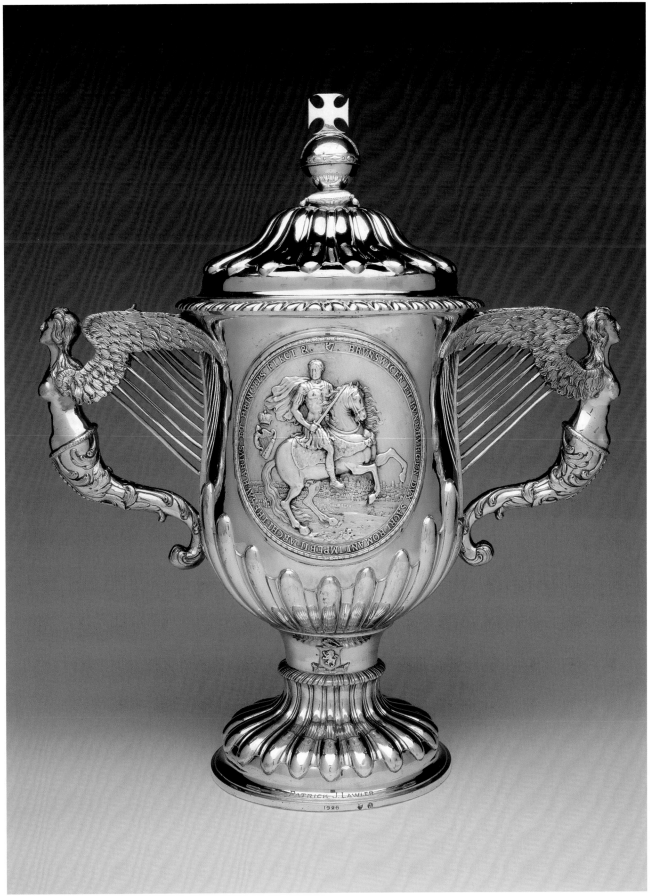

striking and included its promotion of the Irish language and the Belfast Harp Festival of 1795, which in turn led Edward Bunting to his crucial project of collecting traditional folk music. The harp motif appeared in the organization's newspapers and ballads, especially after the group became radicalized and dedicated to open rebellion in 1796. In the 1798 rebellion, which the United Irishmen organized but did not altogether control, some rebel flags featured the harp with the cap of liberty and the motto *Erin go bragh* (Ireland forever).[10] This flag reappeared in the abortive Robert Emmet rebellion of 1803.

The presence of the phrase *Erin go bragh* on a document held by the subject in Robert Fagan's extraordinary *Portrait of a Lady as Hibernia* (FIG. 4) could, therefore, be taken as a sign of political radicalism. However, that phrase, like others in the radical lexicon, had lost some of its revolutionary connotations and taken on exotic literary associations after the Act of Union in 1800, around the time this painting was completed.[11] So had the harp, the wolfhound, and the fashionable shamrock decoration on the sitter's gown, which were common to moderate anti-Union reformers and revolutionary United Irishmen alike. In important ways, the figure recalls the allegorical Hibernia in Vincenzo Valdré's large pro-Union painting commissioned for the ceiling of Saint Patrick's Hall in Dublin Castle (SEE P. 68, FIG. 8); in a green dress, with one breast exposed, Valdré's standing Hibernia assumes a similar pose.

Dillon family tradition suggests that Fagan's Hibernia is, in fact, a historical figure: Margaret Simpson, mistress of Henry Dillon, 13th Viscount Dillon. This might explain her pose and the overt sexuality of the painting, which includes a provocative female figure on the harp who mocks the stylized winged maiden motif on the royal arms.[12] The Dillon connection alone suggests complex politics.

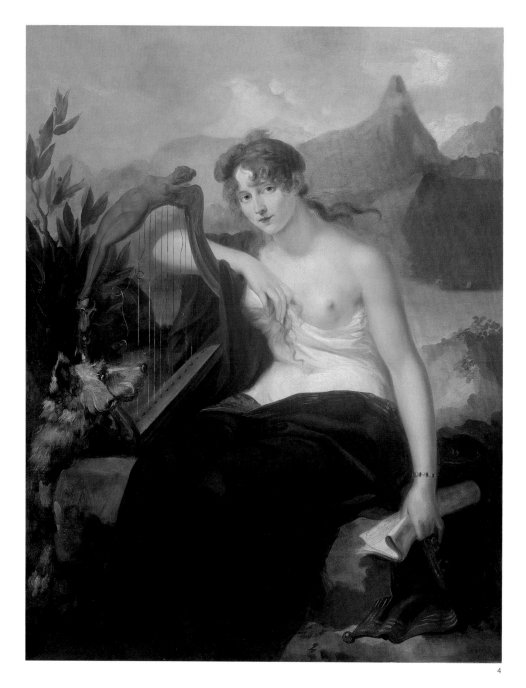

4

The family were for many years Catholic Irish Jacobites, and the twelfth viscount only converted to the established church in 1766, subsequently becoming a member of parliament and Knight of Saint Patrick. The Dillons had a strong military tradition and were heavily involved in a regiment of the Irish Brigade in the French Army; "Dillon's Regiment" was disbanded in 1791 due to its loyalty to the French monarchy. Three years

Fig. 4
Robert Fagan. *Portrait of a Lady as Hibernia*, c. 1801. Private collection. Cat. 37.

later, the future thirteenth viscount became an honorary colonel of a reconstituted version that was part of an émigré Catholic Irish Brigade now recruited into the British Army only to be wiped out almost immediately during a campaign in Jamaica. The flag of the French regiment had featured a crowned harp in the center of a cross with the Catholic motto *In hoc signo vinces* (In this sign you shall conquer).[13] If there is a Dillon subtext to the painting, the broken strings of the harp may refer to the destruction of a proud military tradition, and *Erin go bragh* could be a Catholic Jacobite cry rather than a contemporary revolutionary one.

Such a meaning would resonate with Fagan's own background and likely politics. Born in London to a prosperous Irish-born baker, the artist was brought up and remained a Catholic, and spent most of his career in Italy, where he found patrons among English Catholics.[14] The thirteenth Viscount Dillon remained Catholic in sympathy, publishing pamphlets in favor of Catholic emancipation. William Laffan's comparison of Fagan with the better-known Irish Catholic artist James Barry is an interesting one, but the political stance common to both may have been Catholic rather than republican.[15]

In the early decades of the nineteenth century, the harp was further transformed from a radical Irish symbol to an upper-class British fashion. In ages past, performers were itinerant male musicians playing the old airs on large, traditional, wire-strung harps; now, they were mainly women in drawing rooms who accompanied contemporary sentimental songs on small, new-style instruments with gut strings.[16] No one better represented—and promoted—this change than the romantic, highly political novelist Sydney Owenson, Lady Morgan (SEE FIG. 5). Her mixed Irish and English parentage was symbolic of the union to which she was passionately committed and which informed the political subplot of her Irish novels. The author identified hugely with her father, Robert Owenson, who grew up speaking Irish and singing traditional songs such as Carolan's but made his early career playing stereotypical Irish parts on the London stage. Moving to Dublin to establish a new national theater in support of the patriotic Whigs, he imbued his daughter with the politics that she carried through life.[17] He also provided her with the material for *The Lay of the Irish Harp* (1807), in which she—or rather he, because she spoke little Irish—translated the "wild and plaintive strains" of his songs into English.[18] This small volume was aimed at a market Owenson herself had done much to create the previous year with her best-seller *The Wild Irish Girl*, which featured a sophisticated harp-playing Gaelic heroine, Glorvina, who, however, was no naïve enthusiast for Irish music and song but often preferred an English "Ossianic style" to "the wild effusions of the modern and unlettered bards of Ireland."[19] Crucial to the success of this didactic novel was the author's public identification with her heroine. In her memoirs, Owenson delights in the fact that she was known as "Glorvina" until her marriage and that her appearances in Dublin and London society playing the harp and singing Irish songs inspired new fashions not only for the instrument itself but also for harp-shaped broaches and ornamental hairpins called Glorvinas.[20]

Owenson's success in transforming the harp's image, however, was eclipsed by that of her old Dublin friend, the poet, singer, and songwriter Thomas Moore. Also a youthful associate of United Irish activists, Moore was never a revolutionary or radical. He belonged rather to the middle-class Catholic tradition of masking deeply felt resentment at injustice with a deferential rhetoric of petition and appeal to the liberal instincts of English Whigs. He thus continued the Catholic antiquarian tradition but added to its invocation of history

5

Fig. 5
Thomas Hargreaves. *Portrait of Sydney Owenson, Lady Morgan*, c. 1820. The Art Institute of Chicago, the Colonel Alexander F. and Jeannie C. Stevenson Memorial Collection, 1957.63. Cat. 54.

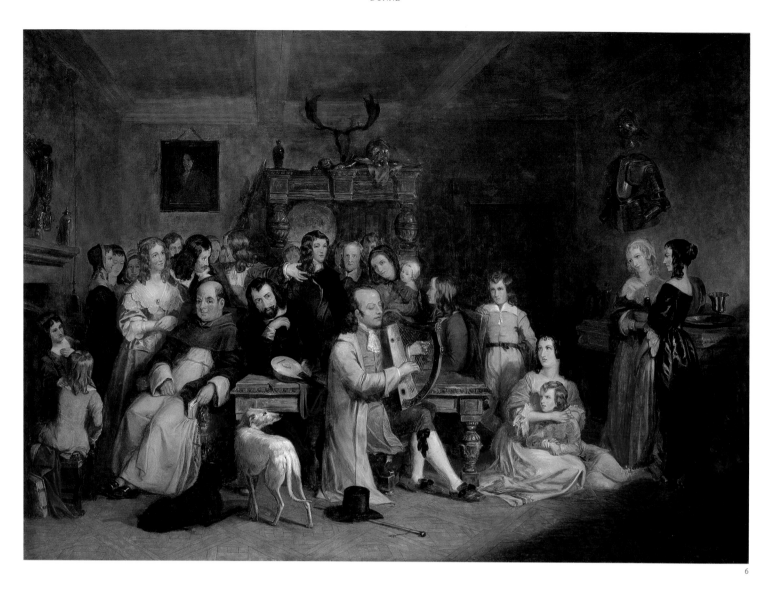

6

and justice an appeal, above all, to sentiment. In "Oh! Blame Not the Bard," after lamenting that "the patriot heart" cannot be invoked because of the broken state of Ireland, he claims that all he as a modern bard can do is to keep the name and wrongs of "loved Erin" alive in his songs: "Till thy masters themselves, as they rivet thy chains/Shall pause at the song of their captor and weep."[21]

While Moore was interested in the harp as a symbol, he had little affection for the Gaelic harp tradition, which, he maintained, contained few airs "of a civilized description" prior to modern times. He was mainly interested in the harp as a symbol, and in Irish music as "the truest of all comments on our history" and the

best reflection of national character, which he described as a "romantic mixture of mirth and sadness."[22] Moore's *Irish Melodies* (1808), however, stresses sadness over mirth, whereas the song and harp tradition mainly featured "lively airs," as Edward Bunting pointed out in the preface to the 1840 edition of *The Ancient Music of Ireland.*[23] Moore's great theme was loss, and in this and in other respects, he unconsciously echoed major themes of praise poetry from the sixteenth and seventeenth centuries, when the colonial revolution began to destroy the polity and culture of the Gaelic elite.[24] Yet, like Morgan's, Moore's representation of the harp was primarily Ossianic, an echo of Macpherson's primitive, blind, feeble

Fig. 6
James Christopher Timbrell. *Carolan the Irish Bard,* c. 1844. The O'Brien Collection. Cat. 127.

bard who sings of a remote past and poses no threat to the status quo. Like Morgan also, he disassociated his invocation of Irish "wrongs" from both "dangerous politics" and "any appeal to the passions of an ignorant and angry multitude."[25]

The attenuated manner in which Moore's *Irish Melodies* helped to keep the memory of Carolan alive is reflected in the first and only representation of the blind harper in a history painting, Timbrell's *Carolan the Irish Bard* (FIG. 6). Little is known of Timbrell beyond the fact that he exhibited one painting in the Royal Hibernian Academy before his 1830 move to London, where he showed his work in British Institution exhibitions and, in the case of this one painting, at the Royal Academy.[26] Before leaving Ireland, the artist also contributed slight, charming, and stereotypical illustrations of peasant figures to Anna Maria Hall's *Sketches of Irish Character* (1820). His illustrations for Mr. and Mrs. S. C. Hall's *Ireland: Its Scenery, Character, etc.* (1841) were more complex and interesting, especially a series of three on peasant funerals. Carefully and respectfully observed, they belong to a type of representation of Irish life that developed from the time of the Union, in which traditional English (and essentially colonial) representations of Irish lawlessness, poverty, and superstition were combated with depictions of domesticity, gentility, and piety, although—as was the case of the fictions they mirrored—elements of the stereotype, humorously presented, might still survive.[27]

Here, Timbrell depicted Carolan playing the harp in an aristocratic setting, a room with ancient armor, fine furniture, and paintings. His audience, wearing indeterminately archaic clothes, is focused on the blind musician, whose own social status is reflected in the top hat and cane at his feet. A corpulent Dominican friar sits in a place of honor, which indicates that this is a Catholic household. Redolent of tradition and respectability,

Timbrell's painting ignores the colorful eighteenth-century accounts of Carolan as a quintessentially Irish character, a genius noted for his mischievous wit and fondness for drink as well as music. He is presented instead as a forerunner of Moore and his *Irish Melodies*, a player of harp music for respectable society. On the eve of the Great Famine, this canvas offered an image of Ireland that was affirmative and reassuring, with the harp, as Sir John Davies had envisaged it in 1615—and James Barry had represented it after the Union—making "good harmony in the common weal" rather than being a threatening symbol of O'Connelite mass politics, in which it had figured extensively, or of Young Ireland, for whom it had gestured toward rebellion.[28]

NOTES

1 See McCoy 1979.

2 The fullest account of the Irish harp is E. Cullen 2008.

3 See D. O'Sullivan 1958.

4 Deane 1999, vol. 1, pp. 667–68. Originally published in the *British Magazine*, July 1760.

5 T. Campbell 1777, p. 450; Walker 1786, appendix 6, "Life of Carolan."

6 Figgis and Rooney 2001, pp. 85–86.

7 Leerssen 2007.

8 F. Cullen 1997, pp. 66–71.

9 Drennan 1785, p.74

10 See Thuente 1994; Bunting 1796. Two more editions of the latter appeared in 1809 and 1840.

11 For example, Lady Morgan's heroine, Glorvina, in the *Wild Irish Girl* (1806), sighing "over the chords of her national lyre - - - faintly murmured Campbell's ancient air of 'Erin go brach.'"

12 Laffan 2011, pp. 116–17

13 McCoy 1979, pp. 66–68; Robert Harrison (rev. Marie-Louise Legg), "Henry Augustus Dillon-Lee, 13th Viscount Dillon, 1777–1832, Writer," in *Oxford Dictionary of National Biography*, 60 vols. (Oxford University Press, 2004), vol. 33, p. 75.

14 Laffan 2001a.

15 See Dunne 2005.

16 See the contrast between John Egan's new Portable Irish Harp and the traditional Bunworth Harp (P. 208, FIG. 2, AND P. 207, FIG. 1).

17 Dunne 1987.

18 Owenson 1807; Dixon 1863, vol. 1, pp. 263–67.

19 Owenson 1806, vol. 2, pp. 106, 111–12.

20 Dixon 1863, vol. 1, pp. 277, 408–10, 416–18.

21 Moore 1853, vol. 3, pp. 264–66.

22 Moore 1853, vol. 4, pp. 117–35.

23 For an excellent discussion of Bunting and Moore, see White 1998, chap. 3.

24 See Dunne 1988, pp. 85–88.

25 Moore 1853, vol. 4, pp. 129–30.

26 Strickland 1913, vol. 2, pp. 448–49.

27 The interiors painted by John George Mulvany offer good examples of this approach, and Daniel Maclise's *Snap Apple Night* (1833; private collection), exhibited in the Royal Academy shortly after Timbrell moved to London, may have been an influence. The contrast between Timbrell's conventional depiction of the iconic Irish harper and the fashionable medievalism and cult of chivalry that were defining signatures of Maclise's history paintings is striking. Maclise used the harp as a symbol of a number of the indigenous cultures—Anglo-Saxon and Welsh as well as Irish— that were assimilated to the composite identity of "Britons," initially through Norman power. See Dunne 2008.

28 For Barry's *Minerva Turning from Scenes of Destruction and Violence to Religion and Arts*, see Dunne 2005, p. 135. See also E. Cullen 2008, pp. 158–72.

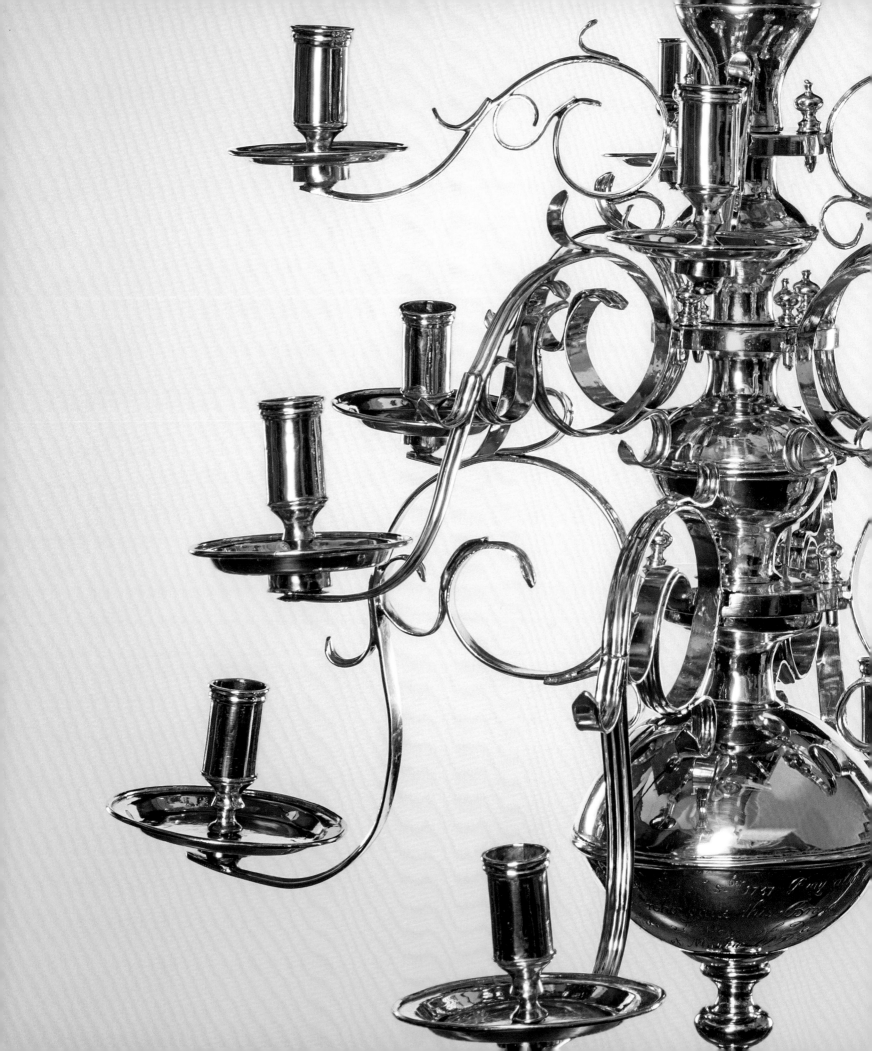

PART TWO

THE ARTS OF IRELAND

Made in Ireland: Production, Patriotism, and Prowess

TOBY BARNARD

UNTIL THE LATER seventeenth century, the description "made in Ireland" was seldom a recommendation. Prior to that, only a few native products were in demand outside the island: fiery spirits known as *usquebagh*; hawks, hounds, and falcons; and "marble," a variety of limestone quarried around Kilkenny and from veins in north County Cork. So too was timber, mostly used for building ships for the growing Royal Navy.[1] Within Ireland, the relative ease with which the accessories of daily life could be imported retarded the development of home manufactures. Yet, among the majority of people, cost and convenience made it essential for clothing, dwellings, and furnishings to be made locally. Much was severely utilitarian, rudimentary, and perishable. Despite the short lives of the objects, traditions in the fashioning and ornamentation of raw materials—clays, metals, skins, stones, and wood—passed from generation to generation

Samuel Dixon. *To the Countess of Hillsborough—Summer Duck, Red-billed Whistling Duck, and Shells* (detail), from *Twelve Prints of "Foreign and Domestick" Birds*, c. 1755. Cat. 35 (see p. 136, fig. 12, top row, right).

of artificers. Imports, and the preferences and skills brought by successive waves of immigrants from Continental Europe and Britain, mingled with and modified the indigenous styles. Since the south of Ireland tended to be settled by newcomers from western England and Wales and the north by emigrants from Scotland, forms and details of dress, furniture, and housing diverged. By the eighteenth century, as retailing intensified, material cultures across all Ireland were tending toward, but never achieving, greater homogeneity. Indeed, while fashions from Dublin, England, and the Continent reached distant corners of the island, access to the market varied, and local idiosyncrasies persisted.

Customers in Ireland inevitably differed in what they were able to spend on both necessities and need-nots. But, as elsewhere, they also disagreed as to which was which. As shoppers made choices, their calculations diverged: utility obviously mattered, as did fitness for purpose and durability, but these attributes were hard to judge without experience. Availability was another determinant. Outside Dublin and the largest towns, choice was largely limited to what was stocked by the general stores that were becoming ubiquitous

in market towns.[2] Customers found alternatives in the seductive displays in the stalls and booths at markets and religious festivals, and in regular open-air markets. These offerings were supplemented by peddlers who walked the remoter roads and tracks.[3] By the eighteenth century, provincial buyers enlarged the range of what they might purchase not only by asking neighbors and kindred to shop for them when in Dublin or England, but by reading the numerous advertisements in newspapers. The problem was to match the often hyperbolic printed descriptions to known and imagined objects, and seeing what family and friends had brought back from the capital or abroad helped.

For most would-be consumers, price was crucial. Few had much money to spare. Indeed, many struggled—and periodically failed—to subsist, so they were forced to pare down their spending to a minimum. Manufacturers and retailers competed with increasing ingenuity and unscrupulousness to persuade the reluctant to buy their particular commodities. A favored sales pitch was to trade on patriotism. An item's Irish manufacture, it was hoped, would override its higher price, unremarkable style, or inferior quality. By the

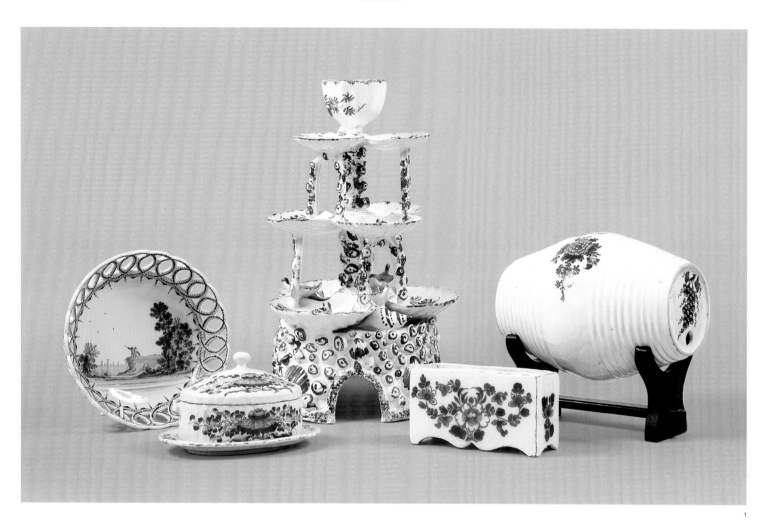

1

1730s, propagandists wrote of the economic damage inflicted by Irish consumers' addiction to imported goods and identified what they saw as the physical and moral harm caused by the taste for luxuries.[4] During the 1770s and 1780s, an upsurge of civic activism directed into the Volunteer movement made buying Irish a patriotic duty. To reinforce the message, fabrics and pottery were embellished with the movement's iconography.[5]

To overcome resistance to homemade products, sustained campaigns tried to improve their fashioning. As a result, allure was added to Irish ceramics, furniture, glass, and silver, such as the tin-glazed earthenware produced at the World's End Pottery outside Dublin from about 1735 to about 1773 (SEE FIG. 1). However, the fashionable acclaim attached to the latest from France or England

was never wholly trounced. One consequence was that manufacturers wavered between embracing local materials and idioms and adopting or adapting features originating from outside Ireland.

Innovations in the types of goods and the techniques used to produce them can sometimes be traced to the import not just of prototypes to be copied but of experienced artisans. Refugees first from the Low Countries, then from France, the Rhineland, and even Scotland brought skills important to the development of Irish glassmaking, potting, silversmithing, and textile manufacture, like Robert Goble, a Huguenot émigré from France (SEE FIG. 2). More intensive settlement from England in the later sixteenth and seventeenth centuries increased the demand for goods and the supply of specialist workers. However,

Fig. 1
World's End Pottery, under the direction of Henry Delamain, Mary Delamain, or William Delamain and Samuel Wilkinson. Bowl, Butter Dish and Stand, Epergne/Sweetmeat Dish, Flower-Brick, and Wine Barrel, 1755/70. Private collection. Cats. 189, 198, 190, 199, and 197.

Fig. 2
Robert Goble. Tankard with the Arms of the Day Family, c. 1710. Private collection by arrangement with S. J. Shrubsole, New York. Cat. 270.

Fig. 3
Robinson of Ballsbridge. Bed Curtain, c. 1780–1800. The Metropolitan Museum of Art, New York, Everfast Fabrics Inc. Gift Fund, 1973. Cat. 325.

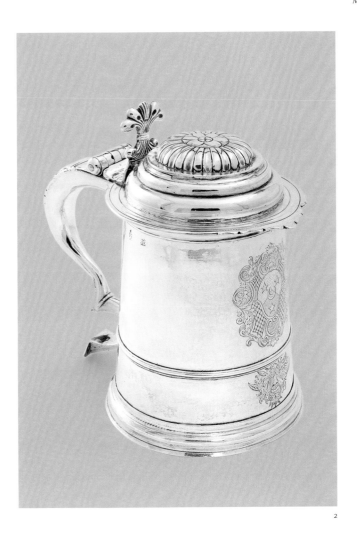

2

3

both of these had been growing even before this moment.[6]

England, in subjecting Ireland to renewed colonization, wanted to create a possession that not only reproduced desirable English characteristics—industry and obedience—but also would serve as a captive market for English goods. The last aim conflicted with another ambition: to transform Ireland into a thriving and productive dependency. In trying to reconcile these objectives, the Westminster Parliament stunted some Irish industries that might compete against English ones, notably the production of wool cloth, and fostered others, conspicuously, linen.[7]

As the Irish population increased, a modest prosperity spread, and aspirations and ideas about how to live altered, domestic requirements supported more local

manufactures of ceramics, glass, metalwares, textiles, and furnishings.[8] Partly because of the hostile tax regime imposed by England, few Irish goods other than linen were in great demand outside Ireland. Accordingly, most innovations were aimed to boost sales among Irish customers. There were notable successes as well as some spectacular failures.[9] Linen manufacturers, for example, experimented with colorfast copperplate printing in order to ensure the continuing repute of their product and extend its market (SEE FIG. 3). The resulting designs, including scenes of Volunteers parading, appeared on furnishing and dress fabrics (SEE P. 198, FIG. 7).[10] Patriotism even affected the choice of horse-drawn coaches. When in the 1790s the lord chancellor, John FitzGibbon, 1st Lord Clare, paraded provocatively in an English-made carriage, Dublin's dignitaries

responded by ordering vehicles from the city's leading makers, including John Hutton (SEE FIG. 4).

A love for melody and music making among the native Irish was said to date from the Celtic dawn.[11] The favored, but tricky, instrument was the harp (see Darcy Kuronen's essay in this catalogue).[12] More common were simpler and cheaper alternatives, notably the fiddle, the human voice, and the pipes. Traditions were complicated as instruments and tunes arrived from overseas. Most of these were destined for private performances, but public activity was quickening, as festivities in Dublin Castle marked the sovereign's birthday and other red-letter days. Operas were performed, and most plays were interspersed with songs or musical entr'actes. Charities started to stage fund-raising concerts, the

Fig. 7
One of Four Side Chairs with the Falcon
Crest of the Earls of Meath, c. 1730.
Neville and John Bryan. Cat. 221.

Fig. 8
Armchair, c. 1750. Private collection.
Cat. 224.

Fig. 9
Decanter Stand, c. 1760. Collection
of Mr. and Mrs. Jerold D. Krouse.
Cat. 242.

Fig. 10
Side Table, c. 1760. Private collection
by arrangement with Mallett. Cat. 238.

Fig. 11
Tea Table, c. 1740-60. Tara Kelleher and
Roy Zuckerberg. Cat. 235.

10

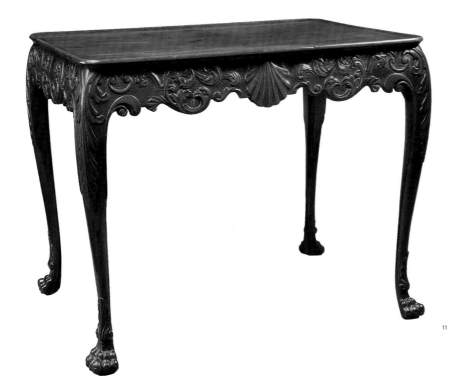

11

detailing of chairbacks. More generally, the deeply carved aprons of side tables, with their bold masks, and the paw feet and hooves of chairs and tables had an exuberance that has been characterized as distinctively Irish (SEE FIGS. 8–11). Craftsmen introduced a similar elaboration of standard antique, chinoiserie, floral, and Rococo motifs into silver and plasterwork. At the same time, the essential types and forms of beds, chairs, cupboards, dressers, looking glasses, and tables did not deviate massively from those current throughout Britain, North America, and parts of Continental Europe. In Ireland, regional variations arose not just from the available materials but also from traditions preserved by settlers whose ancestors had arrived from elsewhere.[23]

As the quality of what was made in Dublin improved, buying Irish was no longer unfashionable. Even so, it would be misleading to portray all, including members of the political and social elites, as enslaved to constantly shifting vogues. There were many who contented themselves with durable and serviceable products, even when they were no longer in the most up-to-the-minute style. Marriage and inheritance were the two likeliest occasions for a radical overhaul of the house; in the former case, extra money was sometimes available, and a bride arrived with her own desires. Working against dramatic innovations were both economy and sentiment. The familiar, even when unfashionable, retained an appeal, and consumers were known to mix inherited objects (and those of different vintages) with the new. Pragmatism showed, too, in the willingness to buy items secondhand or rent them for special occasions.[24] Auctions became frequent events both in Dublin and the countryside when possessions were dispersed. From about 1730, sales of important furnishings by notable owners, such as the Ingoldsbys and Wingfields in Dublin, were accompanied by printed catalogues and advertised extensively in the newspapers.[25]

local materials with a quest for the rare and distinctive. They continued to use native woods such as oak, although the destruction of Irish woodlands reduced the supply. Imported varieties—especially walnut and mahogany but also the more mundane pine, or deal—were widely employed for both showy and utilitarian pieces; around 1730, for example, the Brabazons, earls of Meath and owners of

a substantial tract of Dublin, commissioned a suite of elegant walnut chairs (SEE FIG. 7). As with other designs, it was relatively easy to copy prototypes from Paris and London. It is also clear that, by the eighteenth century, patterns made in Dublin were sent into the provinces— for example, to Galway and County Down—to be reproduced.[22] Provincial craftsmen introduced touches of their own in the shaping and

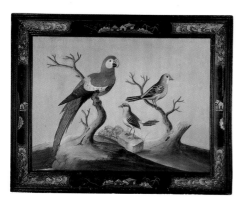

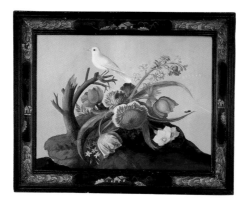

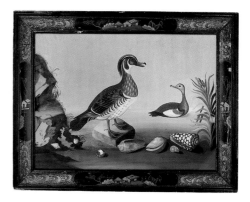

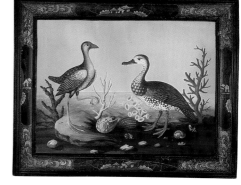

Fig. 12
Samuel Dixon. *Twelve Prints of "Foreign and Domestick" Birds*, c. 1755. Private collection. Cat. 35.

Fig. 13
Study of a Grouse and *Study of a Sparrow*, 1797/1800. Tom Shudell. Cat. 141.

12

13

Refreshing dwellings that looked fusty and old-fashioned could be accomplished quickly and inexpensively by introducing vivid textiles and relatively modest novelties. The latter might include sets of Wedgwood vases; engravings of topical personalities and wonders; the embossed paper pictures marketed by Samuel Dixon (FIG. 12);[26] and the confections of feathers, felts, papers, pressed flowers and ferns, and shells in which the women of some leisured households became expert (SEE FIG. 13).[27]

Norms of smartness were set by hosts and hostesses who aimed to lead and dictate taste, and by manufacturers and suppliers who hoped to profit by inflaming cravings for novelty. Yet surrender to these artificially induced appetites was always selective, never universal. But the widening of the market ensured that many of these goods could be bought relatively cheaply. Glassware; small items of silver such as teaspoons; ceramic tea- and coffee-services or pots in which to plant flowering bulbs; mezzotints and engraved prospects of Dublin's public buildings and Killarney's lakes; oval miniatures and silhouette portraits; all of these were to be had for shillings or, at most, a few pounds: sums which the middling sorts as well as the swanky could afford. Increasingly, buyers were able to find such articles at country auctions and shops in larger provincial towns. Yet, just as for those at the forefront of modish consumption, who found it necessary to shop on the Continent or in London, provincial buyers preferred what had come from Dublin rather than from a local craft worker.

NOTES

1 Everett 2014; E. McCracken 1971.

2 Barnard 1998; Crawford 1996.

3 For these strategies, see account book of the Reverend Andrew Rowan, 1672–1680, Public Record Office of Northern Ireland, Belfast, D 1614/3; Gillespie 2005b; Legg 2005.

4 Barnard 1999; Dunlevy 1992.

5 S. O'Connor 2008.

6 Flavin and Jones 2009.

7 P. Kelly 1980; Crawford 2005.

8 A. FitzGerald 2015; A. FitzGerald and O'Brien 2001; Francis 1994; Francis 2000b; Francis 2000c; Moran 2003; Moran 2011; Roche 2007.

9 S. Foster 1997, 2008; Moran 2008a.

10 A. Hall 1861–62; Longfield 1955; Wilson 2011. In 1775 John Murray saw at Mr. Harper's manufactory near Leixlip in County Kildare "print chintz, muslin, cotton, linen and woollens." John Murray, Journal, s.d. June 5, 1775, National Library of Scotland, MS 43018.

11 Walker 1786; White 1998, pp. 13–35.

12 Ó Catháin 1997; Rimmer 1969.

13 Flood 1914; *Belfast Newsletter*, February 14–17, 1775.

14 Barnard 2006; Gillespie 2005a; Muriel McCarthy 1980.

15 Muriel McCarthy 1986; Westerhof 2010.

16 John Murray, Journal, s.d. July 2, 1775, National Library of Scotland, MS 43018; Meredith 2001.

17 Pollard 1989; Phillips 1998.

18 Muir 2010.

19 Craig 1954; Healy and McDonnell 1987.

20 Barnard 2014; Craig 1953; Kinane 1985.

21 P. McCarthy 2008a.

22 Barnard 2004, pp. 124–26.

23 Bebb 2007; Cotton 2008; C. Gilbert 1991; Kinmonth 1993; cf. Choux 1973.

24 Barnard 2004, pp. 122–50.

25 *Catalogue of the Goods* 1729; *Catalogue of the Goods* 1731; *Catalogue of the China Ware* 1731.

26 The pictures by Dixon illustrated in figure 12 have printed dedications pasted on their verso. Top left, *To the Countess of Antrim—Black-billed Whistling Duck, Purple Water Hen and Corals.* Top middle, *To the Countess of Carrick—Red and Blue Macaw, Grey Finch, and Wax-bill.* Top right, *To Lady Castlecomer—Blue and Yellow Macaw, Indian Redstart, and Sparrow of Paradise.* Second row, left, *To the Countess of Cork—Canary Bird, Hyacinths, Tulips, and Anemones.* Second row, middle, *To the Duchess of Dorset—Goldfinch, Honeysuckle, and Ranunculuses.* Second row, right, *To the Duchess of Hamilton—Cock Butcher-bird, Poppies, Ranunculuses, and Roses.* Third row, left, *To the Countess of Hillsborough—Summer Duck, Red-billed Whistling Duck, and Shells.* Third row, middle, *To the Countess of Howth—Indian Bee-eater, Black and White Indian Starling, and Brazilian Finch.* Third row, right, *To the Countess of Kildare—White-headed Parrot and Grapes.* Bottom left, *To the Dowager Countess of Kildare—Bullfinch, Blue Titmouse, and Fruit.* Bottom middle, *To the Countess of Meath—Chaffinch, Convolvulus, and Snowdrops.* Bottom right, *To Lady Molesworth—Green-winged Dove, Cock and Hen Red-throated Hummingbirds, and Nest.*

27 G. Cockburn, inventory of furniture, Rutland Row, Dublin, 1763, with later additions, British Library, London, additional MS 48,314, p. 19; Laird and Weisberg-Roberts 2009; Longfield 1975, 1980; Moffat 2012; Reynolds 1984; Wilson 2011, pp. 53–56.

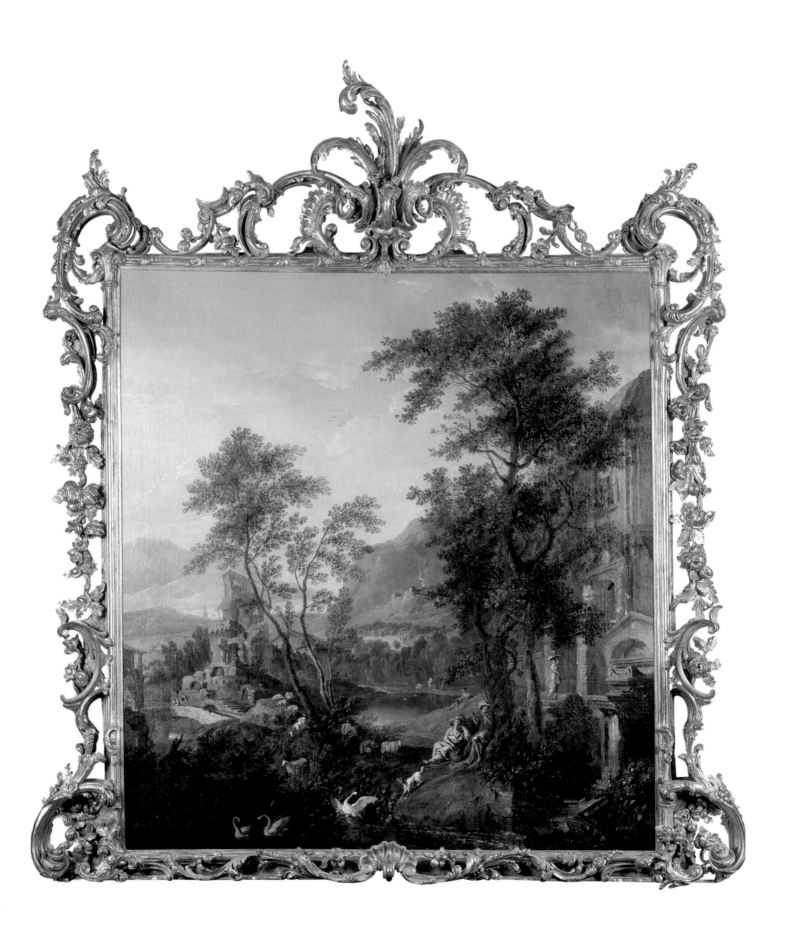

Regarding Irish Eighteenth-Century Artists: Comment, Culture, and Community

BRENDAN ROONEY

JUST AS IRELAND WELCOMED German furniture makers and Huguenot silversmiths to its shores, its own artists were inclined to look toward London and Continental Europe for training, inspiration, and professional advancement. This pervasive impulse is perhaps unsurprising, as the tradition of indigenous easel painting, which originated in the seventeenth century, to a large extent followed foreign models. The larger marketplaces of London and further afield, meanwhile, enticed ambitious artists seeking a broader clientele.[1] The influence of Europe's artistic centers, whether direct or indirect, contributed greatly to the refinement of art practice, the stimulation of patronage, and the development of a cultural infrastructure in Ireland.

James Latham, already a mature professional, was among the first Irish painters to travel abroad, enrolling in the Guild of Saint Luke in Antwerp in 1724. While there is little evidence of Flemish influence in his canvases, his assured portraiture suggests a debt to

French painters whose work he is likely to have seen in Paris. Latham demonstrated a boldness of touch uncommon among his peers. He relied on strength of line and firmness of modeling—qualities exemplified by his portrait of General Thomas Bligh (FIG. 1)—and avoided a tendency among portrait painters to overembellish and congest their compositions.

In keeping with stylistic movements throughout Europe, Irish artists turned their gaze increasingly toward Italy as the eighteenth century progressed, and an incipient Italian Classicism reveals itself not just in the work of practitioners with firsthand experience of the country, but also in the paintings of those who observed the art it inspired. Many Irish artists traveled to Italy, shadowing lofty paymasters on their grand tours.[2] Others, who never visited Italy, produced copies or derivations of Italian pictures. George Barret, for example, enlarged copies of views of Roman antiquities by Giovanni Battista Busiri, executing them as part of a rather outmoded decorative scheme for Joseph Leeson's Russborough, County Wicklow. Such efforts attest to the interest among Irish patrons in Italian classicism but perhaps more tellingly to artists' appropriation of Continental

motifs. Barret also made copies after Claude Lorrain, as did John Butts and later William Ashford, whose work included a pastiche of Claude's *Landscape with Narcissus and Echo* (1644; National Gallery, London).[3] Robert Hunter, for his part, looked to more recent Italian sources, basing his portrait of Peter La Touche of Bellevue (1775; National Gallery of Ireland, Dublin) on the exquisite painting of Sir Humphry Morice (1761–62; private collection) by Pompeo Batoni, who was much sought after by Irish grand tourists.[4] Not all artists endorsed Italian influence with fervor, however. Robert Carver is recorded as having claimed sarcastically to an interested Irish connoisseur that he would have to adopt a foreign-sounding sobriquet such as "Signor Somebodini" to have his works endorsed by Irish patrons.[5] However, prestige certainly accrued from personal association with Italy. London-based Nathaniel Hone never traveled there, but his younger brother Samuel arranged for him to be elected in absentia to the Accademia del Disegno in Florence.

If Continental Europe exercised a strong but mediated influence over Irish artistic sensibilities, London occupied a more immediate and integral place in the collective

William van der Hagen. *A Capriccio Landscape with Ruins by a Lake,* 1736. Private collection. Cat. 47.

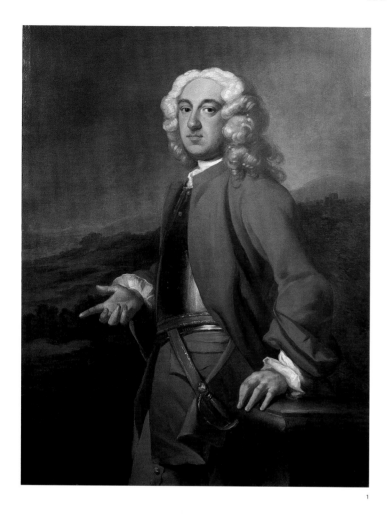

1

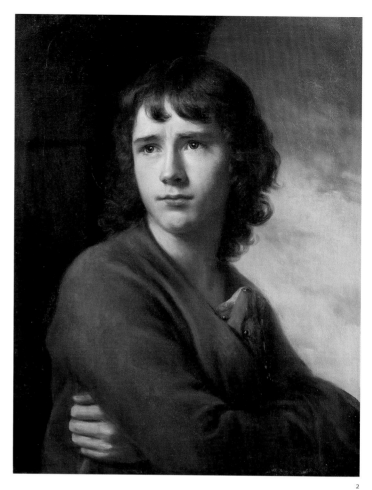

2

consciousness of both artists and patrons. While the reasons for this are many and varied—administrative, linguistic, political, social—the consequences were clear. Many prominent Irish figures had their portraits executed in London.[6] Even Hunter, for decades the foremost portrait painter in Dublin, seemed to endorse the primacy of English portraiture late in life by executing drawings after his celebrated English peers, including Francis Cotes, Thomas Gainsborough, Thomas Hudson, and Sir Joshua Reynolds, on his only recorded visit to London.

Some key Irish artists abroad transcended any lingering feelings of inadequacy or provincialism. Nathaniel Hone's monumental painting *The Conjuror* (1775; National Gallery of Ireland, Dublin), in which he lampooned what he perceived to be Reynolds's shameless reliance on Old Masters, was the most audacious

work of its generation in Britain.[7] Rejected by the Royal Academy in 1775, it served as the centerpiece for Hone's one-man show that year, the first recorded exhibition of its kind in London. The irascible artist asserted his parity in his published notes on the exhibition, expressing clearly disingenuous consternation at the censure he received from fellow academician Angelica Kauffman.[8] Hone's attack on Reynolds, his protestations notwithstanding, provoked a predictable rebuff. To one contemporary, Hone himself was the charlatan, as he had "made his establishment secure, and gave general satisfaction by offending truth and outraging taste."[9] In reality, the furor merely confirmed the artist's status among his peers. Hone received the endorsement of the Royal Academy that year in any case, as *The Spartan Boy* (FIG. 2) appeared in the exhibition. Horace Walpole admired the work, noting

Fig. 1
James Latham. *Portrait of General Thomas Bligh*, c. 1740 Private collection. Cat. 76.

Fig. 2
Nathaniel Hone. *The Spartan Boy, a Portrait of John Camillus Hone, the Artist's Son*, c. 1775. Private collection. Cat. 68.

Fig. 3
George Barret. *A Wooded River Landscape with Anglers and a Ruined Mill*, 1762. Private collection, Chicago. Cat. 10.

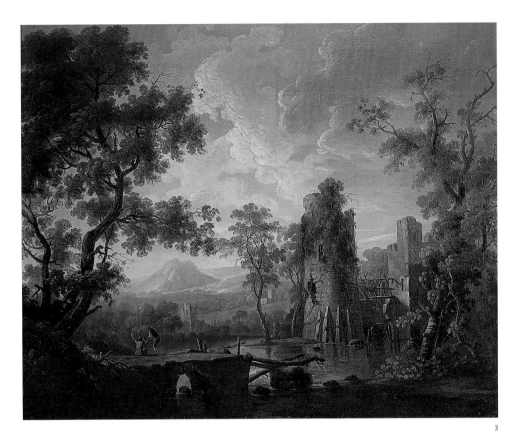

3

its fine coloring and "good expression," a judgment all the more remarkable as Walpole was among those to defend Reynolds against Hone's calumny.[10] *The Spartan Boy*, whose model was Hone's son John Camillus, was an instructive submission, as it typified not only the artist's virtuosity but also the tenderness that found expression in several portraits of his wife and children.

It has been posited that Hone's very public attack on Reynolds may have emanated "from a friction between the periphery and the center."[11] However, it seems more likely that the obloquy stemmed from Hone's conviction that he held a firm position at that very center. He had, after all, moved to London by choice, married an Englishwoman, and played a prominent role in cosmopolitan art circles. More significant still, however, was the fact that he had not arrived from some backwater, but from Dublin, the British Empire's second city. In any case, Hone already commanded an enviable reputation. He and George Barret were, in 1768,

the sole Irish artists among thirty-four founding members of the Royal Academy, an august body with royal patronage.[12]

Barret's early experience of London was rather less auspicious than Hone's. Although the artist traveled with a number of Irish landscapes with which to announce himself, including views of Powerscourt demesne (SEE P. 112, FIG. 22), he endured such hardship that he was forced to "grind colours for a livelihood."[13] That said, he received a mention in London's *Universal Magazine* as early as November 1748 and soon after was attracting widespread and positive attention.[14] Barret's career was dogged by financial difficulty despite the agency and assistance of his influential friend Edmund Burke, but his reputation remained intact. Edmund Garvey, the Irish painter, credited Barret with spurring the great Welsh landscapist Richard Wilson to adopt a more vibrant palette.[15] Wilson conceded to no such influence, quipping that Barret "complains of my not finishing my pictures

& I see in his Eggs and Spinnage."[16] While the journalist and satirist Anthony Pasquin hardly flattered Barret with false praise, he did acknowledge that the Irishman had "arrived to that height in his art, which if it cannot be denominated excellence, most assuredly approximated to that sublime point" (SEE FIG. 3).[17]

Burke was also instrumental in helping James Barry to forge a career outside Ireland, bringing him to London when he was in his early twenties and financing his sojourn in Italy between 1765 and 1771. Barry's experiences in the latter and his exposure to the art of antiquity had a profound impact on his work. His figures, exemplified by those in his masterful *The Education of Achilles* (FIG. 4), are decidedly sculptural, relying for their presence on contour and outline. Moreover, the artist's interest in the antique was as much intellectual as it was visual. His trenchant belief that history painting occupied the highest station of the pictorial hierarchy inspired his outstanding, if personally ruinous, murals for the Society of Arts in London.

The Royal Academy exhibition of 1775 featured *The Spartan Boy* and also five works by Barret and two by Barry. It was also, significantly, the first of the academy's shows in which William Ashford participated. Ashford was unusual in the present company, as he had moved from England to Dublin, albeit in pursuit of a profession other than art. He is understood to have left Birmingham at age eighteen to assume a clerical role in the Ordnance Office, but he soon committed himself to painting. Having enjoyed six decades of critical success and widespread patronage, painting exemplary views throughout Ireland (SEE PP. 110–11, FIGS. 20–21), he became the first president of the Royal Hibernian Academy in 1823.

While antiquarianism, international Neoclassicism, and the draw of London had a profound impact on Ireland's art, local

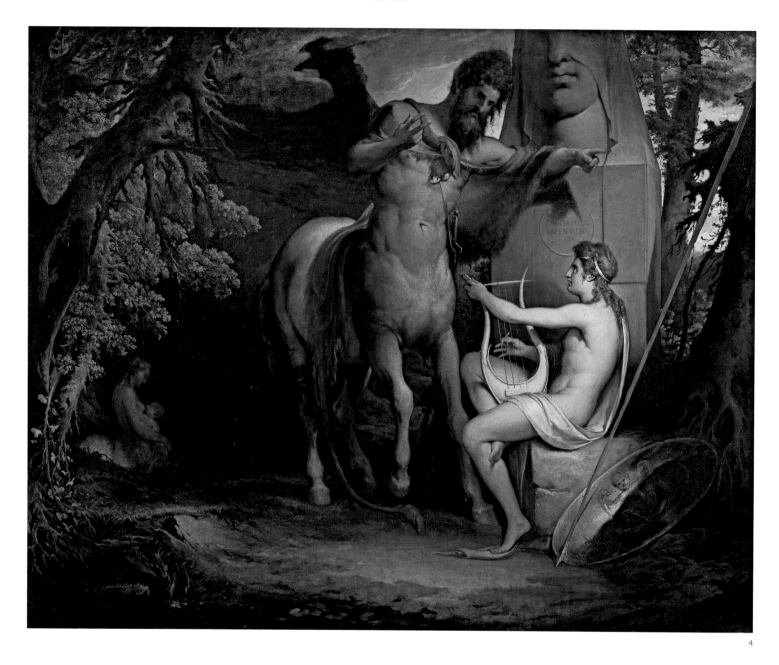

4

factors also helped to shape its creative milieu. Among the most important of these was the Dublin Society's opening of its drawing schools in 1746. The provision of formal education based on European practices provided artists with an alternative or adjunct to the apprenticeship system on which art training had been based thus far. Acting in the spirit of the Enlightenment but also displaying admirable pragmatism, the founders sought to promote the development of art, manufactures, and science in Ireland by providing formal, organized, and up-to-date training methods. Under the

stewardship of the gifted draftsman Robert West, the schools adopted a French model of instruction, stressing the paramount importance of drawing and encouraging students to hone their skills in the use of pastels in particular.[18] Until the division of the schools into specialist disciplines, the training was general; students learned principally by copying engravings and drawings, of which the society boasted a number of excellent examples.[19]

While the majority of these pupils became artisans and craftsmen who embraced drawing as an invaluable professional skill,

Fig. 4
James Barry. *The Education of Achilles*, c. 1772. Yale Center for British Art, Paul Mellon Fund. Cat. 11.

Fig. 5
Thomas Roberts. *A Frost Piece*, c. 1769. Private collection. Cat. 102.

5

many outstanding artists, encouraged by annual awards for superior work, also emerged from the ranks.[20] This corresponded to the philosophy of the schools' visionary founder, Samuel Madden, who conceived them as playing an active role in a general process of social and cultural improvement.[21] The focus on drawing in dry media evidently suited some young students.[22] Robert Healy, who enrolled in the School of Landscape and Ornament under James Mannin around 1765, developed a technique that was at once brilliantly controlled and distinctive. His unrivaled series of pastels for the Conolly family (SEE P. 149, FIG. 4) are all the more impressive when one considers that he had received specialist training in neither portraiture nor animal painting.[23] If Healy seems to have worked exclusively with chalk, the careers of his close contemporaries Hugh Douglas Hamilton and Thomas Roberts serve to invalidate the Reverend Thomas Campbell's claim of the schools that "to expect Painters from mere Workers in Chalk would be to expect Philosophers from a Grammar-School."[24] It is a testament to Hamilton's talent,

but also to the instruction he received, that he produced works in oil as accomplished as those he executed in other media. The refined judgment that characterizes Thomas Roberts's early paintings such as *A Frost Piece* (FIG. 5) must also be attributable in some measure to the regimen that prevailed at the schools, though the sophisticated rendering of "effects" was singularly his own. That relatively rare subject—a frozen, idealized landscape—is a tour de force by a man still in his early twenties.[25]

Artists, and landscapists in particular, were well served throughout the eighteenth century by a complementary branch of the arts: the theater. In stating that John Butts had been forced through circumstance to bury his "brilliant talents amid the dust and tinsel of a second-rate Dublin theatre, battling with the 'res augusta domi,' and extracting a miserable pittance from his efforts as a scene painter," the nineteenth-century writer Justin O'Driscoll grossly underestimated the contribution that the theater made to Irish art.[26] The competition between thriving playhouses such

as Smock Alley and Crow Street in Dublin stimulated artistic ambition, as they became surrogate exhibition venues that artists were invited to define as much as decorate.[27] In 1757 the *Universal Advertiser* reported that John Lewis, also an accomplished easel painter (SEE FIG. 6), erected at Smock Alley "a Noble Design for the Sounding Board, Ceiling, Lattices &c. in a new Taste."[28] Many artists would have found release from the conventions of formal portraiture in particular to be an attractive proposition. *Alexander the Great*, the inaugural performance at Crow Street in 1722, was accompanied by "lofty scenes entirely new and painted by Mr Vander Hagen, lately arriv'd from London."[29] William van der Hagen was born in the Low Countries but traveled in his youth to England before making a propitious move to Dublin.[30] He pioneered in Ireland the development of ideal landscape painting, and his elaborate *capricci* (SEE P. 138) anticipated the less artificial, more sophisticated and "Irish" landscapes of George Barret and Thomas Roberts.[31]

Dublin's theaters sat cheek by jowl with the residential areas most favored by the artistic community. James Coy, Robert Healy, Thomas Roberts, and Henry Tresham, for example, all lived at some time at the Horseshoe and Magpye tavern at 2 Dame Street, whose proprietor was the wife of the drawing master and landscapist George Mullins. Such social hubs, frequented by the theatrical and artistic fraternity, were surely hives of creative activity. The gifted pastelist Charles Forrest (SEE P. 150, FIG. 7) and the miniaturist Gustavus Hamilton lived next door at 1 Dame Street, while William Ashford exhibited from the Indian Queen tavern on the same street, then from the Ordnance Office in Dublin Castle, and later at nearby 27 College Green. Thomas Ivory, himself a master at the Dublin Society Schools, also lived on Dame Street in the 1760s, while many other artists and artisans resided on adjacent streets.[32]

Fig. 6
John Lewis. *A Landscape with the Story
of Cimon and Iphigenia*, 1758. Private
collection. Cat. 79.

6

Also situated in this emergent artistic quarter at the heart of the city were the premises of the Dublin Society Schools at Shaw's Court, Temple Bar. The Society of Artists in Ireland would also situate itself in the vicinity upon its timely foundation in 1764. A more loosely organized body than its London namesake, the group provided artists with a means of displaying their work in a professional rather than educational or theatrical context. The members declined the Dublin Society's invitation to use its premises for the inaugural exhibition, preferring instead to hold the event at the rooms of Charles Napper in nearby George's Lane; eight subsequent shows were staged in a purpose-built, top-lit, octagonal exhibition room in William Street. The organization, which was dedicated to contemporary practice, allowed patrons and the public at large to compare, criticize, and assess commercially the work of practicing artists.[33]

This concentration of artistic activity and interaction was hugely significant, as it encouraged competition and collaboration, and provided an environment in which aspiring artists were visible to both peers and patrons. Personal associations were key to success, and artistic alliances echoed patterns of patronage. For example, some of George Mullins's most eminent clients, among them James Caulfeild, 1st Earl of Charlemont, in due course sought out the services of his protégé Thomas Roberts. Connections between certain artists were particularly strong. A series of relatively mundane documents from 1769 exemplifies the close-knit nature of the Dublin artistic community. Relating to a property belonging to the deceased carver Richard Cranfield, it entrusts Gustavus Hamilton and Jacob Ennis with the responsibility of extending a lease to fellow artists Jonathan Fisher and James Reily.[34] In the same year, Mullins's familial associations allowed him to introduce Roberts to Hugh Douglas Hamilton, whose wife, Mary, appears to have been a sister of Mullins's wife. Roberts actually sat for Hamilton, who was visiting from London in 1769, and the resulting pastel (National Gallery of Ireland, Dublin) is a pictorial testament to the close contacts between the Dublin and London artistic communities.[35]

The consolidation of the Dublin Society Schools, the establishment of the Society of Artists, the prominent role of artists in the theater, and the evolution of an artistic quarter in Dublin indicate that a broader, albeit limited conversation was taking place regarding the profile and encouragement of the arts. One anonymous writer, for example, keen to redress the neglect of the Society of Artists in the press, furnished the *Hibernian Magazine* with an account of the 1772 exhibition, declaring himself neither artist nor connoisseur, "but barely a Lover of the fine arts."[36] Just months later, the *Public Monitor* published exchanges between two fictitious characters regarding prominent figures in the arts. The tone is satirical, and the comments range from the elegiac to the defamatory, but the texts testify to the fact that Irish artists were becoming figures of note. That many decided to move abroad suggests the pressure to succeed under which they labored, but paradoxically, also expedited the development of a genuine artistic scene in Ireland. The exodus of some key practitioners and the reputations they gleaned abroad

was itself a catalyst for greater ambition back home. It is inconceivable that young artists in Ireland were not conscious of the accomplishments of their older compatriots in London and beyond. The formalization of education and exhibition practice in Dublin provided them with practical, quantifiable means of emulating their predecessors. Furthermore, clear ties of friendship and industry bound those artists working abroad and those who remained in Ireland.

NOTES

1 According to John T. Gilbert, George Barret left Dublin for London in 1762 or 1763, bemoaning the lack of encouragement of the arts in his native country; J. Gilbert 1861, vol. 3, p. 318. Justin O'Driscoll expressed dismay that his fellow Corkonians James Barry and John Butts had not met with more generous fortune in their native city; O'Driscoll 1871, p. 9.

2 Among those to spend significant periods there were Solomon Delane, James Forrester, Hugh Douglas Hamilton, Thomas Hickey, and John Trotter. Hickey remained in Italy for four or five years, Hamilton for nine. The latter was unusual in having already turned forty by the time he traveled there. Several artists, acting in a personal capacity or as agents, purchased paintings as well as producing their own there.

3 For Butts, see Strickland 1913, vol. 1, p. 143. None of these artists traveled to Italy.

4 For the portrait of La Touche, see Figgis and Rooney 2001, vol. 1, pp. 248–50.

5 It seems possible that Carver was referring explicitly here to Gabriele Ricciardelli, a Neopolitan painter employed in Dublin from the 1750s before moving to London, but his comment invites broader interpretation; J. Gilbert 1861, vol. 3, p. 347. Carver's status in London was acknowledged publicly in 1778, when he was appointed president of the Incorporated Society of Artists.

6 These sitters included among the second Earl of Clanbrassil, who sat for George Stubbs in 1765, and Philip Tisdall, painted by Angelica Kauffman in the early 1770s. All of Sir Joshua Reynolds's Irish sitters sat for him in England.

7 For *The Conjuror*, see Figgis and Rooney 2001, pp. 226–31.

8 A similar self-regard is evident in Hone's newspaper advertisement, in which he stated that while admission to his exhibition was one shilling, "catalogues, with Mr Hone's Apology to the public, [were available] gratis." John T. Smith 1828, p. 143.

9 Pasquin 1796, p. 9.

10 Algernon Graves, author of *Royal Academy Exhibitors 1776–1904* (1906, Henry Graves and Company), had access to a set of Royal Academy catalogues annotated by Horace Walpole, which belonged to the Earl of Rosebery. Walpole appealed to the academy's esteemed president never to succumb to "the taunting jest, the idle sneer; —nor heed the Conjuror's wand!" March 7, 1785, "Consolitory Stanzas. Addressed to Sir Joshua Reynolds, upon seeing Hone's celebrated Picture of the Conjuror," *Anecdotes of Painting in England*, Hilles and Daghlian 1937, vol. 5, p. 68.

11 F. Cullen 1997, p. 24.

12 The founding membership was, as one might expect, dominated by English-born artists. Alongside them were an American, a Frenchman, a Swede, a Welshman, two Germans, two Swiss, and four Italians.

13 Pasquin 1796, p. 36. This was not unusual. The hapless John Butts was "compelled to paint signs and coach panels to procure food and raiment for himself and a numerous family"; Pasquin 1796, p. 10. Thomas Roberts, meanwhile, earned "his pocket money by painting the black eyes of those persons who had been fighting and bruising each other in his master's tap-room on the preceding evening"; Pasquin 1796, p. 8.

14 *Universal Magazine* 3 (November 1748).

15 Farington 1979–98, vol. 6, February 14, 1804, p. 2274. Farington himself noted that he did not agree with this assessment.

16 Farington 1979–98, vol. 8, June 3, 1807, p. 3056.

17 Pasquin 1796, p. 36. Barret's standing was enhanced further by his collaboration with British painters of note, among them Reinagle, Romney, Stubbs, and Zoffany.

18 Robert West (d. 1770) had trained in France. None of his drawings survives. In general see Turpin 1990.

19 The School of Figure Drawing was established in 1756, Architectural Drawing in 1764 and, finally, Modelling in 1811. The Dublin Society still holds drawings by artists such as Watteau and Marco Ricci.

20 These included George Barret, Hugh Douglas Hamilton, Robert Healy, Thomas Hickey, and George Mullins.

21 He believed that the schools should aim to "employ and enrich our People" through the promotion of "those politer arts" and attendant premiums. Madden 1738, p. 186.

22 It was not until the establishment of the Royal Hibernian Academy in 1823 that organized teaching in the use of oils was made available to Irish students.

23 His heavily stylized, attenuated horses, Classical in character but also lithe and animated, evidently appealed to those well placed to judge. A contemporary observed that Healy drew horses "so admirably that he got plenty of employment from those who had favourite hunters, racers or ladies' palfreys." O'Keeffe 1826, vol. 1, p. 28. A palfrey is a horse for everyday riding.

24 T. Campbell 1778.

25 The painting was one of six (including two other winter scenes) that Roberts exhibited at the Society of Artists in Dublin in 1769.

26 O'Driscoll 1871, p. 9.

27 Just as the opening of the Aungier Street Theatre in 1732 had prompted the rebuilding of the Theatre Royal in Smock Alley, so "the erection of [Spranger] Barry's new theatre in Crow-street prompted considerable renovation to the older house"; Stockwell 1988, p. 118. The Aungier Street Theatre did not enjoy the success of its competitors and was closed by 1750.

28 *Universal Advertiser*, August 20, 1757.

29 *Harding's Impartial Newsletter*, September 29, 1722.

30 Van der Hagen is also associated with Waterford, where his works included the altarpiece for Saint Patrick's Church and a singularly important view of the city quays commissioned by the city government; he was also responsible for perhaps the earliest known view of Cork Harbor, painted in 1738.

31 Van der Hagen's last recorded work is a view of Powerscourt Waterfall, the celebrated Wicklow landmark that would become the most significant motif in George Barret's Irish work.

32 Castle Street, Fishamble Street, Grafton Street, Lazar's Hill, Parliament Street, and Winetavern Street all recur in the catalogues of the Society of Artists.

33 Exhibiting in Dublin did not, of course, compromise an artist's capacity or inclination to show work in London as before, and many individuals continued to do so.

34 Documents 276-8-175814 (April 3–4, 1769) and 278-93-17701 (May 30, 1769), Registry of Deeds, Dublin.

35 For the pastel, see Laffan and Rooney 2009, p. 14. To the best of our knowledge, Roberts himself left Ireland just three times: once to undertake a commission for the London townhouse of Sir Watkin Williams Wynn, and later to seek, in vain, amelioration of his health in Bath and Lisbon.

36 Anon., "Exhib in William Street," *Hibernian Magazine or Compendium of Entertaining Knowledge* 2 (May 1772), pp. 229–30.

A Particular Passion for Pastel

SUZANNE FOLDS MCCULLAGH

IT IS ONE OF THE CURIOSITIES of Irish art history that while drawing played a central role in art education, the chief contribution of eighteenth-century Irish artists can be found not in traditional preparatory studies but in independent, finished, specialized works in charcoal and pastel. Their cultivation of these media was quite exceptional within European art and closely related to their taste for another unusual medium on paper, the mezzotint (see Martha Tedeschi's essay in this catalogue). Both media offered a heightened sense of materiality—pastel with immediacy, mezzotint with laborious diligence.

The highest achievements in this arena can be demonstrated by the works of the three principal pastel portrait artists gathered here. The story begins with the prophetic work of Henrietta de Beaulieu Dering Johnston, who took the art of pastel portraiture to the New World at the beginning of the century. It takes a unique, specifically Irish turn in the hands

of the short-lived graphic genius Robert Healy and finds its greatest proponent and legacy in the long and prolific career of Hugh Douglas Hamilton.

In the eighteenth century, one of the chief attributes of pastel was its ability to create the illusion of human flesh, powdered wigs, silk dresses, and velvet coats. Not only does it impart a sense of spontaneity, but it also entailed a swift and tolerable assignment for the sitter. An artist could map out the figure with charcoal, then quickly turn to vivid color pencils and pastels, which had become available by the middle of the century. Working on a relatively small scale was an innovation of the Irish school, which made the production time even more contained and the work itself easier to glaze and carry about. Very quickly, small pastel or chalk portraits became ubiquitous, much as family photographs are today.

The history of the pastel medium is primarily allied with portraiture, beginning with Leonardo da Vinci's pastel-heightened image of Isabella d'Este (1499; Musée du Louvre, Paris), purportedly inspired by French artists at the court of Milan. The pinnacle of eighteenth-century European pastel portraiture was achieved by French artists such as

Maurice Quentin de La Tour, who produced large, impressive tours de force. Of legendary inspiration to French artists and well known across Europe, the Venetian Rosalba Carriera is credited with bringing the art of pastel to Paris in 1720, but she also had several Irish patrons, including the Leeson family of Russborough, County Wicklow.[1]

A generation earlier than either of these, however, another woman artist working in Dublin, London, and the New World established the fashion for small-scale pastel portraiture that became the hallmark of the Irish eighteenth century. Henrietta de Beaulieu was a Huguenot refugee in Dublin who married into the prominent Perceval family in 1694. She lost her husband in 1703 and her daughter Helena the following year. Between 1703 and 1705, when she married again, the artist made pastel portraits of the Percevals. Her second husband, Gideon Johnston, became a missionary to colonial America. They left Ireland in 1708, settling in Charleston, South Carolina, where she became the first recorded professional woman artist in colonial North America. She was also the first American to work in her medium, as crayon and chalk drawings were not widespread outside of France, except in

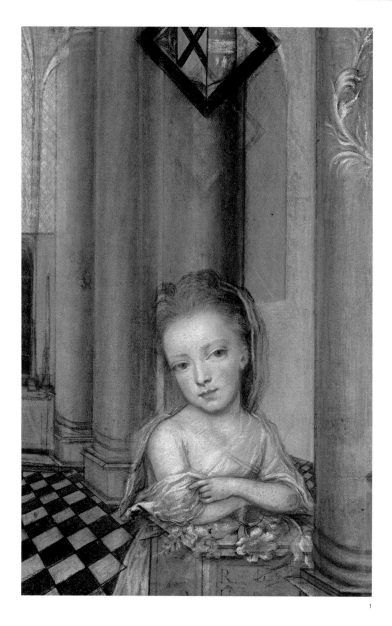

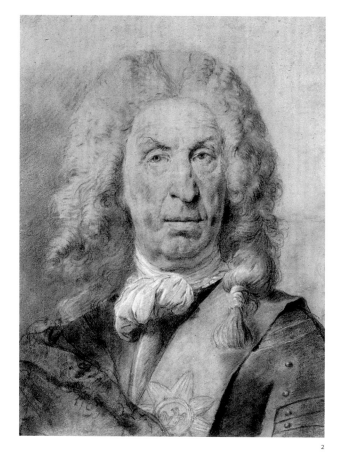

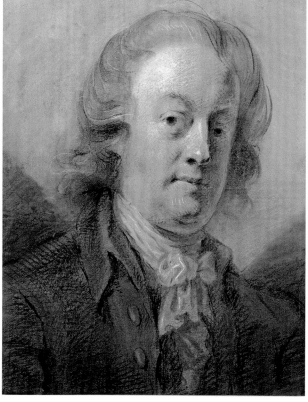

Fig. 1
Henrietta de Beaulieu Dering Johnston. *Helena Dering*, c. 1704. John and Judith Herdeg. Cat. 72.

Fig. 2
Giovanni Battista Piazzetta (Italian, 1682–1754). *Portrait of Marshal von der Schulenburg*, c. 1735. Black chalk and charcoal, heightened with white chalk, on blue-gray laid paper, discolored to cream, laid down on wood pulp board; 50.6 × 38.5 cm (19 ¹⁵⁄₁₆ × 15 ¹³⁄₁₆ in.). The Art Institute of Chicago, restricted gift of the Joseph and Helen Regenstein Foundation, 1971.325.

Fig. 3
Francis Robert West (Irish, c. 1749–1809). *Portrait of a Gentleman*, c. 1770. Pastel on paper; 45.7 × 35.6 cm (18 × 14 in.). Private collection.

Fig. 4
Robert Healy. *Tom Conolly of Castletown Hunting with His Friends*, 1769. Yale Center for British Art, Paul Mellon Collection. Cat. 56.

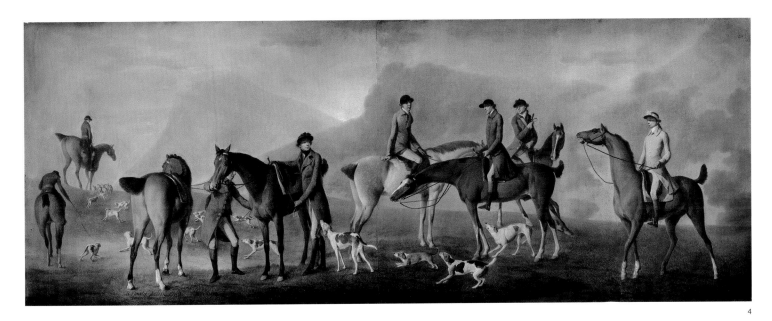

4

Ireland. Although the couple found it difficult to support themselves in their mission, there were colonists who aspired to the aristocratic lifestyle they had left behind, and Johnston was able to supplement the family income by making small portraits in chalk and pencil. Materials, however, proved difficult to find, which may account for the somewhat spare technique of some of her American portraits.[2] Only about fifty portraits by Johnston are known today, all roughly the same size. The artist's haunting portrait of her dead daughter (FIG. 1), set in a church interior with a funeral hatchment bearing her parents' initials, is more elaborate than most of her adult portraits.

If Johnston's work was too early to have been influenced by that of Carriera, a decided Venetian inspiration can be discerned in the next generation of Irish artists, notably in the prints and pastels of Thomas Frye, whose large head studies, both drawings and mezzotints (SEE P. 156, FIG. 5 AND PP. 216–17, FIG. 4), bear a clear affinity to those of Giovanni Battista Piazzetta, a Venetian master much patronized by grand tourists (SEE FIG. 2). Piazzetta's influence is evident in the large charcoal drawings by Francis Robert

West (SEE FIG. 3), son of Dublin's principal art teacher at midcentury.

With the establishment of the Dublin Society Drawing Schools in the 1740s, the primacy of draftsmanship in Irish artistic education became official. In general, the approach followed the French method, in which students progressed from copying prints and drawings to studying from plaster casts or sculpture, and finally to rendering the human form from life. This training was the basis for all the arts, although the school did not teach anything but drawing.[3] The Dublin Society's emphasis on draftsmanship produced a unique talent in Robert Healy. The son of a successful architect and decorator, Healy developed a distinctive drawing style, working primarily in grisaille and undoubtedly influenced by Frye's contemporary monochrome portraits.[4] At most twenty-five works are currently known by the short-lived artist, the most important being a series of nine hunting, shooting, and skating scenes commissioned by Tom Conolly in 1768/69 for the estate he inherited at Castletown. Built in the 1720s by the wealthy Whig politician William Conolly, the Palladian mansion was finished by his great-nephew Tom and his wife, Louisa

Lennox, and became renowned for informal hospitality. His patron's love of equestrian pursuits is the subject of Healy's masterpiece, *Tom Conolly of Castletown Hunting with His Friends* (FIG. 4). In this striking composition, which extends across two sheets of paper, Conolly is third from the right. Not only was Healy known for the subtle blend of monochrome and color seen here, but also for brooding charcoal portraits such as *Miss Cunningham Holding Her King Charles Spaniel* (P. 146).

Hugh Douglas Hamilton, the son of a wig maker, also studied at the Dublin Society Drawing Schools under Robert West, taking first prize in 1755 and moving in 1764 to London. Hamilton specialized in small oval pastel portraits that he sold for nine guineas. Louisa Lennox Conolly's older sister, Emily, had married James FitzGerald, later 1st Duke of Leinster, in 1747, and lived at Carton, the neighboring estate to Castletown. The two families were Hamilton's first and greatest patrons. Louisa was renowned for her Pastel Room on the first floor of Castletown, where she displayed at least ten oval portraits by Hamilton, while the Carton inventory of 1885 records as many as twenty-eight oval portraits in "crayons" hanging in the duke's

Fig. 5
Hugh Douglas Hamilton. *Charles Cornwallis, 1st Marquess Cornwallis*, 1772. Private collection. Cat. 51.

Fig. 6
Hugh Douglas Hamilton. *William Robert FitzGerald, 2nd Duke of Leinster*, c. 1782. Private collection. Cat. 53.

Fig. 7
Charles Forrest. *Portrait of Surgeon-General [Alexander?] Cunningham, Seated by a Window*, c. 1770. Private collection. Cat. 42.

Fig. 8
Alexander Pope. *Self-Portrait*, 1791. Private collection. Cat. 100.

8

grisaille technique reliant on charcoal. Pope's *Self-Portrait* (FIG. 8) from the last decade of the century is set against a dark, cloudy sky and takes Hamilton's inspiration to the brink of the Romantic era. Pope's success was centered on London, where he exhibited sixty-seven works at the Royal Academy between 1785 and 1821. Like Forrest, he painted the principal actors and actresses of the day. An actor himself, Pope was handsome, had a good voice, dressed well, lived luxuriously, and possessed exquisite taste in wine and food. The elegance of this work and its artist-subject suggest the wider ways in which the art of pastel reflected the highest attainment of eighteenth-century Ireland's artists and the rich cultural life of its many personalities.

study, intimate works that testified to personal attachments between family and friends.[5] The basic form of Hamilton's pastels can be seen in the portraits *Charles Cornwallis, 1st Marquess Cornwallis* (FIG. 5) and *Jonathan Fisher* (P. 60, FIG. 31). They were often rather slight in execution, reliant on graphite shading heightened with red and black chalks or pastel, and were known for highly expressive eyes.[6] In all, there are 224 Hamilton portraits in which the sitter is known by name.[7] The artist produced most of these before he went to Italy from 1779 to 1792, at which point he took up oil as a medium and history painting as a goal. His mature work can be appreciated in *William Robert FitzGerald, 2nd Duke of Leinster* (FIG. 6), which depicts the eldest surviving son of James FitzGerald and Emily Lennox. In its larger-than-usual scale and outdoor setting, the piece anticipates Hamilton's evolution into full-length portraiture in Italy.

Hamilton's influence can be seen in the works of Charles Forrest and Alexander Pope. Forrest's portrait of Surgeon General Cunningham (FIG. 7) reflects a mixture of Hamilton's style and Healy's. Forrest was best known for his pastels of actors in their theatrical roles, often depicted full-length in a

NOTES

1 Drumm 2003.

2 Her husband wrote back to his London sponsor, the Society for the Propagation of the Gospel, "My wife who greatly helped me by drawing pictures has long ago made an end of her materials." "A small present of Crayons" was reportedly on its way from the society to Charleston in early 1711. See Rauschenburg 1991, p. 11; see also Herdeg 2003.

3 In general see Turpin 1990.

4 See Wynne 1976, pp. 412–13, 415. Healy was especially known for his talent in representing horses, but few examples, aside from this exquisite work, survive.

5 See Mayes 2011, pp. 128–42. The price of a pastel could be as little as six guineas, compared to fifty guineas for a head-size portrait in oil. See Kenny 2008.

6 Noted by Thomas James Mulvany, "Hugh Douglas Hamilton," *Dublin Monthly Magazine* (January–June 1842), p. 68.

7 Kenny 2008, p. 17.

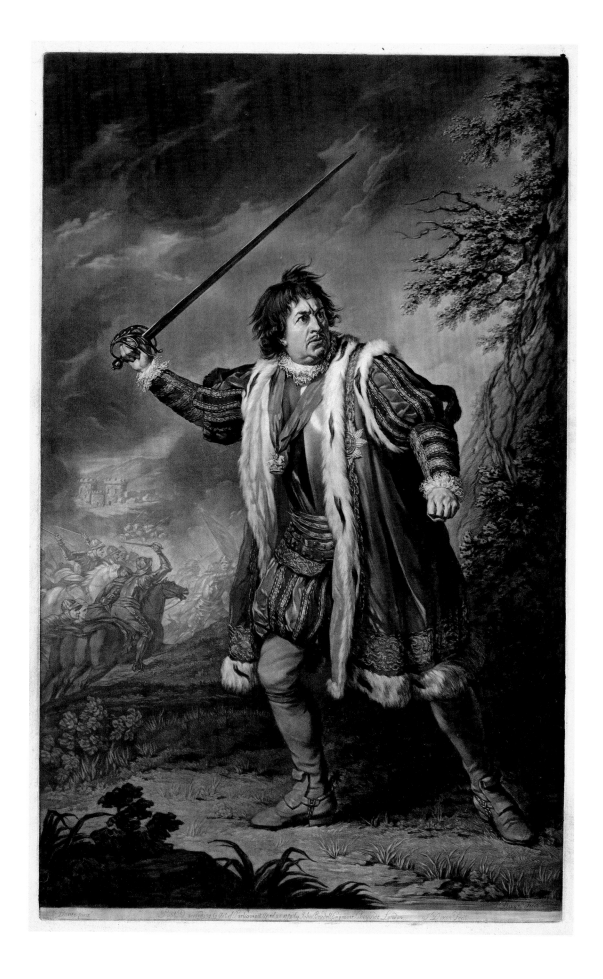

Brandt pinx. Publish'd according to Act of Parliament April 25 1775 by John Boydell Engraver Cheapside London Dixon fecit

Out from Darkness: The Irish Mezzotint Comes of Age

MARTHA TEDESCHI

PRACTICED BRILLIANTLY, as it was by a group of Irish engravers of the Georgian age, the art of mezzotint is capable of evoking almost indescribable sensations. In a fine early impression, the viewer can experience viscerally the flicker of candlelight, the sheen of satin, the translucency of fine lace, the soft cheek of a beautiful lady, or the haunted wind of a nocturnal forest. In the right hands, mezzotint proved to be an art perfectly suited to the evocation of the poetic and the theatrical, the sublime and the beautiful, the dark and the passionate. Between 1750 and 1775, the right hands turned out to be Irish hands—those of John Brooks, John Dixon, Edward Fisher, Thomas Frye, James McArdell, James Watson, and a few others who came to be known collectively as the Dublin Group.[1]

Mezzotint is a form of intaglio printmaking in which an artist employs a copper plate and works it over with a fine-toothed rocker until the entire surface has been roughened. When inked, a plate grounded in this way will print pure black. The mezzotint engraver creates the design by burnishing down areas of the plate to create highlights and intermediate tones. The most polished spots hold the least ink and thus will print lightest. As one early writer commented, "In a drawing we shadow ye darks, in a plate we heighten the lights."[2] Mezzotint engravers quite literally pull their pictures out from darkness. Though the delicate surfaces of the plates wear down very quickly during the printing process, early impressions can have a surface so sensuous and velvety that it invites touching. The possibility of such rich, tactile effects, coupled with the almost infinite range of tones that could be achieved by a skilled engraver, made mezzotint an ideal medium for the translation of oil paintings.

Invented in rudimentary form in Germany in the mid-seventeenth century, the technique soon flourished in Holland. In England, Prince Rupert, Count Palatine—an early amateur member of the Royal Society—developed the rocking tool that became essential to the medium.[3] When Dutch printmakers, including Abraham Blooteling, began to arrive in London in the 1670s, a market for mezzotints took root. Sir Peter Lely was one of the first prominent painters to take an interest in their potential for reproducing his paintings. From this time, it was common for painters to become closely associated with a trusted mezzotint engraver, as was the case with Sir Godfrey Kneller and John Smith at the end of the century.

While line engraving continued to dominate on the Continent, mezzotint practice become so entrenched in Britain in the early eighteenth century that it was dubbed *la manière anglaise*. The preferred means for reproducing portraits, mezzotints became ubiquitous, and high demand encouraged an industry that churned out mediocre plates for domestic and European markets.[4] As quality suffered, so did England's international reputation, and by midcentury the decline was being remarked upon by writers on the arts.[5]

At this seemingly inauspicious moment, a number of Irish engravers left Dublin to seek their careers in London and within a short span of years had elevated the mezzotint to new artistic and technical heights. The beginning of the revival can be traced to the visit John Brooks made to London in 1740, when he

John Dixon, after Nathaniel Dance. *Mr. Garrick in "Richard the Third,"* published April 28, 1772. The Art Institute of Chicago, the John H. Wrenn Memorial Endowment and the Stanley Field funds, 2012.378. Cat. 33.

1

2

learned the mezzotint technique. Upon his return to Dublin, he applied the medium to the translation of Irish portraits such as James Latham's *Dr. George Berkeley, Bishop of Cloyne* (FIG. 1). Engaging several students, including the gifted James McArdell, Brooks embarked on an ambitious print publishing scheme. In 1746, after it had failed to thrive, he left Ireland and established himself on the Strand in London, taking McArdell and other pupils with him. By 1750 McArdell, too, was working independently and, as David Alexander has posited, this date marks the true ascendency of the Dublin Group of engravers.[6]

Why mezzotint quite suddenly achieved such distinction in the hands of Irish engravers is not entirely clear, but the phenomenon is certainly connected to matters of both practical training and theory. In the Dublin Society Drawing Schools, founded in the 1740s to nurture Irish talent, students were instructed in grisaille pastel. This taught them to render the nuanced tones between black and white, approximating color with a rich palette of grays. The practice is exemplified in works such as Robert Healy's *Miss Cunningham Holding Her King Charles Spaniel* (P. 146); Healy's pastels were, in fact, specifically compared by his contemporary Anthony Pasquin to "fine proof prints of the most capital mezzotint engravings."[7] Indeed, there is a close affinity between the two media, as

Fig. 1
John Brooks, after James Latham.
Dr. George Berkeley, Bishop of Cloyne,
1740/56. Private collection. Cat. 19.

Fig. 2
Edward Fisher, after Sir Joshua
Reynolds. *Lady Sarah Bunbury*, 1766.
The Art Institute of Chicago, Sara R.
Shorey Endowment, 1998.78. Cat. 40.

Fig. 3
Print room at Castletown.

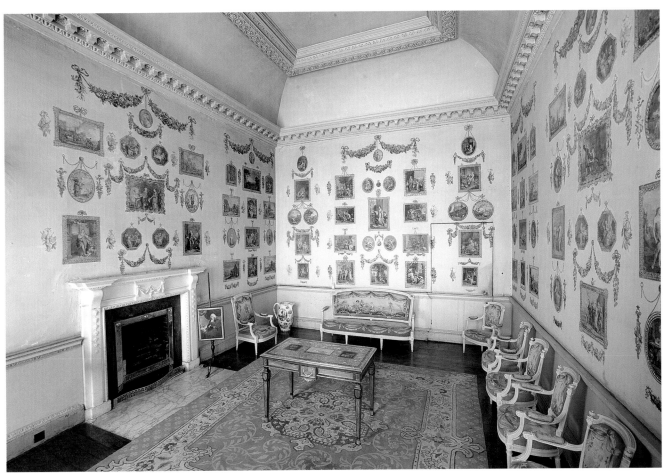

3

many engravers employed black and white chalks to mark up their compositions directly on the mezzotint plate. Healy and his contemporaries were inspired by the Irish philosopher and statesman Edmund Burke, who penned his theories of a mysterious sublime "wrapped up in shades of its own incomprehensible darkness" when he was still a teenager.[8] By the late 1760s, Burke's circle in England included Sir Joshua Reynolds and David Garrick, both figures well known in the engravers' milieu. His ideas found ready parallels in the aesthetic possibilities of pastel and mezzotint. Practitioners of the latter now understood that they could bring emotion, mood, and meaning to their translations of painting.

McArdell was famed for his virtuosity in rendering painterly effects and fabrics, and for his images of beautiful society women such as *Emily, Countess of Kildare* (CAT. 88), a mezzotint after Reynolds. His career benefited tremendously from the improved market for contemporary portraiture in this period. Reynolds, who established his studio in 1753, quickly recognized McArdell's talent and the advertising potential of his mezzotints. As a consequence, McArdell began to work on larger plates that were more suitable for full-length portraits. As Carol Wax and David Alexander have documented, the price of mezzotints began to increase along with the scale and technical complexity of the plates.[9] By the 1760s, regular impressions from larger plates were selling for half a guinea, while early proofs were even more expensive.[10]

McArdell's success attracted more Irish engravers to London's expanding international print market.[11] Two of considerable promise arrived from Dublin in about 1756 and 1760, respectively, and were employed at first by McArdell. These men, Edward Fisher and James Watson, soon distinguished themselves in the exhibitions of the Society of Artists, a precursor to the Royal Academy. McArdell and his Irish associates maintained their connections with Dublin print sellers, and their works continued to be sought after by aristocratic Irish patrons, who displayed them in black-and-gold frames or used them to embellish their portfolios and print rooms; popular in the Georgian period, the latter featured pasted wall decorations that helped to stimulate the enormous expansion of England's print trade.[12] Fisher's mezzotint *Lady Sarah Bunbury* (FIG. 2), based on Reynolds's grand portrait (1763/65; Art Institute of Chicago), is a case in point: this portrait of Lady Louisa Conolly's sister became the centerpiece of one wall in her print room at Castletown (SEE FIG. 3). Completed in 1773 after a decade of

4

5

assiduous collecting, it is today one of only three surviving print rooms of the period and the only one in Ireland.[13]

The career with the most lasting impact was that of Thomas Frye. Born near Dublin in 1710, Frye originally traveled to England as a painter in the 1730s. He produced a few mezzotints between 1737 and 1741 but ultimately made his name as the manager of the Bow Porcelain Factory, where he helped to develop the recipe for bone china. When he retired from Bow in 1759, Frye returned to mezzotint but followed an extraordinary path. While the medium had almost always been practiced as a reproductive one, Frye began an ambitious project for a series of original life-size heads based on his own drawings (SEE PP. 216–17, FIG. 4). These were advertised in June 1760

as "drawn from Nature and as large as Life from Designs in the manner of Piazzetta of Rome."[14] The set included a wide range of types, from elderly sitters to exotic poses and subjects, including a turbaned figure and faces illuminated by candlelight. A second group of six "Fancy" heads of unnamed, fashionable women followed in 1761 and 1762. Frye engraved twenty monumental plates in the last three years of his life. His gift for marrying the rich tones of mezzotint with dramatic possibilities had enormous impact on his pupils; one of considerable talent was William Pether, who went on to engrave several of Joseph Wright of Derby's candlelight pictures. The direct lineage between Frye and Wright is nowhere more evident than in Wright's grisaille pastels such as *Self-Portrait in a Fur Cap* (FIG. 4), which

is clearly an homage to Frye's bold mezzotint heads, including the engraver's own commanding self-portrait (FIG. 5).

Frye died in 1762 and McArdell three years later, dealing a blow to Irish dominance of the mezzotint trade. Yet Reynolds continued to favor Irish engravers, including Fisher and Watson, who did much to circulate Irish subject matter through their prints. The latter engraved a total of sixty plates after the painter, including the 1770 portrait *Edmund Burke* (SEE P. 40, FIG. 1). Late in his career, he worked for publisher John Boydell and retired a prosperous man in 1780. Fisher's oeuvre included the self-portrait of Irish-born painter Nathaniel Hone (FIG. 6 AND P. 59, FIG. 29) and served the popular market for contemporary theatrical plates after Reynolds with such

Fig. 4
Joseph Wright of Derby (English, 1734–1797). *Self-Portrait in a Fur Cap*, 1765/68. Monochrome pastel (grisaille) on blue-gray laid paper; 42.5 × 29.5 cm (16 ¹¹⁄₁₆ × 11 ⁹⁄₁₆ in.). The Art Institute of Chicago, Clarence Buckingham Collection, 1990.141.

Fig. 5
Thomas Frye. *Ipse (Self-Portrait)*, 1760. Mezzotint in black on ivory laid paper; 47.7 × 35.2 cm (18 ¾ × 13 ⅞ in.) (image); 50.7 × 35.3 cm (19 ¹⁵⁄₁₆ × 13 ⅞ in.) (plate); 52.4 × 37 cm (20 ⅝ × 14 ½ in.) (sheet). The Art Institute of Chicago, the Amanda S. Johnson and Marion J. Livingston Fund, 2011.264.

Fig. 6
Edward Fisher, after Nathaniel Hone. *Nath. Hone, Pictor*, 1758/81. Private collection. Cat. 38.

Fig. 7
Edward Fisher, after Sir Joshua Reynolds. *Garrick between Tragedy and Comedy*, 1762. Yale Center for British Art, Paul Mellon Fund. Cat. 39.

6

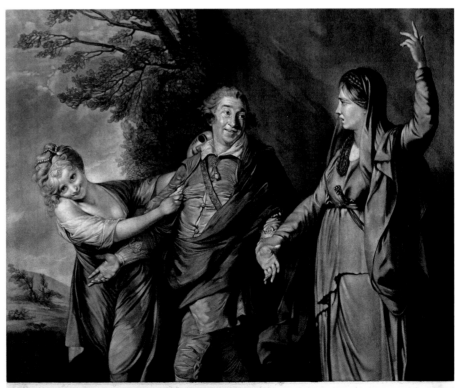

7

8

images as the monumental *Garrick between Tragedy and Comedy* (FIG. 7), a subject that graces the position above the fireplace in the Castletown print room. Interest in famous personalities remained an important underpinning of the mezzotint trade. Letters such as those exchanged between Lady Louisa Conolly and her sister document how eagerly Irish collectors awaited new mezzotints from London, counting on their friends and family to act as their agents.[15] In 1770 Oliver Goldsmith wrote to his brother, "I will shortly send my friends over the Shannon some mezzotinto prints of myself and some more of my friends here, such as Burke, Johnson, Reynolds and Coleman."[16]

In about 1765, new blood had arrived from Dublin in the form of John Dixon. Distinguished for his excellent drawing ability, developed as a student in the Dublin Society Schools, Dixon became a regular exhibitor at the Society of Arts. He developed a highly personal mezzotint technique that included the use of drypoint to create furry lines of burr that enhanced the textures and contours of clothing, seen upon close examination of *William Robert, 2nd Duke of Leinster* (FIG. 8). The atmospheric *Mr. Garrick in "Richard the Third"* (P. 152), published by John Boydell in 1772, marries a contemporary theatrical subject with Burke's notion of a dark, mad sublime; it is one of four portraits of the ever-popular Garrick that Dixon engraved. Despite his great promise, the artist faded from the scene too quickly, marrying a rich widow who required him to retire from his profession in 1775. It is that year that marks the end of Irish preeminence. Although Fisher and Watson continued to produce work until about 1780, neither exhibited publicly at the end of their careers.

Steeped in the example of the Dublin Group, who unlocked the expressive potential of mezzotint, English engravers such as Richard Earlom, Valentine Green, and John Raphael Smith came into their own. Green's

Fig. 8
John Dixon, after Sir Joshua Reynolds. *William Robert, 2nd Duke of Leinster,* 1774. Yale Center for British Art, Paul Mellon Fund. Cat. 34.

Fig. 9
Valentine Green (English, 1739–1813), after Joseph Wright of Derby (English, 1734–1797), printed by John Boydell (English, 1719–1804). *A Philosopher Shewing an Experiment on the Air Pump,* 1769. Mezzotint with traces of engraving, in black, on ivory laid paper; 44.8 × 58.5 cm (17 ⅝ × 23 in.) (image/plate); 45.7 × 59 cm (18 × 23 ¼ in.) (sheet). The Art Institute of Chicago, the Amanda S. Johnson and Marion J. Livingston Fund, 2013.1271.

9

celebrated 1769 mezzotint of Wright's *A Philosopher Shewing an Experiment on the Air Pump* (FIG. 9), a pinnacle in the history of the medium, shows how quickly the innovations of Frye and his compatriots were assimilated. Between 1750 and 1775, Irish engravers had effectively pulled their mysterious art out of darkness, burnished its artistic possibilities, and brought it to a world stage on the London and Dublin art markets.

NOTES

1 The most thorough account of the Dublin Group to date is D. Alexander 1973, published on the occasion of an exhibition of the work of Irish mezzotint engravers at Castletown. More recently, see Wax 1990, pp. 41–50, for consideration of the Irish contribution, including technical innovations, in the larger context of the English print market.

2 Edward Luttrell, "The true way of laying a ground on a copper plate for working in mezzotinto," from his 1683 manuscript treatise. Yale Center for British Art.

3 Prince Rupert's important experiments were first described in Evelyn 1662. A more thorough early account of the process is "The Manner or Way of Mezo Tinto" in Brown 1669. The first dated English mezzotint, a portrait of King Charles II by William Sherwin, was published the same year.

4 Some sense of the volume of the trade can be gained from John C. Smith 1883, a four-volume compendium.

5 D. Alexander 1973, pp. 73–74, cites Smith, who quoted French Academician Rouquet's 1755 statement that "mezzotinto engraving is very much on the decline in England." Wax 1990, p. 32 attributes this decline to the poor state of portrait painting in England in this period.

6 D. Alexander 1973, p. 75.

7 Pasquin 1970, p. 18.

8 E. Burke 1759, p. 109. See also Prior 1854, p. 18. On the importance of darkness and mystery in Burke's theories of the sublime, see Healy 2001.

9 Wax 1990, p. 42.

10 D. Alexander 1973, p. 79. The expense of large plates by well-known engravers created a demand for smaller, cheaper copies by lesser practitioners of the medium such as Charles Spooner and Richard Purcell.

11 Not all Irish engravers thrived in London. In the early 1750s, Spooner and Purcell arrived from Dublin, but neither rose to the forefront of their trade, their careers plagued by ongoing problems with drink and debt. See D. Alexander 1973, p. 77.

12 J. Fitzgerald 2005.

13 Johnstone 2011.

14 Quoted in D. Alexander 1973, p. 81; quoted in full in Hughes 1970, p. 120.

15 Excerpts from this correspondence are quoted in Johnstone 2011, pp. 68–69.

16 Quoted in Salaman 1910, p. 32, and D. Alexander 1973, p. 79.

Jewels above All Prize: Portrait Miniatures on Enamel and Ivory

PAUL CAFFREY

DURING THE EIGHTEENTH and early nineteenth centuries, Ireland was an important center of miniature painting, with over three hundred miniaturists recorded at work. This was in part due to the lessons in drawing provided by the Dublin Society Schools, which were responsible for educating at least forty-seven miniaturists.[1] Dublin, Cork, and Kilkenny were the main centers of miniature painting, but practitioners traveled to all parts of the country for commissions. Irish-born and -trained artists left to work in London and Bath, while others went to North America, where they were among the first to paint miniature portraits.[2]

Miniature painting was a technique quite separate from full-scale oil on canvas portraiture. The main materials used were watercolors on vellum or ivory and enamel; in most cases, ivory was the first choice. Miniatures were often placed in lockets or boxes; they served as essentially private images, the expressions of intimate sentiments that were usually associated with family and frequently commissioned to mark engagements and marriages. The portrait itself was only one element of a piece of jewelry such as a gold locket that held braided hair and monograms of the sitter's initials on the reverse. Women usually wore such objects on a chain or as a brooch pinned to the décolletage, emblematically close to the heart. Men typically kept them on a watch chain or on a chain around the neck that they could conceal inside their waistcoat. Miniature portraits were housed in rings and worn in bracelet settings on the wrist, as may be seen in Charles Forrest's portrait of Surgeon General Cunningham (P. 150, FIG. 7).

They were also used to decorate every type of box, including *bomboniere*, the patch boxes that held women's fashionable beauty spots, and snuffboxes. A particularly fine example of such a use is Nathaniel Hone's *Portrait of a Lady* (FIG. 1), which is set inside the lid of a tortoiseshell snuffbox.[3]

Hone and Rupert Barber, both enamelists, were among the first professional miniaturists working in Ireland. They did preliminary drawings of their sitters and then painted with metal oxides on an enamel surface over a copper or gold base. This was a very difficult technique that required that each color be fired individually in a kiln. Often the painting of flesh tones resulted in very pink highlights. Barber appears to have been particularly interested in capturing the sitter's personality and character, as may be seen in *William Thompson, a Dublin Beggar, Aged 114* (FIG. 2). A cabinet miniature such as this would have hung on a wall as part of a room's decoration. The preliminary drawing for this work is an extremely rare survival (FIG. 3).[4]

Barber was the son of the poet Mary Barber, the protégée of Jonathan Swift. He studied enameling in Bath and by 1743 was working in Dublin, where he was encouraged by Swift's friend Mary Delany, wife of Dean Patrick Delany (SEE P. 114, FIG. 24). She introduced him to many of his future patrons and commissioned him to paint portraits of her family and wide circle of acquaintances. Barber married a niece of Dean Delany, and they lived in a cottage in the garden of Delville, the Delanys' house at Glasnevin, Dublin, where he had a studio.[5]

Hone adopted the difficult watercolor-on-ivory technique during the 1750s. An early example is his portrait of the prolific playwright George Colman (FIG. 4).[6] In order to overcome the difficulties of working on ivory, Hone used

Horace Hone and followers. *Four Portraits of Lord Edward FitzGerald,* c. 1797–c. 1820. Private collection. Cat. 63.

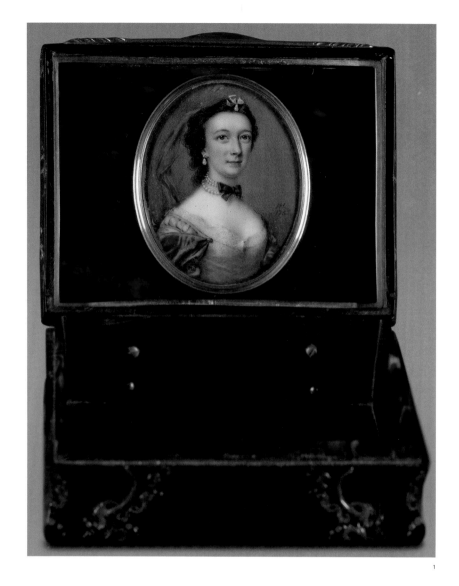

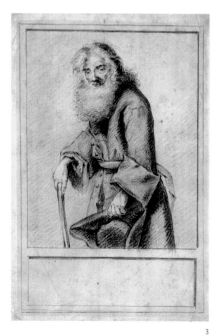

2 3

a dark background and gum-laden gouache in painting the coat; he employed dotted stipple brushstrokes in the shading of the sitter's features. The artist applied paint in tiny, linear brushstrokes of watercolor mixed with gum arabic, which helped it adhere to the ivory surface. Colman's portrait only begins to suggest the larger way in which the world of the theater functioned as an important source of commissions for miniaturists.

Hone's refined style and distinctive technique may be seen in his portrait of Sarah Sophia Banks (FIG. 5), which displays his mastery of painting on ivory. The sitter is informally posed and attired in the fashionable dress and jewelry of the 1760s, which is rendered in opaque layers of gouache. Created when Banks was twenty-four, this miniature must have been done for an admirer; never married, she was a collector of books, coins, engravings, and objects of natural history that were donated to the British Museum.[7] Hone, for his part, abandoned miniature painting and went on to work in oil, serving as a founding member of the Royal Academy.

The rare self-portrait by Hone's son, Horace (FIG. 6), is an exceptional example of his enameling.[8] He was taught miniature painting by his father and later attended the Royal Academy School, London. The younger Hone settled in Dublin in 1782 and worked almost exclusively in Ireland until 1804, when he returned to London. His principal patroness was Elizabeth, Marchioness of Buckingham, who played a significant part in promoting him as the miniaturist of the viceregal court when her husband, the first Marquess of Buckingham, was serving as lord lieutenant. Hone painted the leading figures of the day, including Lord Edward FitzGerald (SEE P. 160).[9]

Sampson Towgood Roch, who was both deaf and mute, was probably taught to paint by his friend Horace Hone. He executed his portrait of an artisan (FIG. 7) when he was living at 152 Capel Street, Dublin.[10] His notebooks

Fig. 1
Nathaniel Hone. *Portrait of a Lady*, 1750.
Yale Center for British Art, Paul Mellon
Collection. Cat. 65.

Fig. 2
Rupert Barber. *William Thompson,
a Dublin Beggar, Aged 114*, 1744. New
Orleans Museum of Art, Gift of Mrs.
Richard B. Kaufmann, 74.396. Cat. 8.

Fig. 3
Rupert Barber (Irish, 1719–after 1778).
*William Thompson, a Dublin Beggar,
Aged 114*, 1744. Charcoal on paper; 30.4 ×
21.5 cm (12 × 8 7/16 in.). National Gallery
of Ireland, Presented, Mr. H. Sinclair,
1921.

Fig. 4
Nathaniel Hone. *Portrait of George
Colman*, 1761. The Art Institute of
Chicago, Mary Louise Stevenson Fund,
1958.415. Cat. 66.

Fig. 5
Nathaniel Hone. *Portrait of Sarah
Sophia Banks*, 1768. The Art Institute
of Chicago, Mary Louise Stevenson for
addition to the Colonel Alexander F.
and Jeannie C. Stevenson Memorial
Collection, 1962.1062. Cat. 67.

Fig. 6
Horace Hone. *Self-Portrait*, 1804. The
Art Institute of Chicago, the Colonel
Alexander F. and Jeannie C. Stevenson
Memorial Collection, bequest of Mary
Louise Stevenson, 1964.433. Cat. 62.

Fig. 7
Sampson Towgood Roch. *An Artisan*,
1788. Cincinnati Art Museum, Gift of
Mr. and Mrs. Charles Fleischmann III,
2004.274. Cat. 113.

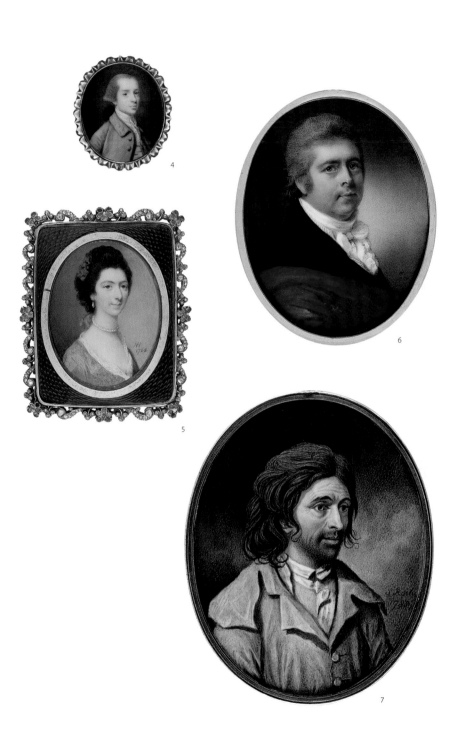

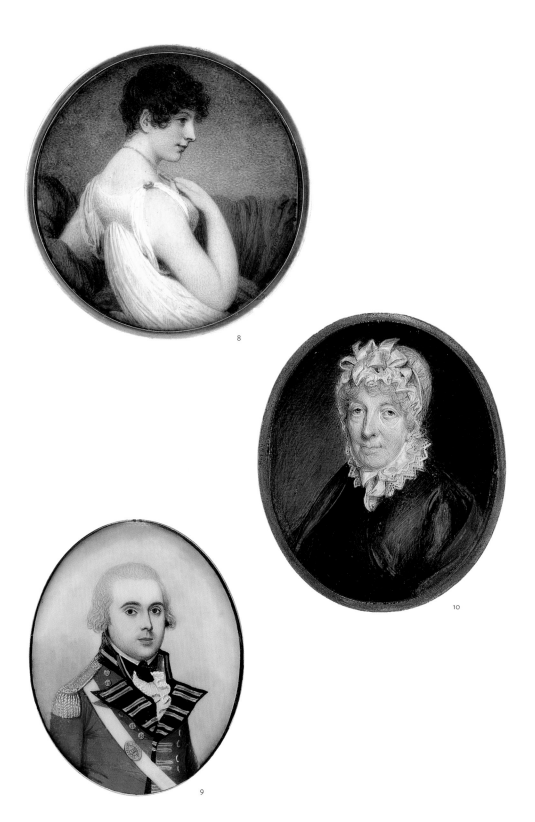

8

10

9

Fig. 8
Adam Buck. *Portrait of a Woman*, 1805.
Museum of Fine Arts Houston, The
Rienzi Collection, Bequest of Caroline
A. Ross. Cat. 20.

Fig. 9
Frederick Buck. *Portrait of Captain
John James*, c. 1800. The Art Institute
of Chicago, the Colonel Alexander F.
and Jeannie C. Stevenson Memorial
Collection, 1958.67. Cat. 22.

Fig. 10
John Comerford. *Anne Helena Trench*,
1818. Cincinnati Art Museum, Gift of
Mr. and Mrs. Charles Fleischmann
in memory of Julius Fleischmann,
1990.1875. Cat. 27.

and drawings (Ulster Museum and private collection) are full of scenes from everyday life—much of it outdoors—and are one of the most important records of pre-Famine Ireland. Along with Barber's portrait of William Thompson and Hugh Douglas Hamilton's *Cries of Dublin* (SEE P. 22, FIGS. 3–4) they are evidence of the occasional demand for images of Dublin characters and street life. This example shows the neatness of Roch's portraits and the incipient smile on the sitter's lips that was a hallmark of his work. The artist's miniatures are always delicately painted, and he paid great attention to the details of hair and costume.[11]

Adam Buck was an exceptional miniaturist by virtue of his serious interest in Classical Greek vase painting and Roman art, as may be seen in *The Artist and His Family* (P. 60, FIG. 30).[12] Buck's interest in the antique pervades works such as *Portrait of a Woman* (FIG. 8), which was painted on ivory.[13] This material was particularly appropriate for the display of Neoclassical taste, since its whiteness could replicate the effect of muslin and marble. Buck was able to achieve the desired effect by depicting his sitters in profile and employing linear brushstrokes and Neoclassical hairstyles and costumes. His younger brother Frederick was the leading miniaturist in Cork, where he had a large practice during the Napoleonic Wars, when the city was a significant military and naval center. Frederick Buck specialized in keepsake miniatures of young officers in scarlet uniforms set against an unpainted ivory background, as may be seen in his portrait of Captain John James (FIG. 9).

John Comerford was the most prolific and successful miniaturist to spend his entire career in Ireland, working mostly in Cork, Dublin, and Kilkenny (apart from visits to London and Paris).[14] Educated at the Dublin Society Schools, he came under the influence of Gilbert Stuart, who resided in the city from 1787 to 1793; he later recalled that "he owed more to [Stuart] for what he now is than to all the rest of the artists in the world."[15] Comerford was encouraged to concentrate on miniature painting by the English miniaturist George Chinnery, who gave lessons to established artists when he was in Dublin between 1795 and 1802. Like Chinnery, he painted in bold, broad brushstrokes that may be seen in his portrait of Anne Helena Trench (FIG. 10).[16] Born Anne Helena Stewart, the sitter was the wife of Michael Frederick Trench, who collaborated with architect James Gandon to design the family seat at Heywood, County Laois.[17]

The fine *Portrait of Lady Morgan* by the English miniaturist Thomas Hargreaves (P. 123, FIG. 5) captures the flamboyant Sydney Owenson, who was known as the "dictatress" of Irish artistic, literary, and musical society. A novelist, travel writer, and the first Irish art historian—she wrote a biography of Salvator Rosa—Owenson was the daughter of actor-manager Robert Owenson (originally MacOwen).[18] In 1805 she achieved national prominence with the publication of her collection of Irish music, which was one of the first to be compiled; a year later, she published her novel *The Wild Irish Girl*, which brought her both a cult following and the sobriquet "Glorvina," after the heroine of the title.

The miniature portrait was too close to photography not to suffer from its invention. Although the practice remained popular throughout the first half of the nineteenth century, the vogue for photography spread rapidly, and miniature painting reverted to the status of an amateur pursuit.

NOTES

1 For a full account of Irish miniature painting, see Caffrey 2000.

2 Thomas Dawson, Charles Cromwell Ingham, John Ramage, Walter Robertson, and Lawrence Sully were Irish-born miniaturists who had careers in the United States.

3 Noon 1979, p. 37.

4 Caffrey 2000, pp. 55–56.

5 A. Hall 1861–62, vol. 2, pp. 415, 429; vol. 3, p. 116.

6 Ingamells 2004, pp. 111–13, records this miniature at Sotheby's, February 14, 1957, lot 22. See also Ashton 1997, pp. 71–72.

7 The identification of this portrait is based on a comparable miniature portrait by Nathaniel Hone, also dated 1768, in the National Gallery of Ireland, Dublin; Caffrey 2000, pp. 60–61.

8 An earlier self-portrait, c. 1785, is in the collection of the National Gallery of Ireland, Dublin, and another, dated 1795, in the National Portrait Gallery, London; Caffrey 2000, p. 94.

9 For Hone's signed and dated (1795 and 1797) miniatures of FitzGerald, see Caffrey 2000, pp. 98–99.

10 Caffrey 1986.

11 Aronson and Wieseman 2006, pp. 269–70.

12 Jenkins 1988.

13 For a similar composition, see Caffrey 2000, p. 108.

14 Caffrey 1999.

15 The American portrait painter Chester Harding visited Comerford in Dublin in October 1824. Gilbert Stuart gave him a letter of introduction to the painter, whom Harding described as "Mr. Comerford, a protégé of Mr Stuart, who is the principal artist (a miniature painter) in Ireland." See Harding 1866, p. 135. Harding wrote to Stuart on January 6, 1825, where he recorded Comerford's debt to Stuart; the letter is transcribed in Mason 1879, p. 73, and quoted in Barratt and Miles 2004, p. 76, n. 8.

16 This work was painted in Dublin on July 5, 1818, for fifteen guineas. John Comerford, *Account Book* (1810–28), National Portrait Gallery, London. Comerford executed another version of this portrait, which is in the collection of the Office of Public Works, Kilkenny Castle.

17 Bence-Jones 1978, pp. 149–50.

18 Caffrey 2000, p. 136; Joep Leerssen, "Sydney Owenson, Lady Morgan," in McGuire and Quinn 2009, vol. 7, pp. 1024–26.

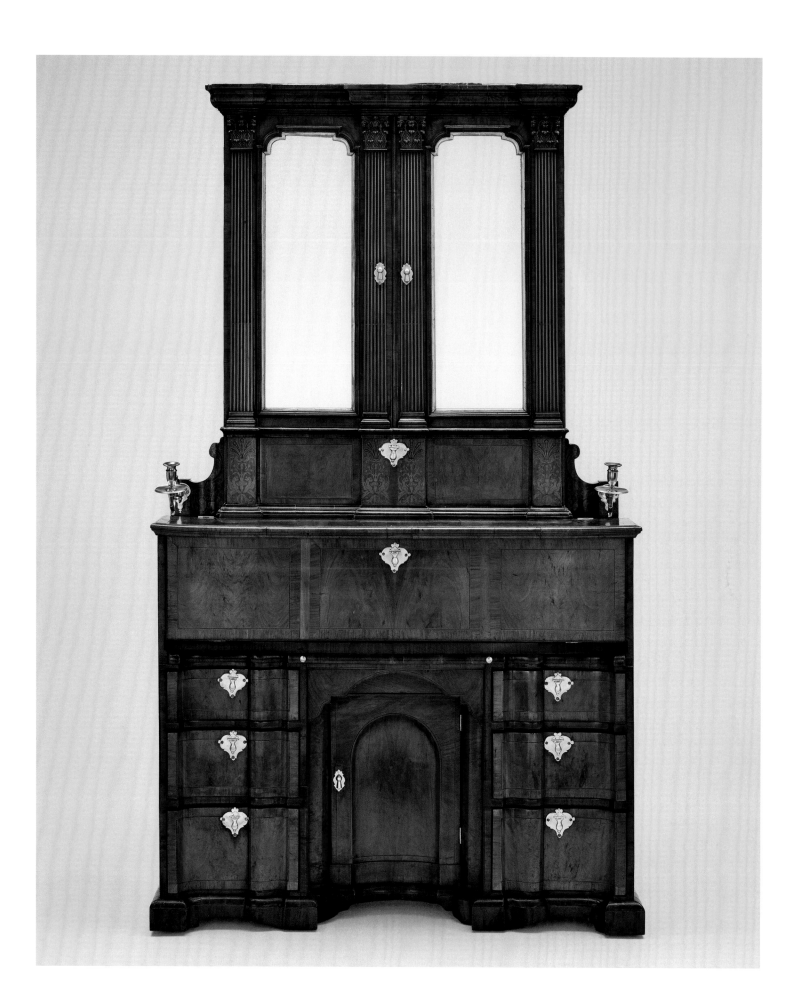

Irish Furniture

JAMES PEILL

THE HISTORY OF IRISH FURNITURE is intricately intertwined with the history of Irish woodwork, carving, and country houses. Owing to the country's turbulent history, very little survives from before the Restoration period, and we can but only imagine what furniture existed by studying contemporary inventories. However, a period of relative peace and prosperity from the late seventeenth through the early nineteenth century released a flowering of creativity in the arts. Carvers, some of Continental extraction, flourished under enlightened patrons and talented architects, as can be seen at the Royal Hospital Kilmainham (P. 66, FIG. 4), which was built in 1684 to designs by Sir William Robinson for Lord Lieutenant James Butler, 1st Duke of Ormonde. There, members of the Huguenot Tabary family carved the bravura trophies of arms in the exterior door tympana and exquisite foliage in the chapel.[1] The altar table is probably also by them, and if so is the earliest attributed piece of Irish

furniture. Other examples of high-quality woodcarving can be seen in Dublin, where the Classical style was making its mark on the burgeoning city. Saint Ann's, Saint Mary's, and Saint Michan's churches all have superior carving, as do Dr. Steevens's Hospital, Marsh's Library, and Trinity College; a set of chairs from the former is among the first documented pieces of Irish furniture.[2] Carving in country houses such as Eyrecourt, County Galway (c. 1665; SEE P. 98, FIG. 1); Beaulieu, County Louth (c. 1720); and Mount Ievers, County Clare (c. 1730); show that talented carvers were not just restricted to Dublin.

A group of marquetry furniture has been identified as Irish with the exciting discovery of a signature on a desk and bookcase now in the Art Institute of Chicago (P. 166; see also Christopher Monkhouse's coda to this catalogue).[3] The work's maker, John Kirkhoffer, was probably of Palatine origin, and his signature, together with the date 1732, helps build a framework for Irish furniture studies upon which more pieces can be placed. Other items of marquetry furniture, although not attributed to Kirkhoffer, were produced around this time, such as a walnut games table with backgammon and chess boards

(SEE FIG. 1) and marquetry chairs inlaid with a crest on their splats (SEE P. 134, FIG. 7). Often the marquetry only appears as a small piece of decoration, such as a kilted figure on the interior of a bureau.[4] It is likely that furniture makers were able to buy sheets of marquetry ready-made and apply them in the same way that they would veneer.

The second quarter of the eighteenth century saw a further blossoming of the arts in Ireland, partly due to the founding of the Dublin Society in 1731 and the movement to support native industries promoted by improvers such as Samuel Madden and Bishop George Berkeley. Perhaps the most important Irish craftsman of this period was the carver John Houghton, who had a thriving workshop in Dublin and counted among his pupils the famous English carver and designer Thomas Johnson. Houghton was responsible for the frame of Jonathan Swift's portrait at Saint Patrick's Deanery, and a superb mahogany mirror (FIG. 2) can be attributed to him. The design is composed of a tightly controlled group of Classical ornaments, including acanthus, flowers, and shells. Houghton, whom Johnson described in his autobiography as "the most eminent carver in Dublin," also worked

John Kirkhoffer. Desk and Bookcase, 1732. The Art Institute of Chicago, gift of Robert Allerton, 1957.200. Cat. 217.

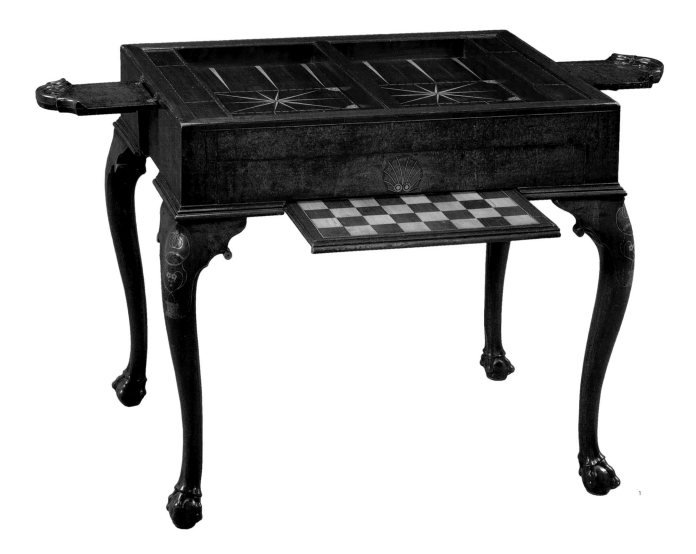

with John Kelly, the carver of Dr. Bartholomew Mosse's bed, for which an itemized bill has survived that lists such details as his family crest.[5] Documented examples of Irish furniture before 1800 are extremely rare, although the occasional use of heraldry enables a provenance to be established.

Contemporary Irish newspapers, particularly for Dublin, reveal an extensive trade in carving, furniture making, gilding, japanning, and upholding—the eighteenth-century term for upholsterers, who were responsible for the fitting up of most of the interior and were, in effect, interior decorators. Dublin was clearly a thriving center of creativity, although it is sometimes difficult to distinguish between

craftsmen of Irish origin and those of English origin who may have traded for only a short time in the city. Much of the furniture that was emanating from these workshops can be recognized for its peculiarly Irish characteristics and was made for general day-to-day use: chairs, case furniture (blanket chests, cabinets, chests of drawers, desks), mirrors, and tables (for cards, dining, games, serving food, and writing) (SEE FIG. 3). Although closely related to English furniture of the same period, Irish features include the faceted or paneled pad foot; the trifid foot, composed of tightly scrolled volutes; and the squared lion's-paw foot. Stretchers on chairs, particularly flat ones, continued to be used well into

the mid-eighteenth century, long after English chair makers had abandoned them. Gracious, vase-shaped splats between serpentine stiles, sometimes with a double top rail (SEE FIG. 4), are common on dining chairs. Irish tables often have deep aprons centered by a basket of flowers, an eagle, a lion's mask, a shell, or a shield that is flanked by flowers, foliage, and fruit drapery (SEE FIG. 5). The symbolism is Classical: the flowers for perpetual spring, the eagle for Jupiter, the lion's mask for Bacchus, and the shell badge for Venus. As a nation, the Irish have always been famous for their hospitality and love of feasting and drinking, and this is borne out by some of the furniture: card and games tables, generous serving

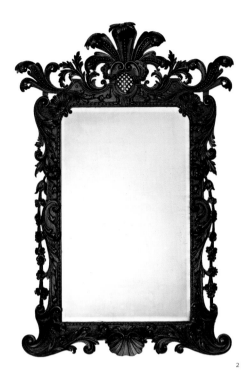

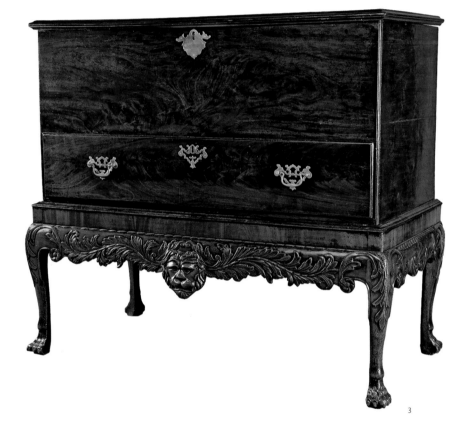

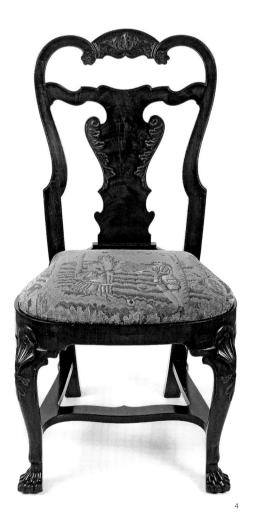

Fig. 1
Games Table, c. 1740. Private collection
by arrangement with Mallett. Cat. 232.

Fig. 2
Probably John Houghton. Pier Glass
(One of a Pair), c. 1750. L. Knife and
Son, Inc. Cat. 239.

Fig. 3
Chest on Stand, c. 1750-60.
Collection of Mr. and Mrs. Jerold D.
Krouse. Cat. 219.

Fig. 4
Side Chair, c. 1750. Filoli: Historic House
and Gardens. Cat. 225.

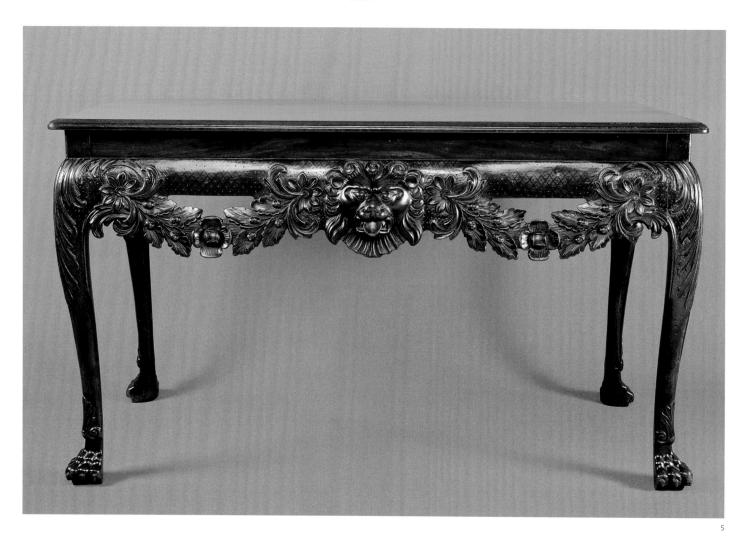

5

tables, and bottle stands. Dining rooms were often the largest room in the house, and much Irish furniture was made for them. A particular form of writing desk with a two-door cabinet above seems to have developed in Ireland in the mid-eighteenth century. This is a variation on the secretary cabinet with a central knee-hole, which is also common, such as one at Newbridge and one from Adare Manor, County Limerick, which are attributed to Christopher Hearn (SEE FIG. 6).

In comparison to English examples, the carving on Irish furniture has a certain flatness to it, and Irish mirrors are no different. Perhaps the most common motif is a basket or spray of flowers. Many Irish mirrors bear trade labels on the reverse, enabling the oeuvres of several makers to be reconstructed. The

Booker family had a thriving workshop in Dublin, and many of the mirrors with their label are distinctly architectural in form, with a pair of columns below a broken pediment and a mirrored apron (SEE FIG. 7).[6] They were clearly influenced by English pattern books such as William Jones's *The Gentlemen's or Builder's Companion* of 1739. As the eighteenth century progressed and the Neoclassical style became fashionable, the Bookers produced mirrors in the new taste, and so did other carvers and gilders such as Richard Cranfield and the Jacksons. Because Irish craftsmen were working from the same pattern books as their English contemporaries across the Irish Sea, it is often impossible to distinguish between Irish and English Neoclassical furniture unless a piece is documented or has an Irish

Fig. 5
Side Table, c. 1750–60. Collection of Mr. and Mrs. Jerold D. Krouse. Cat. 236.

Fig. 6
Possibly Christopher Hearn. Desk and Bookcase, c. 1750–60. The Collection of Richard H. Driehaus, Chicago. Cat. 216.

Fig. 7
Probably Francis and John Booker (Irish, active 1750–72). Georgian Giltwood Mirror, c. 1772. Wood and mirror glass; 205.7 × 106.7 × 10.2 cm (81 × 42 × 4 in.). The State Museum of Florida, Florida State University, Collection of The John and Mable Ringling Museum of Art, Bequest of John Ringling, 1936.

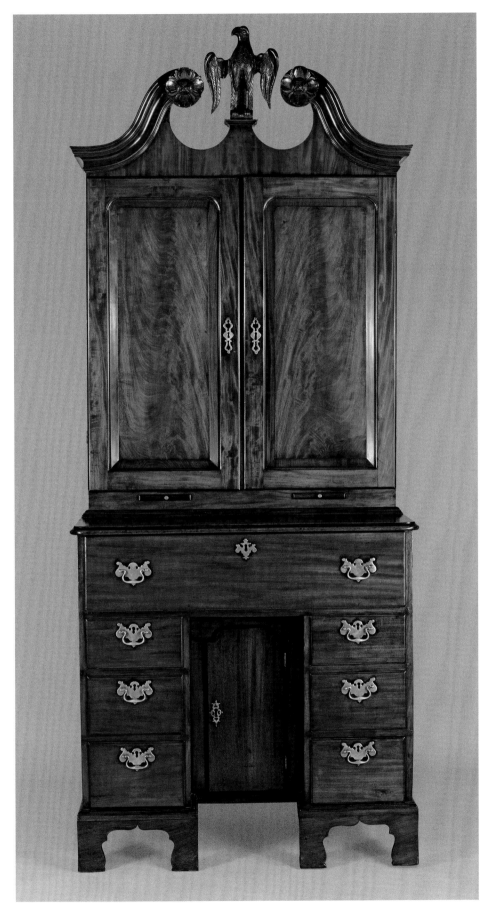

6

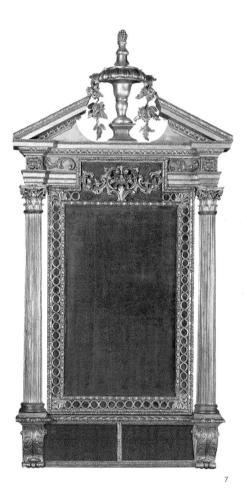

7

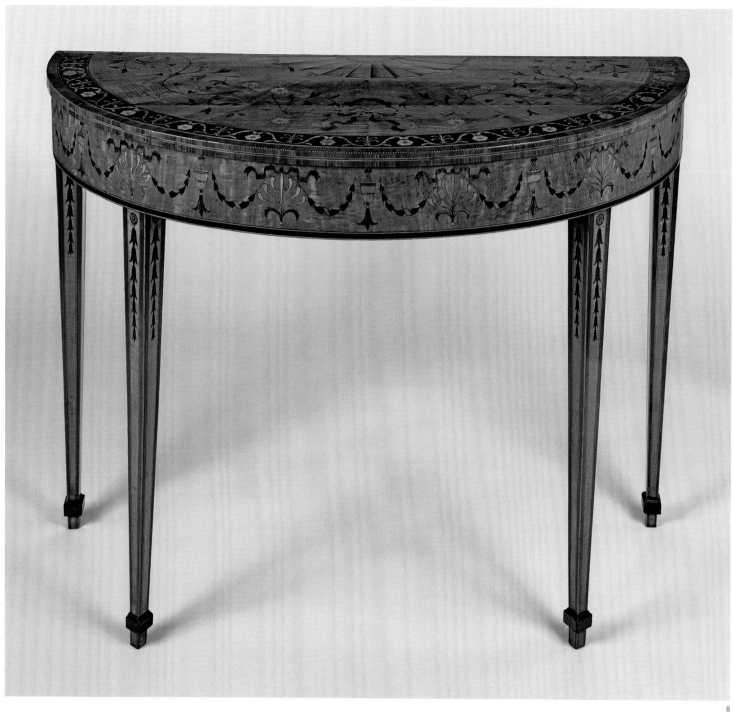

8

Fig. 8
William Moore. Pier Table (One
of a Pair), c. 1785. Cooper Hewitt,
Smithsonian Design Museum,
Smithsonian Institution, Gift of Neil
Sellin. Cat. 229.

Fig. 9
Probably Mack, Williams and Gibton,
after a design attributed to Francis
Johnston. Cellarette, c. 1821/25. L. Knife
and Son, Inc. Cat. 240.

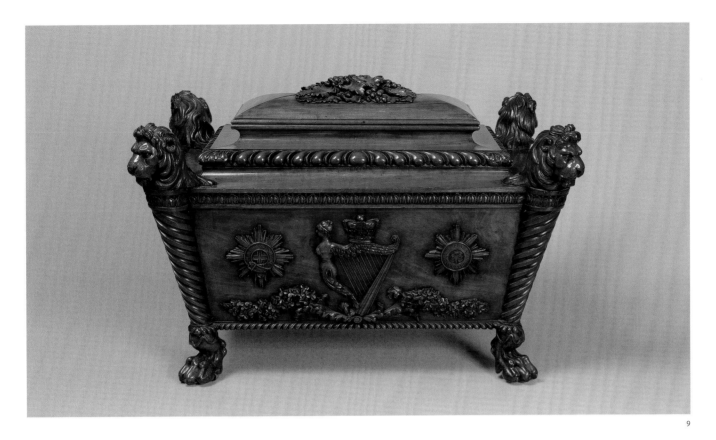

9

provenance. However, one cabinetmaker we can identify as active in Dublin during this period is William Moore, whose works are sometimes revealed as Irish by his use of a shamrock motif. Moore tells us in his advertisements that he trained in the London workshop of Mayhew and Ince, one of England's leading Neoclassical furniture makers, who specialized in exquisite engraved marquetry.[7] Moore supplied a demi-lune marquetry commode to William Cavendish Bentinck, 3rd Duke of Portland, when he was lord lieutenant (1782; private collection), and from this piece other attributions to Moore are possible, including the demi-lune pier table with a shamrock-and-bellflower motif (FIG. 8) in this exhibition. Moore also built cases for stringed instruments that are often little more than fancy pier tables (SEE P. 210, FIG. 5). Another Neoclassical cabinetmaker whose work can be identified is John Wisdom, who supplied a demi-lune pier table to Thomas Cobbe for Newbridge, County Dublin.[8] Many Irish country houses of

this period had delicate Neoclassical interior plasterwork that furniture such as this would have complemented.

The Act of Union at the beginning of the nineteenth century inevitably led to a decline in commissions as parliament moved to London, but the Irish aristocracy continued to spend lavishly on country seats such as Ballyfin, County Laois, in the 1820s, and there were some notable cabinetmakers active at this time, some of whom supplied complete furnishing schemes. Among these firms was Mack, Williams, and Gibton, who made robust, crisply carved, fashionable furniture of high quality (SEE P. 219, FIG. 7). Like their eighteenth-century predecessors, they were probably working from many of the same pattern books as English cabinetmakers; sometimes, however, they displayed a remarkable inventiveness (SEE FIG. 9). Their furniture can often be identified by a stamped name, reference number, or occasionally a label. Gillingtons was a similar firm whose craftsmen often

stamped their work. Another well-known and clearly flourishing workshop was that of John and Nathaniel Preston, who furnished some of the rooms at James Wyatt's Neoclassical masterpiece Castle Coole, County Fermanagh.[9] Their rich, stylish window dressings demonstrate how capable Irish upholsterers and cabinetmakers still were by 1840.

NOTES

1 Glin and Peill 2007, pp. 32–35, figs. 23–27.

2 Glin and Peill 2007, p. 44, fig. 36.

3 Glin and Peill 2008, pp. 140–45.

4 Glin and Peill 2007, p. 54, fig. 55.

5 Thomas Johnson, *The Life of the Author* (1793), quoted in Glin and Peill 2007, p. 87; Glin and Peill 2007, pp. 88–89, figs. 112–14.

6 Glin and Peill 2007, pp. 140–47, figs. 190–201.

7 Glin and Peill 2007, p. 163.

8 Glin and Peill 2007, p. 167, fig. 228.

9 Glin and Peill 2007, pp. 188–90, fig. 254.

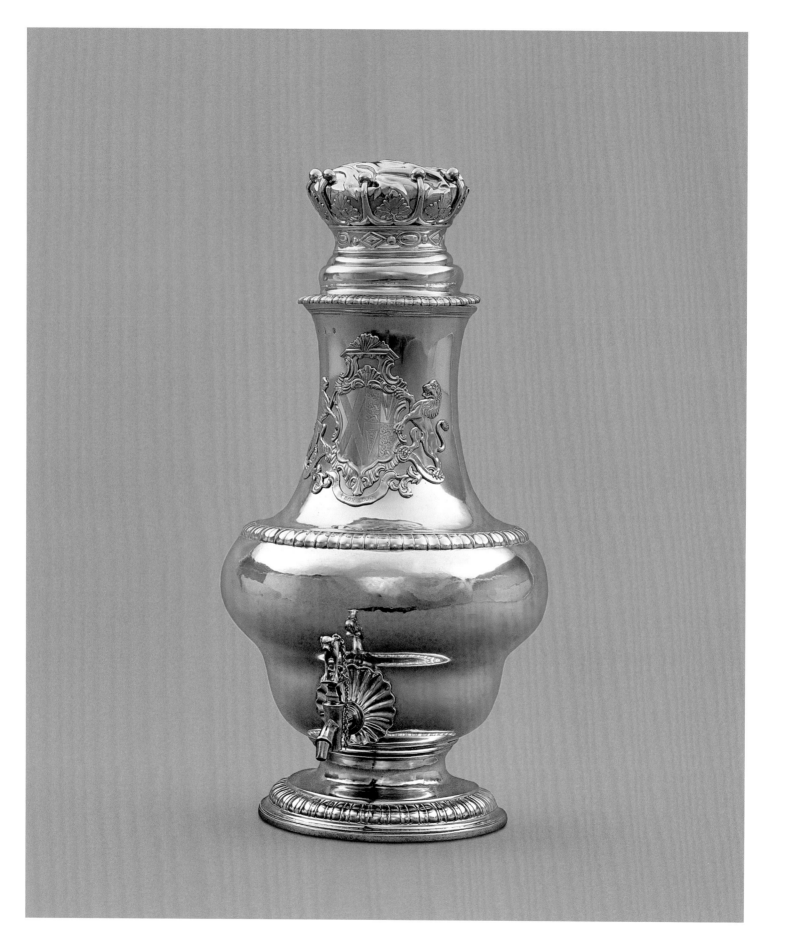

A Sterling Trade: Making and Selling Silver in Ireland

ALISON FITZGERALD

IN THE PERIOD BETWEEN 1650 AND 1850, fundamental changes occurred in the range of household goods that were being manufactured, advertized, and imitated in Europe.[1] As imported products like sugar, tea, and tobacco reached Ireland, they generated considerable demand for new commodities, stimulating local markets for ceramics, furniture, and metalwork. The consumer revolution that has been identified by historians of eighteenth-century Britain inevitably affected Irish manufacturers. Not only were they required to jostle for business with native competitors, but they also faced sustained competition from British imports that were often defined by novelty, technological ingenuity, and, in the case of London products, metropolitan allure.[2] In the field of Irish metalwork, as in other sectors of the market for luxury goods, the circulation of objects, patterns, and people between Dublin and London had a decisive impact on the demand for Irish-made products, on their design sources, and on the advertising rhetoric employed by those who retailed them.[3]

The earliest example of metalwork in this catalogue, a silver salt dating to about 1640 (FIG. 1), illustrates one way in which designs spread within the British Isles. The maker was George Gallant, a migrant London craftsman who, like a number of his compatriots during the early seventeenth century, relocated to Ireland in search of work.[4] Gallant is named in the 1637 charter of the Company of Goldsmiths of Dublin but appears to have originated in Berkshire, completing an apprenticeship in London with the goldsmith Richard Morrell and becoming free of the goldsmiths' guild there in 1615.[5] In 1638, a year for which detailed Dublin Assay Office records survive, he submitted a diverse range of objects for hallmarking, including not only salts but also bowls, cans, spoons, and wine cups.[6] Gallant's decision to move to Dublin was fortuitous, since guild records show that between 1638 and 1649 his workshop was the second most productive in the city.[7] This scroll salt, a form that evolved in English silver of the 1630s, can be seen as an early precursor to the table centerpiece and is a rare survival for Irish silver of this date.[8]

While attitudes to plate changed over time, its potential for signifying status was widely understood.[9] A poem published in Dublin in 1728 satirizes the common theme of

the ill-matched couple: "*Lucia* thinks happiness consists in state; She weds an *ideot*; but she eats in *plate*."[10] A year earlier, the Dublin goldsmith Thomas Sutton had completed an impressive silver cistern (FIG. 2) for Robert FitzGerald, 19th Earl of Kildare. His son, James, 1st Duke of Leinster, would complete the ensemble with a wall fountain by Robert Calderwood in 1754 (P. 174). Later, and rather caustically, John Boyle, 5th Earl of Cork and Orrery, commented that Kildare made "a much better show of his plate than of his virtues."[11] Undoubtedly, the silver amassed by the earl and his son signified to those within and beyond their circle the family's preeminent position in Irish society. It was acquired from leading London and Dublin goldsmiths including Calderwood, Sutton, George Wickes, and David Willaume.[12] Sutton was the most prolific Dublin goldsmith during the 1720s.[13] He took on at least six apprentices over the course of his career and retailed, by his own account, "all kinds of goldsmiths' and jewellers' work in the newest and most fashionable manner."[14] The Kildare cistern, commissioned for cooling wine and rinsing glasses, was later redeployed for use as a table centerpiece when the short-lived vogue for silver cisterns had long since passed.[15] A comparable example in the collection of

Robert Calderwood. Wall Fountain, 1754. Fowler Museum at UCLA. Cat. 265.

Fig. 1
George Gallant. Scroll Salt, 1640.
Minneapolis Institute of Arts, Gift of
James F. and Louise H. Bell. Cat. 268.

Fig. 2
Thomas Sutton. Wine Cistern, 1727.
Dallas Museum of Art, The Karl and
Esther Hoblitzelle Collection, Gift of
the Hoblitzelle Foundation. Cat. 286.

Fig. 3
Thomas Bolton. Two-Handled Cup
and Cover with the Crest of Broderick
of Midleton, County Cork, 1694/96.
Museum of Fine Arts, Boston, Gift of
Richard C. Paine. Cat. 258.

Fig. 4
Robert Calderwood. Salver, 1745/46. San
Antonio Museum of Art, Bequest of
John V. Rowan, Jr. Cat. 264.

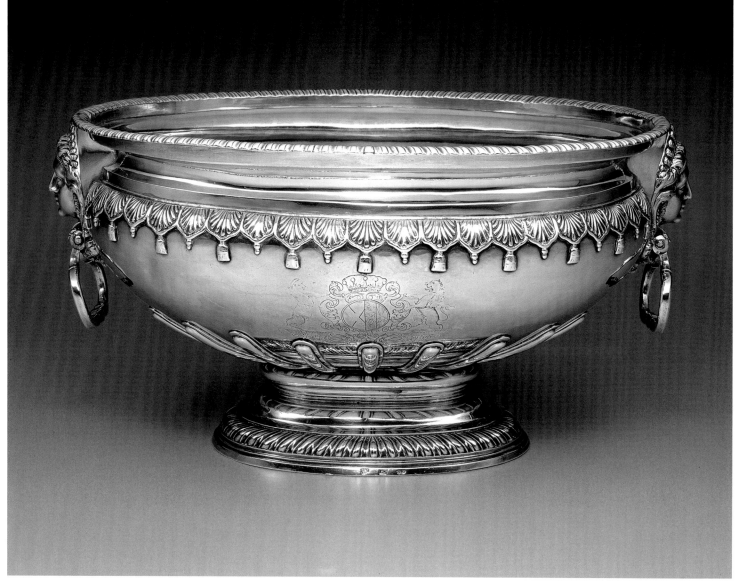

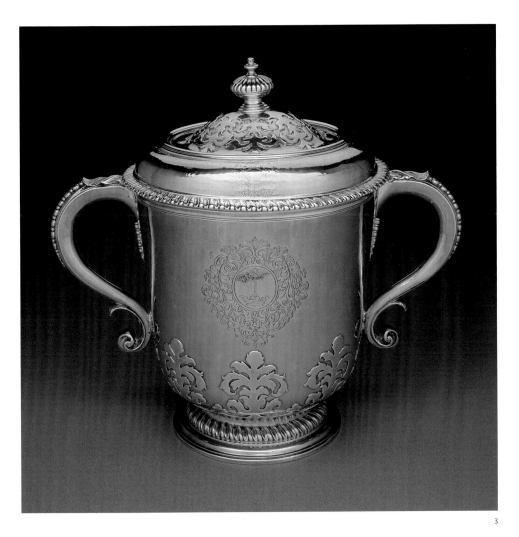

3

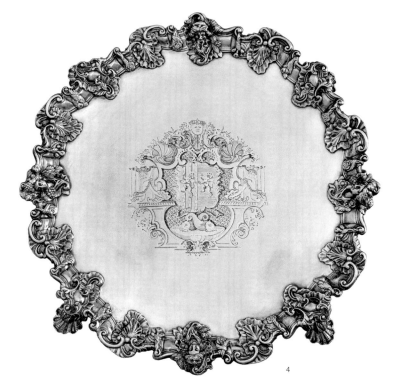

4

the Ulster Museum, Belfast, bears the mark of Sutton's contemporary John Hamilton, but in the context of extant Irish silver of this period, cisterns are exceedingly rare.

Although the volume of plate manufactured in Dublin increased exponentially from the early seventeenth to the late eighteenth century, a small number of workshops dominated the market at any one time. Thomas Bolton, who was responsible for a number of magnificent examples of domestic plate featured in this catalogue (SEE FIG. 3), ran one of the busiest workshops in the city from the 1690s until his death in 1736.[16] Like Bolton, Calderwood enjoyed a long and productive career, overseeing one of Dublin's most prominent workshops between 1727 and 1766.[17] He registered the largest number of apprentices with the guild over the course of the eighteenth century, developed an ancillary business manufacturing silver wire, and was an elected officer of the Dublin Society, which promoted Irish manufactures. A silver salver (FIG. 4), which would have been used for serving a variety of different kinds of food and drink, exemplifies one of the wide range of goods that he supplied to some of Ireland's most elite clients.[18] A decade earlier, the Dublin edition of the *Spectator* proposed by way of astute publicity that "a salver of *Spectator's* would be as acceptable an entertainment to the ladies, as a salver of sweetmeats," indicating the extent to which the term had been absorbed into common usage.[19]

In early modern Ireland, gifts of plate were bestowed in political contexts by municipal and trade corporations, in professional contexts by grateful employers to employees, and in personal contexts between relatives and friends. The way in which they were acquired inevitably shaped what they meant to those who consumed them. Church accounts reveal the extent to which plate was donated or purchased in eighteenth-century Dublin. An average of twenty-five items of

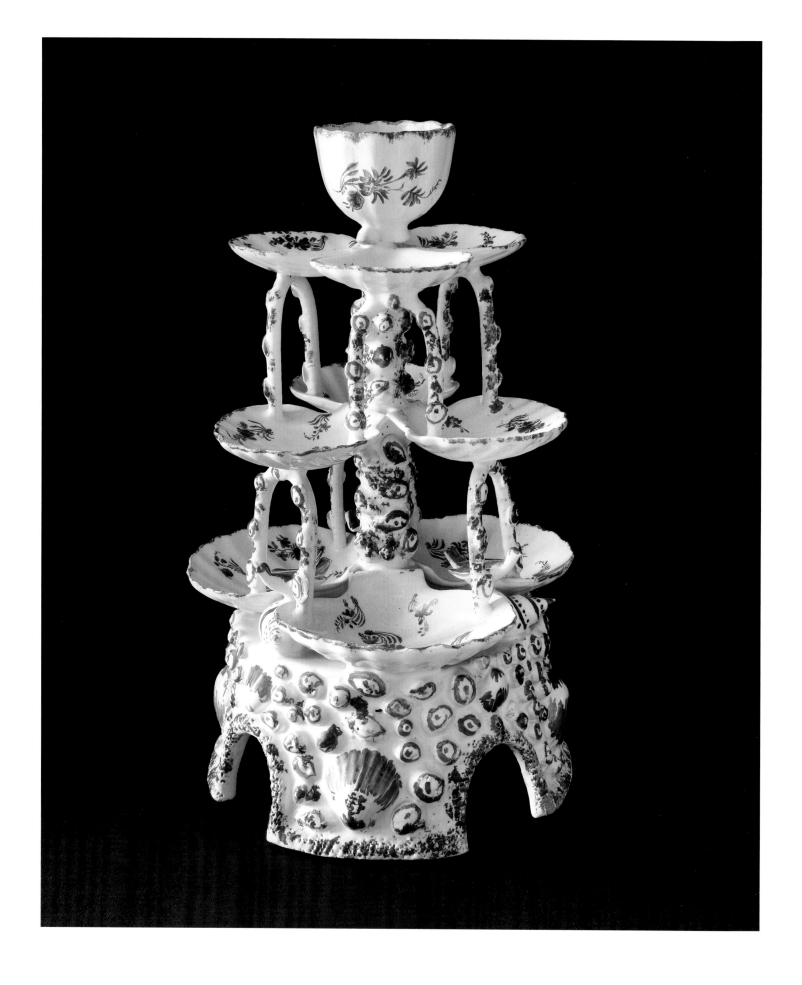

"Burned with … Turf": The Unique Charm of Irish Ceramics

PETER FRANCIS

WITH THE SOLE EXCEPTION of Belleek porcelain, early Irish ceramics remain greatly underappreciated, even within Ireland.[1] Yet during the seventeenth and eighteenth centuries, Irish potters conquered a far greater range of seemingly insurmountable obstacles than any other group of native decorative artists. In England the manufacture of ceramics was revolutionized by a sequence of major technical advances between 1690 and 1840, but naturally these discoveries were not freely shared with competitors. Irish potters were thus forced to improvise, often radically, in their attempts to introduce comparable wares made entirely of local materials. In so doing, they discovered new clay sources that influenced the industry far beyond Ireland; they also invented new types of kilns and sought out rare ores for glaze colors, creating a distinctive range of ceramics that—like so many Irish objects at this time—often combined sophistication and naïveté in equal measure. This was especially

World's End Pottery, under the direction of Henry Delamain, Mary Delamain, or William Delamain and Samuel Wilkinson. Epergne/ Sweetmeat Dish, 1755/65. Private collection. Cat. 190.

true during the eighteenth century, when tin-glazed earthenware, or "delftware," was the most common fine ceramic in general use.

Ireland's delftware industry began in 1697, when a London-based potter, Matthew Garner, returned to his hometown of Belfast.[2] Bankrupted by a dubious financier and perhaps guided by local knowledge of delftware clays in nearby Carrickfergus, Garner sought support from the city's wealthy merchant elite. Principal among these was David Smith, the owner of a transatlantic sugar business and the town's "sovereign," or mayor, whose backing allowed the Belfast Potthouse to begin working by 1698. The establishment appears to have continued uninterrupted until 1722, when a newspaper advertisement indicates that it was offered for sale, adding the rather incredible information that its "large kiln" was "burned with … turf," the only evidence of a peat-fired delftware kiln ever recorded.[3] Production probably ceased upon Garner's death around 1725.

Despite the pottery's comparatively long duration and several archaeological excavations of its site in recent years, surviving examples of Belfast delftware have proven exceptionally rare. The most exciting recent attribution is a small, two-handled blue-and-white cup that precisely matches cup

wasters excavated in 1993 (FIG. 1A).[4] This in turn indicates that a large, spectacular two-handled cup and cover (FIG. 1B) was also made in Belfast and hence represents the earliest colored example of Irish delftware known to date.[5] Its unusual, soft colors were to remain a feature of ceramics produced in Dublin and Belfast throughout the following century.

Although the Belfast Potthouse ceased work during the 1720s, the special, chalk-rich delftware clays these potters discovered had a more enduring legacy. Previously, all of the known delftware clay deposits were located on England's southeast coast, close to London. The discovery of this new clay source at Carrickfergus, seven miles from Belfast, allowed delftware manufacturing centers to develop on the western coast of England, for instance, in Bristol, Lancaster, and Liverpool. Crucially, a scattering of new potteries also arose throughout Ireland, most importantly in Dublin, one hundred miles south of Belfast.[6]

The earliest Dublin pottery was founded at the World's End, on the city's eastern edge, by John Chambers, who was probably originally employed at the Belfast Potthouse.[7] His operation was certainly working by 1735, a date that appears on the reverse of two finely painted armorial plates (SEE FIG. 2) gifted to

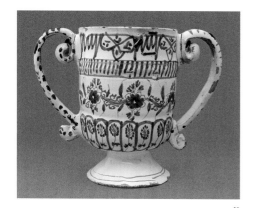

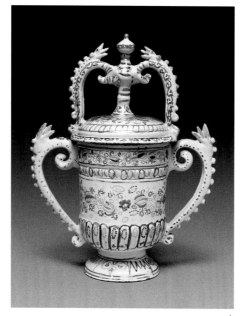

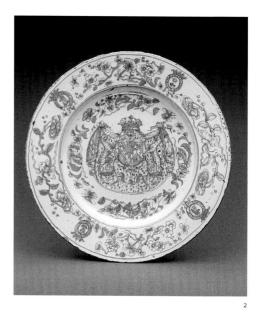

the lord lieutenant of Ireland, Lionel Sackville, 1st Duke of Dorset, presumably in pursuit of government support. Sadly, Chambers's efforts went unrewarded, and the pottery changed hands twice more before it was acquired in 1753 by a key figure in Irish ceramic history, the renowned Captain Henry Delamain.

By any measure, Delamain was a remarkable character. According to his widow, "he expended his entire fortune to the amount of £6000 and upwards" in transforming Chambers's modest enterprise into one of the most ambitious delftware potteries in the British Isles.[8] Although he died in 1757, the business continued to manufacture delftware until 1771. During these two decades, the World's End Pottery created a vast, diverse range of decorative tableware and ornamental items, many of which have only been recognized for the first time in recent years.

In fact, more pieces can now be attributed to World's End than to any other individual delftware pottery in the British Isles because of a small idiosyncrasy in Delamain's manufacturing practice: his decorators, who seem to have been employed on a piecework basis, tagged their items with unique, distinguishing monograms and numbers.[9] The great

majority of the patterns they created were copied directly from Chinese porcelain, often mimicking the originals in precise detail (SEE FIG. 3).[10] Indeed, when Chinese export source-designs are placed alongside Dublin copies, it is clear that the quality achieved by the Irish painters was frequently superior. Clients in Ireland and North Wales commissioned armorials that exhibit a similarly high quality of draftsmanship.[11]

Some early designs copied contemporary English porcelains. The impressive epergne (P. 180), for example, is a replica in delftware of a porcelain original made at the famous factory at Bow, near London. Dublin potters do not appear to have had access to the specialist, ancillary craftsmen such as mold makers that supported the pottery industry in England, and so they instead pirated existing forms wherever necessary. For example, elements of the impressive Castle Leslie wine coolers (FIG. 4), such as the face masks and swags, were probably formed in molds lifted directly from contemporary Irish furniture.

Delamain also looked to Continental Europe for inspiration. Among his first creations was a very fine set of Continental-style landscape-painted plates (SEE FIG. 5) once

Fig. 1a
Belfast Potthouse. Two-Handled Drinking Cup, c. 1710/15. Delftware; h. 13.2 cm (5 ¼ in.). Private Irish collection.

Fig. 1b
Probably Belfast Potthouse. Unusual Two-Handled Cup and Cover, 1712. Buff earthenware, tin-glazed and painted in blue, yellowish-green, and yellow; h. 36.2 cm (14 ¼ in.). The Fitzwilliam Museum, Cambridge, Great Britain.

Fig. 2
World's End Pottery, under the direction of John Chambers. Dish, 1735. The Metropolitan Museum of Art, New York, Gift of R. Thornton Wilson, in memory of Florence Ellsworth Wilson, 1947, 47.132. Cat. 185.

Fig. 3
Left, Bowl, Kangxi period, 1710–20. Private collection. Cat. 212. *Right*, World's End Pottery, under the direction of Mary Delamain or William Delamain and Samuel Wilkinson. Plate, 1760/70. Private collection. Cat. 201.

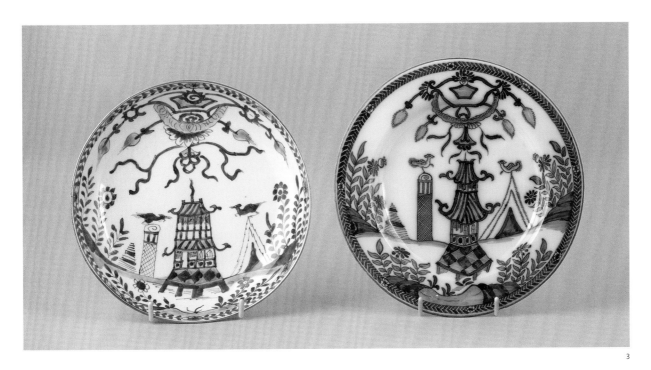

3

4

Fig. 4
World's End Pottery, under the
direction of Henry Delamain. Pair
of Wine Cisterns, c. 1755. Private
collection. Cat. 187.

again made as a presentation gift for the lord
lieutenant. The distinctive landscapes created
for this commission were to remain a staple at
World's End for as long as delftware was made
there. Today, for many, this wonderful range of
ceramics continues to represent the high point
of ceramic manufacture in Georgian Ireland.

Irish customs records mention no sig-
nificant exports of Dublin delftware during
the entire eighteenth century, but the fact

that three of the pottery's principal agents
had retail outlets in Cork, the final port of call
for ships headed to America, suggests that
such exports did indeed exist, possibly as
private cargoes.[12] Unexpected confirmation
that this was probably the case came from the
discovery of the remains of thirty-five punch
bowls (SEE FIG. 6) excavated on the site of
an eighteenth-century tavern in Chesterfield
County, Virginia, many of which bear a typical

5

6

Dublin painter's number on the base.[13] None of the patterns, decorated in an odd, freehand style known as "coarsely painted," had previously been recorded on Dublin delftware, but now that a number of intact examples have also been recognized, the group's Irish origins are obvious.[14] More exciting still, the fact that a single American site contained so much Dublin delftware suggests that many other Irish pieces remain to be unearthed there.

By the early 1770s, delftware was widely regarded as old-fashioned, having been superseded by technical developments in England. At the expensive end of the market, porcelain, both Chinese and English, remained popular well into the nineteenth century, but the availability of a new, lead-glazed earthenware known as creamware brought white, utilitarian ceramics to ever larger sections of society. The World's End potters attempted to create their own version of this new creamware from 1771 onward, but facing direct competition from Josiah Wedgwood, who opened his largest retail outlet outside London in Dublin, it is little wonder they had failed entirely by 1773.[15] More serious competitors for Wedgwood later arose

in Liverpool and northern England. Although most of their works fell short of his high standard of quality, they were also less expensive and hence played their own role in allowing poorer sections of Irish society to afford a piece of fine-quality pottery for the first time.

With the introduction of free trade and more liberal commercial conditions during the period known as Grattan's Parliament (1783–1800), one of Belfast's wealthiest merchants, Thomas Greg, optimistically undertook the Herculean task of competing with Wedgwood.[16] Exploiting newly discovered creamware clay deposits at Larne, County Antrim, Greg created one of the largest potteries ever built in Ireland, the Downshire Pottery, in Belfast in 1787.[17] Alas, the new commercial and legislative reforms did not last, so the firm was forced out of business shortly before the Irish rebellion of 1798, in which Greg's eldest son, Cunningham, was directly involved. Attempts were made to resuscitate the works for a few years after 1800, but examples of the creamwares made there (SEE FIG. 7) remain among the rarest and most charming Irish ceramics of all.

Fig. 5
World's End Pottery, under the direction of Henry Delamain. Plate, c. 1753–55. Private collection. Cat. 186.

Fig. 6
World's End Pottery, under the direction of Mary Delamain or William Delamain and Samuel Wilkinson. Punch Bowl, 1760/70. Private collection. Cat. 202.

Fig. 7
Probably Downshire Pottery. "Stag" Plate, c. 1800–06. Private collection. Cat. 184.

Fig. 8
Stick-Decorated Plate, 1820/35. England, decorated in Ireland. Creamware; diam. 21 cm (8 ¼ in.). Private collection.

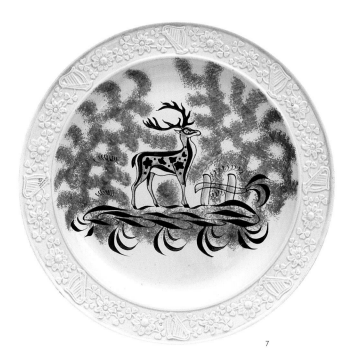

7

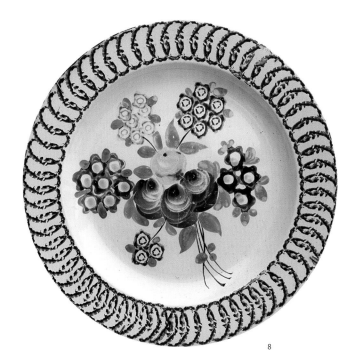

8

The Act of Union in 1800 caused such severe damage to the Irish pottery industry that no new manufacturers attempted to make fine ceramics for a further fifty years. Certain fine-china merchants in Dublin, such as James Jackson and his competitor James Donovan, the "Emperor of China," made valiant attempts to create luxury goods locally, training their own artists to decorate imported English porcelain blanks.[18] In Belfast some anonymous Irish decorators made similar use of enameling kilns at the defunct Downshire Pottery to create a much more modest range of "stickware" designs using the stems of cow parsley plants (SEE FIG. 8).[19] Fine-quality ceramic manufacture may have ceased entirely by the mid-1830s, but judging from the spectacular results these stickware decorators achieved with such simple materials, Ireland's potters clearly remained inventive and resourceful to the very end.

NOTES

1 The Belleek porcelain works began manufacture in 1857 and thus fall outside the period of this study.

2 Francis 2000b, pp. 11–20, provides a full history of the Belfast Potthouse. The two-handled cup and posset pot shown in figure 1 were discovered in 2009.

3 *Dublin Courant*, May 26, 1722, information courtesy John Rogers.

4 *Wasters* are the discarded remains of ceramic objects that become damaged or deformed during firing.

5 For further discussion and images of this unique posset pot, see Archer 2013, pp. 212–13. Such vessels were designed to serve a warm, spiced drink popular from the Middle Ages to the nineteenth century.

6 For further information on the Carrickfergus clay trade, see Francis 2000b, appendix 1, pp. 165–70.

7 Francis 2000b, pp. 35–45.

8 Mary Delamain, petition to the Irish House of Commons, November 9, 1759; see Francis 2000b, pp. 46–66.

9 For more on the distinguishing characteristics of Dublin delftware, see Francis 2000b, pp. 67–82. The numbers and monograms recorded up to 2000 are shown as figure 58, but some additional marks, including the number *16*, have been found since.

10 Francis 2000b, pp. 89–94.

11 Francis 2000b, pp. 100–104, describes Dublin armorial wares.

12 Francis 2000b, pp. 83–88, discusses this new class of Dublin delftware in greater detail. The recognition of this group rests entirely on the discoveries made on the excavations at Chesterfield County, Virginia.

13 Austin 1994, pp. 20–23.

14 At least eight such patterns have been recognized since 2000. In addition to the marks, the style of the handwritten text on these pieces can also be helpful in identification.

15 Dunlevy 1984; see also Francis 2000b, pp. 65–66.

16 Francis 2000c contains a full account of Thomas Greg's attempts to make creamware in Belfast using Irish materials.

17 Francis 1997. The clays discovered by Greg and his partners were later exploited by the independent Larne Pottery Company from about 1844 onward.

18 Dunlevy 1985.

19 Peter Francis, "Stickware—an Irish Innovation," forthcoming. Around forty examples of these stickwares have now been found, mostly in the north of Ireland. A large number were exported to North America by the antiques trade in the 1960s and 1970s.

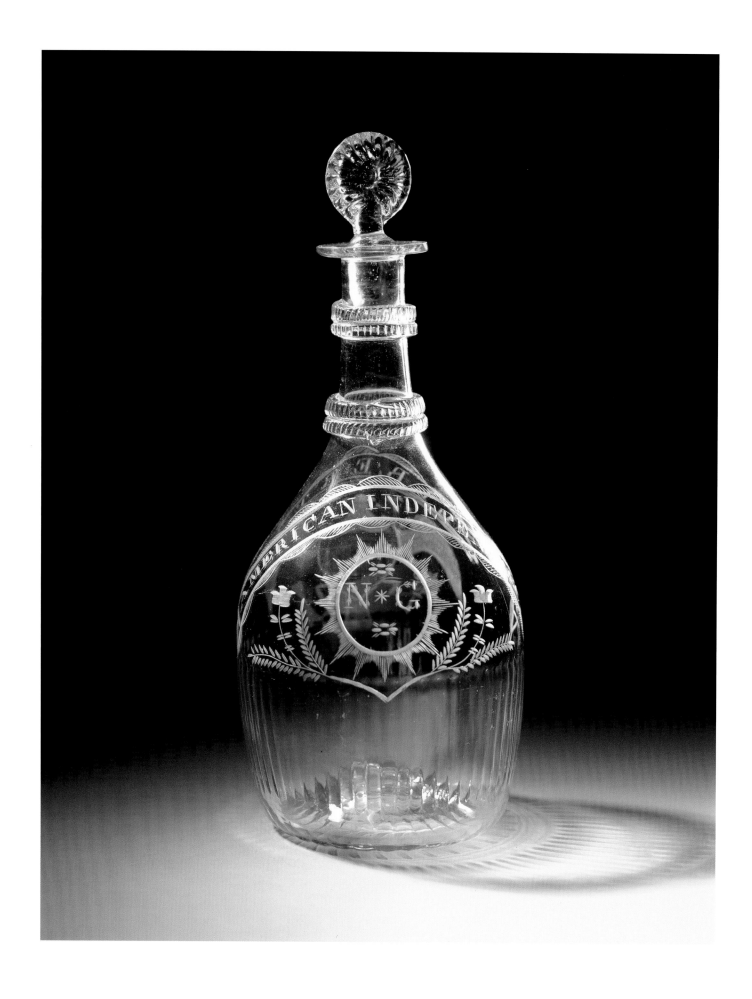

The Enduring Myths of Irish Glass

PETER FRANCIS

TRADITION SUGGESTS THAT fine-quality glass was made in Ireland throughout the eighteenth century, culminating in a so-called Age of Exuberance that extended from roughly 1780 to 1835, when manufacturers throughout the country created fabulous cut lead crystal of unparalleled quality.[1] Revived by modern factories from 1951 at Waterford, then later in Cavan, Galway, Tyrone, and elsewhere, this legendary material ultimately developed into an internationally recognized luxury brand, one of the country's most prestigious exports.

There may be some disappointment, therefore, in discovering that this exhibition and catalogue, rather than showcasing a classic range of Irish Georgian cut lead crystal, includes just three examples. This is because there has been a growing realization in recent years that this longstanding traditional narrative of Irish glass history—including even the notion of the Age of Exuberance itself—is not supported by historical facts.[2] This is not to say that early Irish glass was not

unique, distinctive, or indeed fabulous. On the contrary, the revisions indicate that Ireland's comparatively small industry exerted far greater international influence than was ever understood previously, but the true nature of its contributions was more subtle than the accepted history would suggest.

One surprising, recent discovery, for example, is that Ireland played a significant role in the development of lead glass from the very beginning. Modern techniques of lead crystal manufacture are now believed to have originated in the Netherlands during the 1660s and 1670s, and were apparently brought to the British Isles when two glassmakers from Nijmegen, the Spaniard John da Costa and the Italian John Odacio Formica, fled French military invasion in 1672.[3] Da Costa traveled to London where, in partnership with the merchant George Ravenscroft, he obtained a royal patent to manufacture lead crystal in England beginning in 1674. The following year, his partner in Nijmegen, John Odasha (as he became known in Ireland), journeyed onward to Dublin, where he secured an almost identical patent to make his own "particular sort of Crystalline Glasses resembling Rock-Chrystal."[4]

Despite these legal protections, both patents proved unenforceable in practice, especially in England. Even in the smaller marketplace of Dublin, at least one further glasshouse (SEE FIG. 1) was producing "Great Glasses" and a "Grate many of ye other sortes" of lead table glass as early as 1680 without regard for any patent.[5] Sadly, no pictorial records survive of the drinking glasses that were made then, but fragments recovered on archaeological excavations around Dublin in recent years have begun to provide clues.[6] Remarkably, many of these very early vessels exhibit an exceptionally high lead content of around 33 percent, directly comparable to modern Waterford crystal. A number also display one particularly distinctive feature, a collar, or "merese," at the junction of the bowl and stem that seems to have been more common on Irish examples of this period than English ones. Alas, the fragile bowls of these Venetian-style glasses were exceptionally thin and easily broken, to the extent that only a single intact goblet has been located to date (FIG. 2).[7]

There is no doubt that these seventeenth-century Irish glassmakers fully intended to trade internationally, and they probably succeeded for a time as fragments

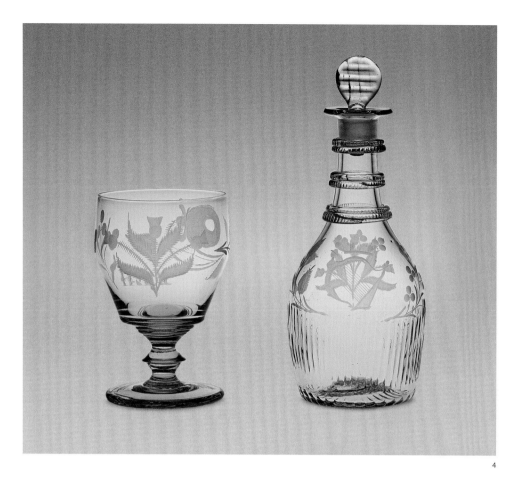

4

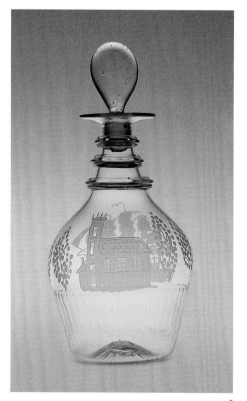

5

Fig. 4
Left, Wine Glass or Rummer, c. 1810–20.
Private collection. Cat. 252. *Right*,
Decanter, c. 1810–20. Private collection.
Cat. 249.

Fig. 5
Decanter, c. 1825–30. Private collection.
Cat. 250.

Fig. 6
Footed Bowl, c. 1820. Maris and Maija
Zuika. Cat. 255.

in the individual molds, it is often possible to differentiate items made in Belfast, Cork, and Waterford on the basis of the engraving, form, and mold even when a manufacturer's mark is not present. The Newry glassworks, for instance, did not employ marked molds, and as a result its products long remained anonymous. The decanter in this exhibition (FIG. 5), which was the first piece to be recognized, features a unique engraving that may represent Saint Patrick's Church in Newry, a striking local landmark.

Much larger and more ambitious objects, such as the salad bowls that exemplify Irish Georgian glass, were also formed in such relatively simple dip molds, but these were further enhanced with skilfully worked stems and wheel cutting (SEE FIG. 6). As time progressed, however, the complexity of the molds increased, and it is significant that several glassworks came to incorporate sophisticated metal foundries to facilitate their production.[15] Single and two-part molds in turn led to the development of the three-part complex mold, which allowed the entire surface of an object to be molded in imitation of cutting. The resulting blown three-mold technique ultimately became even more popular among manufacturers in North America, especially after 1819, when cut glass—already expensive— was subjected to an additional 30 percent import tax there.[16] For now, however, the precise geographic origins of these molds remain a subject of debate.

The introduction of the Act of Union in 1800 was accompanied by a slew of adverse tax measures that forced many Irish glasshouses to resort to smuggling in order to stay in business, reducing quality even further. These wares were often hidden within larger containers such as butter barrels, but there are occasional records of more enterprising modes of transportation. One customs officer in Glasgow, for example, recalled in 1823 how "a few weeks ago a woman came to Ayr; she

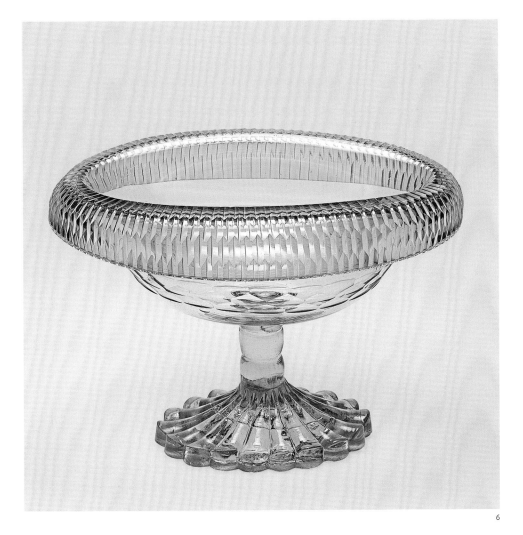

6

appeared to be very bulky; one of the tide waiters laid hold of her and he heard the glasses jingling . . . she had no less than a gross of glasses, 144 glass, about her."[17] Such accounts, and the evidence of the objects presented in this exhibition, strongly suggest that most Irish glass of this period was a far cry from the richly cut luxury glassware that is usually attributed to Ireland. Even so, these wares possess an undeniable and unique charm that seems well suited to their humble origins.

When English excise duties were imposed in 1825, the fact that the Irish manufacturers were already reduced to making a poor-quality, inexpensive product only hastened their decline. Some smaller enterprises, such as the glasshouse at Newry, continued to arise and operate for a few years more, while retailers such as James Jackson's in Dublin persevered

for a time in commissioning molded Irish glassware bearing their names. Yet within ten years, almost all of the Irish glasshouses had closed, and even Waterford, acknowledged among contemporaries as one of the finest of all, ceased entirely by 1851.

NOTES

1 Phelps Warren introduced and defined the term *Age of Exuberance*, but the distinctive character of Irish Georgian cut glass was recognized as early as the 1870s; Warren 1970, p. 19.

2 See Ross 1982. This pioneering study of government papers revealed that the "cut glass" narrative was entirely at odds with true events. Ross's work has been repeatedly borne out by others, most notably by Anna Moran's various researches on the Waterford papers; see Moran 2008b.

3 Francis 2000a introduces much of the early lead-glass research described here. For additional information, see Myles 2010.

4 Quoted in Francis 2000a, p. 47.

5 Francis 2000a, pp. 50–51. The early reference to "flint" (lead) glass derives from correspondence between a Belfast merchant and Captain John Nicholls, the owner of the Lazy Hill glasshouse between 1679 and 1680. Nicholls was a competitor of John Odasha.

6 Francis 2000a, pp. 50–52.

7 The glass was illustrated for sale by London dealer Howard Phillips in the early 1980s. Bought soon afterward by an Australian antique glass dealer, it now resides in a private collection in Australia.

8 Francis 2000a, pp. 52–53.

9 "590 ft. Glasse, value £7 7sh. 6d., exported from Dublin to the English Plantations." Ireland 4759 (Papers Relating to the Trade and Revenue of Ireland, Returns of Import and Export Trade, December 24, 1682–December 24, 1683), British Library, London.

10 Public Record Office, Kew, Boards of Customs and Excise (CUST), 15: 1 (1698).

11 M. S. Dudley Westropp provides details of the various glasshouses that arose in Dublin during this time, some of very short duration; Westropp 1920, pp. 37–67.

12 The two Dublin glasshouses of Charles Mulvany and Richard Williams were supplemented by Chebsey and Company (Dublin), Benjamin Edwards (Belfast), Hayes et al. (Cork), the Penroses (Waterford), and Quin, Dunbar and Company (Newry). Westropp 1920, pp. 37–67.

13 Figures conservatively estimated from *Account of Duty Charges and Drawback paid on Glass in the United Kingdom, 1826–39, Parliamentary Papers* 46 (1839), illustrated as fig. 3 in Ross 1982.

14 Lead-content study of approximately twenty samples by the author, based on specific gravity, suggests that most Irish mold-blown decanters contained 21 to 24 percent lead but ranged as low as 16 percent. Contamination of the glass ingredients by trace amounts of iron, which imparts a yellowish tone, are normally counteracted by adding a decolorant such as manganese, which imparts a duller, gray tone. This type of inferior glass, commonly called "tale glass" in the early nineteenth century, is still known today in the Czech Republic as "sad gray."

15 For example, Benjamin Edwards in Belfast operated a large-scale, independent foundry close to his glasshouse. The Gatchell family also went on to establish a highly successful foundry in Dublin after the closure of the Waterford glasshouse.

16 Helen and George McKearin provide further discussion of blown three-mold decanters made in America and illustrate many examples. It is tempting to believe that the technique originated in Ireland and was then adopted in America, but there is no evidence to prove this was the case. Similar molds were also used in England at this time: an extremely rare, marked square example in the collection of A. Milford, Brighton, bears the name *Buggins, Birmingham.*

17 *Twelfth Report of the Commission into the Revenue* (1825), app. 117; quoted in Ross 1982, p. 59.

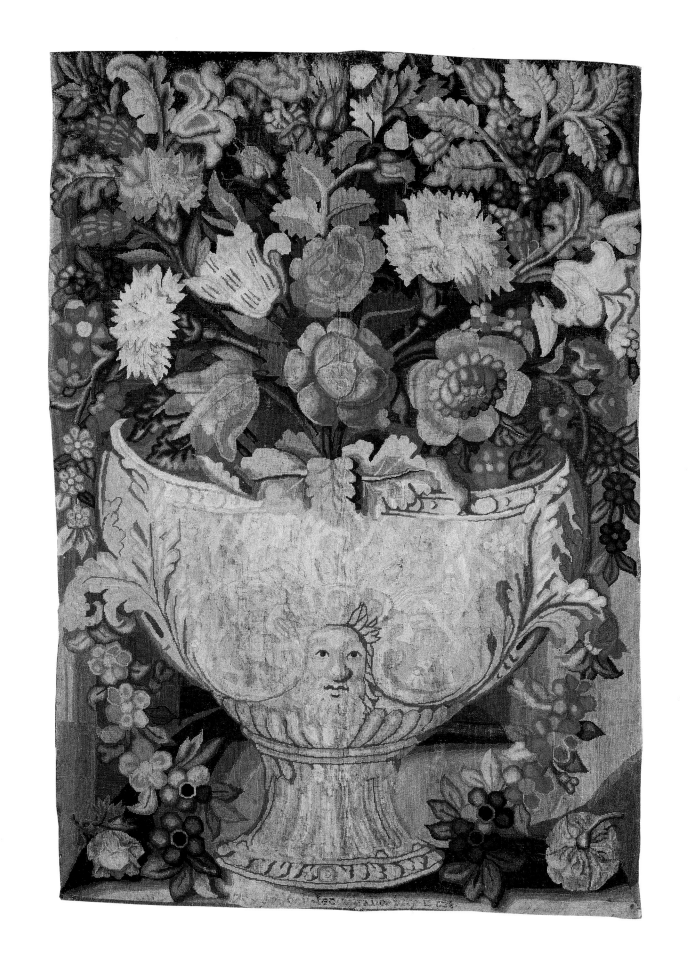

Dressing Irish: Textiles in Ireland

TOBY BARNARD

AS WITH MANY OTHER COMMODITIES in eighteenth-century Ireland, the urge to proclaim status and wealth through fashionable foreign textiles conflicted with impulses to promote native manufactures. The latter were stunted by the English, anxious lest a flourishing textile industry in Ireland compete too successfully with the English and Scots. In consequence, laws passed at Westminster, notably in 1698, severely curtailed the export of Irish-made woolens and sought to divert activity into the production of linen. The second objective appeared to have been triumphantly achieved by midcentury, when Irish linens enjoyed high repute outside as well as within the island. The climate was particularly conducive to growing flax, while the several stages of preparation and weaving offered employment to relatively unskilled women and children as well as to specialists. Yet the renown of Irish linens should not obscure the continuing output of wool cloth, ostensibly for the home markets. Indeed, there were towns such as Carrick-on-Suir, which was famous for

its manufacture of wool cloth, or ratteen, and Dundalk, the beneficiary of a cambric factory.[1] Users tended to value Irish fabrics for durability and price, not for fashion; nor did they preserve them in the manner of costly silks and linens.

State subsidies and skillful propaganda helped to give Irish linen its prestige. For instance, the Warings, a gentry family of County Down, advertised the superiority of their—or their tenants'—products by making an elaborately decorated tablecloth to celebrate George II's coronation in 1727.[2] Grandees led by Katherine Conolly, wife and later widow of Ireland's leading politician, dispatched specially commissioned linen damask tablecloths and napkins to influential friends in Britain. In 1782 pride in the success of this branch of Irish industry led William Hincks to prepare and publish a dozen engravings showing the successive stages of production (FIG. 1).[3]

A patriotic urge to cut back on expensive imports even extended to tapestries. In previous centuries, the important and affluent in Ireland had hung their walls with panels depicting Classical and biblical scenes; these works were woven outside Ireland, usually in the Low Countries and France

but occasionally in England. The dukes of Ormonde, for example, set a standard in their Kilkenny houses with Brussels tapestries after designs by Rubens.[4] During the 1660s Edward Brabazon, 2nd Earl of Meath, patronized the Lambeth manufactory in London (SEE FIG. 2). In order to curb the draining of money away from Ireland, tapestry making was sponsored in Dublin. Some of the results adorned the city's newly completed Parliament House by the 1730s. Unusually, recent Irish events such as the Battle of the Boyne and the Siege of Londonderry were portrayed.

However, the demand for such artworks, always rivaled by prized Continental ones, was also prey to the vagaries of taste. The fashion for decking walls with textiles dwindled as wooden paneling, plaster reliefs and borders, and then painted and printed papers became fashionable. Yet textiles did not disappear from Irish interiors but were used instead for curtains on both beds and windows and for upholstering furniture. Rooms beguiled thanks to a rich play of colors, patterns, and textures; the former became lighter and brighter under the influence of chintzes and calicoes shipped from Asia.[5] In their choices, consumers mingled the indigenous with the imported

Needlework Panel from a Pole Screen,
1738. Private collection. Cat. 328.

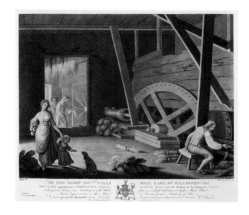

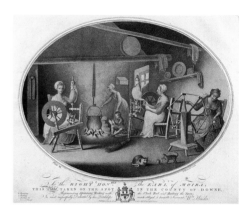

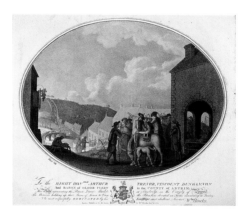

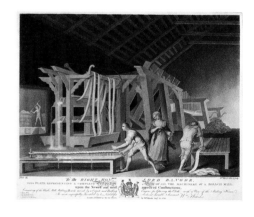

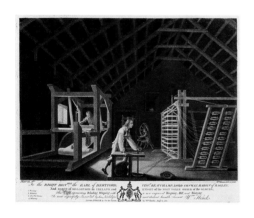

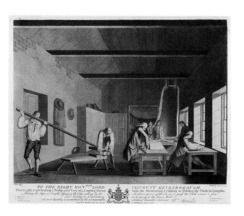

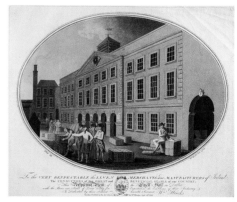

1

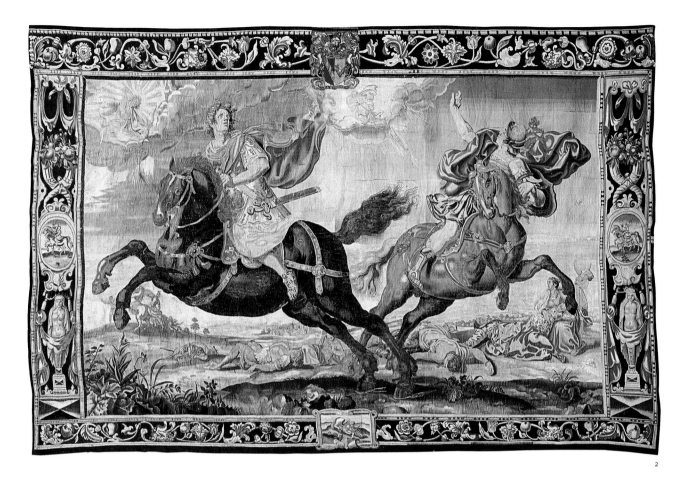

2

Fig. 1
William Hincks. *Twelve Engravings
Showing the Stages of Flax and
Linen Fabrication in Ireland,* 1783. Private
collection. Cat. 58.

Fig. 2
After designs by Francis Cleyn. *The
Destruction of Niobe's Children,* from the
series *The Great Horses,* c. 1665.
S Franses, London. Cat. 320.

and were able to select from products that
ranged from the homely to the ostentatiously
sumptuous. A printed auction catalogue for
the Wingfield family's effects, sold from their
Dublin and County Wicklow residences in 1729,
suggests how older materials—leather seat
covers and tapestries depicting Caesar burn-
ing the library in Alexandria, for example—
were giving way to flimsier, more vivid fabrics.
The dining room, for example, boasted five
pairs of "yellow India damask" curtains and
suites of chairs and stools covered with the
same fabric, "perfectly new and fashionable."[6]
The terms "Indian" and "Persian" suggested
stuffs imported by the East India Company,
but there was also Genoese damask. Soon pro-
ducers in England, and then in Ireland, were
striving to weave their own cheaper versions.

Furnishing fabrics, like those for cloth-
ing, offered business to designers, makers, and
retailers. But their production also offered

an outlet for domestic talents. Proficiency in
needlework and embroidery was regarded as a
particularly female attribute. Taught at home
and in schools, these skills equipped their pos-
sessors to earn honest livelihoods. For those
whose inheritances or marriages removed any
need to labor for pay, such skills were looked
upon as a component of housewifery, and
even the grand chatelaines such as Katherine
Conolly and Mary Delany, who was married to
a dignitary of the Church of Ireland, prac-
ticed them. In female circles, a woman might
display her superior "fancy" or taste both in
conceiving and executing a showpiece. Delany
in particular graduated to virtuosic collages
of cut paper (SEE P. 114, FIG. 24) and felt, and
spurred on others.[7] Gilbert Stuart's portrait
Anna Dorothea Foster and Charlotte Anna Dick
(FIG. 3) captures the popularity of such pur-
suits at the highest levels of Protestant society.
Here, Foster works at her circular tambour

frame while Dick holds the paper pattern to be followed. Aptitude on such a device was a skill advertised in the curriculum of girls' schools, such as that kept by Mrs. Ivory at Armagh in 1766.[8]

Patterns customarily reproduced what had been seen or had originated elsewhere, although individuals could introduce their own variants. The woman who embroidered the fire screen at Tralee, County Kerry, in 1738 (P. 192) tailored the stitches and design to what contemporaries were making in Britain. The term *Irish stitch* implied something distinctive to Ireland, but the same design was variously called "flame" after its wavelike look and "Hungarian" or "Florentine" stitch. Precious fragments, sometimes panels of brocade and silk, were recycled in hangings and vestments for parish churches and chapels. The Kirwan vestments, donated to a Galway convent in 1781, were fashioned from silk that was probably made in Lyons nearly fifty years earlier. The donor, a nun, had two brothers active as merchants in Dublin who may have been the source of the rich material.[9] Among the Catholic majority of the population, the church offered a focus for the fine needlework and embroidery that was absent from their modest homes. Nuns were chiefly responsible for this activity—at least on the evidence of the rare survivals, notably from the Dominican and Poor Clare convents in Galway—and passed their knowledge to their young charges.[10] By the nineteenth century, it was the time-consuming and highly prized art of lace making that was encouraged in convents and their schools. Inevitably, as with most other textiles, Irish producers had to compete against both British and Continental rivals and against the rush to mechanization. Even so, the laces of Limerick and Carrickmacross retained their reputation.[11]

Textiles, in both their making and their uses, tended to be linked strongly with women. Schools, including charitable foundations,

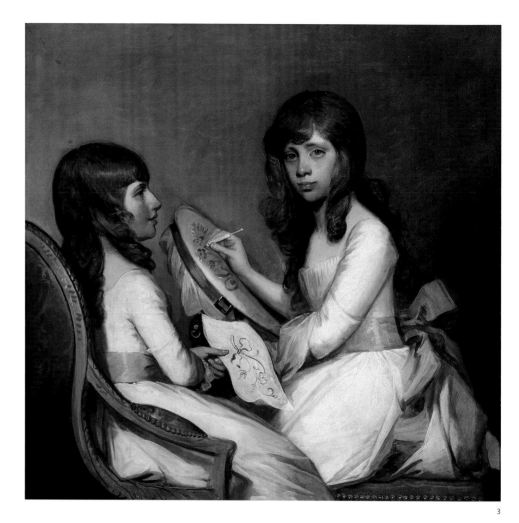

3

proliferated in the eighteenth century. Needlework and embroidery loomed large in the advertised syllabus. In 1764 a woman from Dublin proposed opening a school in Belfast where she would teach "young ladies to work the sampler, embroider, Dresden, catgut, plain work of all kinds, flocks, and knot stitch, and draw all kinds of drafts for needlework and men's lace" as well as reading and spelling.[12] In 1777 the Belfast poorhouse sought a mistress to teach knitting, sewing, and spinning.[13] Competence in spinning and weaving could equip the young to earn their own livelihoods and become useful members of society. In many cases, what was learned in the class-room supplemented what might be picked up at home from mothers, siblings, or servants. Much of this was severely utilitarian and

Fig. 3
Gilbert Stuart. *Anna Dorothea Foster and Charlotte Anna Dick*, 1790–91. Charlotte Hanes. Cat. 125.

Fig. 4
Eliza Bennis. Quilt, 1782. Winterthur Museum, Bequest of Henry Francis du Pont. Cat. 318.

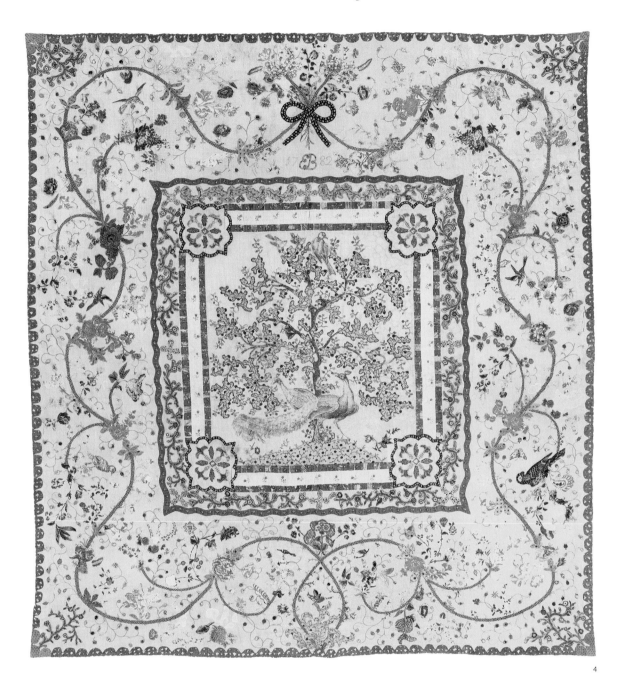

4

involved making, ornamenting, and repairing everyday clothing and furnishings; women took on commercial work to supplement their family's scanty income. These labors were often pursued in groups and accompanied with singing and talk.

As with other worldly goods, large sections of Irish society owned only a meager stock of textiles. For the majority, poverty explained the paucity, but attitudes also played a role. Catholics, scholars have argued,

may have abstained deliberately from show in order not to attract hostile attention. For others, especially Protestant dissenters, biblical teaching enjoined restraint. Even so, utility could justify a woman's proficiency with the needle and embroidery hook. So it was that Eliza Bennis, well known as a Methodist in Waterford, made an elaborate bedcover (FIG. 4). Other extant quilts can be traced to Presbyterian and Quaker families as well as to the landed elite.[14] Individuals displayed

their knowledge and skills in samplers sewn at school and at home, a few of which have survived. Jean Warnock created one on board the *Wilmington* en route from Belfast to Philadelphia in 1793; Eleanor O'Beirne, living in County Roscommon, made another in 1823 (FIG. 5). Comparable dexterity went into embroidered silk-work maps of Ireland. In 1832 Dorothy Tyrrell showed her prowess as a needlewoman while a pupil at the Female Model School in Dublin (FIG. 6).[15]

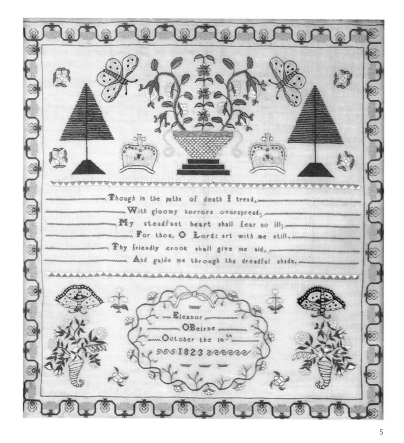

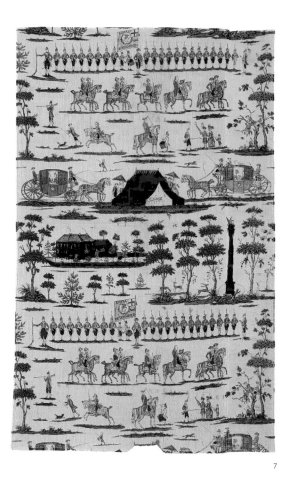

5

6

7

Fig. 5
Eleanor O'Beirne. Sampler, 1823.
Collection of Leslie B. Durst. Cat. 324.

Fig. 6
Dorothy Tyrrell. Needlework Sampler
Book Executed in the Female Model
School, Kildare Place, Dublin, 1832.
Private collection. Cat. 327.

Fig. 7
Probably designed by Gabriel Beranger,
printed by Thomas Harpur. *The Irish
Volunteers,* 1782. The Art Institute of
Chicago, gift of the Illinois Chapter
of the American Institute of Interior
Designers, 1963.749. Cat. 319.

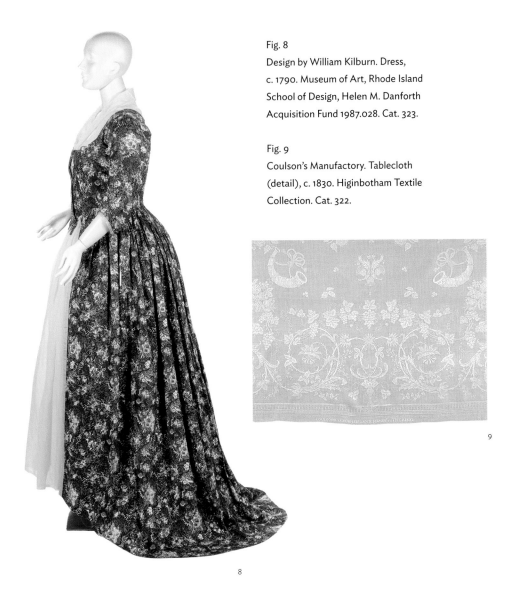

8

Fig. 8
Design by William Kilburn. Dress,
c. 1790. Museum of Art, Rhode Island
School of Design, Helen M. Danforth
Acquisition Fund 1987.028. Cat. 323.

Fig. 9
Coulson's Manufactory. Tablecloth
(detail), c. 1830. Higinbotham Textile
Collection. Cat. 322.

9

damasks (SEE FIG. 9), which were regularly presented to members of the British royal family and bought by well-to-do clients.[21] But the cachet of the exclusive was increasingly hard to preserve in the face of mass production.

NOTES

1 Barnard 2003, pp. 283–85; Clarkson 1989; H. O'Sullivan 2006, pp. 4–5, 17.

2 Lewis 1984.

3 Crawford 1994, 2005. The following are abridged titles of Hinks's engravings: plate 1, *Ploughing, Sowing the Flax Seed and Harrowing*; plate 2, *Pulling the Flax when grown, Hooking or putting it up to Dry, Ripling or saving the Seed and Boging or burying it in Water*; plate 3, *Taking the Flax out of the Bog when it has lain a sufficient time to separate the Rind which is the Flax from the Stem and strengthen it, spreading it to dry, stoving, beetling, and breaking it*; plate 4, *The Common Method of Beetling, Scutching and Hackling the Flax*; plate 5, *Perspective View of a Scutch Mill, with the Method of Breaking the Flax*; plate 6, *Spinning, Reeling with the Clock Reel and Boiling the Yarn*; plate 7, *Winding. Warping with a new improved Warping Mill and Weaving*; plate 8, *The Brown Linen Market at Banbridge in the County of Downe*; plate 9, *Perspective View of all Machinery of a Bleach Mill*; plate 10, *View of a Bleach Green Taken in the County of Down*; plate 11, *Perspective View of a Lapping Room, with the Measuring, Crisping or Folding the Cloth in Lengths*; and plate 12, *Perspective View of the Linen Hall in Dublin*.

4 Fenlon 2001, pp. 31–33.

5 Barnard 2004, pp. 79–121; Peck 2013, pp. 104–19.

6 *Catalogue of the Goods* 1729.

7 Laird and Weisberg-Roberts 2009, pp. 94–109, 150–71, 224–35.

8 *Belfast Newsletter*, March 9, 1773.

9 McDonnell 1995, p. 44; Dunlevy 2011, p. 77. For other examples of recycling costly European textiles for liturgical uses, see Peck 2013, pp. 218–20, 224–29.

10 McDonnell 1995, pp. 42–43.

11 Longfield 1970, pp. 26–43; Ó Cléirigh and Rowe 1995, pp. 11–66.

12 *Belfast Newsletter*, April 17, 1764.

13 *Belfast Newsletter*, March 26–29, 1776.

14 McCrum 1998.

15 Laffan 2003b, pp. 304–05.

16 Feller 2012, pp. 38, 45–46, 49–50.

17 Barnard 2004, p. 256; J. Kelly and Lyons 2014, vol. 3, pp. 436–37; vol. 4, pp. 396–97.

18 John Murray, Journal, s.d. June 5, 1775, National Library of Scotland, Edinburgh, MS 43018; Longfield 1972.

19 Longfield 1981.

20 Sheehy 1980.

21 Wilson 2011, pp. 96–97.

Samplers stitched at Quaker schools such as Mountmellick look austere, almost ascetic. Lettering, not fanciful imagery, sufficed to proclaim accomplishment.[16]

To counter the appeal of imported goods, authorities sometimes seized and destroyed them.[17] More constructive were efforts to increase the attractiveness of native products. For example, the firms of Robinson of Ballsbridge (SEE P. 131, FIG. 3) near Dublin and Harpur at Leixlip pioneered novel processes for printing cottons and linens.[18] The latter blatantly appealed to the patriotic sentiments of the 1780s by imprinting cloth with scenes of the military Volunteer Corps (SEE FIG. 7).

Meanwhile, William Kilburn (SEE FIG. 8) drew on familiar British and Continental motifs for his book of designs now held in the Victoria and Albert Museum, London.[19] It was not until more aggressively commercial manufacture of Irish commodities began in the 1850s that a repertoire of Hibernia, round towers, and wolfhounds became popular.[20]

Fierce competition, accelerating mechanization, spreading prosperity, and altered attitudes toward comfort and display as indicators of respectability and refinement all spurred changes in textile design, marketing, and technology. Coulson's, established at Lisburn in 1764, exemplified this through their handwoven

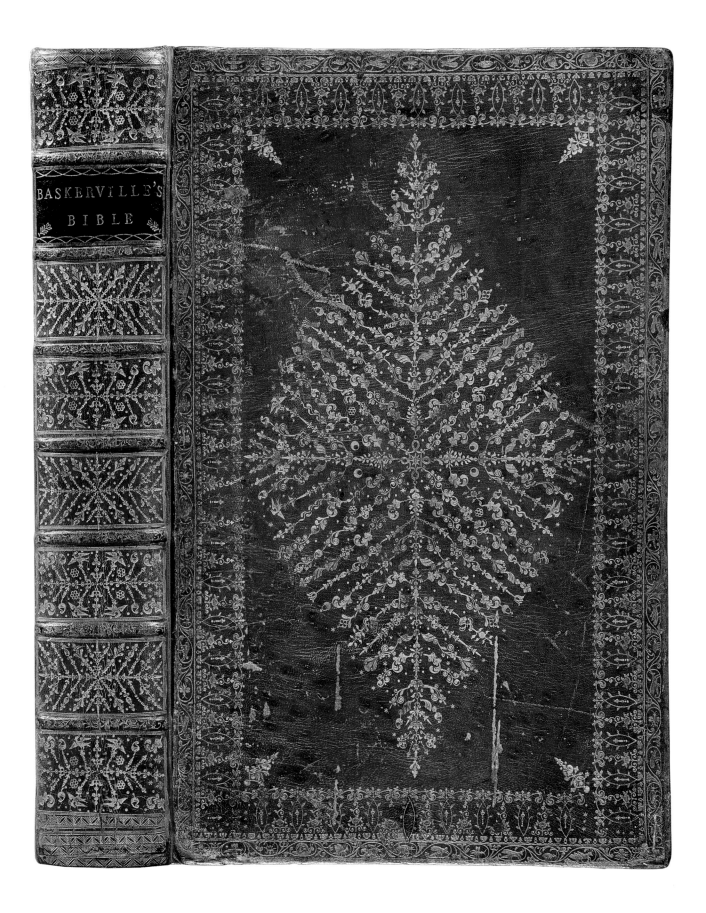

Irish Bookbinding

PHILIP MADDOCK

IRELAND IN THE LATE SEVENTEENTH and early eighteenth centuries was a country with severe status anxiety.[1] The Irish Parliament that met in Dublin was particularly sensitive about comparisons with the English Parliament in Westminster and in 1727 voted to erect the first purpose-built parliament building in the world.[2] At the same time, members voted that fair copies—which is to say neat, exact copies of corrected drafts—should be made of all of the journals of both the House of Lords and the House of Commons and that they be bound appropriately. The Lords journal for 1731 records a payment in March of that year to Enoch Sterne of 426 pounds, 13 shillings, and sixpence for transcribing the old journals from 1634 to 1666, and in March 1737 he was paid 583 pounds, 6 shillings, and eightpence for transcribing and binding the journals from 1698 to 1715.[3] Each journal measured approximately twenty-one by fourteen inches, and as every volume was richly decorated with gold tooling, this represented a huge volume of work and a significant subsidy for the bookbinders of Dublin.

Following the Act of Union in 1800, the Irish parliamentary journals were placed in storage. In about 1895 they were brought to the attention of Sir Edward Sullivan, an amateur bookbinder who made rubbings of all 149 volumes and took photographs of nineteen.[4] His plan was to publish a monograph with illustrations of fifty volumes.[5] Unfortunately, there was insufficient support for the project, and his book was never realized. In 1922 all 149 volumes of the journals were destroyed in the burning of James Gandon's Neoclassical Four Courts building during the Irish Civil War. The only extant records are the rubbings that are housed in the National Library of Ireland and the negatives of fifteen photographs now in the National Photography Archive.

Fortunately we know what the Irish parliamentary journals looked like both from the rubbings and from a number of Irish bindings, such as one on John Baskerville's 1763 edition of the Bible, which is closest in size to the journals (P. 200). It is covered in red goatskin, and the covers are framed by a gold-tooled insect roll, a thistle roll, and then a border made with individual foliate tools. The central panel is filled with a diamond-shaped lozenge that was created by the repeated use of individual small tools. This particular

example is very close to the Lords journal for the same year, which features the same outer insect roll and a central, multilobed figure with an eight-pointed star.[6] French bindings on larger folios of the same period achieve a similar richness. However, the French binders employed large engraved brass plates and an arming press, using a few hand tools more selectively. This gives a somewhat flat effect, whereas the Irish bindings, which were tooled entirely by hand, are much more lively. Since each hand tool encountered the goatskin at a slightly different angle, the reflections change continuously as the book is moved, unlike the flat reflection achieved when a single plate was used. In this example, apart from the rolls, there are over two thousand individual tool impressions.

Another example of the 1763 Baskerville folio Bible (FIG. 1), also covered in red goatskin, has boards framed by five rolls, from a simple "dog's tooth" roll on the outside to a "smiling sun roll" on the inside, with repeated use of a pomegranate motif. The central lozenge, a characteristic of Irish bindings, comprises curved, leafy branches and was again filled up through the use of many small hand tools. The central roundel was created by the repeated application of a broad-based flame

Bound by a Parliamentary binder, printed by John Baskerville. The Holy Bible, 1763. Private collection. Cat. 159.

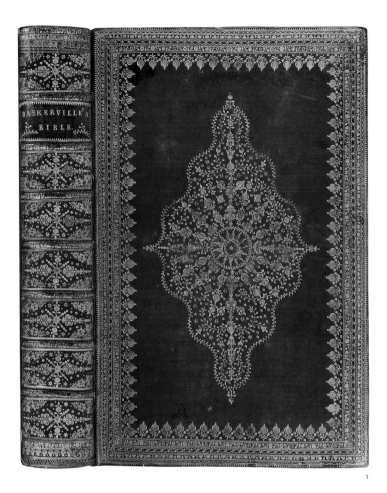

tool. The curved leafy tool is first seen in the 1767 Commons journal and last observed in the 1786 volume; the other tools used in this binding would place it in the later end of this range of dates. The armorial bookplate of Thomas Taylor, then 1st Marquess of Headfort, is inside the front cover.

In 1752 the House of Commons authorized printed editions of the parliamentary journals, and the great majority were bound in calfskin with varying amounts of ornamentation. A number of sets, however, were placed in elaborate bindings for presentation to dignitaries such as William Fitzwilliam, 3rd Earl Fitzwilliam (SEE ALSO P. 133, FIG. 5). Volume eight, the index volume of the set, was bound in red goatskin and decorated with the familiar gold-tooled frame and a central lozenge made up of repeated marks from small hand tools (FIG. 2).

The second major source of patronage for Irish bookbinding was Trinity College Dublin.[7] In 1732 the college inaugurated Samuel Madden's premium scheme, whereby the best-performing students in each class were given a book in a prize binding. Six years later, work started on the Printing House at the instigation, and with the financial support, of John Stearne, bishop of Clogher. The architect was Richard Castle, and the building remains an architectural gem in the center of the campus to this day (SEE P. 64, FIG. 2).[8] The first book produced at the University Printing House was the 1738 edition of Plato's *Dialogues*, in an edition of 780. While most were bound up in plain or lightly decorated calfskin, thirty deluxe copies were printed on larger paper and finely bound. The binding, which is covered in a blue-black goatskin, is credited to Joseph Leathley or one of the craftsmen who worked for him (FIG. 3). The

covers are framed by a border comprising two rolls and two single gilt lines, or fillets, and the central lozenge is made up by the repeated use of small tools. Other schools and institutions followed the Trinity example of giving out prize books. A fine example of this is a 1750 edition of Julius Caesar, given out by the Hibernian Academy as a prize binding (CAT. 167).

In 1745 Trinity College published the first three volumes—*Virgil*, *Horace*, and *Terrence*—of John Hawkey's famous Classical translations. *Juvenal* and *Perseus* came out in 1746, and the final volume, *Sallust*, appeared in 1747. The Hawkey classics have proven to be the most enduring of the early-eighteenth-century Irish bindings, and this exhibition includes two examples of the works of Terrence that suggest the range of finishing techniques that could be applied to different copies of the same book (FIGS. 4A–B). One is bound in red goatskin

Fig. 1
Bound by a Parliamentary binder,
printed by John Baskerville. The Holy
Bible, 1763. Philip and Niamh Maddock.
Cat. 160.

Fig. 2
Bound by Boulter Grierson's binder,
printed by Boulter Grierson. *The
Statutes at Large Passed in the
Parliaments Held in Ireland*, index, 1765.
Philip and Niamh Maddock. Cat. 149.

4a

3

Fig. 3
Bound by Joseph Leathley's
binder, printed by Trinity College,
E Typographia Academiae. Plato,
Dialogues, 1738. Private collection.
Cat. 154.

Figs. 4a–b
Bound by Joseph Leathley's binder,
edited by John Hawkey, printed
by Trinity College, E Typographia
Academiae. *Terentius*, 1745, 2 copies.
Private collections. Cats. 155–56.

4b

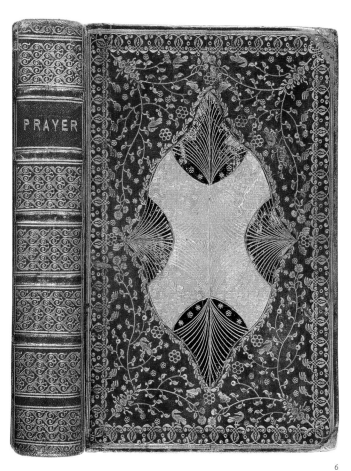

5

6

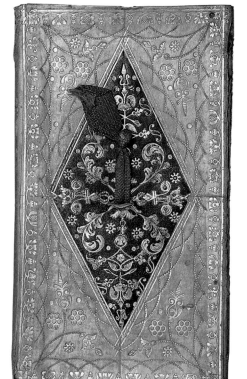

7

8

Fig. 5
Printed by John Baskerville. *Novum Testamentum Graecum*, 1763. Philip and Niamh Maddock. Cat. 169.

Fig. 6
Printed by John Baskerville. The Book of Common Prayer, 1762. Private collection. Cat. 168.

Fig. 7
Bound by Watson Bindery, printed by Samuel Watson. Memorandum Book, 1764. Philip and Niamh Maddock. Cat. 163.

Fig. 8
Printed by J. Watson Stewart. Memorandum Book, 1810. Philip and Niamh Maddock. Cat. 172.

with a roll-produced gilt border and a central lozenge formed with multiple individual small tools (FIG. 4B); the other is larger and features gold tooling that is particularly bright and crisp (FIG. 4A).

Individual patrons also commissioned fine bindings. A particularly striking example is the Baskerville 1762 Book of Common Prayer bound for James Stewart of Killymoon, County Tyrone (SEE P. 133, FIG. 6). In this case the central lozenge was accentuated by a paper onlay, and the gold tooling was applied directly on the paper. This use of paper as an onlay is one of the distinguishing features of eighteenth-century Irish bookbindings.

Baskerville's 1763 *Novum Testamentum Graecum* (FIG. 5) and 1761 Book of Common Prayer (FIG. 6) illustrate another technique characteristic of Irish bindings: the repeated use of either solid or dotted gouge tools to produce an effect known as featherwork. The greatest examples of featherwork occurred on the Commons journal of 1753, now unfortunately destroyed. The 1761 Book of Common Prayer is a particularly important example, as it is a recent discovery and gives rise to hope that further examples of these rare bindings are extant. In this particular case, the laid lines on the white onlay are clearly visible and confirm that it is paper.

Dublin printers and publishers also produced fine bindings as a speculative commercial venture, the most obvious examples being the almanacs the Dublin printer William Watson made throughout most of the eighteenth century. Less well known are memorandum books, which were presented in ornate goatskin slipcases.[9] The books themselves could be quite simply bound in silk or matching vellum binding, as seen in an example from 1764 (FIG. 7); a miniature memorandum book from 1810 is virtually identical to a contemporary London production (FIG. 8).

In 1800 the Act of Union passed, and the Irish Parliament was abolished. Copyright law now applied to Ireland, and the Irish book trade went into decline. Fine and highly accomplished bindings were still produced, but the designs were now mostly indistinguishable from English or Continental models.

NOTES

1 For the subject of Irish bookbinding in general, see Craig 1954.

2 Johnston-Liik 2002, p. 40.

3 Lascelles 1852, vol. 2, vii, pp. 30, 33.

4 Sullivan 1914.

5 "A Volume Containing Rubbings by Sir Edward Sullivan of the Bookbindings of the Irish Houses of Parliament. With Two Facsimiles in Colour," c. 1900, National Library of Ireland, Dublin, MS 3017.

6 The endpapers of the Baskerville Bible are Dutch marbled paper, and one of the free endpapers has manuscript additions concerning the genealogy of the family of the Reverend W. P. Turpin of Ballycommmon Glebe in King's County, now County Offaly.

7 Healy and McDonnell 1987.

8 Kinane 1994, p. 59 and following.

9 For a discussion of the recently discovered provenance of an Irish memorandum book in this exhibition (CAT. 166), see Fitzpatrick 2014.

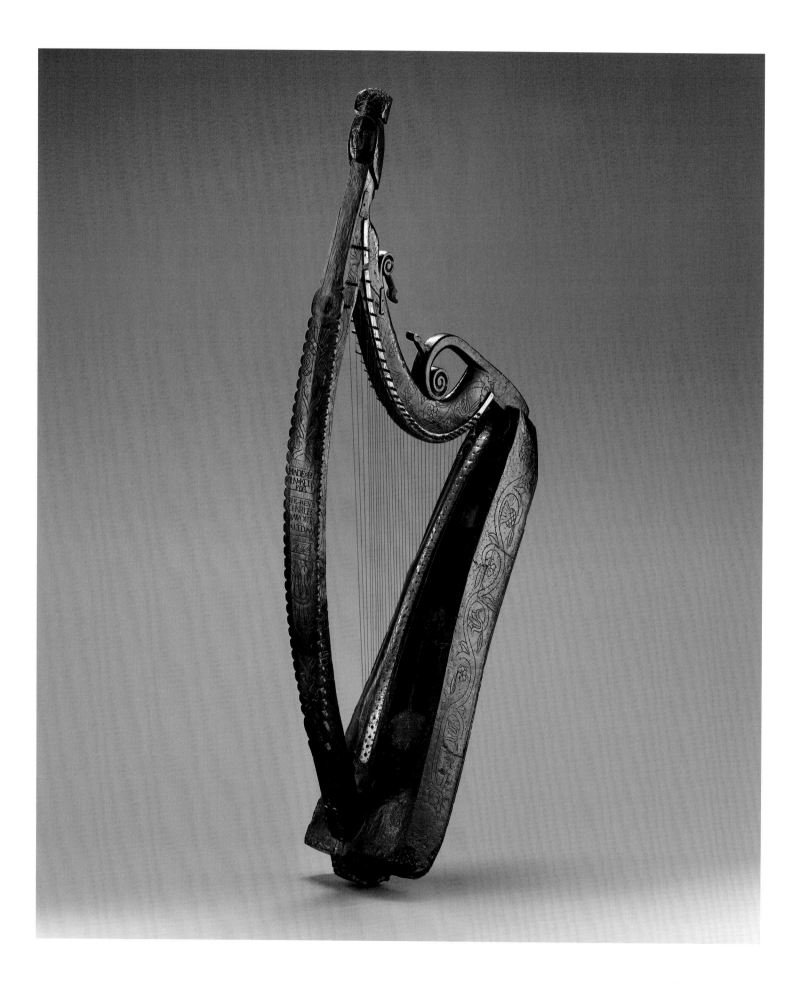

Early Musical Instrument Making in Ireland

DARCY KURONEN

NO OTHER INSTRUMENT is more connected with Ireland than the harp (*cláirseach* in Irish), a symbol that is featured on the nation's coinage. Triangular-frame harps are first documented in Ireland by at least the twelfth century, and a few noteworthy survivors may date to the sixteenth century or earlier.[1] During its early history, the *cláirseach* rose to a place of high musical stature, played to accompany the recitation of bardic poetry. With the decline of Gaelic culture, its social standing was gradually eroded, though instruments continued to be manufactured into the mid-1700s. From its beginnings, the *cláirseach* grew in size from a smallish instrument that could be held on the lap to a much larger one that rested on the floor and stood as tall as sixty-five inches. Unique among European harps, the *cláirseach* has strings of brass rather than gut and was plucked with long, pointed finger-nails rather than fingertips, which produced a bright and resonant tone. An example by John Kelly dating from 1734 (P. 206) was made for

John Kelly. Harp (*Cláirseach*), 1734.
Museum of Fine Arts, Boston, Leslie
Lindsey Mason Collection. Cat. 308.

the Reverend Charles Bunworth of Baltdaniel, County Cork, a great musical patron who helped preserve the dying tradition of Irish harp playing during the eighteenth century. Of the fifteen or so prerevival Irish harps of this type, this is the only one located outside of Ireland and Scotland.

Such was the association of the harp in Ireland that soon after the fashion for playing the early wire-strung version died out in the late eighteenth century, the Dublin craftsman John Egan began introducing new models that musicians could use to carry on the nation's harping tradition. His first, in 1809, was a wire-strung instrument that he essentially made to resemble the ancient *cláirseachs* but with a sound box that is curved and laminated like that of the concert pedal harp. Egan is better known, however, for his gut-strung Portable Irish Harp, introduced in 1819 and later called the Royal Portable Harp (SEE FIGS. 1–2).[2] These small instruments were available in black, blue, green, and natural finishes and decorated with foliate patterns of gold shamrocks and acanthus. Over eighty extant examples of these handsomely ornamented harps have been documented, and although many were likely owned by musical amateurs,

one exceptional instrument was presented to George IV during his 1821 visit to Ireland. In lieu of pedals to change the pitch of selected strings, Egan devised various hand-operated mechanisms. On simpler models these took the form of brass blades placed near the upper ends of the strings, which could be turned individually by hand to raise the pitch of a string by a half step. On his more elaborate instruments, however, he added a series of five levers, or "ditals," placed in the front column; when engaged, these activate a mechanism in the neck that acts upon all the notes of the same pitch, as is the case with pedal harps.

Violins are today closely linked with traditional Celtic fiddle music, but research has not yet revealed exactly when the first examples were manufactured in Ireland. The country never produced instruments rivaling those of the great Italian luthiers, but starting in the eighteenth century, there were a handful of Irish makers possessing the skills to create violins of better-than-average quality.[3] Chief among these was Thomas Perry in Dublin, whose business partner after 1790 was William Wilkinson. In 1794 Wilkinson became Perry's son-in-law and carried on the business until at least 1828, ten years after Perry's

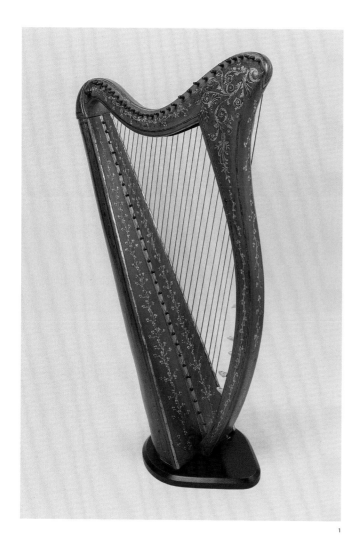

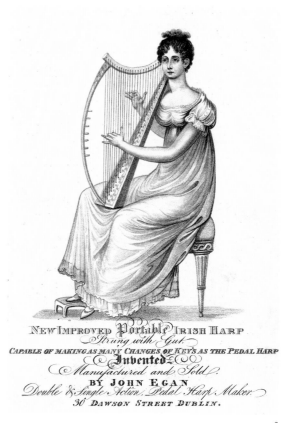

death. Instruments from their shop are both dated and numbered, but the numbering, which ranges as high as 4848, apparently does not reflect serial production. Their firm was undoubtedly prolific, however, producing numerous violins, violas, cellos, and basses. They also made at least a few dance master's violins (SEE FIG. 3), a diminutive type that was used from the sixteenth through the nineteenth century by dance instructors. Although the sound was small and delicate, it was loud enough to provide music for private lessons that took place in small chambers. In France such an instrument was called a *poche* or *pochette* (referring to a pocket, where it was sometimes carried), but in English-speaking countries it was often referred to as a "kit." The most interesting product from Perry's

workshop is an instrument called a cither viol, of which several examples survive (SEE FIG. 4). Marketed as a bowed companion to the so-called English guitar, a type of cittern that became popular during the 1700s (and which Perry also occasionally manufactured), the cither viol has up to five pairs of metal strings rather than individual ones of gut, as does a regular violin. Exactly how these instruments were played is unknown, but some of them are elegantly appointed, with ivory finger-boards and tailpieces and gold-plated tuning mechanisms.

The piano has a rich history in late-eigh-teenth- and early-nineteenth-century Ireland, with a small group of Dublin craftsmen pro-ducing some remarkably handsome pieces.[4] The leading light in this group was William

Fig. 1
John Egan. Portable Harp, c. 1820. The O'Brien Collection. Cat. 307.

Fig. 2
Handbill Printed for John Egan, Harp-Maker, Dublin, c. 1820–35. Laid paper; 24.8 × 16.5 cm (9 ¾ × 6 ½ in.). Private Irish collection.

Fig. 3
Thomas Perry. Kit/Pochette, early 19th century. Yale University Collection of Musical Instruments. Cat. 310.

Fig. 4
Perry & Wilkinson. Cither Viol (Sultana), 1794. Museum of Fine Arts, Boston, Leslie Lindsey Mason Collection. Cat. 309.

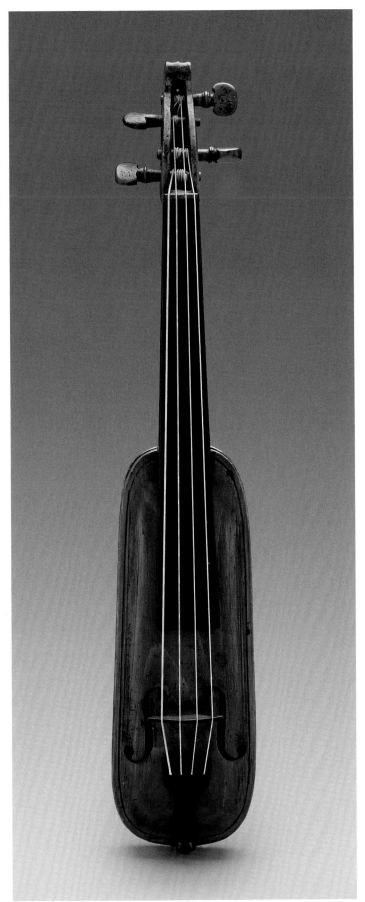

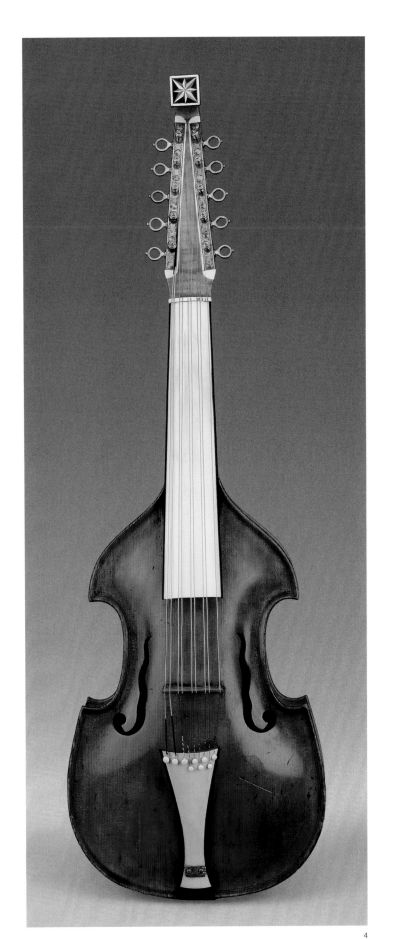

3

4

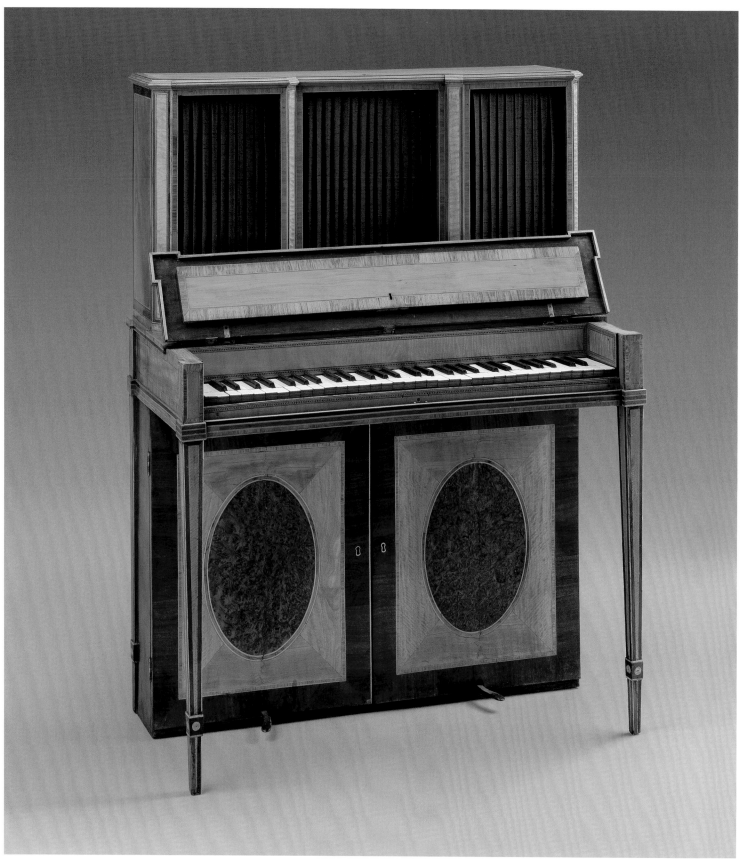

Southwell, who created several exceptionally original designs with very elegant casework. Southwell's career and surviving instruments have been well documented, but far less is known about Robert Woffington, who worked in the same city and was probably influenced by him.[5] It is also entirely possible that the same cabinetmaker executed the case decoration on some of these instruments, which would help explain their similarities. Only five extant instruments by Woffington have been documented—two upright pianos (SEE FIG. 5), two harpsichords, and a chamber organ—but the two pianos are quite progressive in their form. Scholarship on upright pianos in which the strings extend down to the floor (rather than starting at the level of the keyboard and extending only upward) places their origins at around 1800. But based both on musical and furniture elements, Woffington's would seem to date from about 1790, if not slightly earlier. The one shown here reputedly belonged at one time to the novelist Sydney Owenson, better known as Lady Morgan (SEE P. 123, FIG. 5), who, as shown by Tom Dunne in his essay in this catalogue, was instrumental in promoting interest in the music and imagery of the harp.

There were numerous makers of woodwinds and brasswinds active in Dublin during the eighteenth and nineteenth centuries, producing a variety of instruments including clarinets, flutes, and keyed bugles. But a far more prominent wind instrument associated with Ireland is the bagpipe, especially union pipes or *uilleann* pipes, a particular type developed by the early eighteenth century.[6] Unlike the more familiar Scottish highland bagpipes, the air bag of union pipes is filled not by the breath but by a leather bellows pumped with the right arm. A player renders the melody on a small single pipe, called the chanter, and produces chords by using the right wrist to press keys on the long pipes, or regulators. With this unique capability of full chordal harmony, union pipes have sometimes

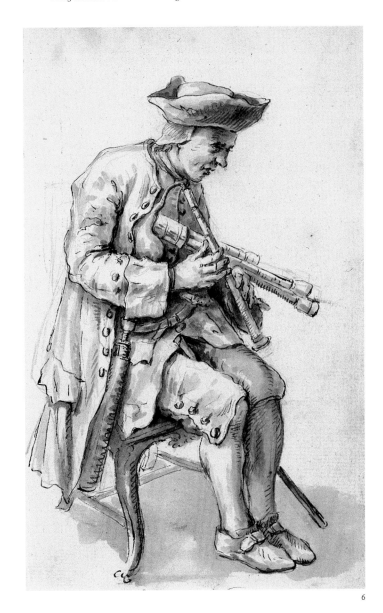

6

been called the Irish organ. One of the earliest known depictions of the *uilleann* pipes being played occurs in the sketch *Blind Daniel the Piper* (FIG. 6) from Hugh Douglas Hamilton's remarkable album of drawings, *The Cries of Dublin* (CAT. 50; SEE ALSO P. 22, FIGS. 3–4).[7]

NOTES

1 Armstrong 1970.

2 Hurrell 2003.

3 Milnes, Baker, and Fairfax 2000, pp. 68–73.

4 Flood 1909.

5 For Southwell, see Cobbe 1997.

6 See O'Neill 1973, pp. 156–68.

7 Laffan 2003b, pp. 134–35.

Fig. 5
Robert Woffington, casework possibly by William Moore. Upright Piano, c. 1790. Museum of Fine Arts, Boston, Gift of the New England Conservatory of Music. Cat. 311.

Fig. 6
Hugh Douglas Hamilton. *Blind Daniel the Piper*, from *The Cries of Dublin*, 1760. Private collection. Cat. 50.

the Seal of Common Pleas, both of which he possessed while lord chancellor from 1703 to 1707. As James Butler, 2nd Duke of Ormonde, served as lord lieutenant at that time, both of their coats of arms appear within foliate cartouches on the work's fluted sides.[7]

The monteith was acquired by Chicagoan Mary Hooker Dole, a good friend and generous donor to the Art Institute's departments of Asian art and decorative arts. She initially lent it to the museum's exhibition of English eighteenth-century domestic silver, which was organized in 1940 under the "active auspices" of the Antiquarian Society, which has long served as a support group for the decorative arts.[8] Dole then left the object on long-term loan and bequeathed it upon her death in 1949. The monteith, which was originally used for cooling wine glasses or for serving punch, immediately became the centerpiece of the Art Institute's British silver collection in light of its monumental presence and illustrious provenance. Dole also bequeathed a handsome pair of wine ewers (FIG. 2) made in the 1740s by David Bomes, a Dublin silversmith of Huguenot descent.[9] These works contributed further luster to the Art Institute's connection with Ireland through their typically flat chasing that incorporates bunches of grapes as well as pinecone finials from the thyrsus, or staff, of Bacchus.

The Bolton monteith is not the only instance in this exhibition of the Great Seal of Ireland being melted down and made into another form at the request of a lord chancellor. Following the death of George II in 1760, John Bowes, the current occupant of that office, transformed his seal into a covered, double-harp-handled cup (SEE P. 121, FIG. 3) with the assistance of the Dublin silversmith Samuel Walker. Unlike his predecessor Cox, who discreetly affirmed his monteith's prior history through an inscription, Bowes celebrated his cup's earlier incarnation by prominently incorporating into its design

modified portraits of the king enthroned and on his mount, echoing those that originally appeared on the Great Seal from his reign. Nothing is known of the Bowes cup's subsequent provenance until it appeared for sale in the antiques department at Wanamaker's Department Store in Philadelphia in 1926. Patrick J. Lawler purchased the work, and the estate of his daughter Margaret donated it in 2008 to the Philadelphia Museum of Art, where it is at home with other fine English and Irish silver, much of which has been given over the years by the McIlhenny family.

After the Dole bequest in 1949, the next important Irish object entered the Art Institute's collection eight years later, when Robert Allerton, a great supporter of the Department of European Decorative Arts, saw an advertisement in *The Magazine Antiques* for an early-eighteenth-century walnut desk and bookcase (P. 166). Conveniently, it was on offer by Dorothy G. Hale, a dealer based in Chicago.[10] Allerton and the museum's curators envisioned the desk, which was described as originating in "England c. 1710," in one of the Art Institute's English period rooms. Acknowledging the top section's pronounced setback from its base, the application of marquetry inlay in an arabesque pattern enriching the surface, and the elaborate block-fronted drawers in the kneehole section, curator Meyric Rogers observed, "Occasionally . . . an object of pre-eminent quality appears which although so-to-speak off-center, adds zest and sparkle to the collection by its very variation from the norm."[11] Such quirkiness has come to be seen as peculiarly Irish, and the well-known English furniture historian Robert Wemyss Symonds had already suggested an Irish origin for the desk in a 1956 article in *Antique Collector*. In his essay, titled "Dean Swift's Writing Cabinet and Two Others," Symonds linked Chicago's desk with a strikingly similar example at the Victoria and Albert Museum, London, which boasted

a largely indecipherable inscription suggesting it had once belonged to Jonathan Swift.[12] Such an august Irish provenance only seemed to confirm the desk's place of manufacture. By 2007, when Desmond FitzGerald, Knight of Glin, and James Peill included Chicago's desk in their seminal *Irish Furniture*, the only change in the record had come with the discovery of a fourth closely related example.[13]

When the Knight of Glin and Peill traveled to Chicago in the autumn of 2007 to launch the publication of *Irish Furniture* at an event organized by the Chicago chapter of the Irish Georgian Society, they visited the Art Institute and of course wanted to see the desk again. When the curators showed it to them, they mentioned that the English furniture conservator Peter Holmes had discovered a pencil inscription on the bottom of the lower-right drawer—*John Kirkhoffer/fecit/1732*—on a visit to Chicago a few years earlier. This new information inspired the authors to publish an article in the October 2008 issue of the magazine *Antiques* announcing the discovery of the earliest known signed and dated example of Irish furniture in the hope that it might inspire more such examples to come out of the woodwork.[14] Furthermore, that discovery was used to propose an Irish attribution for the extended group of related examples. It also reinforced the idea that the Art Institute of Chicago should mount a survey of the arts in eighteenth-century Ireland in response to the Knight of Glin's long-cherished wish.

Indeed, the Knight of Glin's presence pervades this exhibition through his many scholarly publications, which have influenced the research of every author included here, as well as through his remarkable eye. The Art Institute's Department of Medieval to Modern Painting and Sculpture contacted him in 1995 regarding a full-length portrait in its collection (FIG. 3) that was a victim of mistaken identity. At the museum since 1922, it arrived as the work of John Singleton Copley.[15] The

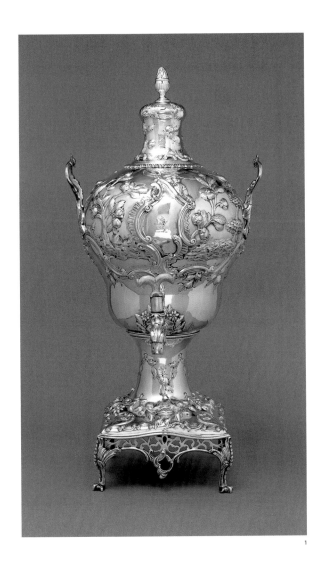

1

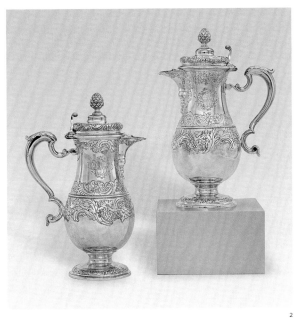

2

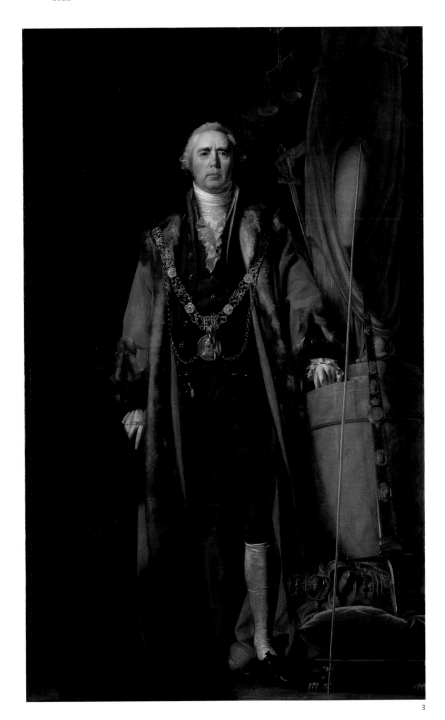

3

Fig. 1
John Laughlin, Jr. Covered Hot Water
Urn, 1770. Private collection. Cat. 277.

Fig. 2
David Bomes. Pair of Wine Ewers,
c. 1740. The Art Institute of Chicago,
bequest of Mary Hooker Dole,
1950.2032a–b. Cat. 263.

Fig. 3
William Cuming. *Charles Thorp as
Lord Mayor of Dublin*, c. 1800. The Art
Institute of Chicago, A. A. Munger
Collection, 1922.2196. Cat. 28.

Art Institute had then been searching for an important Copley for its holdings, and the Erich Galleries in New York produced this portrait, whose sitter was identified as Brass Crosby, a lord mayor of London. Thanks to the Knight of Glin's keen judgment and some detective work, however, the picture finally regained its true identity both in terms of its portraitist, Dubliner William Cuming, and its sitter, Charles Thorp, who served as the city's lord mayor at the turn of the nineteenth century.[16]

The portrait of Thorp took many cues for its ambient detail from Copley's American compatriot, Gilbert Stuart, who worked in Dublin between 1787 and 1793. In 1791 the artist secured one of his two most important Irish commissions, a full-length portrait of John Foster, the last speaker of the Irish House of Commons (P. 73, FIG. 15).[17] Stuart depicted Foster in the full regalia of his office, standing inside the Commons' column-lined chamber in the Houses of Parliament, which were designed by Sir Edward Lovett Pearce. A similar columnar screen can be seen in the background of Cuming's portrait: this is the interior of Dublin's Royal Exchange, which was built to the designs of Thomas Cooley in the 1770s, and where Thorp had executed the interior plasterwork.[18] The loan of the Foster portrait from the Nelson-Atkins Museum of Art in Kansas City makes it possible for viewers to appreciate for the first time just how much Cuming must have benefited from seeing Stuart's portrait of Foster.

In May 2009, Christie's London salesroom sold two hundred objects that the Knight of Glin spent a lifetime collecting for his ancestral home, Glin Castle, in County Limerick. As a result, a number of objects came to America, including six of the works found in this exhibition.[19] One, in fact, has a permanent home at the Art Institute, thereby linking the Knight of Glin to this museum forever. The piece in question is a small, full-length pastel portrait, *Miss Cunningham Holding Her King Charles Spaniel*

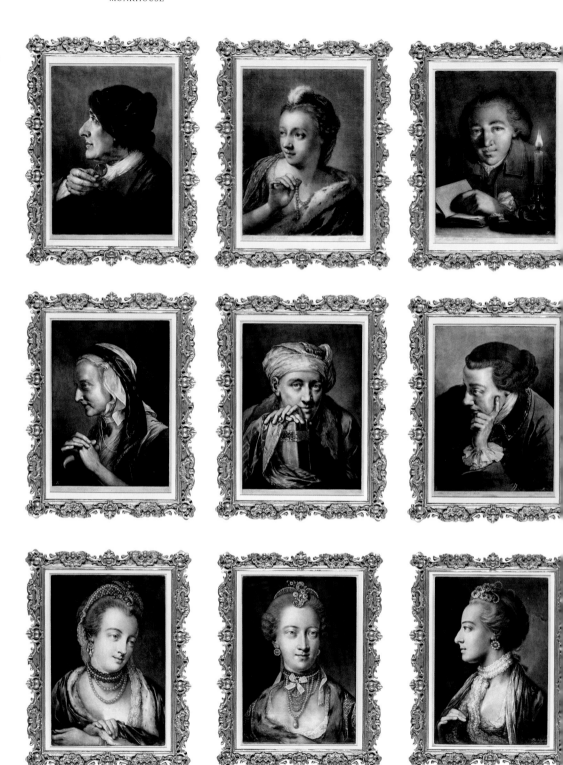

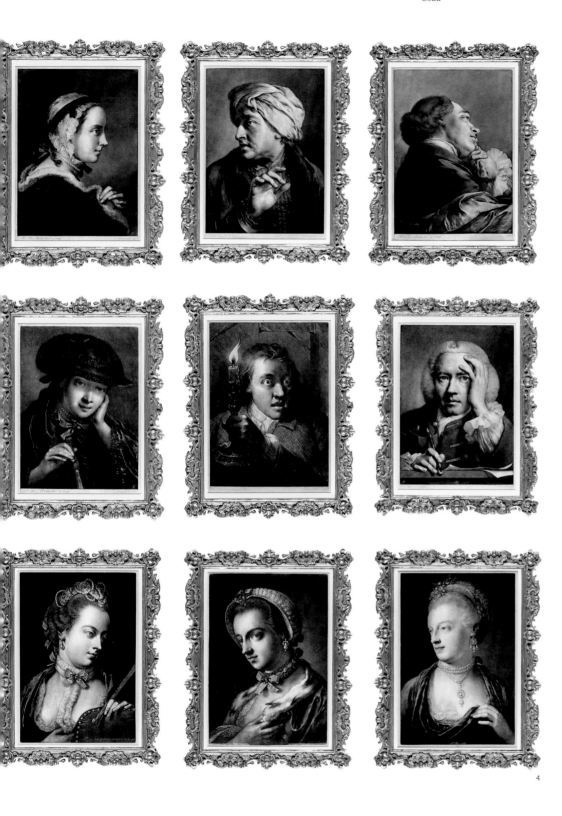

Fig. 4
Thomas Frye. Top and middle rows, *Life-Sized Heads*, 1760; bottom row, *Ladies, Very Elegantly Attired in the Fashion, and in the Most Agreeable Attitudes*, 1761–62. John Richardson. Cat. 43.

(P. 146), signed and dated *Rt: Healy. 1770*. As the Art Institute's Department of Prints and Drawings takes particular pride in its comprehensive holdings of eighteenth-century pastel portraits, a work by the highly accomplished but short-lived Dublin pastelist Robert Healy was high on their list of desired acquisitions. While studying at the Dublin Society Schools, Healy had developed a grisaille technique that was almost unique to himself and that a contemporary critic, Anthony Pasquin, likened to mezzotint engraving. Because mezzotints are another area of strength for this department, Healy's winsome portrait conveniently addresses in one work these two different mediums.

Mezzotints by the Irish-born artist Thomas Frye also appealed to the Knight of Glin; he collected for Glin Castle at least twelve impressions of *Life-Sized Heads* and *Ladies, Very Elegantly Attired in the Fashion*, which the artist made between 1759 and 1762, the last three years of his life.[20] The Knight of Glin was instrumental in securing the loan of a set of eighteen of these mezzotints (FIG. 4) that enjoy the rare distinction of having lived together since they were framed; the identical gilded, pressed-paper frames that still surround each of them suggest they were intended to be hung as a group. Given the delicacy of the medium, such frames contributed considerably to the viewer's pleasure, especially when seen under flickering candlelight. The vulnerability of pressed paper, however, has left few survivors, especially in such large numbers. The Knight of Glin felt the entire set should be included in this exhibition, and fortunately their owner, Picasso biographer Sir John Richardson, readily concurred.[21]

An important card table (FIG. 5) illustrated and discussed in *Irish Furniture* is included in the exhibition as a loan from the Philadelphia Museum of Art.[22] Made of dense, dark mahogany with robustly carved surfaces, such furniture appealed to

early-twentieth-century American collectors of the so-called robber baron class, such as patent lawyer Francis Garvan, who sought out the finest mid-eighteenth-century English and Irish furniture for his New York City residence.[23] He often consulted with Robert Symonds, author of a standard reference book on the subject, *The Present State of Old English Furniture* (1921). The publication includes an illustration of the table, which Symonds described in a 1928 letter to Garvan as "the finest Irish card table I have come across." "It is," he continued, "of exceptional quality as regards carving and [is] of an unusual elaborate design and entirely in its original condition as regards patina and color of the mahogany . . . It is an outstanding example of Irish furniture."[24] It also had an impeccable provenance, having most recently been owned by Percival Griffiths, a legendary collector of eighteenth-century English furniture and early textiles. Garvan clearly found Symonds's observations convincing: he bought the table, which his widow later gave to the museum in his memory in 1951.[25]

With the appearance of a mahogany chair from the entrance hall at Castle Coole, County Fermanagh, on the cover of *Irish Furniture* (SEE FIG. 6), this form, while attributed to the English architect James Wyatt, has become an icon of Irish Neoclassical furniture.[26] Wyatt may also have been responsible for including these chairs, with their distinctive saber legs and scrolled arms, in his alterations for the Daly family residence, Dunsandle in County Galway, as well as at Mount Kennedy, County Wicklow, which he designed for Lieutenant General Robert Cuningham, later 1st Lord Rossmore. The form was later adapted with much success by Mack, Williams and Gibton, the leading Dublin cabinetmaking firm in the first half of the nineteenth century, whose bench is included here (FIG. 7).[27] Now in the Museum of Art, Rhode Island School of Design, the bench previously sat in the front hall of

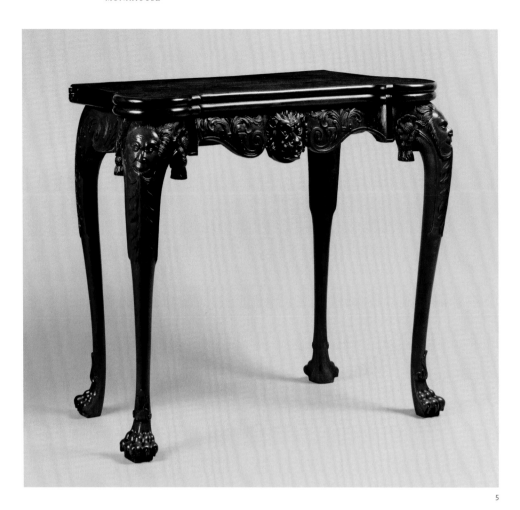

5

the New York apartment of the Irish glass specialist Phelps Warren, where the Knight of Glin and I frequently encountered it.[28] Warren inherited the bench from an uncle who most likely bought it, along with two side chairs, in New York in the 1920s, when so much Irish furniture was available for sale, including the hall chairs from Mount Kennedy.[29]

Denis Daly, a descendant of the aforementioned Daly family, brought *his* set of Wyatt-designed hall chairs from Dunsandle to Russborough, County Wicklow, which he acquired in 1931 (SEE P. 24, FIG. 7). In this magnificent Palladian country house, built in the late 1740s by Joseph Leeson, later first Earl of Milltown, Daly used the chairs once again in the entrance hall. On this occasion, the chairs sat beside niches originally intended for Classical sculptures that Leeson brought back from Rome.[30]

IRISH FURNITURE

THE KNIGHT OF GLIN AND JAMES PEILL

6

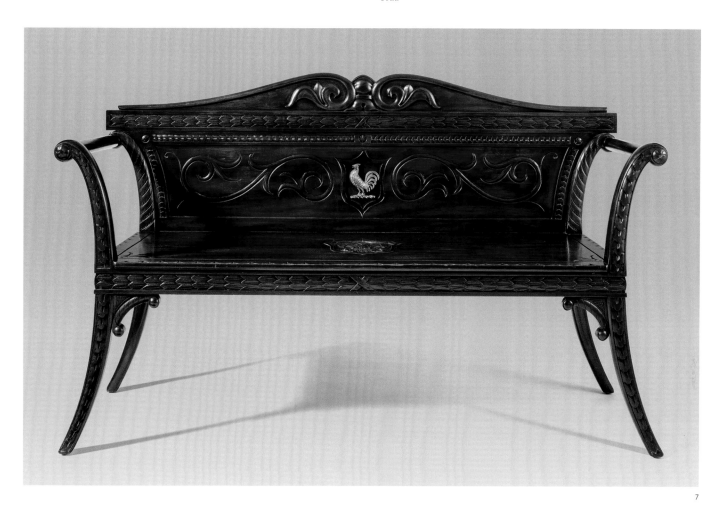

7

Fig. 5
Card Table, c. 1740. Philadelphia Museum of
Art, Gift of Mrs. Francis P. Garvan in memory
of her husband, 1951. Cat. 231.

Fig. 6
Front cover of Knight of Glin and James Peill,
Irish Furniture (Yale University Press), 2007.

Fig. 7
Williams and Gibton, after a design attributed
to James Wyatt. Hall Bench, 1829/42.
Museum of Art, Rhode Island School of
Design. Cat. 220.

Before Daly moved into Russborough,
the house had been requisitioned during the
Anglo-Irish War (1919–21) and subsequent Civil
War (1922–23). With troops near at hand, a
number of the marble sculptures and plaster
casts appear to have been used for target
practice, with some reduced to fragments. A
highly conscientious landlord, Daly consulted
the National Gallery of Ireland about the fate
of the fragments; the gallery had received
other antique sculptures from Russborough as
part of the Milltown gift in 1902. They jointly
concluded that the works were beyond repair,
and they were disposed of—by some accounts
in Russborough's lake.

In the mid-1980s, with Russborough now
owned by Sir Alfred and Lady Beit, the estate
administrator and a former gardener exhumed
the sculptures while the Beits were away and
sent them to London for auction at Phillips,

Son and Neale. Presumably in an effort to
make it difficult to trace the marbles back
to Russborough, the consignors provided a
limited and somewhat ambiguous provenance
that explained, "The following five lots were
Grand Tour acquisitions recently excavated
from the bed of a lake in the grounds of a 17th
century house."[31] The successful bidder for the
outstanding lot in the group—a diaphanously
draped statue of Venus Genetrix from the
second century A.D. (SEE P. 24, FIG. 8)—was
McAlpine Ancient Art. That firm sold the
work to the New York collectors and bene-
factors Lawrence and Barbara Fleischman
in 1987, who in turn donated it to the J. Paul
Getty Museum, Los Angeles, in 1996. The only
information accompanying the gift was the
description from the 1986 auction catalogue. In
light of that, the Getty confined its provenance
research to English seventeenth-century

country houses, obviously without success. When I asked the Knight of Glin where an antique sculpture with an eighteenth-century Irish provenance could be found in North America, he simply replied, "The Getty," hence its inclusion in this exhibition.[32]

As a souvenir of travel, the Venus Genetrix speaks for the high end, as it was a grand tourist's trophy sculpture purchased in Rome. At the other end of the spectrum are the small, crudely carved wooden crucifixes, often mistakenly referred to as penal crosses, such as the example on loan to this exhibition from the Snite Museum of Art at the University of Notre Dame (SEE P. 21, FIG. 2). This crucifix is one of many made as souvenirs for pilgrims to Lough Derg in County Donegal, the site of Saint Patrick's purgatory. The earliest known example is dated 1702, with the one included here incised 1776 on the verso.[33] The manufacture of crucifixes became something of a cottage industry for local inhabitants, who carved them from solid yew during the long winter months following the pilgrimage season, which extends from June to September. During that time, thousands of pilgrims worshipped at Lough Derg, often staying as long as nine days. The incised dates on the crucifixes record the year of the pilgrimage and the approximate date of manufacture. Otherwise there is little variation in their appearance between 1702 and the 1840s. On the recto Christ is shown in relief, surrounded by incised symbols of the Passion, with *INRI*—the Latin acronym for the inscription nailed to the Cross—above his head and a cock or skull and bones at his feet. On the verso, *IHS*, the first three letters in the Greek spelling of the name of Jesus, is incised on the transom, with the date of the pilgrim's visit on the shaft below.[34]

Any number of these objects must have crossed the Atlantic to Canada and the United States as cherished family heirlooms. Once in North America, and thus far removed from

their original context, their apparently primitive appearance came to be mistaken for the work of the Iroquois under the influence of French Jesuit missionaries in Canada. In that guise, this particular crucifix entered Notre Dame's Native American collection.[35] Only when it was lent to an exhibition of Native American art and artifacts in 1993 did a priest come forward with the correct identification, providing yet another example of recovered identity.[36]

We hope this exhibition will present Ireland as a complex mix of cultural cross-currents, that it will—in the Knight of Glin's words—"waken up the world to [the] staggering array of art that was manufactured . . . during this period."[37] In such a setting, a native silversmith like Thomas Bolton could find himself plying his trade in close proximity with the German-born cabinetmaker John Kirkhoffer, and the Dublin portraitist William Cuming might work alongside artist Gilbert Stuart, a rising star from America.

NOTES

1 Sotheby's 1929. G. W. Panter was a member of the Royal Society of Antiquaries in Ireland and the Royal Irish Academy, and he served a term as president of the Bibliographical Society of Ireland.

2 Sotheby's 1929. With pencil inscription in upper-right corner of cover signed *B.B.* for Bessie Bennett, whose thirty-nine-year career at the Art Institute included serving as curator of decorative art from 1914 to 1939, making her the first female curator in a major museum in the United States. Bennett figured prominently in the 2011 exhibition *Making History: Women of the Art Institute*, organized by Bart Ryckbosch for the museum's Ryerson and Burnham Libraries. An accompanying label acknowledged Bennett's ability to cultivate collectors and turn them into donors; such individuals would have included Robert Allerton and presumably Mary Hooker Dole.

3 For the study of Irish silver before the Panter sale catalogue of 1929, collectors and curators had to rely almost entirely on Jackson 1905 and Jackson 1911.

4 Sotheby's 1929, lot 64.

5 Alcorn 2000, pp. 332–33.

6 Sotheby's 1929, p. 12, lot 24.

7 Sotheby's 1933, frontispiece and pp. 18–19, lot 131. See also McCabe 2002, p. 57.

8 In 1940 decorative arts curator Meyric Rogers reported that the silver exhibition based on private Chicago collections was extended for six months. Rogers 1941, p. 26.

9 The accession number for the Bolton monteith is 1950.2031; the Bomes wine ewers are 1950.2032a–b. In addition to the Irish silver, Dole bequeathed the Art Institute nineteenth-century English ceramics and Chinese jades.

10 The advertisement for the walnut desk and bookcase appeared in *The Magazine Antiques* (June 1956), p. 489, which noted that the firm had a London branch at 15 King Street, Saint James's.

11 Meyric R. Rogers, "Three New Picassos for the Art Institute," *Art Institute of Chicago Quarterly* 51, 4 (November 15, 1957), pp. 82–85, quotation on p. 85.

12 Symonds 1956, pp. 60–63. Recent infrared photography by the Victoria and Albert Museum has revealed that the pencil inscription does not refer to Jonathan Swift.

13 Glin and Peill 2007, pp. 50–54.

14 Glin and Peill 2008, pp. 140–45.

15 "Copley's Portrait of Lord Mayor of London Is Acquired by the Chicago Art Institute," *American Art News* 20, 30 (May 6, 1922), p. 1.

16 O'Byrne 2013, p. 55. During research for the exhibition, another portrait by an Irish artist who had also suffered from identity theft came to light at the Norton Museum of Art in West Palm Beach, Florida. Although not included in this exhibition, it clearly indicates that the transformation of Cuming into Copley was not an isolated case. The portrait in question belonged to the John Schaffer Phipps family and hung in their Long Island home, Westbury House, before they donated it to the Norton. A full-length representation of George II, it bore a metal plaque identifying the artist as Sir Godfrey Kneller. When Sir Oliver Millar, Surveyor of the Queen's Pictures, spotted it during a visit to the museum, he immediately detected the hand of one of Kneller's students, the Irish-born Charles Jervas. Jervas was first appointed principal painter to George I in 1723, and he retained that honor until his death in 1739 during the reign of George II.

17 Barratt and Miles 2004, pp. 83–87.

18 For information on Thorp as a plasterer, see Lucey 2007, pp. 29–30.

19 See Christie's, London 2009, *p. 46*, lot 53 (CAT. 16); *p. 72*, lot 103 (CAT. 74); *p. 82*, lot 117 (CAT. 42); *p. 82*, lot 118 (CAT. 57), and *p. 93*, lot 150 (CAT. 215), and p. 104, lot 181 (CAT. 4).

20 Christie's, London 2009, p. 84, lots 119–21. Not surprisingly, the Art Institute's collection enjoys great strength in mezzotints, with an especially fine impression by Frye (SEE P. 157, FIG. 5) included in a related exhibition at the Art Institute, *Burnishing the Night: Baroque to Contemporary Mezzotints from the Collection*, curated by Suzanne Karr Schmidt and on display from February 21 to May 31, 2015.

21 Richardson has owned this group since he bought

them in the middle of World War II, after Christie's King Street headquarters in London was bombed and the firm had, by necessity, relocated to Spencer House overlooking Green Park.

22 Glin and Peill 2007, p. 116.

23 Symonds 1921, fig. 112. John D. Rockefeller, at Pocantico Hills, New York, and Henry Huntington, at San Marino, California, each had in their front halls examples of classic Irish side tables with squared, lion's-paw feet and broad aprons that sported masks. Furthermore, a pair of card tables nearly identical to Garvan's belonged at one time to William Randolph Hearst; Glin and Peill 2007, p. 234.

24 The letter is dated July 29, 1928. Transcriptions of Symonds's correspondence with Garvan are kept with the curatorial files of the Department of European Decorative Arts at the Philadelphia Museum of Art.

25 A copy of the December 29, 1951, letter offering the table to the Philadelphia Museum of Art, written by the secretary of Mabel Brady Garvan to the museum's director, Fiske Kimball, can be found in the curatorial files, Department of European Decorative Arts, Philadelphia Museum of Art.

26 In recent correspondence Angela Alexander noted that she found a reference to the London cabinet-maker William Kidd supplying the Castle Coole hall chairs in 1797. In Pat Kirkham's extended entry on the firm of Kennett and Kidd, she notes that in 1803 William Kidd "supplied a large amount of furniture to Castle Coole, County Fermanagh, for the 1st Earl Belmore" (Kirkham 1986). It should be noted that in the most recent Castle Coole guidebook the hall chairs have been described as the work of "Kidd of Dublin"; Garnet 2008, p. 9.

27 As the hall bench is stamped *Williams & Gibton*, it would date between 1829 and 1842, when that combination of names was in use. See A. Alexander 1995, p. 144.

28 The bench and chairs are illustrated in the Warren apartment; see Warren 1963, p. 328. Phelps Warren was the author of Warren 1970. For further discussion of nineteenth-century Irish furniture, including this bench and the firm of Mack, Williams, and Gibton, see A. Alexander 2014. For an illustration of a side chair from this suite, see Glin 1985, fig. 26.

29 For a discussion of James Wyatt at Mount Kennedy, see Robinson 2012, pp. 106–08. Shortly after the Gun Cuninghame family vacated Mount Kennedy in 1928, ten hall chairs from there appeared in New York for sale at Au Quatrieme, the forth-floor antiques department at John Wanamaker's. They were spotted by a relative who had spent part of his childhood at Mount Kennedy, and for sentimental reasons he acquired two for his own home in New York City. When his widow donated a family portrait by Angelica Kauffman to the Philadelphia Museum of Art that had also hung at Mount Kennedy, she wrote a detailed letter about her husband's possessions that is now kept in the curatorial files of the European paintings department at the Philadelphia Museum of Art.

30 O'Reilly 1998, pp. 88–89.

31 Phillips, Son and Neale, London 1986, pp. 33–36. Despite the ambiguity of the catalogue notes, the Beits found out what had happened and pursued the matter in a court case that they ultimately lost. Needless to say, they fired their estate administrator!

32 O'Boyle 2010, pp. 37–39; see also Mulvin 2001.

33 A. Lucas 1953, p. 146.

34 A. Lucas 1953, pp. 169–72.

35 The University of Notre Dame has maintained a collection of Native American artifacts since the 1870s.

36 Peterson 1993, p. 82.

37 Glin and Peill 2007, p. 5.

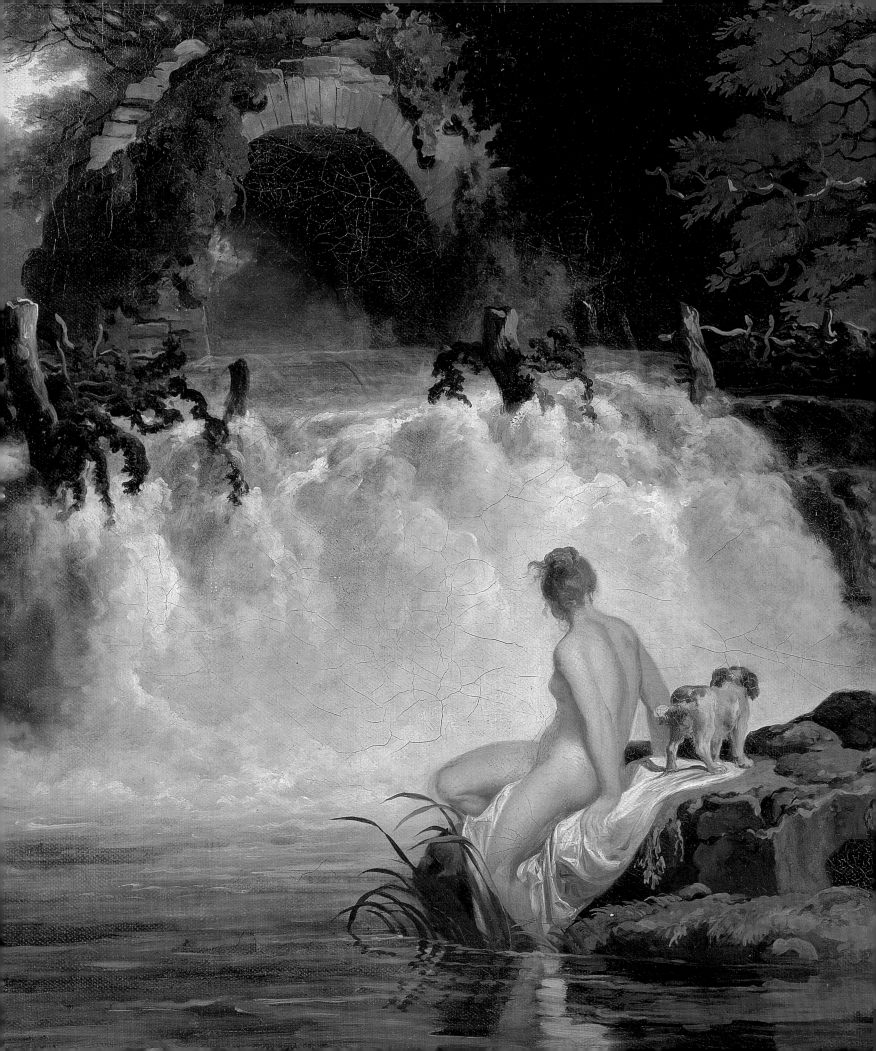

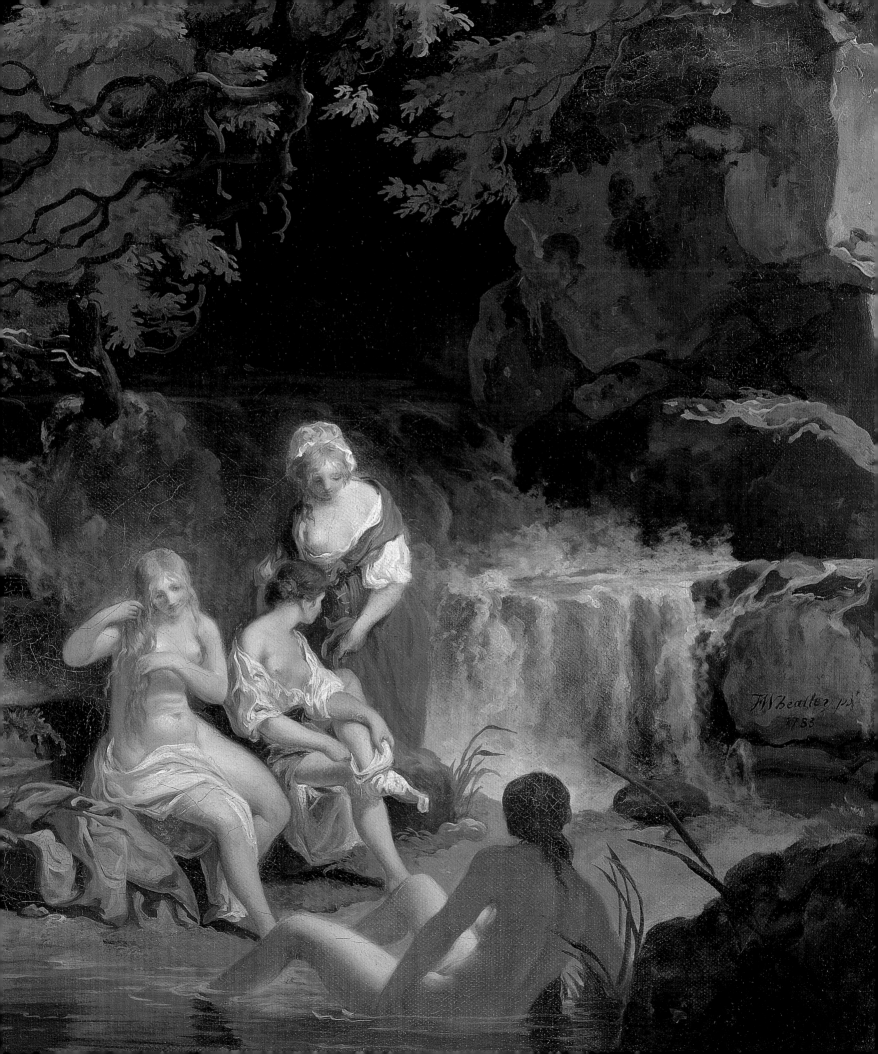

IRELAND

5

CHECKLIST OF THE EXHIBITION

Objects appear in the following order: paintings, portrait miniatures, and works on paper; antlers; arms and militaria; bookbindings; books; ceramics; furniture; glass; metalwork; musical instruments; sculpture; and textiles.

PAINTINGS, PORTRAIT MINIATURES, AND WORKS ON PAPER

ROBERT ADAM
Scottish, active in England, 1728–1792

1
Headfort House, Ireland: Design of a Chimneypiece for the Eating Parlour, 1771
Ink, wash, and graphite on paper; sheet: 65.2 × 37 cm
(25 ¹¹⁄₁₆ × 14 ⁹⁄₁₆ in.)
Yale Center for British Art, Paul Mellon Collection

2
Headfort House, Ireland: Elevation of the Eating Parlour, 1771
Ink, wash, and graphite on paper; sheet: 36.8 × 65.1 cm (14 ½ × 25 ⅝ in.)
Yale Center for British Art, Paul Mellon Collection

3
Headfort House, Ireland: Section of One End of the Parlour, 1771
Ink and wash on paper; sheet: 36.8 × 50.8 cm
(14 ½ × 20 in.)
Yale Center for British Art, Paul Mellon Collection

AGOSTINO AGLIO
Italian, 1777–1857

4
The Abbey on Inisfallen Island, Killarney, County Kerry, c. 1812
Watercolor on paper; 21.3 × 26.4 cm (8 ⅜ × 10 ⅜ in.)
Private collection

AARON ARROWSMITH
English, 1750–1823

5
Map of Ireland, 1811
Hand-colored engraving on paper, laid down on linen; each section 94.6 × 73.7 cm
(37 ¼ × 29 in.)
The O'Brien Collection

WILLIAM ASHFORD
English, active in Ireland, c. 1746–1824

6
Belan House, County Kildare, c. 1780
Oil on canvas; 106.6 × 79 cm (42 × 31 ⅛ in.)
University of Michigan Museum of Art, Gift of Booth Newspapers, Inc., in memory of George Gough Booth and Ralph Harmon Booth

7
Mount Kennedy, County Wicklow, Ireland, 1785
Oil on canvas; 42.1 × 61.1 cm (16 ⁹⁄₁₆ × 24 ¹⁄₁₆ in.)
Yale Center for British Art, Paul Mellon Collection

RUPERT BARBER
Irish, 1719–after 1778

8
William Thompson, a Dublin Beggar, Aged 114, 1744
Enamel in an ivory and ormolu frame; 9.8 × 7.9 cm
(3 ⅞ × 3 ⅛ in.)
New Orleans Museum of Art, Gift of Mrs. Richard B. Kaufmann, 74.396

GEORGE BARRET
Irish, active in England, c. 1732–1784

9
Powerscourt, County Wicklow, 1760/62
Oil on canvas; 73.3 × 97.2 cm (28 ⅞ × 38 ¼ in.)
Yale Center for British Art, Paul Mellon Collection

10
A Wooded River Landscape with Anglers and a Ruined Mill, 1762
Oil on canvas; 100 × 124.5 cm (39 ½ × 49 in.)
Private collection, Chicago

JAMES BARRY
Irish, active in England, 1741–1806

11
The Education of Achilles, c. 1772
Oil on canvas; 102.9 × 128.9 cm (40 ½ × 50 ¼ in.)
Yale Center for British Art, Paul Mellon Fund

POMPEO BATONI
Italian, 1708–1787

12

James Caulfeild, 4th Viscount Charlemont (Later 1st Earl of Charlemont), 1753–56
Oil on canvas; 97.8 × 73.7 cm (38½ × 29 in.)
Yale Center for British Art, Paul Mellon Collection

13

Robert Clements, Later 1st Earl of Leitrim, 1754
Oil on canvas; 101 × 73 cm (39¾ × 28¾ in.)
Hood Museum of Art, Dartmouth College, Hanover, purchased though a gift from Barbara Dau Southwell, Class of 1978, in honor of Robert Dance, Class of 1977, a gift of William R. Acquavella, and the Florence and Lansing Porter Moore 1937 Fund

14

Mary Quin Taylor, Viscountess Headfort, Holding Her Daughter, Mary, 1782
Oil on canvas; 178.4 × 146.7 cm (70¼ × 57¾ in.)
Sarah Campbell Blaffer Foundation, Houston

15

Thomas Taylor, Viscount Headfort, 1782
Oil on canvas; 178.4 × 146.7 cm (70¼ × 57¾ in.)
Sarah Campbell Blaffer Foundation, Houston

NATHANIEL BERMINGHAM
Irish, active in England, c. 1709–1779

16

The Arms of John Boyle, 5th Earl of Cork and Orrery, c. 1740
Cut paper laid between glass; 38.1 × 31.1 cm (15 × 12¼ in.)
Private collection

16

SAMUEL FREDERICK BROCAS
Irish, c. 1792–1847

17

A View of Limerick, 1820/30
Oil on canvas; 27.9 × 38.1 cm (11 × 15 in.)
Private collection

WILLIAM HENRY BROOKE
Irish, 1772–1860

18

Portrait of a Girl Sketching, 1st quarter of the 19th century
Ink, watercolor, and gouache on paper; 22.2 × 16.5 cm (8¾ × 6½ in.)
Yale Center for British Art, Paul Mellon Collection

JOHN BROOKS
Irish, active in England, c. 1710–after 1756
After James Latham
Irish, 1696–1747

19

Dr. George Berkeley, Bishop of Cloyne, 1740/56
Mezzotint on paper; sheet: 36.8 × 26 cm (14½ × 10¼ in.)
Private collection

ADAM BUCK
Irish, active in England, 1759–1833

20

Portrait of a Woman, 1805
Watercolor on ivory; 7.9 × 7 cm (3⅛ × 2¾ in.)
Museum of Fine Arts Houston, The Rienzi Collection, Bequest of Caroline A. Ross

21

The Artist and His Family, 1813
Watercolor, ink, and graphite on card; 44.6 × 42.4 cm (17⁹⁄₁₆ × 16¹¹⁄₁₆ in.)
Yale Center for British Art, Paul Mellon Collection

FREDERICK BUCK
Irish, 1771–1840

22

Portrait of Captain John James, c. 1800
Watercolor on ivory; 7.5 × 5.1 cm (2¹⁵⁄₁₆ × 2 in.)
The Art Institute of Chicago, the Colonel Alexander F. and Jeannie C. Stevenson Memorial Collection, 1958.67

18

CATHERINE MARIA BURY, COUNTESS OF CHARLEVILLE
Irish, 1762–1851

23

Charleville Forest, County Offaly, 1812/20
Aquatint and etching on paper; 7.7 × 11.6 cm (3 × 4⁹⁄₁₆ in.)
Rolf and Magda Loeber

SIR WILLIAM CHAMBERS
Scottish, born Sweden, active in England, 1723–1796

24

Designs for Two Chimneypieces in Lord Viscount Charlemont's Casino at Marino, Dublin, c. 1758–59
Ink and wash on paper; 41.6 × 28.9 cm (16⅜ × 11⅜ in.)
The Metropolitan Museum of Art, New York, The Elisha Whittelsey Collection, the Elisha Whittelsey Fund, 1953

GIOVANNI BATTISTA CIPRIANI
Italian, active in England, 1727–1785

25

Four Studies for Statues of Apollo, Venus, Bacchus, and Ceres for the Marino Casino, Clontarf, County Dublin, 1760
Ink and wash over graphite on paper; each approx. 25 × 14 cm (9⅞ × 5½ in.)
Private collection

CHARLES COLLINS
Irish, 1694/1704–1744

26
Still Life with Game, 1741
Oil on canvas; 96.5 × 111.8 cm (38 × 44 in.)
Private collection

JOHN COMERFORD
Irish, c. 1770–1832

27
Anne Helena Trench, 1818
Watercolor on ivory; 8.1 × 7 cm (3 3/16 × 2 3/4 in.)
Cincinnati Art Museum, Gift of Mr. and Mrs. Charles
Fleischmann in memory of Julius Fleischmann,
1990.1875

WILLIAM CUMING
Irish, 1769–1852

28
Charles Thorp as Lord Mayor of Dublin, c. 1800
Oil on canvas; 228.7 × 141.6 cm (90 1/16 × 55 3/4 in.)
The Art Institute of Chicago, A. A. Munger
Collection, 1922.2196

PUBLISHED BY WILLIAM DARTON, JR.
English, c. 1781–1854

29
*Walker's Tour through Ireland: A New Geographical
Pastime*, published March 9, 1812
Engraving with watercolor on paper; map and
instructions: 50 × 85.6 cm (19 11/16 × 33 11/16 in.); sleeve:
17.8 × 10.8 × 1.1 cm (7 × 4 1/4 × 7/16 in.)
Rolf and Magda Loeber

JACQUES-LOUIS DAVID
French, 1748–1825

30
Cooper Penrose, 1802
Oil on canvas; 130.5 × 97.5 cm (51 3/8 × 38 3/8 in.)
Timken Museum of Art, The Putnam Foundation
Collection, San Diego

F. J. DAVIS
Irish, active c. 1845

31
The State Ballroom, Saint Patrick's Hall, Dublin Castle,
mid-19th century
Oil on wood; 95.3 × 130.8 cm (37 1/2 × 51 1/2 in.)
The Irish Art Collection of Brian P. Burns

MARY DELANY
English, active in Ireland, 1700–1788

32
Six Flower "Mosaicks," after 1771
Cut paper and watercolor; each approx. 25.4 ×
20.3 cm (10 × 8 in.)
Private collection
For individual titles, see page 117, note 78.

JOHN DIXON
Irish, active in England, c. 1730–1804
After Nathaniel Dance
English, 1735–1811
Published by John Boydell
English, 1719–1804

33
Mr. Garrick in "Richard the Third," published
April 28, 1772
Mezzotint on paper (proof before letters); plate:
63.5 × 40 cm (25 × 15 3/4 in.); sheet: 71.6 × 53.9 cm
(28 3/16 × 21 3/16 in.)
The Art Institute of Chicago, the John H. Wrenn
Memorial Endowment and the Stanley Field funds,
2012.378

JOHN DIXON
Irish, active in England, c. 1730–1804
After Sir Joshua Reynolds
English, 1723–1792

34
William Robert, 2nd Duke of Leinster, 1774
Mezzotint on paper (first state); 50.8 × 35.6 cm
(20 × 14 in.)
Yale Center for British Art, Paul Mellon Fund

SAMUEL DIXON
Irish, active 1748–69

35
Twelve Prints of "Foreign and Domestick" Birds,
c. 1755
Gouache on embossed paper in original black
lacquer and gilded pearwood frames; each 36.8 ×
48.3 × 1.3 cm (14 1/2 × 19 × 1/2 in.)
Private collection
For individual titles, see page 137, note 26.

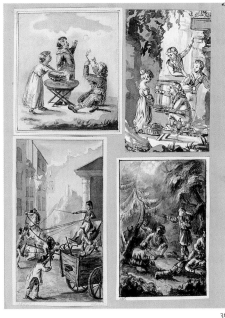

36

CHARLOTTE EDGEWORTH, FRANCES
EDGEWORTH, AND OTHER MEMBERS OF
THE EDGEWORTH FAMILY
Irish, active early 19th century

36
Edgeworth Family Sketchbook, early 19th century
Ireland
Watercolor, pencil, ink, and other media on paper,
bound in quarter-brown calf, with paper-covered
boards, gold tooling, and gold titling on spine;
27 × 19.4 × 2.2 cm (10 5/8 × 7 5/8 × 7/8 in.)
Rolf and Magda Loeber

ROBERT FAGAN
Irish, born England, active in Italy, 1761–1816

37
Portrait of a Lady as Hibernia, c. 1801
Oil on canvas; 137.2 × 106.7 cm (54 × 42 in.)
Private collection

EDWARD FISHER
Irish, active in England, 1722–1785
After Nathaniel Hone
Irish, 1718–1784

38
Nath. Hone, Pictor, 1758/81
Mezzotint on paper; sheet: 40.3 × 30.3 cm
(15 7/8 × 11 15/16 in.)
Private collection

73

JAMES HORE
Irish, active 1829–37

69
The Four Courts, Dublin, from the Quay, c. 1837
Oil on canvas; 40.6 × 55.9 cm (16 × 22 in.)
The Irish Art Collection of Brian P. Burns

JOHN HUTTON
Irish, 1757–after 1790

RUDOLPH ACKERMANN
English, born Germany, 1764–1834

70
Six Designs for Coaches and Carriages, 1790s
Pen, ink, and watercolor, heightened with gold on
paper; each approx. 17.8 × 31.8 cm (7 × 12½ in.)
Private collection

CHARLES JERVAS
Irish, active in England, c. 1675–1739

71
Self-Portrait, c. 1725
Oil on canvas; 127 × 101.6 cm (50 × 40 in.)
Private collection

HENRIETTA DE BEAULIEU
DERING JOHNSTON
French, active in England, Ireland, and North
America, c. 1674–1729

72
Helena Dering, c. 1704
Pastel on paper; 46 × 29.7 cm (18⅛ × 11¹¹⁄₁₆ in.)
John and Judith Herdeg

ANGELICA KAUFFMAN
Swiss, active in England, Ireland, and Italy, 1741–1807

73
Mrs. Hugh Morgan and Her Daughter, c. 1771
Oil on canvas; 24⅞ × 30 in. (63.2 × 76.3 cm)
The Art Institute of Chicago, gift of Mrs. L. E. Block,
1960.873

HENRY KIRCHHOFFER
Irish, c. 1781–1860

74
*Francis Johnston's Belfry and Gothic Folly in His
Garden, Eccles Street, Dublin*, c. 1832
Oil on canvas; 50.8 × 55.8 cm (20 × 22 in.)
Private collection

SIR GODFREY KNELLER
English, born Germany, 1646–1723

75
William Robinson, Later Sir William Robinson, Knight,
1693
Oil on canvas; 127 × 102.6 cm (50 × 40⅜ in.)
The Huntington Library, Art Collections, and
Botanical Gardens, Gift of Beatrix Farrand

JAMES LATHAM
Irish, 1696–1747

76
Portrait of General Thomas Bligh, c. 1740
Oil on canvas; 124.5 × 99.1 cm (49 × 39 in.)
Private collection

SIR THOMAS LAWRENCE
English, 1769–1830

77
Lady Maria Conyngham, c. 1824–25
Oil on canvas; 92.1 × 71.8 cm (36¼ × 28¼ in.)
The Metropolitan Museum of Art, New York, Gift of
Jessie Woolworth Donahue, 1955

SIR PETER LELY
English, born Holland, 1618–1680

78
The Countess of Meath, c. 1674
Oil on canvas; 125.7 × 102.9 cm (49½ × 40½ in.)
National Gallery of Canada, Ottawa, Purchase, 1929

81

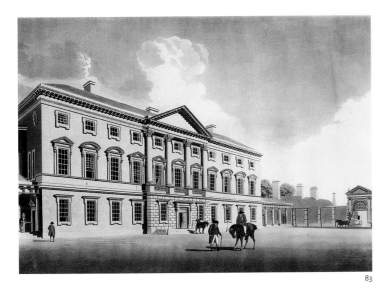

83

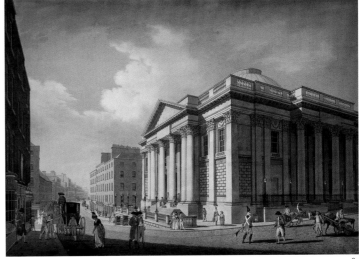

85

86

JOHN LEWIS
Welsh, active in Ireland, 1736–76

79
A Landscape with the Story of Cimon and Iphigenia, 1758
Oil on canvas; 66 × 104.1 cm (26 × 41 in.)
Private collection

CLAUDE LORRAIN
French, active in Italy, 1604/05–1682

80
Coast Scene with Europa and the Bull, 1634
Oil on canvas; 170.8 × 192.1 cm (67¼ × 78⅝ in.)
Kimbell Art Museum, Fort Worth

EDWARD LYONS
Irish, 1726–1801

81
Arms of the FitzGerald Family, 2nd half of the 18th century
Ink and watercolor on paper; 38.7 × 28.7 cm (15¼ × 11⁵⁄₁₆ in.)
Rolf and Magda Loeber

JAMES MALTON
English, active in Ireland, 1765–1803

82
Great Courtyard, Dublin Castle, published July 1792
Hand-colored etching and aquatint on paper; image: 25.7 × 37.3 cm (10⅛ × 14¹¹⁄₁₆ in.); plate: 31.5 × 42.5 cm (12⅜ × 16¾ in.); sheet: 42 × 55.5 cm (16½ × 21⅞ in.)
The Art Institute of Chicago, gift of Mrs. Isaac K. Friedman, 1932.1244.5

83
Leinster House, Dublin, published July 1792
Hand-colored etching and aquatint on paper; image: 26.3 × 37.5 cm (10⅜ × 14¾ in.); plate: 31.5 × 42.5 cm (12⅜ × 16¾ in.); sheet: 42 × 54 cm (16½ × 21¼ in.)
The Art Institute of Chicago, gift of Mrs. Isaac K. Friedman, 1932.1244.10

84
Old Soldiers Hospital, Kilmainham, Dublin, published February 1794
Hand-colored etching and aquatint on paper; image: 26.3 × 37.2 cm (10⅜ × 14⅝ in.); plate: 31.5 × 42.5 cm (12⅜ × 16¾ in.); sheet: 42 × 55.5 cm (16½ × 21⅞ in.)
The Art Institute of Chicago, gift of Mrs. Isaac K. Friedman, 1932.1244.9

85
Dublin, Royal Exchange, 1795
Hand-colored etching and aquatint on paper; 54 × 77.5 cm (21¼ × 30½ in.)
The Huntington Library, Art Collections, and Botanical Gardens

86
The Provost's House, Trinity College, c. 1795
Hand-colored etching and aquatint on paper; 33 × 45.7 cm (13 × 18 in.)
Private collection

87
Parliament House, Dublin, 1797
Pen and watercolor on paper; 54 × 77.5 cm (21¼ × 30½ in.)
The Huntington Library, Art Collections, and Botanical Gardens

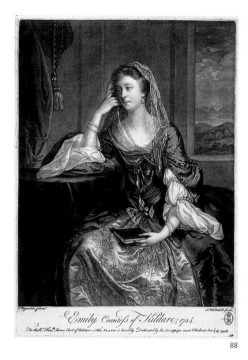

88

89

JAMES MCARDELL
Irish, active in England, c. 1710–1765
After Sir Joshua Reynolds
English, 1723–1792

88
Emily, Countess of Kildare, 1754
Mezzotint on paper (second state); image, 31.5 ×
24.8 cm (12⅜ × 9¾ in.); plate, 35 × 25 cm (13¾ ×
9⅞ in.); sheet, 35.6 × 25.6 cm (14 × 10 1/16 in.)
The Art Institute of Chicago, the Charles Deering
Collection, 1927.4091

POSSIBLY EDWARD MCGAURAN
Irish, active c. 1793–96

89
Silhouette of James Caulfeild, 1st Earl of Charlemont,
c. 1795
Watercolor heightened with gold on card;
15 × 17 cm (6 × 5 in.)
Private collection

ANDREW MILLER
English, active in Ireland, died 1763

AFTER FRANCIS BINDON
Irish, 1690–1765

90
*The Rev'd Jonathan Swift D. D., Dean of Saint Patrick's
Dublin*, 1743
Mezzotint on paper (first and only state); 50.2 ×
35.4 cm (19¾ × 13 15/16 in.)
Yale Center for British Art, Paul Mellon Collection

JOHANN HEINRICH MÜNTZ
Swiss, active in England, 1727–1798

91
*Dublin: Marino House, Design for an . . . Egiptian
Room*, 1762
Pen and wash on paper; 20.3 × 20.3 cm (8 × 8 in.)
Courtesy of the Lewis Walpole Library, Yale
University

GEORGE NAIRN
Irish, 1799–1850

92
*The Interior of the Stables at Carton, County Kildare: A
Liveried Groom, Lord Charles William FitzGerald, and
His Sister, Lady Jane Seymour FitzGerald*, c. 1825
Oil on canvas; 71.1 × 115.6 cm (28 × 45½ in.)
Anne and Bernard Gray

ANDREW NICHOLL
Irish, 1804–1886

93
*A View from Carlingford, County Louth, to Rostrevor,
Beyond a Bank of Wild Flowers*, c. 1835
Watercolor on paper; 35 × 52.6 cm
(13¾ × 20¾ in.)
Private collection

JAMES ARTHUR O'CONNOR
Irish, 1792–1841

94
A View of Irishtown from Sandymount, 1823
Oil on canvas; 35.6 × 45.7 cm (14 × 18 in.)
Private collection

JAMES PAINE II
English, active in Ireland, 1745–1829

95
*Proposed Bridge across the River Foyle, County Derry
(Unexecuted)*, published January 1, 1793
Aquatint and etching on paper, mounted to a
secondary support; 41.4 × 62.1 cm (16 5/16 × 24 7/16 in.)
Rolf and Magda Loeber

WILLIAM PARS
English, active in Ireland, 1742–1782

96
The Falls at Powerscourt, c. 1771
Watercolor and ink over graphite on paper; sheet:
26.7 × 37.8 cm (10½ × 14⅞ in.)
Yale Center for British Art, Paul Mellon Collection

WILLIAM PAYNE
English, 1760–1830

97
*Letters to Mary Tighe, Rosanna, County Wicklow,
with Watercolor Instructions*, January 20, 1796, and
January 9, 1797
Ink and watercolor on paper; 2 sheets, each
29.5 × 38.1 cm (11⅝ × 15 in.)
Private collection

MATTHEW WILLIAM PETERS
Born Isle of Wight, active in England and Ireland,
1742–1814

98
Portrait of John William Peters, the Artist's Son, 1802
Oil on canvas; 58.4 × 43.2 cm (23 × 17 in.)
Private collection

FRANCIS PLACE
English, 1647–1728

99
View of Dublin from the North, c. 1699
Ink and wash on paper; 29.2 × 90.5 cm (11½ ×
35⅝ in.)
Museum of Art, Rhode Island School of Design,
Providence, Anonymous gift 71.153.26

ALEXANDER POPE
Irish, active in England, 1763–1835

100
Self-Portrait, 1791
Pastel on paper; 22.2 × 20.3 cm (8¾ × 8 in.)
Private collection

97

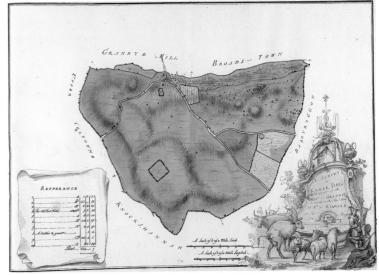

114

SEBASTIANO RICCI
Italian, 1659–1734

101
The Continence of Scipio, c. 1706
Oil on canvas; 140 × 182 cm (55 × 71½ in.)
The Art Institute of Chicago, Preston O. Morton
Memorial Fund, 1970.106

THOMAS ROBERTS
Irish, 1748–1777

102
A Frost Piece, c. 1769
Oil on canvas; 99.1 × 137.2 cm (39 × 54 in.)
Private collection

103
*Knock Ninney and Lough Erne from Bellisle, County
Fermanagh, Ireland*, 1771
Oil on canvas; 57.2 × 91.4 cm (22½ × 36 in.)
Yale Center for British Art, Paul Mellon Collection

104
*Lough Erne from Knock Ninney, with Bellisle in the
Distance, County Fermanagh, Ireland*, 1771
Oil on canvas; 57.2 × 91.4 cm (22½ × 36 in.)
Yale Center for British Art, Paul Mellon Collection

105
*Bold Sir William (a Barb), an Indian Servant and
French Dog in the Possession of Sir Gerald FitzGerald*,
1772
Oil on canvas; 63.5 × 95.3 cm (25 × 37½ in.)
Private collection

106
*A Wooded River Landscape with a Ruined Abbey and
a Travelling Family Resting*, c. 1773
Commissioned by Simon, 1st Earl of Harcourt, while
lord lieutenant of Ireland
Oil on canvas; 48.3 × 67.3 cm (19 × 26½ in.)
Private collection

107
*An Extensive Lake Landscape with Figures Loading a
Cart*, c. 1773
Commissioned by Simon, 1st Earl of Harcourt, while
lord lieutenant of Ireland
Oil on canvas; 48.3 × 67.3 cm (19 × 26½ in.)
Private collection

108
*The Bridge in the Park at Carton with Workmen
Landing Logs from a Boat*, 1775–76
Oil on canvas; 111 × 153 cm (43¹¹⁄₁₆ × 60¼ in.)
Private collection

109
*The Sheet of Water at Carton, with the Duke and
Duchess of Leinster About to Board a Rowing Boat*,
1775–76
Oil on canvas; 111 × 153 cm (43¹¹⁄₁₆ × 60¼ in.)
Private collection

110
*A View in the Park at Carton with the Ivory Bridge in
the Foreground*, 1775–76
Oil on canvas; 111 × 153 cm (43¹¹⁄₁₆ × 60¼ in.)
Private collection

111
A View in the Park at Carton with Haymakers, 1776
Oil on canvas; 111 × 153 cm (43¹¹⁄₁₆ × 60¼ in.)
Private collection

THOMAS SAUTELLE ROBERTS
Irish, 1760–1826

112
Stormy Landscape with Anglers, c. 1820
Oil on canvas; 76.2 × 101.6 cm (30 × 40 in.)
Private collection

SAMPSON TOWGOOD ROCH
Irish, 1759–1847

113
An Artisan, 1788
Watercolor on ivory; 8.6 × 7 cm (3⅜ × 2¾ in.)
Cincinnati Art Museum, Gift of Mr. and Mrs. Charles
Fleischmann III, 2004.274

JOHN ROCQUE
French (Huguenot), active in England and Ireland,
1704–1762

114
*A Survey of the Man[o]r of Graney: Situat'd in the
County of Kildare, Belonging to the Right Honble.
James Earl of Kildare*, 1758
Drawings in ink and wash on paper, bound in
maroon goatskin with gold tooling; 53.3 × 74.9 ×
2.5 cm (21 × 29½ × 1 in.)
Yale Center for British Art, Paul Mellon Collection

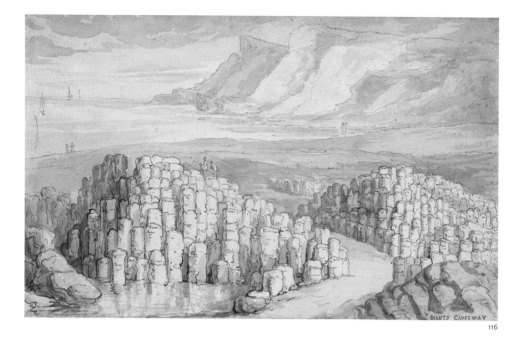

116

119

JOHN ROCQUE
French (Huguenot), active in England and Ireland, 1704–1762
Illustrations by Hugh Douglas Hamilton
Irish, 1740–1808

115
A Survey of Kilkea, One of the Manors of the Right Hon. James, Earl of Kildare, 1760
Drawings in ink and wash on paper, bound in maroon goatskin with gold tooling; 54.1 × 75.6 × 3.2 cm (21 5/16 × 29 3/4 × 1 1/4 in.)
Private collection

THOMAS ROWLANDSON
English, 1756/57–1827

116
Giant's Causeway, Antrim, Ireland, n.d.
Watercolor and ink over graphite on paper; sheet: 14.6 × 23.7 cm (5 3/4 × 9 5/16 in.)
Yale Center for British Art, Paul Mellon Collection

JOHN RYAN
Irish, active 1780–1801

117
Anne Bingham, Wife of Christopher St George of Tyrone House, c. 1785
Oil on canvas; 88.9 × 76.2 cm (35 × 30 in.)
Peter Clayton Mark

118
Laurence Nihell, Bishop of Kilfenora and Kilmacduagh, c. 1790
Oil on canvas; 76.2 × 101.6 cm (30 × 40 in.)
Private collection

ROBERT RICHARD SCANLAN
Irish, active 1826–76

119
The Blacksmith, 1st half of the 19th century
Oil on canvas; 38.1 × 28 cm (15 × 11 in.)
Private collection

SIR MARTIN ARCHER SHEE
Irish, active in England, 1769–1850

120
William Archer Shee, the Artist's Son, c. 1820
Oil on canvas; 76.2 × 63.5 cm (30 × 25 in.)
Chrysler Museum of Art, Norfolk, Virginia, Gift of Walter P. Chrysler, Jr.

STEPHEN SLAUGHTER
English, active in Ireland, 1696/97–1765

121
Windham Quin of Adare, County Limerick, Ireland, c. 1745
Oil on canvas; 101.9 × 128.6 cm (40 1/8 × 50 5/8 in.)
Yale Center for British Art, Paul Mellon Collection

MARIA SPILSBURY-TAYLOR
English, active in Ireland, 1776–1820

122
A Gentleman in a Gothic Library, Possibly Henry Grattan M.P., c. 1815–20
Oil on canvas; 94 × 76.2 cm (37 × 30 in.)
The Irish Art Collection of Brian P. Burns

GILBERT STUART
American, active in England and Ireland, 1755–1828

123
William Burton Conyngham, c. 1785
Oil on canvas; 91.4 × 71.1 cm (36 × 28 in.)
Norton Museum of Art, Bequest of R. H. Norton, 53.189

124
The Marquess of Waterford, c. 1787–92
Oil on canvas; 76.2 × 64.14 cm (30 × 25 1/4 in.)
Snite Museum of Art, University of Notre Dame, Acquired with funds provided by the Lawrence and Alfred Fox Foundation and Edward and Ann Abrams

125
Anna Dorothea Foster and Charlotte Anna Dick, 1790–91
Oil on canvas; 91.4 × 94 cm (36 × 37 in.)
Charlotte Hanes

122

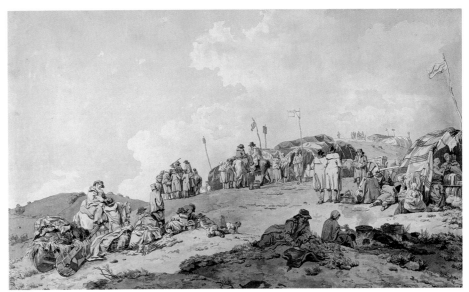

132

126

John Foster, 1790–91
Oil on canvas; 211.5 × 149.9 cm (83¼ × 59 in.)
Nelson-Atkins Museum of Art, Kansas City, Missouri
(Purchase: William Rockhill Nelson Trust), 30-20

JAMES CHRISTOPHER TIMBRELL
Irish, active in England, 1807–1850

127

Carolan the Irish Bard, c. 1844
Oil on canvas; 105 × 147 cm (41⅜ × 57⅞ in.)
The O'Brien Collection

HENRY TRESHAM
Irish, active in Italy, 1751–1814

128

An Archaeological Excavation in Italy, c. 1785
Watercolor on paper; 52.1 × 76.2 cm (20½ × 30 in.)
Private collection

JOSEPH TUDOR
Irish, c. 1695–1759

129

A View of Dublin from Chapelizod, c. 1750
Oil on canvas; 116.8 × 149.9 cm (46 × 59 in.)
Private collection

FRANÇOIS VIVARES
French, active in England, 1709–1780
After Susanna Drury
Irish, c. 1698–c. 1770
Published by John Boydell
English, 1719–1804

130

*The East Prospect of the Giant's Causeway in the
County of Antrim in the Kingdom of Ireland* and *The
West Prospect of the Giant's Causeway in the County
of Antrim in the Kingdom of Ireland*, published
May 1, 1777
Etching and engraving on paper; plates:
41.9 × 69.9 cm (16½ × 27½ in.) and 41.9 × 69.5 cm
(16½ × 27⅜ in.)
Rolf and Magda Loeber

JAMES WATSON
Irish, active in England, c. 1740–1790
After Sir Joshua Reynolds
English, 1723–1792

131

Edmund Burke, 1770
Mezzotint on paper (first state); plate: 37.9 × 27.6 cm
(14¹⁵⁄₁₆ × 10⅞ in.); sheet: 39.1 × 28.6 cm (15⅜ × 11¼ in.)
Yale Center for British Art, Paul Mellon Fund

FRANCIS WHEATLEY
English, active in Ireland, 1747–1801

132

Donnybrook Fair, 1782
Ink and watercolor on paper; sheet:
32.1 × 54.6 cm (12⅝ × 21½ in.)
Yale Center for British Art, Paul Mellon Collection

133

*Portrait of John Swiney of Mountjoy Square, Dublin,
Standing at the Edge of a Wood*, 1783
Oil on canvas; 91.4 × 71.1 cm (36 × 28 in.)
Private collection

134

*Portrait of Michael Swiney of Woodbrook, County
Dublin, Standing on the Sea Shore*, 1783
Oil on canvas; 91.4 × 71.1 cm (36 × 28 in.)
Private collection

135

The Salmon Leap, Leixlip, 1783
Oil on canvas; 67.6 × 64.8 cm (26⅝ × 25½ in.)
Yale Center for British Art, Paul Mellon Collection

JOSEPH WILSON
Irish, active 1766–89, died 1793

136

The Adelphi Club, Belfast, 1783
Oil on canvas; 61 × 73.7 cm (24 × 29 in.)
Private collection

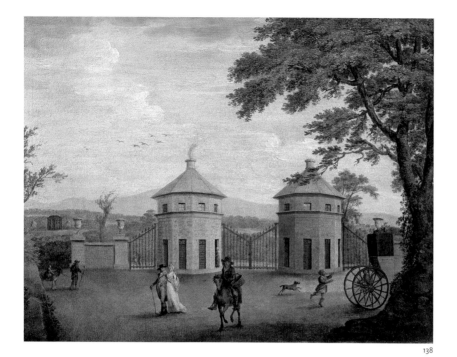

138

139

142

WILLEM WISSING
Dutch, active in England, 1656–1687

137
Elizabeth Jones, Countess of Kildare, c. 1684
Oil on canvas; 125.7 × 101 cm (49½ × 39¾ in.)
Yale Center for British Art, Paul Mellon Fund

ROBERT WOODBURN
Irish, died 1803

138
The Gates of Belline, County Kilkenny, 1800
Oil on canvas; 63.5 × 83.8 cm (25 × 33 in.)
Private collection

GEORGE MOUTARD WOODWARD
English, c. 1760–1809
Published by Thomas Tegg
English, 1776–1845

139
Irish Binding for the Caricature Magazine, 1808
Hand-colored etching on paper; 29.2 × 36.8 cm
(11½ × 14½ in.)
Private collection

JOHN MICHAEL WRIGHT
English, 1617–1694

140
Portrait of Sir Neil O'Neill, 2nd Baronet of Killyleagh,
1680
Oil on canvas; 91.4 × 63.5 cm (36 × 25 in.)
Private collection

ARTIST UNKNOWN
Irish

141
Study of a Grouse and *Study of a Sparrow*,
1797/1800
Watercolor, feathers, and paper collage elements
on paper, in original gilt wood frames, with label
of Dublin framer Patrick Burke; each 23.5 × 33.7 cm
(9¼ × 13¼ in.)
Tom Shudell

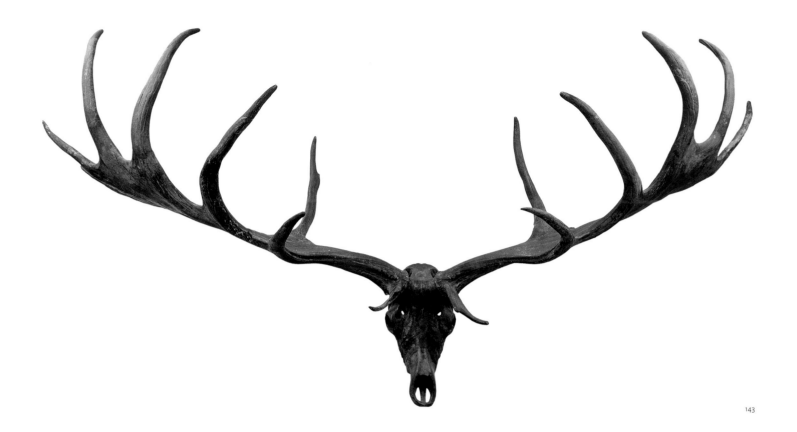

143

ARIST UNKNOWN
Irish

142
Waterfall at Lord Powerscourt's, c. 1830
Watercolor on paper; 29.2 × 34.3 cm
(11½ × 13½ in.)
Private collection

ANTLERS

143
Giant Deer or "Irish Elk" Antlers (*Megaloceros
giganteus*), 11,000/8,000 B.C.
Found in Ballybetagh, County Dublin
Bone; approx. 152.4 × 299.7 × 91.4 cm
(60 × 118 × 36 in.)
American College of Surgeons

ARMS AND MILITARIA

JOSEPH JACKSON
Irish, active 1775–1807

144
Badge of the 2nd Regiment of Royal Dublin
Volunteers, c. 1790
Dublin
Silver; 10.8 × 7.6 × 1.3 cm (4¼ × 3 ×½ in.)
San Antonio Museum of Art, Bequest of John V.
Rowan, Jr.

WILLIAM LAW
Irish, active from 1774, died 1820

145
Gorget of a County Kilkenny Militia, c. 1790
Dublin
Silver; 11.4 × 8.6 × 3.2 cm (4½ × 3⅜ × 1¼ in.)
San Antonio Museum of Art, Bequest of John V.
Rowan, Jr.

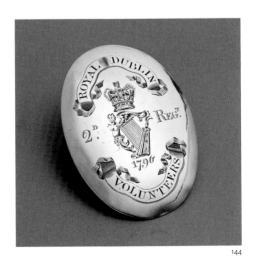

144

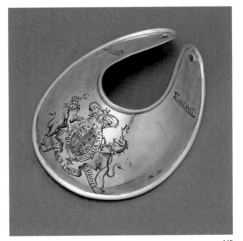

145

237

THOMAS TRULOCK (GUNSMITH)
Irish, active c. 1774–98

THOMAS JONES (SILVERSMITH)
Irish, active c. 1774–1803

146
Pair of Flintlock Pistols, c. 1785
Dublin
Walnut, silver, and steel; each l. 47.5 cm
(18 11/16 in.)
The Metropolitan Museum of Art, New York,
Purchase, Rogers Fund, 1970

GEORGE WEST (SILVERSMITH)
Irish, active 1792–1828

JOHN READ (CUTLER)
Irish, active c. 1799

147
Presentation Saber, 1799
Presented to George Binns, captain of the 8th
Company of the 1st Regiment of the Dublin
Volunteers

Dublin
Saber: silver, steel, gilding, and ivory; 90.2 × 6.4 cm
(35½ × 2½ in.)
Scabbard: gilt copper, leather, and wood; 76.2 × 4.4
× 1.3 cm (30 × 1¾ × ½ in.)
San Antonio Museum of Art, Bequest of John V.
Rowan, Jr.

MAKER UNKNOWN
148
Dublin Castle Pattern 1769 Short Land Musket,
1770–75
Dublin
Iron, steel, brass, and walnut; approx. 25.4 × 149.9
(with bayonet) × 7.6 cm (10 × 59 × 3 in.)
Private collection

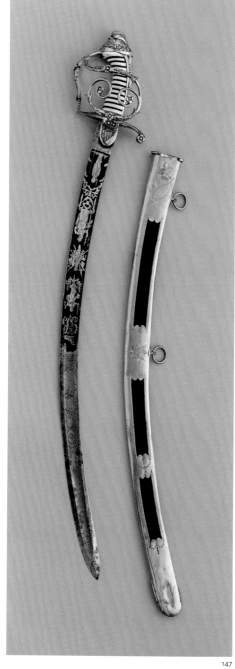

147

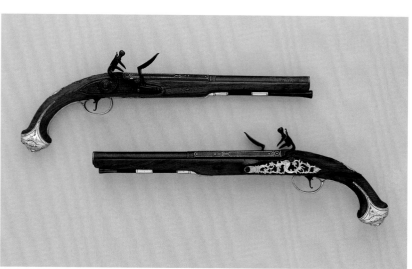

146

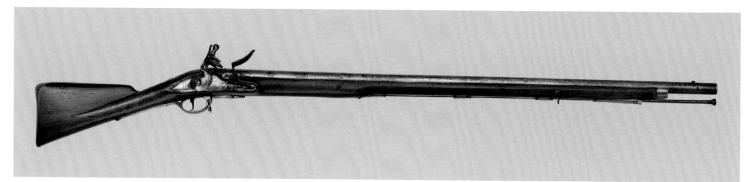

148

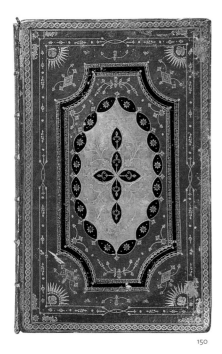

150

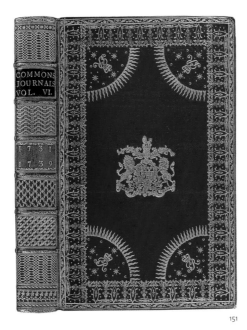

151

BOOKBINDINGS

BOULTER GRIERSON'S BINDER
Irish, active 18th century

149
The Statutes at Large Passed in the Parliaments Held in Ireland, index, 1765
Dublin, Boulter Grierson
Red goatskin with gold tooling; 36.9 × 23 × 4.6 cm
(14 ¾ × 9 ⅝ × 1 ⅞ in.)
Philip and Niamh Maddock

BOUND BY ABRAHAM BRADLEY KING
Irish, active 1780–1801

150
The Book of Common Prayer, printed 1750, bound c. 1790
Dublin, George Grierson
Red goatskin with paper onlay, black staining, and gold tooling; 45.1 × 29.5 × 3.5 cm (17 ¾ × 11 ⅝ × 2 in.)
Private collection

151
The Journals of the House of Commons, vol. 6, *1731–39,* printed 1753, bound c. 1786
Dublin, Abraham Bradley
Red goatskin with gold tooling; 35.5 × 22.5 × 5.8 cm
(14 × 8 ¾ × 2 ⅜ in.)
Philip and Niamh Maddock

152

PROBABLY BOUND BY
ABRAHAM BRADLEY KING
Irish, active 1780–1801

152
The Holy Bible, printed 1772, bound 1790/97
London, Charles Eyre and William Strahan
Red goatskin with paper onlay, black staining, and gold tooling; 49.7 × 33.7 × 5.4 cm (19 ⁹⁄₁₆ × 13 ¼ × 2 ⅛ in.)
Private collection

POSSIBLY BOUND BY
ABRAHAM BRADLEY KING
Irish, active 1780–1801

153
The Statutes at Large Passed in the Parliaments Held in Ireland, vol. 11, 1786
Dublin, George Grierson
Red goatskin with gold tooling; 36.8 × 23.5 × 7 cm
(14 ½ × 9 ¼ × 2 ¾ in.)
Joseph Peter Spang III

JOSEPH LEATHLEY'S BINDER
Irish, active 1720s–1750s

154
Plato, *Dialogues,* 1738
Dublin, Trinity College, E Typographia Academiae
Blue-black goatskin with gold tooling; 22.9 × 13.5 × 4.8 cm (9 × 5 ⁵⁄₁₆ × 1 ⅞ in.)
Private collection

155
John Hawkey, ed., *Terentius,* 1745
Dublin, Trinity College, E Typographia Academiae
Red goatskin with gold tooling; 22.2 × 14.6 × 3.8 cm
(8 ¾ × 5 ¾ × 1 ½ in.)
Private collection

156
John Hawkey, ed., *Terentius,* 1745
Dublin, Trinity College, E Typographia Academiae
Red goatskin with gold tooling; 18.6 × 12.1 × 2.5 cm
(7 ⁵⁄₁₆ × 4 ¾ × 1 in.)
Private collection

157
John Hawkey, ed., *Terentius,* 1745
Dublin, Trinity College, E Typographia Academiae
Plain calf with gold-tooled spine; 23.3 × 15.2 × 3.2 cm
(9 ³⁄₁₆ × 6 × 1 ¼ in.)
Philip and Niamh Maddock

BOUND BY A PARLIAMENTARY BINDER
Irish

158
The Book of Common Prayer, 1761
Cambridge, John Baskerville
Red goatskin with paper onlay, black staining, and
gold tooling; 24.4 × 16.5 × 5.1 cm (9 ⅝ × 6 ½ × 2 in.)
Private collection

BOUND BY A PARLIAMENTARY BINDER
Irish

159
The Holy Bible, 1763
Cambridge, John Baskerville
Red goatskin with gold tooling; 51 × 34.7 × 9.5 cm
(20 ⅛ × 13 ⅝ × 3 ¾ in.)
Private collection

BOUND BY A PARLIAMENTARY BINDER
Irish

160
The Holy Bible, 1763
Cambridge, John Baskerville
Red goatskin with gold tooling; 50.2 × 34.6 × 9.2 cm
(19 ¾ × 13 ⅝ × 3 ⅝ in.)
Philip and Niamh Maddock

PROBABLY BOUND BY A
PARLIAMENTARY BINDER
Irish

161
The Book of Common Prayer, 1761
Cambridge, John Baskerville
Red goatskin with paper onlay, black staining and
gold tooling; 24.8 × 16.2 × 4.8 cm
(9 ¾ × 6 ⅜ × 1 ⅞ in.)
Private collection

RAWDON/GRIERSON BINDER
Irish, active 18th century

162
Charles Lucas, presentation copy of *The State
Tinker to All His Fellow Politicians in Ireland*, letter 2,
1759–60
Dublin, printed and published anonymously
Red goatskin with black goatskin onlay and gold
tooling; 20.3 × 13 × 1.9 cm (8 × 5 ⅛ × ¾ in.)
Private collection

162

WATSON BINDERY
Irish

163
Memorandum Book, 1764
Dublin, Samuel Watson
Slipcase: vellum with blue goatskin onlay and gold
tooling; book: vellum with gold tooling; slipcase:
12.4 × 7 × 1.2 cm (4 ⅞ × 2 ¾ × ½ in.)
Philip and Niamh Maddock

164
Memorandum Book, 1773
Dublin, Samuel Watson
Slipcase: red goatskin with paper onlay and gold
tooling; book: green silk cover; slipcase: 12.6 × 7.3 ×
1.3 cm (4 ¹⁵⁄₁₆ × 2 ⅞ × ½ in.)
Philip and Niamh Maddock

165
Memorandum Book, 1774
Dublin, Samuel Watson
Slipcase: black goatskin with paper onlay and gold
tooling; book: green silk cover; slipcase: 12.5 × 7.4 ×
1.5 cm (4 ¹⁵⁄₁₆ × 2 ⅞ × ½ in.)
Philip and Niamh Maddock

166
Memorandum Book, 1779
Dublin, Samuel Watson
Slipcase: red goatskin with gold tooling; book: paper
wrapper; slipcase: 12.4 × 7.3 × 1.3 cm
(4 ⅞ × 2 ⅞ × ½ in.)
Private collection

BINDER UNKNOWN
Irish

167
Julius Caesar, *Commentarii de Bello Civili*, 1750
Prize binding awarded by the Hibernian Academy
Dublin
Plain calf with gold tooling and gilt stamp of seated
Hibernia; 13.3 × 8.3 × 2.5 cm (5 ¼ × 3 ¼ × 1 in.)
Private collection

164

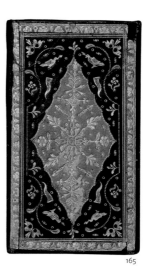

165

166

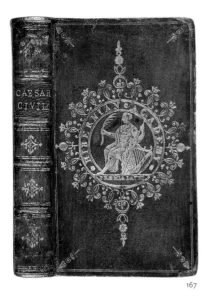

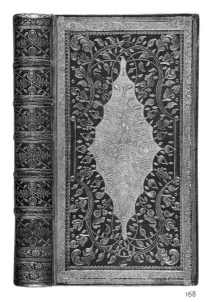

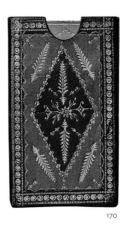

167

168

170

171

BINDER UNKNOWN
Irish

168
The Book of Common Prayer, 1762
Cambridge, John Baskerville
Red goatskin with paper onlay and gold tooling;
17.1 × 10.8 × 3.5 cm (6¾ × 4¼ × 1⅜ in.)
Private collection

BINDER UNKNOWN
Irish

169
Novum Testamentum Graecum, 1763
Oxford, John Baskerville
Red goatskin with gold tooling; 14.3 × 21.6 × 4.5 cm
(5⅝ × 8½ × 1¾ in.)
Philip and Niamh Maddock

BINDER UNKNOWN
Irish

170
Memorandum Book, 1785
Dublin, Samuel Watson
Slipcase: red goatskin with paper onlay and gold
tooling; book: paper with engraved paper onlay
and gold tooling; slipcase: 6.8 × 4 × .5 cm (2¹¹⁄₁₆ ×
1⁹⁄₁₆ × ³⁄₁₆ in.)
Philip and Niamh Maddock

BINDER UNKNOWN
Irish

171
Memorandum Book, 1791
Dublin, N. Callwell
Slipcase: red goatskin with gold tooling; book:
sepia-printed wrappers; slipcase: 12.7 × 7.3 × 1.3 cm (5
× 2⅞ × ½ in.)
Philip and Niamh Maddock

BINDER UNKNOWN
Irish

172
Memorandum Book, 1810
Dublin, J. Watson Stewart
Slipcase: red and tan goatskin and blue paint with
gold tooling; book: blue paste paper wrapper;
slipcase: 7.4 × 4.1 × .5 cm (2⅞ × 1⅝ × ¼ in.)
Philip and Niamh Maddock

BOOKS

EDMUND BURKE
Irish, active in England, 1729–1797

173
*A Philosophical Enquiry into the Origin of Our Ideas
of the Sublime and Beautiful*, 1st edition, 1757
London, R. and J. Dodsley
Ink on paper, modern binding; 19.4 × 12.5 × 2.5 cm
(7⅝ × 4¹⁵⁄₁₆ × 1 in.)
Private collection

SIR WILLIAM CHAMBERS
Scottish, born Sweden, active in England,
1723–1796

174
A Treatise on Civil Architecture, 1759
London, J. Haberkorn
Ink on paper, bound in quarter-goatskin with
paper-covered boards and gold titling on spine;
54.5 × 38 × 7 cm (21½ × 15 × 2¾ in.)
The Art Institute of Chicago, Ryerson and Burnham
Libraries

173

175

JAMES LEWIS
Welsh, c. 1751–1820

175

Original Designs in Architecture: Consisting of Plans, Elevations, and Sections for Villas, Mansions, Town-houses, &c. and a New Design for a Theatre, 1797
London, Cooper and Graham
Ink on paper, bound in tree calf with gold tooling and gold titling on spine; 54.5 × 38 × 3.5 cm (21½ × 15 × 1⅜ in.)
The Art Institute of Chicago, Ryerson and Burnham Libraries

SIR RICHARD MORRISON
Irish, 1767–1849

176

Useful and Ornamental Designs in Architecture, 1793
Dublin, Robert Crosthwaite
Ink on paper, modern binding; 38.7 × 24.1 × 1.3 cm (15¼ × 9½ × ½ in.)
Private collection

REV. JOHN PAYNE
Irish, 1710–1771

177

Twelve Designs of Country-Houses, 1757
Dublin, G. and A. Ewing
Ink on paper, bound in tree calf; 20.3 × 13.3 × 2.5 cm (8 × 5¼ × 1 in.)
Yale Center for British Art, Paul Mellon Collection

GIOVANNI BATTISTA PIRANESI
Italian, 1720–1778

178

Le antichità romane, 1st edition, vol. 1, 1756
Rome, A. Rotilj
Ink on paper, bound in brown calf with the painted arms of Clement August, Prince-Archbishop of Cologne, painted cartouches, and gold tooling; 54 × 40.8 × 4.8 cm (21¼ × 16 1/16 × 1⅞ in.)
The John Work Garrett Library, Johns Hopkins University, Fowler Collection

179

Le antichità romane, 2nd edition, vol. 1, 1757
Rome, A. Rotilj
Engraving on paper, bound in quarter vellum with marbled-paper-covered boards and gold titling on spine; 3.4 × 57.8 × 44.5 cm (1⅓ × 22¾ × 17½ in.)
Vincent and Linda Buonanno

JOHN ROCQUE
French (Huguenot), active in England and Ireland, 1704–1762

180

An Exact Survey of the City and Suburbs of Dublin, 1757
London, J. Rocque
Ink on paper, bound in half-calf with marbled boards; 55.2 × 40.6 × 3.8 cm (21¾ × 16 × 1½ in.)
Yale Center for British Art, Paul Mellon Collection

JONATHAN SWIFT
Irish, 1667–1745

181

Gulliver's Travels, 1st "A" edition, 1726
London, printed for Benjamin Mott
Ink on paper, bound in brown calf with gold tooling on spine; 20.4 × 13.1 × 2.5 cm (8 1/16 × 5⅛ × 1 in.)
The Newberry Library, Chicago

181

183

**HELENA SARAH TRENCH,
LATER LADY DOMVILE**
Irish, died 1859

182
*Heywood Estate, Queen's County: Twenty-Five Views
of Cottages and Gate Houses*, 1815
Etching and engraving on paper, bound in paper;
24.4 × 27 × 1 cm
(9⅝ × 10⅝ × ⅜ in.)
Rolf and Magda Loeber

ARTHUR YOUNG
English, 1741–1820

183
*A Tour in Ireland: With General Observations on the
Present State of that Kingdom*, 1780 edition, vol. 1
Dublin, George Bonham
Ink on paper, bound in tree calf with gilding;
h. 21.5 cm (8.5 in.)
Philip and Niamh Maddock

CERAMICS

Irish Ceramics

PROBABLY DOWNSHIRE POTTERY
Irish, 1787–c. 1806

184
"Stag" Plate, c. 1800–06
Belfast
Pearl ware with sponge decoration; 2.5 × 26 × 26 cm
(1 × 10¼ × 10¼ in.)
Private collection

188

WORLD'S END POTTERY
John Chambers
Irish, active c. 1735–47

185
Dish, 1735
Made for Lionel Sackville, 1st Duke of Dorset,
while lord lieutenant of Ireland, with the Arms of
Sackville and Colyear
Dublin
Tin-glazed earthenware; 4.4 × 30.5 × 30.5 cm
(1¾ × 12 × 12 in.)
The Metropolitan Museum of Art, New York, Gift
of R. Thornton Wilson, in memory of Florence
Ellsworth Wilson, 1947, 47.132

WORLD'S END POTTERY
Henry Delamain
Irish, active 1752–57

186
Plate, c. 1753–55
Dublin
Tin-glazed earthenware; 2 × 23.5 × 23.5 cm
(¾ × 9¼ × 9¼ in.)
Private collection

187
Pair of Wine Cisterns, c. 1755
Made for Castle Leslie, County Monaghan
Dublin
Tin-glazed earthenware; each 23 × 45 × 30.4 cm
(9 × 17¾ × 12 in.)
Private collection

WORLD'S END POTTERY
Henry Delamain
Irish, active 1752–57
Mary Delamain
Irish, active 1757–60
William Delamain and Samuel Wilkinson
Irish, active 1760–68

188
Boughpot, 1755/65
Dublin
Tin-glazed earthenware; 13 × 21 × 11.5 cm
(5⅛ × 8¼ × 4½ in.)
Private collection

189
Bowl, 1755/65
Dublin
Tin-glazed earthenware; 8 × 21.5 × 21.5 cm
(3⅛ × 8½ × 8½ in.)
Private collection

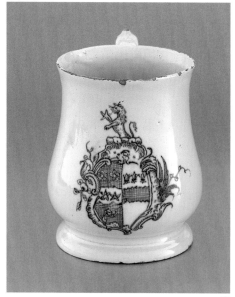

191

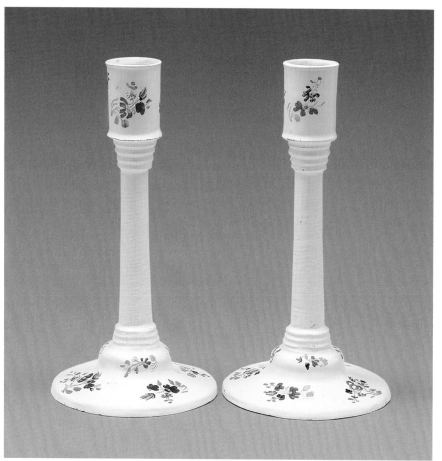

192

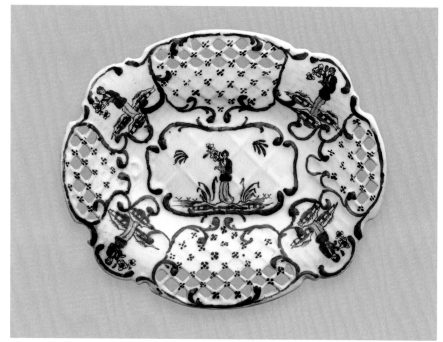

193

190
Epergne/Sweetmeat Dish, 1755/65
Dublin
Tin-glazed earthenware; 41.5 × 23 × 22 cm
(16 ⅜ × 9 × 8 ¾ in.)
Private collection

191
Mug with the Arms of Lamb Impaling Eyles, 1755/65
Dublin
Tin-glazed earthenware; h. 9.5 cm (3 ¾ in.), depth
with handle 11.3 (4 ⁷⁄₁₆ in.)
Courtesy of the Colonial Williamsburg Foundation

192
Pair of Candlesticks, 1755/65
Dublin
Tin-glazed earthenware with polychrome
decoration; each 23.7 × 12.7 × 12.7 cm
(9 ¼ × 5 × 5 in.)
Minneapolis Institute of Arts, Gift of
Mr. and Mrs. George R. Steiner

193
Pierced Dish, 1755/65
Dublin
Tin-glazed earthenware; 5 × 26 × 22 cm
(2 × 10 ¼ × 8 ⅝ in.)
Private collection

194
Plate, 1755/65
Dublin
Tin-glazed earthenware with manganese
decoration; 2 × 25.5 × 25.5 cm (¾ × 10 × 10 in.)
Private collection

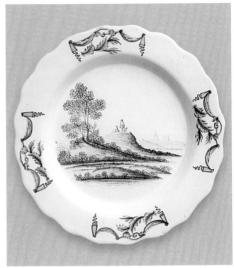

194

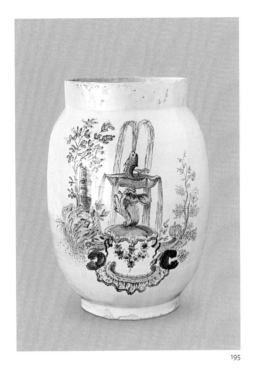

195

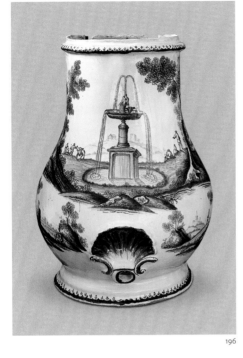

196

195
Vase, 1755/65
Dublin
Tin-glazed earthenware with polychrome
decoration; 24 × 17.7 × 17.7 cm (9½ × 7 × 7 in.)
Private collection

196
Wall Fountain, 1755/65
Dublin
Tin-glazed earthenware; 39 × 28 × 18 cm
(15⅜ × 11⅛ × 7⅛ in.)
Private collection

197
Wine Barrel, 1755/65
Dublin
Tin-glazed earthenware; 23 × 17.5 × 17.5 cm
(9 × 6⅞ × 6⅞ in.)
Private collection

198
Butter Dish and Stand, 1760/70
Dublin
Tin-glazed earthenware; butter dish and lid:
9.8 × 15.5 × 10.8 cm (3⅞ × 5⅛ × 4¼ in.); stand: 2 ×
18.8 × 15.3 cm (¹³⁄₁₆ × 7⅜ × 6 in.)
Private collection

199
Flower-Brick, 1760/70
Dublin
Tin-glazed earthenware; 7 × 15.9 × 8.3 cm
(2¾ × 7¼ × 3¼ in.)
Private collection

200
Garniture of Three Vases, 1760/70
Dublin
Tin-glazed earthenware; baluster-shaped vase: 29.2
× 15.2 × 15.2 cm (11½ × 6 × 6 in.); two trumpet-shaped
vases: each 20.3 × 11.7 × 11.7 cm (8 × 4⅝ × 4⅝ in.)
Courtesy of the Colonial Williamsburg Foundation

201
Plate, 1760/70
Dublin
Tin-glazed earthenware; 2.5 × 23 × 23 cm
(1 × 9 × 9 in.)
Private collection

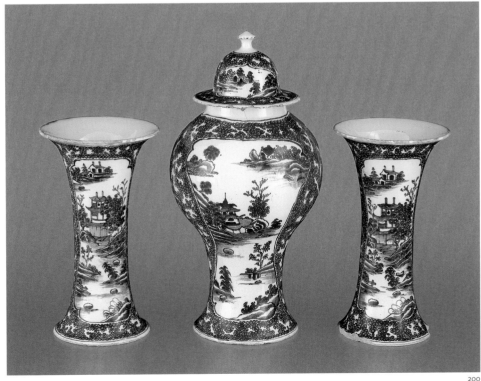

200

205

206

208

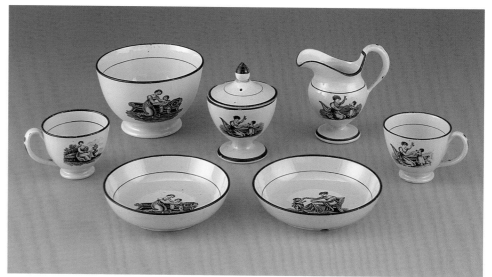

209

202
Punch Bowl, 1760/70
Dublin
Tin-glazed earthenware; 9.5 × 23 × 23 cm
(3¾ × 9 × 9 in.)
Private collection

English Ceramics

BOW PORCELAIN FACTORY
English, 1744–1776
Thomas Frye, Director
Irish, 1710–1762

203
Kitty Clive as the Fine Lady, c. 1750
Bow, England
Soft-paste porcelain; 31 × 15.5 × 17.5 cm
(12³⁄₁₆ × 6⅛ × 6⅞ in.)
Samuel and Patricia Grober Family Collection

DERBY PORCELAIN FACTORY
English, c. 1756–1848
Derby, England

204
Partial Dessert Service Depicting Irish Landscapes
and Demesnes, c. 1795
Soft-paste porcelain with polychrome enamels and
gilding; two round plates: 3 × 24 × 24 cm (1³⁄₁₆ × 9⁷⁄₁₆ ×
9⁷⁄₁₆ in.); four round plates: 3 × 23.3 × 23.3 cm
(1³⁄₁₆ × 9³⁄₁₆ × 9³⁄₁₆ in.); two lozenge-shaped plates:
5.4 × 27.3 × 21.3 cm (2⅛ × 10¾ × in.)
Private collection
For individual titles, see page 95, note 23.

WEDGWOOD MANUFACTORY
English, founded 1758

205
Plate, c. 1780–90
Staffordshire
Creamware with transfer-printed decoration;
1.9 × 22 × 22 cm (¾ × 8⅝ × 8⅝ in.)
Private collection

206
Pitcher, c. 1790
Staffordshire
Creamware with transfer-printed decoration;
17.5 × 18 × 14 cm (6⅞ × 7 × 5½ in.)
Private collection

MAKER UNKNOWN
207
Charger, c. 1690–1700
Lambeth
Tin-glazed earthenware; 6 × 34.3 × 34.3 cm
(2⅜ × 13½ × 13½ in.)
Neville and John Bryan

MAKER UNKNOWN
208
Pitcher, 1783
Liverpool
Creamware with transfer-printed decoration; 17.5 ×
18 × 14 cm (6⅞ × 7 × 5½ in.)
Private collection

246

210

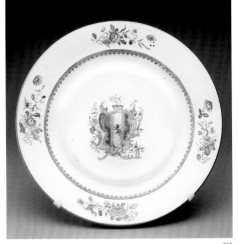

213

MAKER UNKNOWN

Transfer decoration after William Ashford

English, active in Ireland, c. 1746–1824

210

Slop Bowl, c. 1810–20

England

Soft-paste porcelain with gilding and transfer-printed decoration; 6.4 × 13 × 13 cm (2½ × 5⅛ × 5⅛ in.)

Rolf and Magda Loeber

MAKER UNKNOWN

211

Daniel O'Connell, c. 1870

Staffordshire

Earthenware with polychrome decoration; 43.2 × 21.6 × 11.4 cm (17 × 8½ × 4½ in.)

Private collection

Chinese Export Ceramics

MAKER UNKNOWN

212

Bowl, Kangxi period, c. 1710–20

Jingdezhen

Hard-paste porcelain; 3 × 22 × 22 cm (1⅛ × 8¾ × 8¾ in.)

Private collection

MAKER UNKNOWN

213

Charger with the Arms of O'Hara, 1763

Jingdezhen

Hard-paste porcelain with polychrome enamels and gilding; 37.5 × 37.5 cm (14¾ × 14¾ in.)

The Art Institute of Chicago, bequest of Leigh Block, 2014.1059

MAKER UNKNOWN

214

Pair of Covered Tureens and Stands with the Arms of French Impaling Sutton, c. 1765

Jingdezhen

Hard-paste porcelain with polychrome enamels and gilding; tureen with cover: each 22.4 × 34 × 21.8 cm (8¹³⁄₁₆ × 13⅜ × 8⁹⁄₁₆ in.); stand: each 5.5 × 37.2 × 28.7 cm (2⅛ × 14⅝ × 11⁵⁄₁₆ in.)

The Art Institute of Chicago, bequest of Leigh Block, 2014.1060 and 2014.1061

MAKER UNKNOWN

215

Dinner Plate with the Arms of James Caulfeild, 1st Earl of Charlemont, and Insignia of the Order of Saint Patrick, c. 1785

Jingdezhen

Hard-paste porcelain; 2.2 × 24.4 × 24.4 cm (⅞ × 9⅝ × 9⅝ in.)

Private collection

MAKER UNKNOWN

Transfer decoration after Adam Buck

Irish, 1759–1833

209

Partial Child's Tea Service, c. 1810

England

Transfer-printed earthenware; slop bowl: 6.4 × 10.5 × 10.5 cm (2½ × 4⅛ × 4⅛ in.); cup: 4.6 × 7.5 × 5.9 cm (1¹³⁄₁₆ × 2¹⁵⁄₁₆ × 2⁵⁄₁₆ in.); saucer: 10.5 cm × 10.5 cm (4⅛ × 4⅛ in.); sugar bowl and lid: 8.6 × 6.4 × 6.4 cm (3⅜ × 2½ × 2½ in.); creamer: 8.6 × 8.9 × 5.5 cm (3⅜ × 3½ × 2⅛ in.)

The Art Institute of Chicago, Amelia Blanxius Memorial Collection, 1917.176, 1917.177a–b, 1917.179a–b, and 1917.180

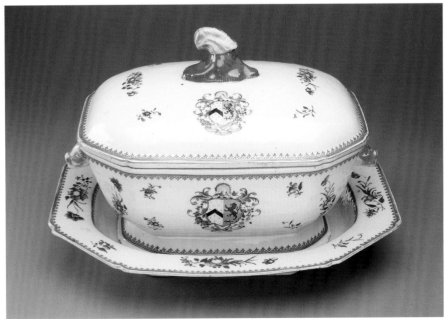

214

FURNITURE

Case Furniture

POSSIBLY CHRISTOPHER HEARN
Irish, active 1757–88

216
Desk and Bookcase, c. 1750–60
Ireland
Mahogany, oak, and brass; 241.6 × 103.5 × 58.4 cm
(95⅛ × 40¾ × 23 in.)
The Collection of Richard H. Driehaus, Chicago

JOHN KIRKHOFFER
Irish, born Germany, active 1730s

217
Desk and Bookcase, 1732
Dublin
Walnut, oak, holly, mirror glass, and brass;
217.2 × 125.7 × 55.9 cm (85½ × 49½ × 22 in.)
The Art Institute of Chicago, gift of Robert Allerton,
1957.200

MAKER UNKNOWN
218
Desk and Bookcase, c. 1740
Ireland
Mahogany, oak, mirror glass, and brass; 211.5 ×
88.3 × 76.2 cm (83¼ × 34¾ × 30 in.)
Courtesy of the Colonial Williamsburg Foundation

MAKER UNKNOWN
219
Chest on Stand, c. 1750–60
Ireland
Mahogany and brass; 112 × 129.5 × 64.5 cm
(44⅛ × 51 × 25⅜ in.)
Collection of Mr. and Mrs. Jerold D. Krouse

Seat Furniture

WILLIAMS AND GIBTON
Irish, 1829–1842
After a design attributed to James Wyatt
English, 1746–1813

220
Hall Bench, 1829/42
Mahogany and brass; 93 × 153.4 × 49.5 cm
(36⅝ × 60⅜ × 19½ in.)
Museum of Art, Rhode Island School of Design,
Providence, Gift of the Estate of W. Phelps Warren
85.075.7A

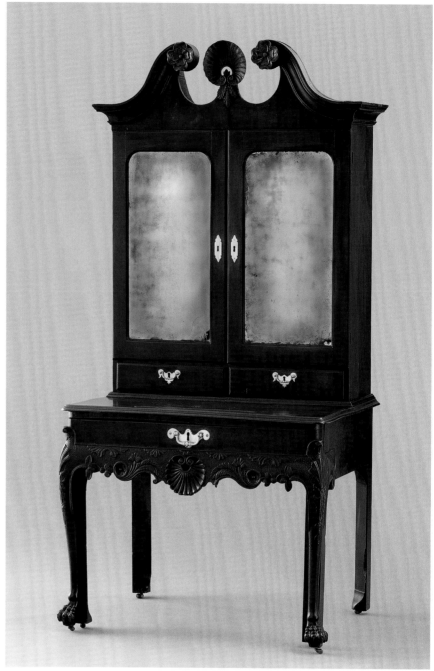

218

MAKER UNKNOWN
221
Four Side Chairs with the Falcon Crest of the Earls
of Meath, c. 1730
Probably made for the 6th Earl of Meath,
Kilruddery, County Wicklow
Dublin
Walnut, boxwood, and fruitwood with silk and wool
upholstery; each 104.1 × 57.2 × 54.6 cm (41 × 22½ ×
21½ in.)
Neville and John Bryan

MAKER UNKNOWN
222
Side Chair, c. 1740
Ireland
American black walnut and white oak with silk,
wool, and linen upholstery; 97.8 × 44.6 × 50.3 cm
(38½ × 17⁹⁄₁₆ × 19¹³⁄₁₆ in.)
Yale University Art Gallery, Mabel Brady Garvan
Collection

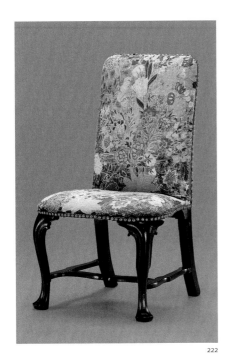

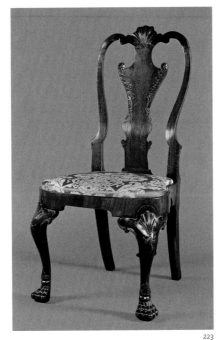

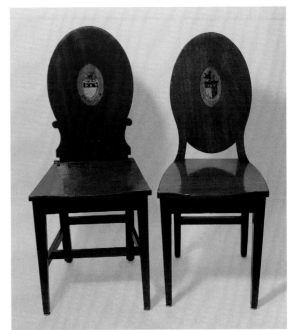

222

223

226

MAKER UNKNOWN

223

Side Chair, c. 1740–50

Ireland

Mahogany with modern silk upholstery, damask
weave; 103.9 × 53.3 × 43.2 cm (40 7/8 × 21 × 17 in.)

Collection of Mr. and Mrs. Jerold D. Krouse

MAKER UNKNOWN

224

Armchair, c. 1750

Ireland

Mahogany with wool and linen upholstery;
97 × 80 × 59 cm (38 1/8 × 31 3/8 × 23 1/4 in.)

Private collection

MAKER UNKNOWN

225

Side Chair, c. 1750

Ireland

Mahogany with modern wool and linen upholstery;
97.2 × 51.4 × 51.4 cm (38 1/4 × 20 1/4 × 20 1/4 in.)

Filoli: Historic House and Gardens

MAKER UNKNOWN

226

Two Hall Chairs, one with the Arms of Handcock
and one with the Arms of Handcock Joined with
Butler, c. 1778

Made for the Dublin home of Matthew Handcock
and Margaret Butler

Dublin

Mahogany with painted coats of arms; each 88.9 ×
37.5 × 38.7 cm (35 × 14 3/4 × 15 1/4 in.)

Christine Du Boulay Ellis

MAKER UNKNOWN

227

Two Closed Armchairs from a Set of Eighteen,
c. 1816

Made for Mount Talbot, County Roscommon

Ireland

Mahogany, tooled gilt leather, and caning; each
88.9 × 58.4 × 51.4 cm (35 × 23 × 20 1/4 in.)

The O'Brien Collection

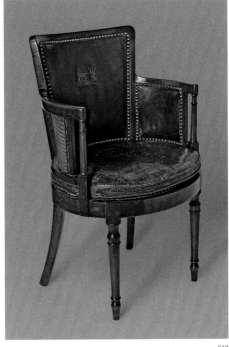

227

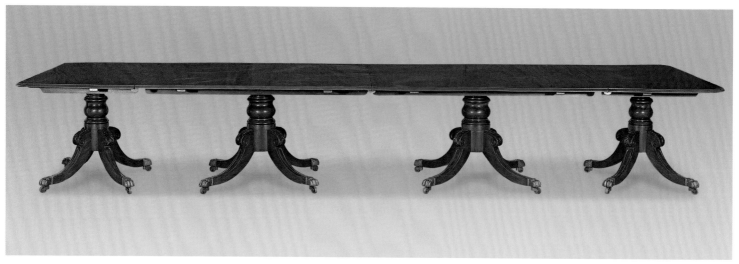

230

Tables

POSSIBLY JOHN HOUGHTON
AND JOHN KELLY
Irish, active 18th century

Irish
228
Side Table, 1760/70
Probably made for the Reverend Francis Hewson of
Ennismore, County Kerry
Dublin
Mahogany; 83.3 × 135.8 × 63.6 cm (32¾ × 53½ × 25 in.)
Private collection

WILLIAM MOORE
Irish, active 1782–1815

229
Pier Table (One of a Pair), c. 1785
Dublin
Satinwood, tulipwood, harewood, and other woods;
89.5 × 119 × 50.5 cm (35¼ × 46⅞ × 19⅞ in.)
Cooper Hewitt, Smithsonian Design Museum,
Smithsonian Institution, Gift of Neil Sellin

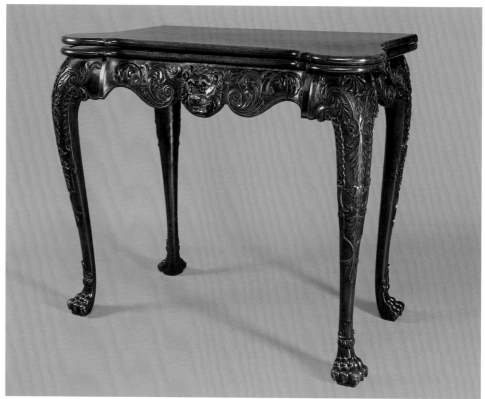

233

POSSIBLY WILLIAMS AND GIBTON
Irish, 1829–1842

230
Pedestal Dining Table, c. 1830–40
Dublin
Mahogany and brass; 73.7 × 647.7 × 143.5 cm
(29 × 255 × 56½ in.)
The O'Brien Collection

MAKER UNKNOWN
231
Card Table, c. 1740
Ireland
Mahogany; 76.2 × 88.9 × 44.5 cm (30 × 35 × 17½ in.)
Philadelphia Museum of Art, Gift of Mrs. Francis P.
Garvan in memory of her husband, 1951

MAKER UNKNOWN
232
Games Table, c. 1740
Ireland
Mahogany and boxwood; 71.1 × 81.3 × 61 cm
(28 × 32 × 24 in.)
Private collection by arrangement with Mallett

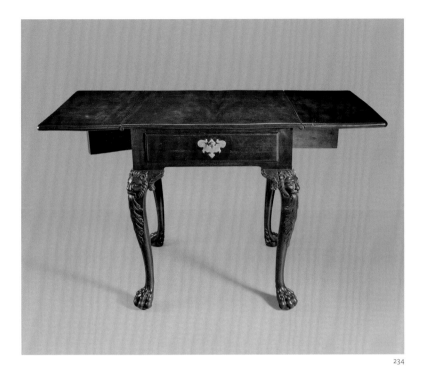

234

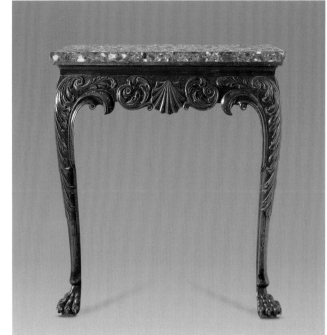

237

MAKER UNKNOWN

233

Card Table, c. 1740–50

Ireland

Mahogany; 75 × 90 × 46 cm (29½ × 35⁷⁄₁₆ × 18⅛ in.)

Collection of Mr. and Mrs. Jerold D. Krouse

MAKER UNKNOWN

234

Pembroke Table, c. 1740–60

Ireland

Mahogany and brass; drop leaves down: 69.2 × 70 × 70 cm (27¼ × 24 × 24 in.); drop leaves extended: 69.2 × 116.8 × 70 cm (27¼ × 46 × 24 in.)

Tara Kelleher and Roy Zuckerberg

MAKER UNKNOWN

235

Tea Table, c. 1740–60

Ireland

Mahogany; 72.4 × 90.2 × 58.4 cm (28½ × 35½ × 23 in.)

Tara Kelleher and Roy Zuckerberg

MAKER UNKNOWN

236

Side Table, c. 1750–60

Ireland

Mahogany; 79.4 × 142.2 × 78.1 cm (31¼ × 56 × 30¾ in.)

Collection of Mr. and Mrs. Jerold D. Krouse

MAKER UNKNOWN

237

Console Table, c. 1760

Ireland

Mahogany and marble; 76.2 × 68.6 × 44 cm (30 × 27 × 17 in.)

Private collection

MAKER UNKNOWN

238

Side Table, c. 1760

Ireland

Mahogany; 76.2 × 152.4 × 72.4 cm (30 × 60 × 28½ in.)

Private collection by arrangement with Mallett

Other Furniture

PROBABLY JOHN HOUGHTON

Irish, active 18th century

239

Pier Glass (One of a Pair), c. 1750

Probably made for the Penrose family of Woodhill, County Cork

Ireland

Mahogany and mirror glass; 141.5 × 91.4 cm (55⁷⁄₁₀ × 36 in.)

L. Knife and Son, Inc.

PROBABLY MACK, WILLIAMS AND GIBTON

Irish, 1811–1829

After a design attributed to Francis Johnston adapted from Thomas Sheriton, *The Cabinet Dictionary* (London, 1803, pp. 68)

Irish, 1760–1829

240

Cellarette, c. 1821/25

Dublin

Mahogany with metal liner; 106.7 × 64.8 × 76.2 cm (42 × 25½ × 30 in.)

L. Knife and Son, Inc.

B. WALTON & COMPANY

English, founded 1840

241

Tray with Scene of Cork Harbor, c. 1840–44

Wolverhampton, England

Papier-mâché with painted decoration; 49.5 × 65.3 × 4.4 cm (19½ × 25⅝ × 1¾ in.)

Private collection

MAKER UNKNOWN

242

Decanter Stand, c. 1760

Ireland

Mahogany; 57 × 72 × 42 cm (22½ × 28½ × 16½ in.)

Collection of Mr. and Mrs. Jerold D. Krouse

243

244

MAKER UNKNOWN

243

Two Wall Sconces, c. 1780

Probably made for Castle ffrench, County Galway

Dublin

Gilt wood; each 55.9 × 38.1 × 17.8 cm

(22 × 15 × 7 in.)

Private collection

MAKER UNKNOWN

244

Reading Stand with Image Titled "Cabinteely House," 1810/20

Ireland

Painted wood with varnished paper onlay; 38.7 × 35.2 × 20 cm (15 1/4 × 13 7/8 × 7 7/8 in.)

Private collection

GLASS

Decanters and Pitchers

CORK GLASS COMPANY

Irish, 1783–1818

245

Cider or Beer Pitcher, c. 1810

Cork

Lead glass; 27.9 × 15.2 × 15.2 cm (11 × 6 × 6 in.)

Private collection

PROBABLY CORK GLASS COMPANY

Irish, 1783–1818

246

Decanter

Made for the American market, with the later engraved initials N G, for Nancy Gay, of Gays Island, Cushing, Massachusetts, now Maine, c. 1815

Probably Cork

Lead glass; 25.4 × 11.1 cm (10 × 4 3/8 in.)

Courtesy of Historic New England, Gift of Mrs. Susan Norton McCullagh, 1954.11

WATERLOO GLASSHOUSE COMPANY

Irish, 1815–1835

247

Decanter, c. 1820

Cork

Lead glass; 26.7 × 12 × 12 cm (10 1/2 × 4 3/4 × 4 3/4 in.)

Private collection

MAKER UNKNOWN

248

Decanter, 1800/10

Probably Cork

Retailed by Mary Carter and Son, Dublin

Lead glass; 27.3 × 11 × 11 cm (10 3/4 × 4 3/8 × 4 3/8 in.)

Private collection

MAKER UNKNOWN

249

Decanter, c. 1810–20

Belfast

Lead glass; 22 × 10 × 10 cm (8 5/8 × 4 × 4 in.)

Private collection

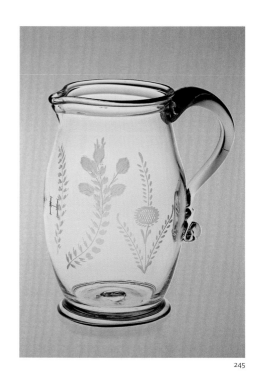

245

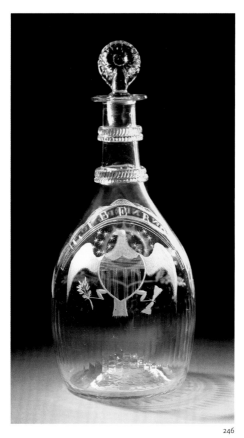

246

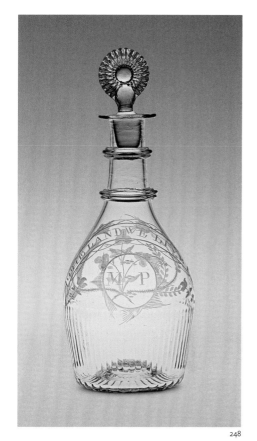

248

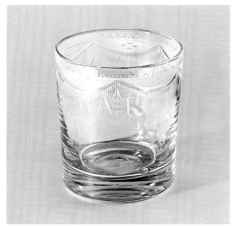

251

253

MAKER UNKNOWN

250

Decanter, c. 1825–30

Newry

Lead glass; 24 × 13 × 13 cm (9½ × 5⅛ × 5⅛ in.)

Private collection

Drinking Glasses

PROBABLY CORK GLASS COMPANY

Irish, 1783–1818

POSSIBLY ENGRAVED AT THE WORKSHOP
OF MICHAEL BUCKLEY

Probably Irish, dates unknown

251

Tumbler, 1805/30

Probably Cork

Lead glass; h. 7 cm (2¾ in.)

Private collection

MAKER UNKNOWN

252

Wine Glass or Rummer, c. 1810–20

Belfast

Lead glass; 13.3 × 9 × 9 cm (5¼ × 3½ × 3½ in.)

Private collection

MAKER UNKNOWN

253

Tumbler, c. 1835–40

Ireland

Retailed by James Jackson, Dublin

Lead glass; 10 × 8.7 × 8.7 cm (4 × 3½ × 3½ in.)

Private collection

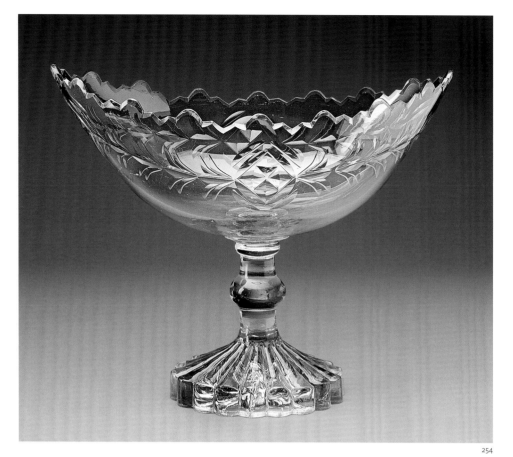

254

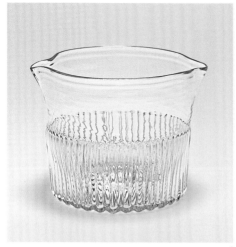

256

257

Footed Bowls

MAKER UNKNOWN

254

Footed Bowl, c. 1800

Ireland

Lead glass; 27.9 × 34.9 × 20.2 cm (11 × 13 ¾ × 7 ¹⁵⁄₁₆ in.)

The Art Institute of Chicago, gift of Robert H. Allerton, 1931.728

MAKER UNKNOWN

255

Footed Bowl, c. 1820

Ireland

Lead glass; 21.3 × 31.1 × 31.1 cm (8 ⅜ × 12 ¼ × 12 ¼ in.)

Maris and Maija Zuika

Rinsers and Finger Bowls

MAKER UNKNOWN

256

Wine Glass Rinser, c. 1790

Probably Belfast

Retailed by Francis Collins, Dublin

Lead glass; 9.5 × 12.9 × 12.9 cm (3 ¾ × 5 ¹⁄₁₆ × 5 ⅛ in.)

Maris and Maija Zuika

MAKER UNKNOWN

257

Finger Bowl, c. 1800

Probably Waterford

Retailed by Armstrong, Ormond Quay, Dublin

Blue-tinted lead glass; 9.2 × 10.2 × 10.2 cm (3 ⅝ × 4 × 4 in.)

Maris and Maija Zuika

METALWORK

Silver

THOMAS BOLTON

Irish, active 1686–1730

258

Two-Handled Cup and Cover with the Crest of Broderick of Midleton, County Cork, 1694/96

Dublin

Silver; 30.5 × 34.2 × 22 cm (12 × 13 ⁷⁄₁₆ × 8 ¹¹⁄₁₆ in.)

Museum of Fine Arts, Boston, Gift of Richard C. Paine

259

Monteith, 1702/03

Commissioned by Sir Richard Cox while lord chancellor of Ireland; made of silver from the Great Seal of Ireland from the reign of William III and the Seal of the Common Pleas

Dublin

Silver; 27 × 36.8 × 36.8 cm (10 ⅝ × 14 ½ × 14 ½ in.)

The Art Institute of Chicago, bequest of Mary Hooker Dole, 1950.2031

260

Sideboard Dish with the Arms of Anne, Queen of Great Britain, 1702/03

Presented to James Butler, 2nd Duke of Ormonde, as part of his ambassadorial service while lord lieutenant of Ireland

Dublin

Silver; 4.4 cm × 57.8 × 57.8 cm (1 ¾ × 22 ¾ × 22 ¾ in.)

Museum of Fine Arts, Boston, Theodora Wilbour Fund in memory of Charlotte Beebe Wilbour

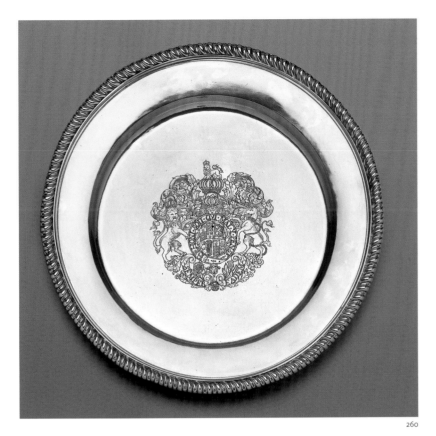

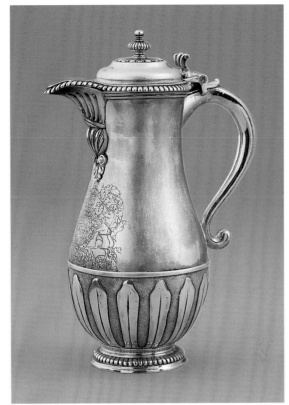

260

261

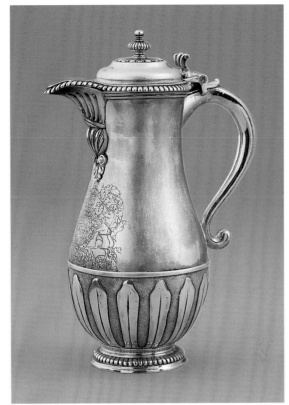

262

261
Covered Ewer with the Arms of Anne, Queen of
Great Britain, 1702/03
Presented to the 2nd Duke of Ormonde when lord
lieutenant of Ireland
Dublin
Silver; 30.5 × 13 × 23.3 cm (12 × 5 ⅛ × 9 3/16 in.)
San Antonio Museum of Art, Bequest of John V.
Rowan, Jr.

262
Toaster with the Arms of Wynne of Ireland, 1715/16
Dublin
Silver and wood; 47.1 × 20.3 × 11.6 cm
(18 ½ × 8 × 4 ⅝ in.)
San Antonio Museum of Art, Bequest of John V.
Rowan, Jr.

DAVID BOMES
French (Huguenot), active in Ireland, active
1731–c. 1766

263
Pair of Wine Ewers, c. 1740
Dublin
Silver; 30.5 × 12.4 × 20.6 cm (12 × 4 ⅞ × 8 ⅛ in.);
30.5 × 11.4 × 20.3 cm (12 × 4 ½ × 8 in.)
The Art Institute of Chicago, bequest of Mary
Hooker Dole, 1950.2032a–b

ROBERT CALDERWOOD
Irish, active 1726–66

264
Salver, 1745/46
Dublin
Silver; 7.6 × 54.6 × 54.6 cm (3 × 21 ½ × 21 ½ in.)
San Antonio Museum of Art, Bequest of John V.
Rowan, Jr.

265
Wall Fountain, 1754
Possibly commissioned by James FitzGerald, 20th
Earl of Kildare, with the arms of Robert, 19th Earl of
Kildare, and Mary, daughter of William, 3rd Earl of
Inchiquin
Dublin
Silver; 57 × 29 × 27 cm (22 7/16 × 11 ⅜ × 10 ⅝ in.)
Fowler Museum at UCLA

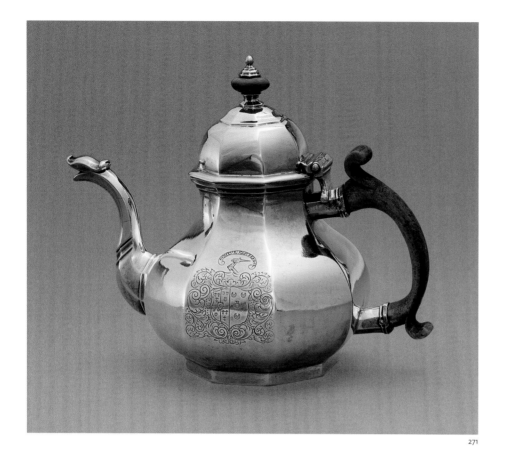

271

266
Dish Ring, c. 1760
Dublin
Silver; 8.9 × 19.7 × 19.7 cm (3½ × 7¾ × 7¾ in.)
Collection of Melinda and Paul Sullivan

PROBABLY MARK FALLON
Irish, active c. 1730

267
Chandelier, c. 1742 or earlier
Made for the Dominican Convent of Jesus, Mary,
and Joseph, County Galway
Galway
Silver; h. 59.7 cm (23½ in.)
Winterthur Museum, Bequest of Henry Francis
du Pont

GEORGE GALLANT
English, active in Ireland c. 1637–49

268
Scroll Salt, 1640
Dublin
Silver; 11.4 × 14.6 × 14.6 cm (4½ × 5¾ × 5¾ in.)
Minneapolis Institute of Arts, Gift of James F. and
Louise H. Bell

ANDREW GREGORY
Irish, active 1664–1700

269
Traveling Chalice, 1680/81
Dublin
Silver; 12.1 × 7.8 × 7.8 cm (4¾ × 3¹⁄₁₆ × 3¹⁄₁₆ in.)
Private collection by arrangement with S. J.
Shrubsole, New York

ROBERT GOBLE
French, active in Ireland, active c. 1665, died 1719

270
Tankard with the Arms of the Day Family, c. 1710
Cork
Silver; 19.7 × 14 × 20 cm (7¾ × 5½ × 7⅞ in.)
Private collection by arrangement with S. J.
Shrubsole, New York

JOHN HAMILTON
Irish, active 1708–51

271
Teapot, 1716/19
Dublin
Silver and wood; 17.3 × 10.8 × 21 cm
(6¾ × 4¼ × 8¼ in.)
San Antonio Museum of Art, Bequest of John V.
Rowan, Jr.

JOSEPH JACKSON
Irish, active 1775–1807

272
Pair of Shoe Buckles, c. 1790
Dublin
Silver; each 5.4 × 7.6 cm (2⅛ × 2⅞ in.)
San Antonio Museum of Art, Bequest of John V.
Rowan, Jr.

CHARLES FREDERICK KANDLER
English, born Germany, active 1735–c. 1750

273
Two-Handled Cup and Cover, 1749/50
Commissioned by Henry Flower, 2nd Baron of
Castle Durrow, for Castle Durrow, County Laois
London
Silver; 42.9 × 35.6 × 17.8 cm (16⅞ × 14 × 7 in.)
Saint Louis Art Museum, Gift of Morton J. May

JAMES KENNEDY
Irish, active 1768–1803

274
Freedom Box, 1795
Presented to Frederick Bowes by the City of
Drogheda on October 6, 1795
Dublin
Parcel-gilt silver with vellum insert; 3.8 × 7.6 × 7.6 cm
(1½ × 3 × 3 in.)
San Antonio Museum of Art, Bequest of John V.
Rowan, Jr.

DAVID KING
Irish, active 1694–1735

275
Monteith with the Arms of William Caulfeild, 2nd
Viscount Charlemont, 1699
Dublin
Silver; 25.4 × 33 × 33 cm (10 × 13 × 13 in.)
Private collection

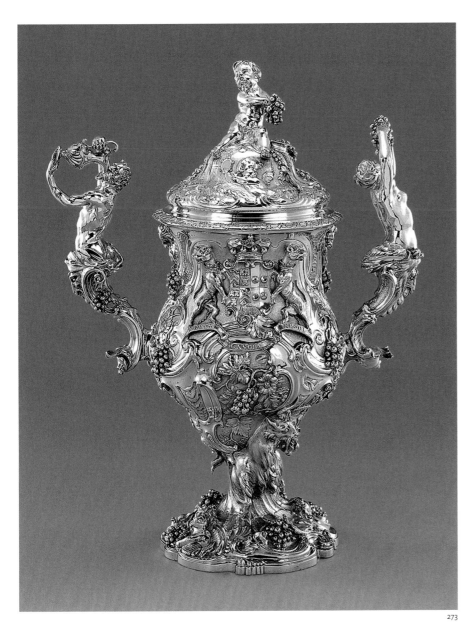

273

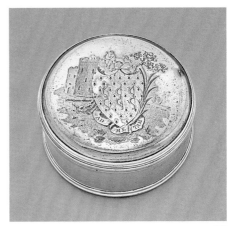

274

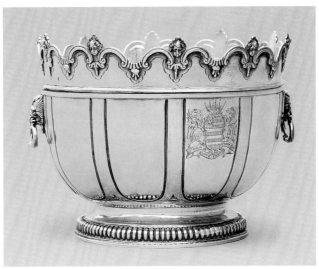

275

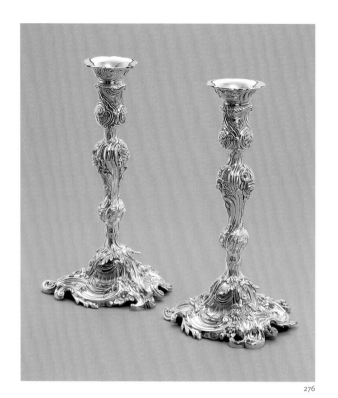

276

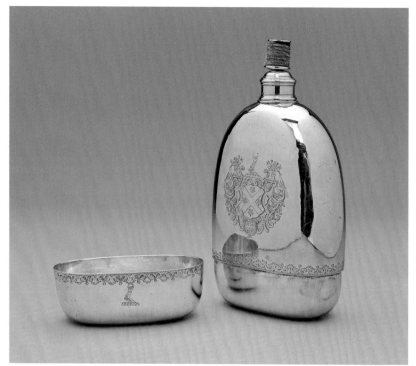

278

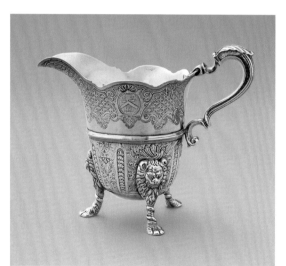

279

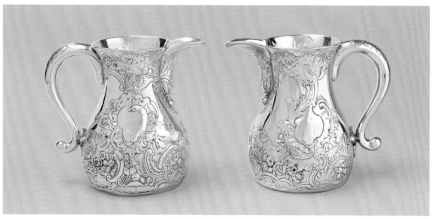

281

CHARLES LAUGHLIN
Irish, active 1752–c. 1755

276
Pair of Candlesticks, c. 1753
Dublin
Silver; each 31.7 × 18.8 × 18.8 cm (12 ½ × 7 ⅜ × 7 ⅜ in.)
San Antonio Museum of Art, Bequest of John V.
Rowan, Jr.

JOHN LAUGHLIN, JR.
Irish, active 1765–c. 1784

277
Covered Hot Water Urn, 1770
Dublin
Silver; 50.8 × 22.9 × 29.5 cm (20 × 9 × 11 ⅝ in.)
Private collection

CHARLES LESLIE
Irish, born Scotland, active 1720–c. 1754

278
Flask, c. 1735
Dublin
Silver; 18.7 × 10.2 × 5.4 cm (7 ⅜ × 4 × 2 ⅛ in.)
Private collection by arrangement with
L & W Duvallier, Dublin

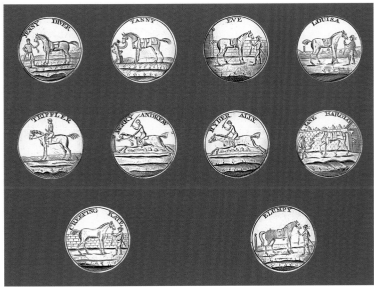

282

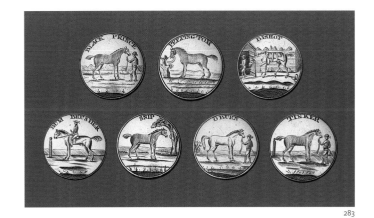

283

279
Cream Jug, c. 1745
Dublin
Silver; 12.1 × 8.3 × 15.2 cm (4 ¾ × 3 ¼ × 6 in.)
San Antonio Museum of Art, Bequest of John V.
Rowan, Jr.

POSSIBLY THOMAS LYNCH
Irish, active 18th century

280
Chalice, 1724
Galway
Made for the Convent of Burisoule (Burrishoole),
County Mayo
Parcel-gilt silver; h. 22.9 cm (9 in.)
Loyola University Museum of Art, Chicago, Martin
D'Arcy, S.J., Collection, Gift of Mr. and Mrs. Donald
F. Roue

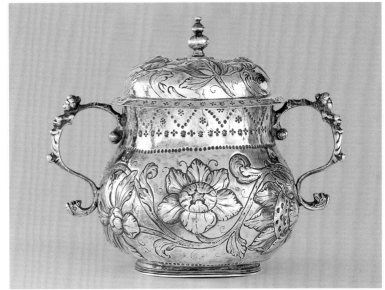

284

JOHN MOORE
Irish, active 1728–67

281
Pair of Beer Jugs, c. 1745
Dublin
Silver; each 15.2 × 12.8 × 19 cm (6 × 5 × 7 ½ in.)
Private collection

JOHN NICKLIN
Irish, active 1784–1800

282
Ten Buttons, 1787
Dublin
Silver; each diam. 3.8 cm (1 ½ in.)
The Metropolitan Museum of Art, New York, the
Hanna S. Kohn Collection, 1951

283
Seven Buttons, 1787
Dublin
Silver; each diam. 3.8 cm (1 ½ in.)
Private collection

SIR ABEL RAM
Irish, active 1665–84

284
Porringer and Cover, c. 1665
Dublin
Silver; 21.6 × 25.4 cm (8.5 × 10 in.)
Kathleen Durdin

RUNDELL, BRIDGE AND RUNDELL
English, 1797–1843

285
Star of the Order of Saint Patrick, c. 1815
Silver and enamel; 12 × 12 cm (4 ¾ × 4 ¾ in.)
Private collection

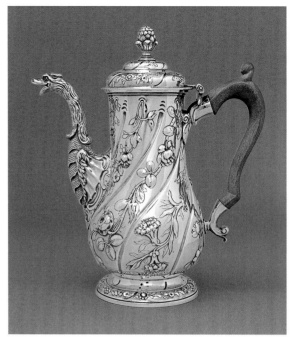

288

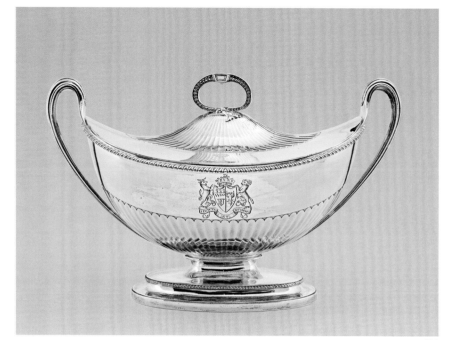

290

THOMAS SUTTON
Irish, active 1717–45

286
Wine Cistern, 1727
With the arms of Robert FitzGerald, 19th Earl
of Kildare, and Mary, daughter of William, 3rd Earl
of Inchiquin
Dublin
Silver; 24.1 × 48.3 × 35.6 cm (9½ × 19 × 14 in.)
Dallas Museum of Art, The Karl and Esther
Hoblitzelle Collection, Gift of the Hoblitzelle
Foundation

CHARLES TOWNSEND
Irish, active 1770–85

287
Dish Ring with the Arms of Sir Michael Cox, 3rd
Baronet, and Elizabeth Massy, of the Manor House,
Dunmanway, County Cork, 1772
Dublin
Silver; 9.8 × 20.3 × 20.3 cm (3⅞ × 8 × 8 in.)
The Art Institute of Chicago, Kay and Frederick
Krehbiel, Joseph P. Gromacki, Jenner and Block, the
Avrum Gray Family Fund, 2011.1169

WILLIAM TOWNSEND
Irish, active from 1736

288
Coffeepot, after 1775
Dublin
Silver; 27.3 × 24.1 × 24.1 cm (10¾ × 9½ × 9½ in.)
Private collection

ABRAHAM TUPPY
Irish, active 1761–88

Dublin
289
Traveling Set, 1786/87
Silver, steel, and rosewood with silver mounts;
case: 21 × 7.1 × 7.1 cm (8¼ × 2¹³⁄₁₆ × 2³⁄₁₆ in.)
San Antonio Museum of Art, Bequest of John V.
Rowan, Jr.

JOHN WAKELIN AND WILLIAM TAYLOR
English, active 1776–c. 1792

290
Tureen with Cover, 1783/84
Commissioned as part of a large service by
Valentine Lawless, Baron Cloncurry
London
Silver; 26 × 14.3 × 22.8 cm (10¼ × 16¼ × 9 in.)
The Art Institute of Chicago, gift of Mrs. Charles F.
Glore through the Antiquarian Society, 1967.431a–b

THOMAS WALKER
Irish, active 1717–58, died 1776

291
Octofoil Salver with the Arms of Sneyd Impaling
Bagot, 1734/35
Dublin
Silver; diam. 64.1 cm (25¼ in.)
San Antonio Museum of Art, Bequest of John V.
Rowan, Jr.

JOSEPH WALKER
Irish, active 1690–1722

292
Reading Lamp, 1720/21
Dublin
Silver; h. 41.9 cm (16½ in.), diam. of base 41 cm
(16⅛ in.)
San Antonio Museum of Art, Bequest of John V.
Rowan, Jr.

SAMUEL WALKER
Irish, active 1731–69

293
Two-Handled Cup and Cover, c. 1761–66
Made of silver from the Great Seal of Ireland from
the reign of George II for Lord Chancellor John Bowes
Dublin
Parcel-gilt silver; 45.7 × 44.5 × 21.7 cm
(18 × 17½ × 8⁹⁄₁₆ in.)
Philadelphia Museum of Art, Gift of an anonymous
donor, 2008

291

292

POSSIBLY JAMES WARREN

Irish, active 1752–89

294
Bread or Cake Basket, c. 1755
Dublin
Silver; 13.9 × 34.9 × 29.5 cm (5½ × 13¾ × 11⅝ in.)
San Antonio Museum of Art, Bequest of John V.
Rowan, Jr.

GEORGE WICKES

English, 1698–1761

295
Epergne and Stand, 1742/43
Commissioned as part of a large service by Joseph
Leeson for Russborough, County Wicklow
London
Silver; 36.8 × 69.9 × 67.3 cm (14½ × 27½ × 26½ in.)
Courtesy of the Colonial Williamsburg Foundation

JOHN WILME

French (Huguenot), active in Ireland, active 1718–51

296
Mace of the Borough of Athy, County Kildare,
1746/47
Presented by James FitzGerald, 20th Earl
of Kildare
Dublin
Silver; 117.5 × 17.8 × 17.8 cm (46¼ × 7 × 7 in.)
San Antonio Museum of Art, Bequest of John V.
Rowan, Jr.

294

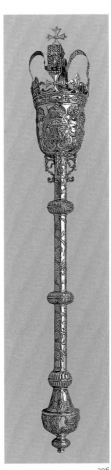

296

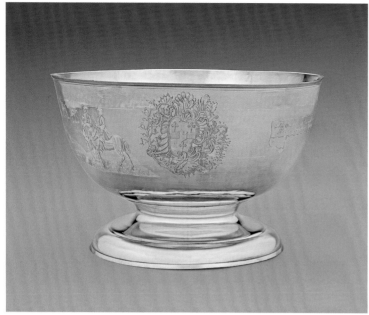

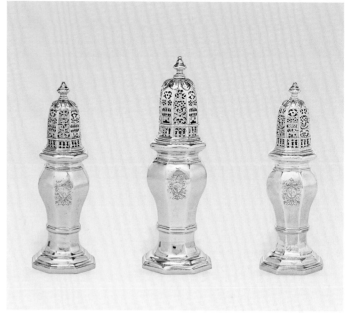

297

298

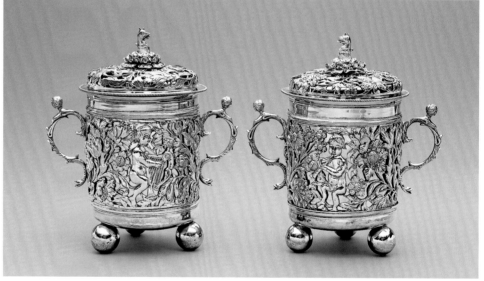

WILLIAM WILLIAMSON II
Irish, active 1734–54
Engraving by Daniel Pomarede
Irish, active 1742–65

297
Racing Trophy Punch Bowl, 1751
Awarded to Sir Ralph Gore of Manor Gore, County
Donegal
Dublin
Silver; 21.9 × 36.2 × 36.2 cm (8⅝ × 14¼ × 14¼ in.)
Museum of Fine Arts, Boston, Theodora Wilbour
Fund in memory of Charlotte Beebe Wilbour

EDWARD WORKMAN
Irish, active 1699–1720

298
Set of Three Casters, 1704/06
Dublin
Silver; tallest caster: diam. 22.9 × 8.3 cm (9 × 3¼ in.);
two shorter casters: each 19.7 × 7.5 cm (7¾ × 2¹⁵⁄₁₆ in.)
The Art Institute of Chicago, gift of Dr. and Mrs.
William C. Brown, 1980.516a–b, 1980.517a–b, and
1980.518a–b

MAKER UNKNOWN
Irish

299
Pair of Sleeve Cups, 1729/30
Dublin
Silver; each 24.1 × 22.2 × 22.2 cm (9½ × 8¾ × 8¾ in.)
San Antonio Museum of Art, Bequest of John V.
Rowan, Jr.

299

MAKER UNKNOWN
300
Snuffbox Inscribed "Richard Brinsley Sheridan,"
c. 1775
Ireland or England
Bloodstone with silver and gilt copper alloy mounts;
2.54 × 6.9 × 5.4 cm (1 × 2¾ × 2⅛ in.)
Private collection

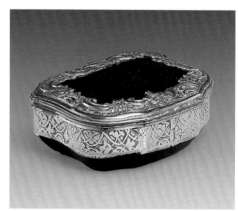

300

301

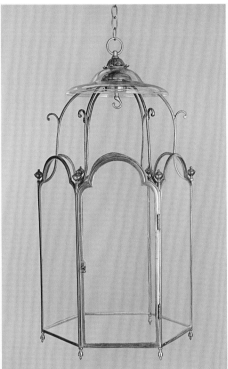

303

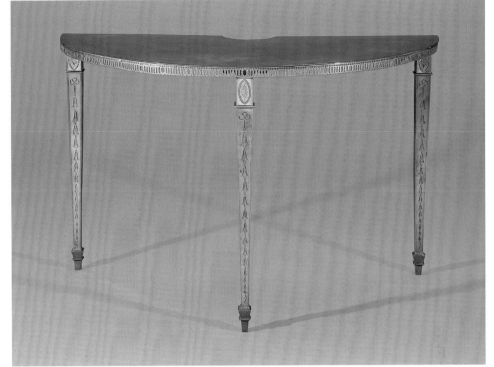

305

304

Gold

MAKER UNKNOWN
Irish

301
Pair of Thimbles, 1768
Dublin
Presented to James FitzGerald, 1st Duke of Leinster,
and Robert William FitzGerald, later 2nd Duke of
Leinster, by the Tailors' Company of Dublin
Gold; each h. 1.5 cm (⅝ in.), diam. 1.5 cm (⅝ in.)
San Antonio Museum of Art, Bequest of John V.
Rowan, Jr.

MAKER UNKNOWN

302
Badge of the Grand Master of the Order of Saint
Patrick, c. 1850
Ireland
Gold and enamel; 9.2 × 3.8 cm (3⅝ × 1½ in.)
Private collection

Base Metals

T. HANBURY
Irish, active late eighteenth century

303
Hall Lantern, 1775/1800
Dublin
Brass and glass; 86.4 × 54.6 × 54.6 cm (34 × 21½ ×
21½ in.)
Private collection

MASON OF DUBLIN
Irish, active from the late 18th century

304
Sundial, c. 1815
Dublin
Brass with wood mount; 14.2 × 21.5 × 21.5 cm
(5½ × 8½ × 8½ in.)
Private collection

PROBABLY SAMUEL MASON
Irish, active 2nd half of the 18th century

305
Demilune Table, c. 1785
Dublin
Silvered copper and brass; 69.2 × 112.4 × 56.5 cm
(27¼ × 44¼ × 22¼ in.)
Private collection

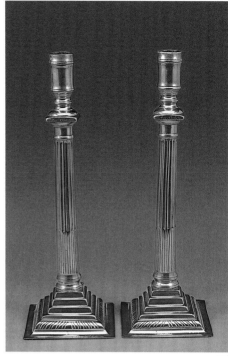

306

MAKER UNKNOWN

306

Pair of Candlesticks Inscribed "St. Mary's Cork 1787," 1787

England or Ireland

Brass; 51.4 × 17.5 × 17.5 cm (20¼ × 6⅞ × 6⅞ in.)

Neville and John Bryan

MUSICAL INSTRUMENTS

JOHN EGAN

Irish, active c. 1801–41

307

Portable Harp, c. 1820

Maple, spruce, ivory, catgut, and green paint with gilt decoration; 90.2 × 49 × 22.1 cm (35½ × 19¼ × 8¹¹⁄₁₆ in.)

The O'Brien Collection

JOHN KELLY

Irish, active 1726–34

308

Harp (*Cláirseach*), 1734

Made for the Reverend Charles Bunworth

Ireland

Painted willow and brass; 167.8 × 78.6 × 33.4 cm (66¹⁄₁₆ × 30¹⁵⁄₁₆ × 13⅛ in.)

Museum of Fine Arts, Boston, Leslie Lindsey Mason Collection

PERRY & WILKINSON

Irish, active 1787–c. 1839

309

Cither Viol (Sultana), 1794

Dublin

Maple, spruce, ivory, and brass; 71.1 × 23 × 3.7 cm (28 × 9¹⁄₁₆ × 1⁷⁄₁₆ in.)

Museum of Fine Arts, Boston, Leslie Lindsey Mason Collection

THOMAS PERRY

Irish, c. 1744–1818

310

Kit/Pochette, early 19th century

Dublin

Maple and ebony; 45.8 × 8.5 × 7.2 cm (18 × 3⅜ × 2⅞ in.)

Yale University Collection of Musical Instruments

ROBERT WOFFINGTON

Irish, active 1773–1823

CASEWORK POSSIBLY BY WILLIAM MOORE

Irish, active 1782–1815

311

Upright Piano, c. 1790

Dublin

Mahogany, maple, satinwood, and kingwood; 125.2 × 91.7 × 45.4 cm (49⁵⁄₁₆ × 36⅛ × 17⅞ in.)

Museum of Fine Arts, Boston, Gift of the New England Conservatory of Music

SCULPTURE

LAWRENCE GAHAGAN

Irish, active 1756–17

312

Arthur Wellesley, Later Duke of Wellington, 1811

Bronze; h. 29.2 cm (11½ in.)

Dr. and Mrs. Leo Ackerman

JAN (JOHN) VAN NOST THE YOUNGER

Flemish, active in England and Ireland, c. 1727–80

313

David La Touche II, 3rd quarter of the 18th century

Marble; 66 × 52.1 × 28 cm (26 × 20½ × 11 in.)

The Huntington Library, Art Collections, and Botanical Gardens

PETER TURNERELLI

Irish, 1774–1839

314

Henry Grattan, 1820

Marble; 60 × 46.5 × 25.5 cm (23⅝ × 17½ × 10 in.)

Private collection

MAKER UNKNOWN

Roman

315

Venus Genetrix, 2nd century A.D.

Purchased in Rome by Joseph Leeson c. 1751 for Russborough House, County Wicklow

Rome

Marble; 97.6 × 30.5 × 31.8 cm (38⁷⁄₁₆ × 12 × 12½ in.)

The J. Paul Getty Museum, Villa Collection, Malibu, California, Gift of Barbara and Lawrence Fleischman

MAKER UNKNOWN

Irish

316

Crucifix, 1776

Lough Derg, County Donegal

Yew wood; 20 × 5.4 × 1.9 cm (7⅛ × 2⅛ × ¾ in.)

Snite Museum of Art, University of Notre Dame, Gift of Rev. James S. Savage

TEXTILES

ROBERT BAILLIE (TAPESTRY MANUFACTURER)

Irish, 1710–1738

JAN (JOHN) VAN BEAVER (TAPESTRY WEAVER)

Flemish, active in Dublin 1727–50

AFTER SIR GODFREY KNELLER

English, born Germany, 1646–1723

FRAME PROBABLY JOHN HOUGHTON

Irish, active 18th century

317

Portrait of George II, 1733/34, frame 1738

Made for Weavers' Hall, Dublin

Dublin

Wool and silk in parcel-gilt frame; 75.6 × 60.3 cm (29¾ × 23¾ in.)

The Metropolitan Museum of Art, New York, Gift of Irwin Untermyer, 1964

ELIZA BENNIS
Irish, 1725–1802

318
Quilt, 1782
County Waterford
Cotton with printed fabric appliques and silk
embroidery; 276.9 × 245.1 cm (109 × 96½ in.)
Winterthur Museum, Bequest of Henry Francis
du Pont

PROBABLY DESIGNED BY GABRIEL
BERANGER
Dutch (Huguenot), active in Ireland, 1729–1817
PRINTED BY THOMAS HARPUR
Irish, active c. 1782

319
The Irish Volunteers, 1782
Leixlip
Linen and cotton, plain weave; copperplate printed,
painted; 126.3 × 79.4 cm (49¾ × 31¼ in.); warp
repeat: 80.1 cm (31½ in.)
The Art Institute of Chicago, gift of the Illinois
Chapter of the American Institute of Interior
Designers, 1963.749

AFTER DESIGNS BY FRANCIS CLEYN
German, 1582–1658

320
The Destruction of Niobe's Children, from the series
The Great Horses, c. 1665
Commissioned by Edward Brabazon, 2nd Earl
of Meath probably for Kilruddery, County Wicklow
Lambeth (London)
Wool and silk; 348 × 531 cm (137 × 209 in.)
S Franses, London

321

COULSON'S MANUFACTORY
Irish, 1764–c. 1950

321
Napkin with the Great Seal of the United States of
America, c. 1818–26
Lisburn
Made for the delegation of the United States of
America in the Azores
Linen, damask weave; 90.2 × 77.5 cm (35½ × 30½ in.)
Museum of Fine Arts, Boston, Gift of Sally Dabney
Parker

322
Tablecloth, c. 1830
Lisburn
Linen, damask weave; 373.3 × 228.8 cm
(147 × 90 1/16 in.)
Higinbotham Textile Collection

DESIGN BY WILLIAM KILBURN
Irish, 1745–1818

323
Dress, c. 1790
London
Block-printed cotton; approx. 172.2 × 63.5 × 101.6 cm
(68 × 25 × 40 in.)
Lent by Museum of Art, Rhode Island School of
Design, Providence, Helen M. Danforth Acquisition
Fund 1987.028

ELEANOR O'BEIRNE
Irish, 1815–1877

324
Sampler, 1823
County Roscommon
Wool with silk yarn; 42.5 × 44.5 cm (16¾ × 17½ in.)
Collection of Leslie B. Durst

ROBINSON OF BALLSBRIDGE
Irish, active c. 1780–1835

325
Bed Curtain, c. 1780–1800
Copperplate-printed cotton and linen;
198.1 × 74.9 cm (78 × 29½ in.)
The Metropolitan Museum of Art, New York,
Everfast Fabrics Inc. Gift Fund, 1973

326

PROBABLY URSULA STUART
Irish, active 19th century

326
Map of Ireland, 1836
County Down
Linen with silk yarn; 48.9 × 42.4 cm (19¼ × 16⅝ in.)
Private collection

DOROTHY TYRRELL
Irish, active c. 1832

327
Needlework Sampler Book Executed in the Female
Model School, Kildare Place, Dublin, 1832
Dublin
25 pages with applied designs in wool, cotton, silk,
and other media, bound in paper; 40 × 5.1 cm
(15¾ × 2 in.)
Private collection

MAKER UNKNOWN
Irish

328
Needlework Panel from a Pole Screen, 1738
Tralee
Wool and canvas; 68.6 × 50.8 × 2.5 cm (27 × 20 × 1 in.)
Private collection

SELECTED BIBLIOGRAPHY

Alcorn, Ellenor M. 2000. *Silver from 1697 including Irish and Scottish Silver.* Vol. 2 of *English Silver in the Museum of Fine Arts, Boston.* MFA Publications.

Alexander, Angela. 1995. "A Firm of Dublin Cabinet-Makers Mack, Williams & Gibton." *Irish Arts Review Yearbook*, pp. 142–48.

——. 2014. "The Post-Union Cabinetmaking Trade in Ireland, 1800–40—a Time of Transition." *Irish Architectural and Decorative Studies* 17, pp. 50–69.

Alexander, David. 1973. "The Dublin Group: Irish Mezzotint Engravers in London, 1750–1775." *Quarterly Bulletin of the Irish Georgian Society* 16, 3 (July–September), pp. 72–92.

Andrews, Malcolm. 1989. *The Search for the Picturesque: Landscape Aesthetics and Tourism in Britain, 1760–1800.* Scolar Press.

Archer, Michael. 2013. *Delftware in the Fitzwilliam Museum.* Philip Wilson.

Armstrong, Robert Bruce. 1970. *The Irish and Highland Harps.* 1904. Repr., Praeger.

Aronson, Julie, and Marjorie E. Wieseman. 2006. *Perfect Likenesses: European and American Portrait Miniatures from the Cincinnati Art Museum.* Exh. cat. Yale University Press.

Ashton, Geoffrey. 1997. *Pictures in the Garrick Club: A Catalogue of the Paintings, Drawings, Watercolours and Sculpture.* Garrick Club.

Austin, John C. 1994. *British Delft at Williamsburg.* Colonial Williamsburg Foundation/Jonathan Horne.

Barnard, Toby C. 1995. Review of *Land, Politics and Society in Eighteenth-Century Tipperary*, by Thomas P. Power. *Eighteenth-Century Ireland/Iris an dá chultúr* 10, pp. 158–60.

——. 1998. "The World of Goods and County Offaly in the Early Eighteenth Century." In *Offaly: History and Society*, edited by William Nolan and Timothy P. O'Neill, pp. 371–92. Geography Publications.

——. 1999. "Public and Private Uses of Wealth in Ireland, c. 1660–1760." In *Luxury and Austerity*, edited by Jacqueline R. Hill and Colm Lennon, pp. 66–83. Historical Studies 21. University College Dublin Press.

——. 2003. *A New Anatomy of Ireland: The Irish Protestants, 1649–1770.* Yale University Press.

——. 2004. *Making the Grand Figure: Lives and Possession in Ireland, 1641–1770.* Yale University Press.

——. 2005. *A Guide to Sources for the History of Material Culture in Ireland, 1500–2000.* Four Courts.

——. 2006. "Libraries and Collectors, 1700–1800." In *The Irish Book in English, 1550–1800*, edited by Raymond Gillespie and Andrew Hadfield, pp. 111–34. Vol. 3 of *The Oxford History of the Irish Book.* Oxford University Press.

——. 2008. *Improving Ireland? Projectors, Prophets and Profiteers, 1641–1786.* Four Courts.

——. 2014. "The Irish Parliament and Print, 1660–1782." *Parliamentary History* 33, 1 (February), pp. 97–113.

Barr, Elaine. 1980. *George Wickes: Royal Goldsmith, 1698–1761.* Rizzoli.

Barratt, Carrie R., and Ellen G. Miles. 2004. *Gilbert Stuart.* Exh. cat. Metropolitan Museum of Art, New York.

Barrett, Cyril. 1975. "Irish Nationalism and Art, 1800–1921." *Studies* 64, 256 (Winter), pp. 393–409.

Bartlett, Thomas. 1994. "'Masters of the Mountains': The Insurgent Careers of Joseph Holt and Michael Dwyer." In *Wicklow: History and Society; Interdisciplinary Essays on the History of an Irish County*, edited by Ken Hannigan and William F. Nolan, pp. 379–410. Geography Publications.

Bebb, Richard. 2007. *Welsh Furniture, 1250–1950: A Cultural History of Craftsmanship and Design.* 2 vols. Saer.

Bence-Jones, Mark. 1978. *Ireland.* Vol. 1 of *Burke's Guide to Country Houses.* Burke's Peerage.

Benedetti, Sergio. 1998. *The La Touche Amorino: Canova and His Fashionable Irish Patrons.* Exh. cat. National Gallery of Ireland, Dublin.

Benn, George. 1877. *A History of the Town of Belfast.* M. Ward.

Bennett, Douglas. 1972. *Irish Georgian Silver.* Cassell.

Blondé, Bruno, Natacha Coquery, Jon Stobart, and Ilja Van Damme, eds. 2009. *Fashioning Old and New: Changing Consumer Patterns in Western Europe, 1650–1900.* Brepols.

Breeze, George, ed. 1985. *Society of Artists in Ireland: Index of Exhibits, 1765–80.* National Gallery of Ireland, Dublin.

Breffny, Brian de. 1988a. "The Building of the Mansion at Blessington, 1672." *Irish Arts Review Yearbook*, pp. 73–77.

——. 1988b. "The Lafranchini." *Irish Arts Review Yearbook*, pp. 212–21.

Brewer, John, and Roy Porter, eds. 1993. *Consumption and the World of Goods.* Routledge.

Bric, Maurice J. 1996. "Ireland, America and the Reassessment of a Special Relationship, 1760–1783." *Eighteenth-Century Ireland/Iris an dá chultúr* 11, pp. 88–119.

Browne, Alexander. 1669. *Ars Pictoria.* J. Redmayne.

Buckeridge, Bainbrigg. 1706. *An Essay towards an English School of Painters.* J. Nutt.

Buckley, John Joseph. 1943. *Some Irish Altar Plate.* Royal Society of Antiquaries of Ireland.

Bunting, Edward. 1796. *A General Collection of Ancient Irish Music.* Preston and Son.

Burke, Edmund. 1759. *A Philosophical Enquiry into the Origins of Our Ideas of the Sublime and the Beautiful.* 2nd ed. R. and J. Dodsley.

Burke, William P. 1907. *History of Clonmel.* N. Harvey.

Caffrey, Paul. 1986. "Sampson Towgood Roch, Miniaturist." *Irish Arts Review* 3, 4 (Winter), pp. 14–20.

——. 1999. *John Comerford and the Portrait Miniature in Ireland, c. 1620–1850.* Kilkenny Archaeological Society.

——. 2000. *Treasures to Hold: Irish and English Miniatures, 1650–1850, from the National Gallery of Ireland Collection.* Exh. cat. National Gallery of Ireland, Dublin.

Calderón, Loreto, and Konrad Dechant. 2010. "New Light on Hugh Montgomerie, Richard Castle and No. 85 St. Stephen's Green." In Casey 2010, pp. 185–94.

Caldicott, C. E. J., Hugh Gough, and J.-P. Pittion, eds. 1987. *The Huguenots and Ireland: Anatomy of an Emigration.* Glendale.

Cameron, Sir Charles A. 1916. *History of the Royal College of Surgeons in Ireland.* 2nd ed. Fannin.

Campbell, R. 1747. *The London Tradesman.* T. Gardner.

Campbell, Thomas. 1777. *A Philosophical Survey of the South of Ireland.* W. Strahan.

——. 1778. *A Philosophical Survey of the South of Ireland.* W. Whitestone.

Canny, Nicholas. 1988. *Kingdom and Colony: Ireland in the Atlantic World, 1560–1800.* Johns Hopkins University Press.

Carpenter, Andrew, ed. 2015. *The Art and Architecture of Ireland*. 5 vols. Royal Irish Academy/Yale University Press.

Casement, Anne. 2010. "James Gibbs's Schemes for the Londonderry Family." *Irish Architectural and Decorative Studies* 13, pp. 146–49.

Casey, Christine. 1988. "Architectural Books in Eighteenth-Century Ireland." *Eighteenth-Century Ireland/Iris an dá chultúr* 3, pp. 105–13.

——. 1990. "Subscription Networks for Irish Architectural Books, 1730–1760." *Long Room* 35, pp. 41–49.

——. 1990–91. "*Miscelanea Structura Curiosa.*" *Irish Arts Review Yearbook*, pp. 85–91.

——. 1995a. "'Such a piece of curiosity': John Aheron's *A General Treatise of Architecture.*" *Georgian Group Journal* 5, pp. 65–80.

——. 1995b. "A Wax Bas-Relief by Patrick Cunningham." *Irish Arts Review Yearbook*, pp. 117–18.

——. 2005a. *Dublin: The City within the Grand and Royal Canals and the Circular Road with the Phoenix Park*. Vol. 3 of *Buildings of Ireland*. Yale University Press.

——. 2005b. "*Miscelanea Structura Curiosa*: Impetus, Sources and Design." In Laffan 2005, pp. 35–45.

——, ed. 2010. *The Eighteenth-Century Dublin Town House: Form, Function, and Finance*. Four Courts.

——. 2012a. "Grand Tour: The Passage of Migrant Craftsmen from Lake Lugano to Co. Kildare." In Gillespie and Foster 2012, pp. 57–74.

——. 2012b. "Stucco and Sterling: The Earning Power of Ticinese *stuccatori*." In Casey and Lucey 2012, pp. 129–42.

Casey, Christine, and Conor Lucey, eds. 2012. *Decorative Plasterwork in Ireland and Europe: Ornament and the Early Modern Interior*. Four Courts.

Casey, Christine, and Alistair Rowan. 1993. *North Leinster: The Counties of Longford, Louth, Meath, and Westmeath*. Vol. 2 of *Buildings of Ireland*. Penguin.

A Catalogue of the China Ware and Linen of the Late Henry Ingoldsby, Esq. 1731. Dublin.

A Catalogue of the Goods and Stock of the Late Edward Wingfield, Esq.; at Powerscourt, and at His House in Dublin. 1729. Dublin.

A Catalogue of the Goods of the Late Henry Ingoldsby, Esq. 1731. Dublin.

Chetwood, William. 1746. *A Tour through Ireland in Several Entertaining Letters*. Peter Wilson.

Choux, Jacques. 1973. *Meubles lorrains*. Hachette.

Christie's, London. 2009. *Glin Castle: A Knight in Ireland*. Introduction by William Laffan. Sale cat. Christie's, May 7.

——. 2012. *The Exceptional Sale, 2012*. Sale cat. Christie's, July 5.

Clark, Mary. 1999. "'A Principal Ornament for the Mayoralty': A Portrait by Joshua Reynolds." *Irish Arts Review Yearbook*, pp. 154–56.

——. 2006. "The Dublin Civic Portrait Collection: Patronage, Politics and Patriotism." Ph.D. diss., University College, Dublin.

Clarkson, L. A. 1989. "The Carrick-on-Suir Woollen Industry in the Eighteenth Century." *Irish Economic and Social History* 16, pp. 23–41.

Clifford, Helen. 2000. "Of Consuming Cares: Attitudes to Silver in the Eighteenth Century." *Silver Society Journal* 12, pp. 53–59.

Cobbe, Alec. 1997. "Beethoven, Haydn, and an Irish Genius, William Southwell of Dublin." *Irish Arts Review Yearbook*, pp. 70–77.

Cobbe, Alec, and Terry Friedman. 2005. *James Gibbs in Ireland: Newbridge, His Villa for Charles Cobbe, Archbishop of Dublin*. Surrey Litho.

Cornforth, John. 2004. *Early Georgian Interiors*. Yale University Press.

Cosgrove, Patrick, Terence Dooley, and Karol Mullaney-Dignam, eds. 2014. *Aspects of Irish Aristocratic Life: Essays on the FitzGeralds of Kildare and Carton House*. University College Dublin Press.

Cotton, Bernard D. 2008. *Scottish Vernacular Furniture*. Thames & Hudson.

Craig, Maurice. 1952. *Dublin, 1660–1860: A Social and Architectural History*. Cresset.

——. 1953. "The Irish Parliamentary Bindings." *Book Collector* 2, pp. 24–36.

——. 1954. *Irish Book Bindings, 1600–1800*. Cassell.

——. 1976. *Classic Irish Houses of the Middle Size*. Architectural Press.

Crawford, W. H. 1994. *The Handloom Weavers and the Ulster Linen Industry*. Ulster Historical Foundation.

——. 1996. "A Ballymena Business in the Late Eighteenth Century." In *An Uncommon Bookman: Essays in Memory of J. R. R. Adams*, edited by John Gray and Wesley McCann, pp. 23–33. Linen Hall Library.

——. 2005. *The Impact of the Domestic Linen Industry in Ulster*. Ulster Historical Foundation.

Crookshank, Anne. 1989–90. "Robert Hunter." *Irish Arts Review Yearbook*, pp. 165–85.

Crookshank, Anne, and Desmond FitzGerald, Knight of Glin. 1994. *The Watercolours of Ireland: Works on Paper in Pencil, Pastel and Paint, c. 1600–1914*. Barrie and Jenkins.

——. 2002. *Ireland's Painters, 1600–1940*. Yale University Press.

Crookshank, Anne, and David Webb. 1990. *Paintings and Sculptures in Trinity College Dublin*. Trinity College Dublin Press.

Cullen, Emily M. 2008. "Meanings and Cultural Functions of the Irish Harp as Trope, Icon and Instrument: The Construction of an Irish Self-Image." Ph.D. diss., National University of Ireland Galway.

Cullen, Fintan. 1984. "The Oil Paintings of Hugh Douglas Hamilton." *Journal of the Walpole Society* 50, pp. 165–208.

——. 1997. *Visual Politics: The Representation of Ireland, 1750–1930*. Cork University Press.

——. 2000a. "Radicals and Reactionaries: Portraits of the 1790s in Ireland." In *Revolution, Counter-revolution and Union: Ireland in the 1790s*, edited by Jim Smyth, pp. 161–94. Cambridge University Press.

——, ed. 2000b. *Sources in Irish Art: A Reader*. Cork University Press.

——. 2004. *The Irish Face: Redefining the Irish Portrait*. Exh. cat. National Portrait Gallery, London.

——. 2012. *Ireland on Show: Art, Union, and Nationhood*. Ashgate.

Cullen, L. M. 2000. *The Irish Brandy Houses of Eighteenth-Century France*. Lilliput.

Culme, John. 1987. "Attitudes to Old Plate, 1750–1900." In John Culme, *The Biographies*. Vol. 1 of *The Directory of Gold & Silversmiths, Jewellers, and Allied Traders, 1838–1914*, pp. xvi–xxxvi. Antique Collector's Club.

Cunningham, Jessica. 2009. "Dublin's Huguenot Goldsmiths, 1690–1750: Assimilation and Divergence." *Irish Architectural and Decorative Studies* 12, pp. 159–85.

——. 2015. "The Design, Production and Consumption of Silver in Ireland in the Seventeenth Century." Ph.D. diss., National University of Ireland, Maynooth.

Curran, C. P. 1967. *Dublin Decorative Plasterwork of the Seventeenth and Eighteenth Centuries*. Tiranti.

Dalsimer, Adele M., and Vera Kreilkamp. 2000. *Irish Paintings from the Collection of Brian P. Burns*. Exh. cat. John F. Kennedy Center for the Performing Arts.

Daunt, William J. O'Neill. 1848. *Personal Recollections of the Late Daniel O'Connell*. 2 vols. Chapman.

Davies, Sir John. 1787. *Historical Tracts*. William Porter.

Deane, Seamus, ed. 1991–2002. *The Field Day Anthology of Irish Writing*. 3 vols. Field Day Publications.

Delaney, Eamon. 2009. *Breaking the Mould: A Story of Art and Ireland*. New Island.

Dickson, David. 1989. "The Demographic Implications of Dublin's Growth." In *Urban Population Development in Western Europe from the Late-Eighteenth to the Early-Twentieth Century*, edited by Richard Lawton and Robert Lee, pp. 178–89. Liverpool University Press.

——. 2014. *Dublin: The Making of a Capital City*. Profile.

Dixon, William Hepworth, ed. 1863. *Lady Morgan's Memoirs: Autobiography, Diaries and Correspondence.* 2 vols. W. H. Allen and Company.

Dooley, Terence A. 2014. *The Decline and Fall of the Dukes of Leinster, 1872–1948: Love, War, Debt and Madness.* Four Courts.

Downes, Trevor. 2011. "Whatever Happened to Jeremiah Garfield?" *Finial* 21 (July–August), pp. 7–11.

Downey, Declan M., and Julio Crespo MacLennan, eds. 2008. *Spanish-Irish Relations through the Ages.* Four Courts.

Drennan, William. 1785. *Letters of Orellana, an Irish Helot.* J. Chambers and T. Heery.

Drumm, Sarah Rhiannon. 2003. "The Irish Patrons of Rosalba Carriera (1675–1757)." *Irish Architectural and Decorative Studies* 6, pp. 202–25.

Dunlevy, Mairead. 1984. "Wedgwood in Dublin, 1772–77." *Irish Arts Review* 1, 2, pp. 36–39.

———. 1985. "James Donovan—Emperor of China." *Irish Arts Review* 2, 3, pp. 28–36.

———. 1992. "Samuel Madden and the Scheme for the Encouragement of Useful Manufactures." In *Decantations: A Tribute to Maurice Craig,* edited by Agnes Bernell, pp. 21–28. Lilliput.

———. 2011. *Pomp and Poverty: A History of Silk in Ireland.* Yale University Press.

Dunne, Tom. 1987. "Fiction as 'the best History of nations': Lady Morgan's Irish Novels." In *The Writer as Witness: Literature as Historical Evidence,* edited by Tom Dunne, pp. 133–59. Cork University Press.

———. 1988. "Haunted by History: Irish Romantic Writing, 1800–1850." In *Romanticism in National Context,* edited by Roy Porter and Mikuláš Teich, pp. 68–91. Cambridge University Press.

———. 2005. "Painting and Patriotism." In Tom Dunne, *James Barry, 1741–1806: "The Great Historical Painter,"* pp. 119–37. Exh. cat. Crawford Art Gallery/Gandon.

———. 2008. "Chivalry, the Harp and Maclise's Contribution to the Creation of National Identity." In *Daniel Maclise, 1806–1870: Romancing the Past,* edited by Peter Murray, pp. 38–79. Exh. cat. Crawford Art Gallery/Gandon.

Eatwell, Ann. 2000. "Capital Lying Dead: Attitudes to Silver in the Nineteenth Century." *Silver Society Journal* 12, pp. 59–65.

Egerton, Judy. 2001. "Lord Charlemont and William Hogarth." In M. McCarthy 2001, pp. 91–102.

Elliott, Marianne. 2012. *Wolfe Tone.* Liverpool University Press.

Evelyn, John. 1662. *Sculptura, or The History and Art of Chalcography and Engraving on Copper.* G. Beedle and T. Collins.

Everett, Nigel. 2014. *The Woods of Ireland: A History, 700–1800.* Four Courts.

Farington, Joseph. 1979–98. *The Diary of Joseph Farington.* 16 vols. Yale University Press.

Feller, Elizabeth. 2012. *Needleprint.* Vol. 2 of *Micheàl and Elizabeth Feller: The Needlework Collection.* Needlepoint.

Fenlon, Jane. 2001. *The Ormonde Picture Collection.* Dúchas/Heritage Service.

———. 2010. "'Woven Frescoes': Tapestry Collections in Seventeenth-Century Ireland." *Irish Architectural and Decorative Studies* 13, pp. 114–29.

———. 2012. "'A good painter may get good bread': Thomas Pooley and Garret Morphey, Two Gentlemen Painters." In Gillespie and Foster 2012, pp. 220–30.

Fenlon, Jane, and William Laffan. 2010. "John Michael Wright (1617–1690), Sir Neil O'Neill (1658–1690)." In P. Murray 2010, pp. 64–69.

Figgis, Nicola. 1986. "Irish Artists and Society in Eighteenth-Century Rome." *Irish Arts Review* 3, 3, pp. 28–36.

Figgis, Nicola, and Brendan Rooney. 2001. *Irish Paintings in the National Gallery of Ireland.* Vol. 1. National Gallery of Ireland, Dublin.

Finegan, Rachel. 2006. "*Tempietto del Clitunno.*" In Gorry Gallery, *An Exhibition of 17th, 18th and 20th Century Irish Painting,* pp. 5–7. Exh. cat. Gorry Gallery.

Fisher, Jonathan. 1795. *Scenery of Ireland.* J. Debrett.

FitzGerald, Alison. 2005a. "Cosmopolitan Commerce: The Dublin Goldsmith Robert Calderwood." *Apollo* 162, 523 (September), pp. 46–52.

———. 2005b. "The Production and Consumption of Goldsmiths' Work in Eighteenth-Century Dublin." Ph. D. diss., Royal College of Art, London.

———. 2008. "The Business of Being a Goldsmith in Eighteenth-Century Dublin." In O'Brien and O'Kane 2008, pp. 127–35.

———. 2012. "Fighting for 'a small provincial establishment': The Cork Goldsmiths and Their Quest for a Regional Assay Office." In Gillespie and Foster 2012, pp. 170–81.

———. 2014. "Desiring to 'Look Sprucish': Objects in Context at Carton." In Cosgrove, Dooley, and Mullaney-Dignam 2014, pp. 118–27.

———. 2015. *Silver in Georgian Dublin: Making, Selling, Consuming.* Ashgate.

FitzGerald, Alison, and Conor O'Brien. 2001. "The Production of Silver in Eighteenth-Century Dublin." *Irish Art and Decorative Studies* 4, pp. 8–47.

FitzGerald, Brian. 1949–57. *The Correspondence of Emily, Duchess of Leinster.* 3 vols. Stationery Office.

FitzGerald, Elizabeth, ed. 2000. *Lord Kildare's Grand Tour: The Letters of William FitzGerald, 1766–1769.* Collins.

Fitzgerald, Julie. 2005. "The Print Room in England and Ireland, 1750–1830." *Quarterly* 55 (July), pp. 23–31.

FitzGibbon, Constantine. 1976. "The Mount Shannon Sale Catalogue." *Bulletin of the Irish Georgian Society* 19 (January–June), pp. 14–19.

Fitzpatrick, Leslie. 2014. "An Eighteenth-Century Engagement Book." *Irish Architectural and Decorative Studies* 17, pp. 128–35.

Flavin, Susan, and E. T. Jones. 2009. *Bristol's Trade with Ireland and the Continent, 1503–1601: The Evidence of the Exchequer Customs Accounts.* Bristol Record Society.

Flood, W. H. Grattan. 1909. "Dublin Harpsichord and Pianoforte Makers of the Eighteenth Century." *Journal of the Royal Society of Antiquaries of Ireland,* 5th ser., 39, 2, pp. 137–45.

———. 1914. "The Account-Book of a Dublin Harpsichord Maker, Ferdinand Weber, 1764–1783." *Journal of the Royal Society of Antiquaries of Ireland,* 6th ser., 4, 4, pp. 338–47.

Foster, R. F. 1988. *Modern Ireland, 1600–1972.* Penguin.

Foster, Sarah. 1996. "Going Shopping in Eighteenth-Century Dublin." *things* 4 (Summer), pp. 33–61.

———. 1997. "Buying Irish: Consumer Nationalism in Eighteenth-Century Dublin." *History Today* 47, 6, pp. 44–52.

———. 2008. "'An honourable station in respect of commerce as well as constitutional liberty': Retailing, Consumption and Economic Nationalism in Dublin, 1720–85." In O'Brien and O'Kane 2008, pp. 30–44.

Francis, Peter. 1994. "The Belfast Potthouse, Carrickfergus Clay and the Spread of the Delftware Industry." *Transactions of the English Ceramic Circle* 15, pp. 267–82.

———. 1997. "Recent Discoveries in Irish Ceramics." *Irish Arts Review Yearbook,* pp. 88–101.

———. 2000a. "The Development of Lead Glass: The European Connections." *Apollo* 151, 456 (February), pp. 47–53.

———. 2000b. *Irish Delftware: An Illustrated History.* Jonathan Horne Productions.

———. 2000c. *A Pottery by the Lagan: Irish Pottery from the Downshire Pottery, Belfast, 1787–c. 1806.* Institute of Irish Studies, Queen's University Belfast.

Friedman, Arthur, ed. 1966. *The Collected Works of Oliver Goldsmith.* 5 vols. Clarendon.

Fryer, Edward, ed. 1809. *The Works of James Barry.* 2 vols. T. Cadell and W. Davies.

Garnett, Oliver. 2008. *Castle Coole.* National Trust.

Geoghan, Patrick M. 2008. *King Dan: The Rise of Daniel O'Connell, 1775–1829.* Gill & Macmillan.

———. 2010. *Liberator: The Life and Death of Daniel O'Connell, 1830–1847.* Gill & Macmillan.

Gilbert, Christopher. 1991. *English Vernacular Furniture, 1750-1900*. Yale University Press.

Gilbert, Sir John Thomas. 1861. *A History of the City of Dublin*. 3 vols. J. Duffy.

Gillespie, Raymond. 2005a. "Irish Cathedral Libraries before 1700." In *That Woman! Studies in Irish Bibliography; A Festschrift for Mary "Paul" Pollard*, edited by Charles Benson and Siobhán Fitzpatrick, pp. 175-92. Lilliput.

———. 2005b. "The World of Andrew Rowan." In *Industry, Trade and People in Ireland, 1650-1950: Essays in Honour of W. H. Crawford*, edited by Brenda Collins, Philip Ollerenshaw, and Trevor Parkhill, pp. 10-30. Ulster Historical Foundation.

Gillespie, Raymond, and R. F. Foster, eds. 2012. *Irish Provincial Cultures in the Long Eighteenth Century: Making the Middle Sort; Essays for Toby Barnard*. Four Courts.

Gilmartin, John. 1967. "Peter Turnerelli: Sculptor, 1774-1839." *Bulletin of the Irish Georgian Society* 10, 4 (October-December), pp. 1-19.

Gilpin, William. 1794. *Three Essays: On Picturesque Beauty; On Picturesque Travel; and On Sketching Landscape: To which is added a poem, On Landscape Painting*. R. Blamire.

Glanville, Philippa. 1987. *Silver in England*. Unwin Hyman.

Glin, Desmond FitzGerald, Knight of. 1964. "Richard Castle, Architect." *Quarterly Bulletin of the Irish Georgian Society* 7, 1 (January-March), pp. 31-38.

———. 1985. "Dublin Directories and Trade Labels." *Furniture History* 21, pp. 258-82.

———. 1988. "A Patchwork of Irish Houses." In Glin, Griffin, and Robinson 1988, pp. 10-32.

Glin, Desmond FitzGerald, Knight of, David Griffin, and Nicholas Robinson. 1988. *Vanishing Country Houses of Ireland*. Irish Architectural Archive/Irish Georgian Society.

Glin, Desmond FitzGerald, Knight of, and William Laffan. 2006. "Michael Ford's Portrait of Lord Chief Justice Singleton." *Irish Architectural and Decorative Studies* 9, pp. 266-84.

Glin, Desmond FitzGerald, Knight of, and Edward Greenway Malins. 1976. *Lost Demesnes: Irish Landscape Gardening, 1660-1845*. Barrie and Jenkins.

Glin, Desmond FitzGerald, Knight of, and James Peill. 2007. *Irish Furniture: Woodwork and Carving in Ireland from the Earliest Times to the Act of Union*. Yale University Press.

———. 2008. "A Newly Discovered Signature on a Piece of Irish Furniture." *Magazine Antiques* 174, 4 (October), pp. 140-45.

Gould, Stephen Jay. 1977. *Ever Since Darwin: Reflections in Natural History*. W. W. Norton/American Museum of Natural History.

Greene, John C. 2011. *Theatre in Dublin, 1745-1820: A Calendar of Performances*. 6 vols. Lehigh University Press.

Griffin, David. 1998. "Richard Castle's Design for Headfort, Co. Meath." In *Dublin and Beyond the Pale: Studies in Honour of Patrick Healy*, edited by Conleth Manning, pp. 269-72. Wordwell/Rathmichael Historical Society.

Griffin, David, and Caroline Pegum. 2000. *Leinster House, 1744-2000: An Architectural History*. Irish Architectural Archive/Office of Public Works.

Gwynn, John. 1749. *An Essay on Design, including Proposals for Erecting a Public Academy*. George Faulkner.

Hall, Augusta Waddington, Lady Llanover, ed. 1861-62. *The Autobiography and Correspondence of Mary Granville, Mrs. Delany*. 6 vols. R. Bentley.

Hall, S. C. 1984. *Hall's Ireland: Mr. and Mrs. Hall's Tour of 1840*. 2 vols. Sphere.

Hamilton, Hugh Douglas. 2005. *John Rocque's Survey of the Kildare Estates: Manor of Kilkea, 1760; A Rediscovered Atlas Ornamented by Hugh Douglas Hamilton*. Robin Halwas Limited.

Harbison, Peter. 2012. *William Burton Conyngham and His Irish Circle of Antiquarian Artists*. Yale University Press.

Harding, Chester. 1866. *My Egotistography*. John Wilson and Son.

Harris, John. 1973. *Headfort House and Robert Adam: Drawings from the Collection of Mr. and Mrs. Paul Mellon*. Exh. cat. Royal Institute of British Architects.

Harris. Neil. 1992. "Selling National Culture: Ireland at the World's Columbian Exposition." In *Imagining an Irish Past: The Celtic Revival, 1840-1940*, edited by T. J. Edelstein, pp. 82-105. Exh. cat. David and Alfred Smart Museum of Art, University of Chicago.

Harrison, Robert, and Marie-Louise Legg. 2004. "Henry Augustus Dillon-Lee, 13th Viscount Dillon, 1777-1832, Writer." *Oxford Dictionary of National Biography*. Oxford University Press.

Hayden, Ruth. 1980. *Mrs. Delany, Her Life and Her Flowers*. British Museum Publications.

Haydon, Colin. 2013. "'[Almost] the only Histories we can boast': The Charter-School Sermons and their Perceptions and Uses of Irish History." *Eighteenth-Century Ireland/Iris an dá chultúr* 28, pp. 78-94.

Healy, Patrick. 2001. "Burke's *The Sublime and the Beautiful* and Irish Landscape." In Laffan 2001b, pp. 10-17.

Healy, Patrick, and Joseph McDonnell. 1987. *Gold-Tooled Bookbindings Commissioned by Trinity College Dublin in the Eighteenth Century*. Irish Georgian Society.

Herdeg, John A. 2003. "Re-Introducing Helena." In *The Walpole Society Note Book for 1999-2000*. Walpole Society, pp. 72-75.

Herron, Thomas, and Brendan Kane. 2013. *Nobility and Newcomers in Renaissance Ireland*. Exh. cat. Folger Shakespeare Library.

Hodge, Anne. 2001. "The Practical and the Decorative: The Kildare Estate Maps of John Rocque." *Irish Arts Review Yearbook*, pp. 133-40.

———, ed. 2008. *Hugh Douglas Hamilton (1740-1808): A Life in Pictures*. Exh. cat. National Gallery of Ireland, Dublin.

Hoffman, Ronald, with Sally D. Mason. 2000. *Princes of Ireland, Planters of Maryland: A Carroll Saga, 1500-1782*. University of North Carolina Press.

Honour, Hugh. 1959. "Antonio Canova and the Anglo Romans, 1." *Connoisseur* 144 (June), pp. 241-45.

Horner, Arnold. 1971. "Cartouches and Vignettes on the Kildare Estate Maps of John Rocque." *Quarterly Bulletin of the Irish Georgian Society* 14, 4 (October-December), pp. 57-76.

———. 1975. "Carton, Co. Kildare, A Case Study in the Making of an Irish Demesne." *Quarterly Bulletin of the Irish Georgian Society* 18, 2-3 (April-September), pp. 45-101.

Howard, David S. 1986. "Chinese Armorial Porcelain for Ireland." *Bulletin of the Irish Georgian Society* 29, 3-4 (July-December), pp. 3-24.

Howe, Stephen. 2008. "Questioning the (Bad) Question: 'Was Ireland a Colony?'" *Irish Historical Studies* 36, 142 (November), pp. 138-52.

Hughes, Therle. 1970. *Prints for the Collector*. Lutterworth.

Hurley, Livia. 2009. "William Burton Conyngham's Antiquarian Tour of the Iberian Peninsula, 1783-84." *Irish Architectural and Decorative Studies* 12, pp. 38-53.

Hurrell, Nancy. 2003. "The Royal Portable Harp." *Journal of the Historical Harp Society* 13, 2 (Spring), pp. 19-21.

Hyland, Cal, and James Kelly. 1998. "Richard Twiss's *A Tour of Ireland in 1775* (London 1776)—the Missing Pages and Some Other Notes." *Eighteenth-Century Ireland/Iris an dá chultúr* 13, pp. 52-64.

Ingamells, John. 1997. *A Dictionary of British and Irish Travellers in Italy, 1701-1800*. Yale University Press.

———. 2004. *National Portrait Gallery Mid-Georgian Portraits, 1760-1790*. National Portrait Gallery, London.

Jackson, Charles James. 1905. *English Goldsmiths and Their Marks: A History of the Goldsmiths and Plateworkers of England, Scotland, and Ireland*. Macmillan.

———. 1911. *An Illustrated History of English Plate*. 2 vols. Country Life/B. T. Batsford.

Jenkins, Ian. 1988. "Adam Buck and the Vogue for Greek Vases." *Burlington Magazine* 130, 1023 (June), pp. 448-57.

Johnston-Liik, Edith Mary. 2002. *History of the Irish Parliament, 1692–1800: Commons, Constituencies, and Statutes*. 6 vols. Ulster Historical Foundation.

Johnstone, Ruth. 2011. "Lady Louisa Conolly's Print Room at Castletown House." In Mayes 2011, pp. 67–77.

Judge, Patric. 1986. "The State of Architecture in Ireland, 1716." *Irish Arts Review* 3, 4, pp. 62–63.

Kavanagh, Ann C. 1997. *John FitzGibbon, Earl of Clare: Protestant Reaction and English Authority in Late Eighteenth-Century Ireland*. Irish Academic Press.

Kelly, James. 1991. "Jonathan Swift and the Irish Economy in the 1720s." *Eighteenth-Century Ireland/ Iris an dá chultúr* 6, pp. 7–36.

———. 2007. *Poynings' Law and the Making of Law in Ireland*. Four Courts/Irish Legal History Society.

Kelly, James, and Mary Ann Lyons, eds. 2014. *The Proclamations of Ireland, 1660–1830*. 5 vols. Irish Manuscripts Commission.

Kelly, Patrick. 1980. "The Irish Woollen Export Prohibition Act of 1699: Kearney Re-visited." *Irish Economic and Social History* 7, pp. 22–44.

Kennedy, Máire, and Geraldine Sheridan. 1999. "The Trade in French Books in Eighteenth-Century Ireland." In *Ireland and the French Enlightenment 1700–1800*, edited by Graham Gargett and Geraldine Sheridan, pp. 173–96. Macmillan.

Kenny, Ruth. 2008. "'Blown from the face-powders of the age': The Early Pastel Portraits, c. 1760–1780." In Hodge 2008, pp. 17–25.

Kinane, Vincent. 1985. "A Fine Set of the Commons' *Journals*: A Study of Its Production History." *Long Room* 30, pp. 11–28.

———. 1994. *A History of the Dublin University Press, 1734–1976*. Gill & Macmillan.

Kinmonth, Claudia. 1993. *Irish Country Furniture, 1700–1850*. Yale University Press.

Kirkham, Pat. 1986. "Kennett and Kidd." In *Dictionary of English Furniture Makers, 1660–1840*, edited by Geoffrey Beard and Christopher Gilbert, pp. 506–07. Furniture History Society/W. S. Maney and Son.

Kitson, Michael. 1973. "Claude's Earliest 'Coast Scene with the Rape of Europa.'" *Burlington Magazine* 849, 115 (December), pp. 775–77, 779.

Korkow, Cory. 2012. "Miniatures by Horace Hone in the Cleveland Museum of Art Collection." http://www.clevelandart.org/art/collections/british-portrait-miniatures/horace-hone.

Laffan, William. 2001a. "Robert Fagan, 1761–1816, *Portrait of Marianne, Lady Acton and Her Children*." In Laffan 2001b, pp. 130–39.

———, ed. 2001b. *The Sublime and Beautiful: Irish Art 1700–1830*. Exh. cat. Pyms Gallery.

———. 2001c. "'Through Ancestral Patterns Dance': The Irish Portraits at Newbridge House." In Laing 2001, pp. 80–86.

———. 2003a. "A Dublin Sampler Book of 1832: Dorothy Tyrrell." In *A Year at Churchill*, edited by William Laffan. Churchill House Press.

———, ed. 2003b. *The Cries of Dublin &c: Drawn from the Life by Hugh Douglas Hamilton, 1760*. Irish Georgian Society.

———, ed. 2005. *"Miscelanea structura curiosa" by Samual Chearnley*. Churchill House Press.

———. 2006. "The Adelphi Club Belfast." In *A Time and a Place: Two Centuries of Irish Social Life*, edited by Brendan Rooney, pp. 125–27. Exh. cat. National Gallery of Ireland, Dublin.

———. 2007. "Capturing the Beautiful Face of the Country: The Origins of Irish Plein-Air Painting." *Apollo* 166, 546 (September), pp. 60–66.

———. 2011. *Irish Art at Churchill*. Churchill House Press.

Laffan, William, and Kevin V. Mulligan. 2010. "'A wide deserted waste'? Rediscovered Views of Ballyfin by William Ashford, c. 1784." *Irish Architectural and Decorative Studies* 13, pp. 130–39.

———. 2013. "Accommodating the 'Graces of sculpture': Drawings by Giovanni Battista Cipriani for the Attic Statuary of the Casino at Marino." *Irish Architectural and Decorative Studies* 16, pp. 144–60.

———. 2014. *Russborough: A Great Irish House, Its Families and Collections*. Alfred Beit Foundation.

Laffan, William, and Brendan Rooney. 2009. *Thomas Roberts, 1748–1777: Landscape and Patronage in Eighteenth-Century Ireland*. Churchill House Press.

———. 2014a. "'I have treated you as an artist': A Letter from Philippe-Jacques de Loutherbourg to Jonathan Fisher." *Irish Architectural and Decorative Studies* 17, pp. 40–48.

———. 2014b. "Painting Carton: The 2nd Duke of Leinster, Thomas Roberts and William Ashford." In Cosgrove, Dooley, and Mullaney-Dignam 2014, pp. 128–37.

Laing, Alastair, ed. 2001. *Clerics and Connoisseurs: The Rev. Matthew Pilkington, the Cobbe Family and the Fortunes of an Irish Art Collection through Three Centuries*. English Heritage/Azimuth.

Laird, Mark, and Alicia Weisberg-Roberts, eds. 2009. *Mrs. Delany and Her Circle*. Exh. cat. Yale University Press.

Lascelles, Rowley. 1852. *Liber Munerum Publicorum Hiberniae*. Public Record Office.

Leerssen, Joep. 2007. "Last Bard or First Virtuoso? Carolan, Conviviality and the Need for an Audience." In *Amhráin Cearbhalláin/The Poems of Carolan: Reassessments*, edited by Liam P. Ó Murchú, pp. 30–42. Irish Texts Society, Suppl. Series 8.

Legg, Marie-Louise, ed. 2005. *The Diary of Nicholas Peacock, 1740–51: The Worlds of a County Limerick Farmer and Agent*. Four Courts.

Lemire, Beverly. 1988. "Consumerism in Pre-Industrial and Early Industrial England: The Trade in Second-Hand Clothes." *Journal of British Studies* 27, pp. 1–24.

Lewis, Elizabeth. 1984. "An Eighteenth-Century Linen Table-Cloth from Ireland." *Textile History* 15, pp. 235–44.

Loeber, Rolf. 1970. "An Introduction to the Dutch Influence in Seventeenth- and Eighteenth-Century Ireland." *Bulletin of the Irish Georgian Society* 12 (January–March), pp. 1–29.

———. 1973. "Irish Country Houses and Castles of the Late Caroline Period: An Unremembered Past Recaptured." *Quarterly Bulletin of the Irish Georgian Society* 26, 1–2 (January–June), pp. 1–69.

———. 1981. *A Biographical Dictionary of Architects in Ireland, 1600–1720*. J. Murray.

Loeber, Rolf, and Livia Hurley. 2012. "The Architecture of Irish Country Houses, 1691–1739: Continuity and Innovation." In Gillespie and Foster 2012, pp. 201–19.

Lomax, James, and James Rothwell. 2006. *Country House Silver from Dunham Massey*. National Trust Books.

Longfield, Ada K. 1955. "Linen and Cotton Printing at Leixlip in the Eighteenth Century." *Journal of the County Kildare Archaeological Society* 13, pp. 177–83.

———. 1970. *Guide to the Collection of Lace*. Stationery Office.

———. 1972. "Early Irish Printed Fabric." *Country Life* 152 (December 7), pp. 1578–1579.

———. 1975. "Samuel Dixon's Embossed Pictures of Flowers and Birds." *Quarterly Bulletin of the Irish Georgian Society* 4, 18 (October–December), pp. 110–34.

———. 1980. "More about Samuel Dixon and His Imitators." *Quarterly Bulletin of the Irish Georgian Society* 23, 1–2 (January–June), pp. 1–32.

———. 1981. "William Kilburn (1745–1818) and His Book of Designs." *Quarterly Bulletin of the Irish Georgian Society* 24, 1 (January–June), pp. 1–28.

Lucas, A. T. 1953. "'Penal' Crucifixes." *Journal of the County Louth Archaeological Society* 13, 1, pp. 145–72.

Lucas, Charles. 1751. "An Eleventh Address." In Lucas, *The Political Constitutions of Great Britain and Ireland Asserted and Vindicated*. N.p.

Lucey, Conor. 2006. "'Deal Raill and Chineas filling': Chinoiserie Stair Balustrades in Georgian Dublin." *Irish Architectural and Decorative Studies* 9, pp. 226–45.

———. 2007. *The Stapleton Collection: Designs for the Irish Neoclassical Interior*. Churchill House Press.

——. 2011. "Keeping up Appearances: Redecorating the Domestic Interior in Late Eighteenth-Century Dublin." In *Domestic Life in Ireland*, edited by Elizabeth FitzPatrick and James Kelly. *Proceedings of the Royal Irish Academy*, section C, vol. 3, pp. 169–92. Royal Irish Academy.

Lyons, F. S. L. 1979. *Culture and Anarchy in Ireland, 1890–1939*. Clarendon.

Lyons, Mary, ed. 1995. *The Memoirs of Mrs. Leeson, Madam*. Lilliput.

MacLeod, Catherine, and Julia Marciari Alexander. 2002. *Painted Ladies: Women at the Court of Charles II*. Exh. cat. National Portrait Gallery, London/Yale Center for British Art.

Madden, Samuel. 1738. *Reflections and Resolutions Proper to the Gentlemen of Ireland*. R. Reilly.

——. 1739. *A Letter to the Dublin Society*. R. Reilly.

Malcomson, A. P. W. 2011. *John Foster (1740–1828): The Politics of Improvement and Prosperity*. Four Courts.

Malton, James. 1792–99. *A Picturesque and Descriptive View of the City of Dublin*. N.p.

Marillier, H. C. 1927. "The Mortlake Horses." *Burlington Magazine* 50, 286 (January), pp. 12–14.

Mark, Gordon St. George. 1982. "A Silver Chandelier from Galway." *Quarterly Bulletin of the Irish Georgian Society* 25, pp. 19–24.

Marson, Peter. 2007. *Belmore: The Lowry Corrys of Castle Coole, 1646–1913*. Ulster Historical Foundation.

Mason, George C. 1879. *The Life and Works of Gilbert Stuart*. C. Scribner's Sons.

Maxwell, Constantia. 1956. *Dublin under the Georges*. Faber and Faber.

Mayes, Elizabeth, ed. 2011. *Castletown: Decorative Arts*. Office of Public Works.

McCabe, Patricia. 2002. "Trappings of Sovereignty: The Accoutrements of the Lord Chancellor of Ireland." *Irish Architectural and Decorative Studies* 5, pp. 48–73.

McCarthy, Michael, ed. 2001. *Lord Charlemont and His Circle: Essays in Honour of Michael Wynne*. Four Courts.

McCarthy, Muriel. 1980. *All Graduates and Gentlemen: Marsh's Library*. O'Brien.

——. 1986. "An Eighteenth-Century Dublin Bibliophile." *Irish Arts Review* 3, 4 (Winter), pp. 29–33.

McCarthy, Patricia. 2008a. "The Planning and Use of Space in Irish Houses, 1730–1830." Ph.D. diss., Trinity College, Dublin.

——. 2008b. "Stables and Horses in Ireland, c. 1630–1840." In *The Provost's House Stables*, edited by Yvonne Scott and Rachel Moss. Associated Editions.

McCoy, Gerard Anthony Hayes. 1979. *A History of Irish Flags from Earliest Times*. Academy Press.

McCracken, Eileen. 1971. *The Irish Woodlands since Tudor Times: Distribution and Exploitation*. David and Charles.

McCracken, Grant. 1988. *Culture and Consumption: New Approaches to the Symbolic Character of Consumer Goods and Activities*. Indiana University Press.

McCrum, E. 1998. "'The Wonder of the Day': Irish Bedcovers of the Eighteenth Century." *Irish Arts Review Yearbook*, pp. 74–83.

McDonnell, Joseph. 1991. *Irish Eighteenth-Century Stuccowork and Its European Sources*. National Gallery of Ireland, Dublin.

——. 1994. "The Influence of the French Rococo Print in Eighteenth-Century Ireland." *Bulletin of the Irish Georgian Society* 34, pp. 63–74.

——. 1995. *Maynooth Bicentenary Art Exhibitions: Ecclesiastical Art of the Penal Era*. Saint Patrick's College.

——. 1997. "Irish Rococo Silver." *Irish Arts Review Yearbook*, pp. 78–87.

——. 2010. "Patrons and Plasterers: The Origins of Dublin Rococo Stuccowork." In Casey 2010, pp. 223–35.

——. 2011. "Continental Stuccowork and English Rococo Carving at Russborough." *Irish Architectural and Decorative Studies* 14, pp. 110–27.

McDonough, Terence, ed. 2005. *Was Ireland a Colony? Economics, Politics, and Culture in Nineteenth-Century Ireland*. Irish Academic Press.

McDowell, Henry, and Hugo Morley-Fletcher. 1997. "A Meissen Rarity for an Irish Family: The MacElligotts of County Kerry." *Irish Arts Review Yearbook*, pp. 102–04.

McEneaney, Eamonn, and Rosemary Ryan, eds. 2004. *Waterford Treasures: A Guide to the Historical and Archaeological Treasures of Waterford City*. Waterford Museum of Treasures.

McGonagle, Declan, Fintan O'Toole, and Kim Levin. 1999. *Irish Art Now: From the Poetic to the Political*. Merrell Holberton.

McGuire, James, and James Quinn. 2009. *Dictionary of Irish Biography: From the Earliest Times to the Year 2002*. 9 vols. Cambridge University Press/Royal Irish Academy.

McKearin, Helen, and George S. McKearin. 1949. *Two Hundred Years of American Blown Glass*. Doubleday.

McMinn, Joseph. 2005. "Images of Devotion: Swift and Portraits." *Irish Architectural and Decorative Studies* 8, pp. 160–85.

McParland, Edward. 1985. *James Gandon: Vitruvius Hibernicus*. Zwemmer.

——. 1991–92. "Eclecticism: The Provincial's Advantage." *Irish Arts Review Yearbook*, pp. 210–13.

——. 2001. *Public Architecture in Ireland, 1680–1760*. Yale University Press.

McParland, Edward, Alistair Rowan, and Ann Martha Rowan. 1989. *The Architecture of Richard Morrison (1767–1849) and William Vitruvius Morrison (1794–1838)*. Irish Architectural Archive.

McVeagh, John, ed. 1995. *Richard Pococke's Irish Tours*. Irish Academic Press.

Meredith, Jane. 2001. "Letters between Friends: Lord Charlemont's Library and Other Matters." *Irish Architectural and Decorative Studies* 4, pp. 53–77.

Milnes, John, Tim Baker, and Andrew Fairfax. 2000. *The British Violin: The Catalogue of the 1988 Exhibition "400 Years of Violin and Bow Making in the British Isles."* Exh. cat. British Violin Making Association.

Minor, Heather Hyde. 2006. "Engraved in Porphyry, Printed on Paper: Piranesi and Lord Charlemont." In Mario Bevilacqua, Heather Hyde Minor, and Fabio Berry, eds., *The Serpent and the Stylus: Essays on G. B. Piranesi*. Memoirs of the American Academy in Rome, supplementary vol. 4, pp. 123–47.

Mitchell, James. 1974–75. "Laurence Nihell (1726–1795), Bishop of Kilfenora and Kilmacduagh." *Journal of the Galway Archaeological and Historical Society* 34, pp. 58–87.

Moffat, Valerie. 2012. "'A Map of Her Jurisdiction': The Account Books of Meliora Adlercron, of Dawson Street, Dublin, 1782–94." *Irish Architectural and Decorative Studies* 15, pp. 128–49.

Molyneux, William. 1698. *The Case of Ireland Being Bound by Acts of Parliament in England, Stated*. Joseph Ray.

Monkhouse, Christopher. 2014. "A Chinoiserie Dish Ring by Charles Townsend." *Irish Architectural and Decorative Studies* 17, pp. 70–79.

Moody, T. W., R. B. McDowell, and C. J. Woods, eds. 1998–2007. *The Writings of Theobald Wolfe Tone, 1763–98*. 3 vols. Clarendon.

Moore, Thomas. 1831. *The Life and Death of Lord Edward FitzGerald*. 2 vols. Longman, Rees, Orme, Brown, and Green.

——. 1853. *The Poetical Works of Thomas Moore, Collected by Himself in Ten Volumes*. Longman, Brown, Green, and Longmans.

Moran, Anna. 2003. "Selling Waterford Glass in Early Nineteenth-Century Ireland." *Irish Architectural and Decorative Studies* 6, pp. 56–89.

——. 2008a. "Merchants and Material Culture in Early Nineteenth-Century Dublin: A Consumer Case Study." *Irish Architectural and Decorative Studies* 11, pp. 140–65.

——. 2008b. "Selling Irish Glass to the English: An Adventure with Waterford Glass in Early Nineteenth-Century England." *Journal of the Glass Association* 8, pp. 14–19.

——. 2011. "From Factory Floor to Fine Dining: Making, Selling and Using Glass in Ireland, c. 1730–c. 1830." Ph.D. diss., University of Warwick.

Morash, Christopher. 2002. *A History of Irish Theatre, 1601–2000*. Cambridge University Press.

Muir, Alison. 2010. "Paper Manufacture in Ireland, c. 1690–1825, with Particular Reference to the North of Ireland." Ph.D. diss., Queen's University Belfast.

Mulligan, Kevin V. 2011. *Ballyfin: The Restoration of an Irish House and Demesne*. Churchill House Press.

——. 2013. *South Ulster: The Counties of Armagh, Cavan and Monaghan*. Vol. 4 of *Buildings of Ireland*. Yale University Press.

Mulvany, Thomas J. 1842. "Hugh Hamilton." *Dublin Monthly Magazine* 1, 1 (January–June), pp. 65–76.

Mulvin, Lynda. 2001. "The Roman Sculptures at Russborough House." In M. McCarthy 2001, pp. 167–76.

Murphy, Paula. 2010. *Nineteenth-Century Irish Sculpture: Native Genius Reaffirmed*. Yale University Press.

Murphy, Seán. 1993. "Charles Lucas, Catholicism and Nationalism." *Eighteenth-Century Ireland/Iris an dá chultúr* 8, pp. 83–102.

Murray, Griffin. 2012. "The Provenance of an Irish Crucifixion Plaque." *Archaeology Ireland* 26, 4 (Winter), pp. 31–32.

Murray, Peter. 2008. *The Cooper Penrose Collection*. Exh. cat. Crawford Art Gallery.

——, ed. 2010. *Portraits and People: Art in Seventeenth Century Ireland*. Exh. cat. Crawford Art Gallery.

Myles, Franc. 2010. "The Archaeological Evidence for John Odacio Formica's Glasshouse at Smithfield, Dublin 7." In *Glassmaking in Ireland: From Medieval Times to the Contemporary*, edited by John M. Hearne, pp. 83–102. Irish Academic Press.

The Nation. 1844. *The Voice of the Nation: A Manual of Nationality by the Writers of the Nation Newspaper*. J. Duffy.

Noon, Patrick J. 1979. *English Portrait Drawings and Miniatures*. Exh. cat. Yale Center for British Art.

Notes on the Pictures, Plate, Antiquities &c., at Carton, Kilkea Castle, 13, Dominick Street, Dublin, and 6, Carlton House Terrace, London. 1871. Privately printed.

O'Boyle, Aidan. 2010. "The Milltown Collection: Reconstructing an Eighteenth-Century Picture-Hang." *Irish Architectural and Decorative Studies* 13, pp. 31–59.

O'Brien, Gillian, and Finola O'Kane, eds. 2008. *Georgian Dublin*. Four Courts.

O'Byrne, Robert. 2013. *The Last Knight: A Tribute to Desmond FitzGerald, 29th Knight of Glin*. Lilliput.

Ó Catháin, Diarmaid. 1997. "Revd Charles Bunworth of Buttevant: Patron of Harpers and Poets." *Journal of the Cork Historical and Archaeological Society* 102, pp. 111–18.

Ó Cléirigh, Nellie, and Veronica Rowe. 1995. *Limerick Lace: A Social History and a Maker's Manual*. C. Smythe.

O'Connell, John, and Rolf Loeber. 1988. "Eyrecourt Castle, Co. Galway." *Irish Arts Review Yearbook*, pp. 40–48.

O'Connor, Arthur. 1800. *The Beauties of the Press, with an Appendix*. John Stockdale.

O'Connor, Cynthia. 1999. *The Pleasing Hours: James Caulfeild, First Earl of Charlemont, 1728–99; Traveller, Connoisseur, and Patron of the Arts in Ireland*. Collins.

O'Connor, Stephen. 2008. "The Volunteers, 1778–1793: Iconography and Identity." Ph.D. diss., National University of Ireland, Maynooth.

O'Connor, Thomas, ed. 2001. *The Irish in Europe, 1580–1815*. Four Courts.

O'Connor, Thomas, and Mary Ann Lyons, eds. 2006. *Irish Communities in Early Modern Europe*. Irish in Europe Monographs. Four Courts.

O'Driscoll, W. Justin. 1871. *A Memoir of Daniel Maclise*. Longmans, Green.

O'Ferrall, Fergus. 1994. "Daniel O'Connell, the 'Liberator,' 1775–1847: Changing Images." In *Ireland: Art into History*, edited by Raymond Gillespie and Brian P. Kennedy, pp. 91–102. Town House.

Ó Floinn, Raghnall, ed. 2011. *Franciscan Faith: Sacred Art in Ireland, AD 1600–1750*. Wordwell.

O'Kane, Finola. 2004a. *Landscape Design in Eighteenth-Century Ireland: Mixing Foreign Trees with the Natives*. Cork University Press.

——. 2004b. "Leamanah and Dromoland: The O'Brien Ambition, Part II." *Irish Architectural and Decorative Studies* 7, pp. 80–105.

——. 2013. *Ireland and the Picturesque: Design, Landscape Painting, and Tourism in Ireland, 1700–1840*. Yale University Press.

O'Keeffe, John. 1814. *The Wicklow Gold Mines*. John Whitworth.

——. 1826. *Reflections of the Life of John O'Keeffe*. 2 vols. Henry Colburn.

O'Neill, Francis. 1973. *Irish Minstrels and Musicians*. 1913. Repr., Norwood.

O'Reilly, Seán. 1993. "Charlemont House—a Critical History." In *Images and Insights*, edited by Elizabeth Mayes and Paula Murphy, pp. 42–54. Hugh Lane Municipal Gallery of Modern Art.

——. 1998. *Irish Houses and Gardens: From the Archives of Country Life*. Aurum.

O'Sullivan, Donal. 1958. *Carolan: The Life, Times and Music of an Irish Harper*. 2 vols. Routledge and K. Paul.

O'Sullivan, Harold. 2006. *Dundalk*. Irish Historic Towns Atlas 16. Royal Irish Academy.

O'Toole, Fintan. 1999. "Ireland." In McGonagle, O'Toole, and Levin 1999, pp. 21–26.

Owenson, Sydney, Lady Morgan. 1806. *The Wild Irish Girl*. 3 vols. Richard Phillips.

——. 1807. *The Lay of the Irish Harp*. Richard Phillips.

Parmentier, Jan. 2005. "The Irish Connection: The Irish Merchant Community in Ostend and Bruges during the Late Seventeenth and Eighteenth Centuries." *Eighteenth-Century Ireland/Iris an dá chultúr* 20, pp. 31–54.

Pasquin, Anthony. 1970. *An Authentic History of the Professors of Painting, Sculpture, and Architecture, Who Have Practiced in Ireland*. 1796. Repr., Cornmarket Press.

Peck, Amelia, ed. 2013. *Interwoven Globe: The Worldwide Textile Trade, 1500–1800*. Exh. cat. Metropolitan Museum of Art, New York/Yale University Press.

Pegum, Caroline. 2010. "'An Ingenious Painter': New Factors in the Early Career of Charles Jervas." *Irish Architectural and Decorative Studies* 13, pp. 78–95.

Peterson, Jacqueline. 1993. *Sacred Encounters: Father De Smet and the Indians of the Rocky Mountain West*. University of Oklahoma Press.

Petty-FitzMaurice, Henry William Edmund, Marquis of Lansdowne. 1937. *Glanerought and the Petty-Fitzmaurices*. Oxford University Press.

Phillips, James W. 1998. *Printing and Bookselling in Dublin, 1670–1800: A Bibliographical Enquiry*. Irish Academic Press.

Phillips, Son and Neale, London. 1986. *Sculpture and Works of Art*. Sale cat. Phillips, Son and Neale, November 18.

Pollard, Mary. 1989. *Dublin's Trade in Books, 1550–1800*. Oxford University Press.

Powell, Martyn J. 2004. *The Politics of Consumption in Eighteenth-Century Ireland*. Palgrave Macmillan.

Praz, Mario. 1969. *On Neoclassicism*. Thames & Hudson.

Price, Sir Uvedale. (1794) 1842. *Sir Uvedale Price on the Picturesque: With an Essay on the Origin of Taste*. Caldwell, Lloyd.

Prior, John. 1854. *Life of the Right Honourable Edmund Burke*. 5th ed. Henry G. Bohn.

Rauschenburg, Bradford. 1991. Introduction to *Henrietta Johnston, "Who greatly helped . . . by drawing pictures."* Exh. cat. Museum of Early Southern Decorative Arts.

Retford, Kate. 2006. "Patrilineal Portraiture? Gender and Genealogy in the Eighteenth-Century County House." In *Gender, Taste and Material Culture in Britain and North America, 1700–1830*, edited by John Styles and Amanda Vickery, pp. 315–44. Yale University Press.

Reynolds, Mairead. 1984. "Wedgwood in Dublin, 1772–1777." *Irish Arts Review* 1, 2, pp. 36–39.

Rimmer, Joan. 1969. *The Irish Harp*. Irish Life and Culture 16. Mercier.

Robinson, John Martin. 2012. *James Wyatt (1746–1813): Architect to George III*. Yale University Press.

Roche, Nessa. 2007. "The Manufacture and Use of Glass in Post-Medieval Ireland." In *The Post-Medieval Archaeology of Ireland, 1550–1850*, edited by Audrey Horning, pp. 405–20. Irish Post-Medieval Archaeology Group Proceedings 1. Wordwell.

Rogan, Marion. 2014. *Charles Tisdall of County Meath, 1740–51: From Spendthrift Youth to Improving Landlord*. Four Courts.

Rogers, Meyric R. 1941. "Decorative Arts." *Bulletin of the Art Institute of Chicago* 35, 3 (March), pp. 25–27.

———. 1957. "Three New Picassos for the Art Institute." *Art Institute of Chicago Quarterly* 51, 4 (November 15), pp. 82–85.

Ross, Catherine. 1982. "The Excise Tax and Cut Glass in England and Ireland." *Journal of Glass Studies* 24, pp. 57–64.

Rowan, Alistair. "The Irishness of Irish Architecture." 1997. *Architectural History* 40, pp. 1–23.

Salaman, Malcolm C. 1910. *Old English Mezzotints*. The Studio.

Sandby, Paul. 1778. *The Virtuosi's Museum*. J. Kearsley.

Schroder, Timothy. 2009. *British and Continental Gold and Silver in the Ashmolean Museum*. Ashmolean Museum, 2009.

Severens, Kenneth. 1990. "Emigration and Provincialism: Samuel Cardy's Architectural Career in the Atlantic World." *Eighteenth-Century Ireland/Iris an dá chultúr* 5, pp. 21–36.

Seville, Adrian. 2010. "Geographic Pastimes: Two Early English Map Games." ImCos International Symposium 2010, http://www.giochidelloca.it.

Sheehy, Jean. 1980. *The Rediscovery of Ireland's Past: The Celtic Revival, 1830–1930*. Thames & Hudson.

Shirley, Evelyn Philip. 1879. *The History of the County of Monaghan*. Pickering.

Sinsteden, Thomas. 1999. "Four Selected Assay Records of the Dublin Goldsmiths' Company." *Silver Society Journal* 11, pp. 143–57.

———. 2004. "Surviving Dublin Assay Records. Part 2 (1708–48)." *Silver Studies* 16, pp. 87–101.

Skinner, David. 2014. *Wallpaper in Ireland, 1700–1900*. Churchill House Press.

Smith, Ben A., and James W. Vining. 2003. *American Geographers, 1784–1812: A Bio-bibliographical Guide*. Praeger.

Smith, John Chaloner. 1883. *British Mezzotinto Portraits, A Descriptive Catalogue*. 4 vols. Henry Sothern.

Smith, John Thomas. 1828. *Nollekens and His Times*. H. Colburn.

Sotheby's, London. 1929. *The Panter Collections: The Superb Collection of Early Irish Silver*. Sale cat. Sotheby's, July 18.

———. 1933. *Old English Silver*. Sale cat. Sotheby's, December 8.

Stafford, Fiona. 2004. "Striking Resemblances: National Identity and the Eighteenth-Century Portrait." *Eighteenth-Century Ireland/Iris an dá chultúr* 19, pp. 138–62.

Stalley, Roger, ed. 1991. *Daniel Grose (c. 1766–1838): The Antiquities of Ireland; A Supplement to Francis Grose*. Irish Architectural Archive.

Standen, Edith Appleton. 1985. *European Post-Medieval Tapestries and Related Hangings in the Metropolitan Museum of Art*. 2 vols. Metropolitan Museum of Art, New York.

Stevenson, Sara, and Duncan Thomson. 1982. *John Michael Wright, The King's Painter*. Exh. cat. Scottish National Portrait Gallery, Edinburgh.

Steward, James Christen. 1988. *When Time Began to Rant and Rage: Figurative Painting from Twentieth-Century Ireland*. Exh. cat. Merrell Holberton.

Stockwell, La Tourette. 1938. *Dublin Theatres and Theatre Customs (1637–1870)*. Kingsport.

Strickland, Walter G. 1913. *A Dictionary of Irish Artists*. 2 vols. Maunsel.

Sullivan, Sir Edward. 1914. *Decorative Bookbinding in Ireland*. Arden.

Symonds, R. W. 1956. "Dean Swift's Writing Cabinet and Two Others." *Antique Collector* 27, 7 (April), pp. 60–63.

Taylor, Elise. 1998. "Silver for a Countess's Levee: The Kildare Toilet Set." *Irish Arts Review Yearbook*, pp. 115–24.

Thorpe, Ruth. 2013. *Women, Architecture and Building in the East of Ireland, c. 1790–1840*. Four Courts.

Thuente, Mary Helen. 1994. *The Harp New-Strung: The United Irishmen and the Rise of Irish Literary Nationalism*. Syracuse University Press.

Ticher, Kurt. 1977. "Galway Silver in a Dominican Convent." *Antique Dealer and Collector's Guide* (October), pp. 71–74.

Tillyard, Stella. 1997. *Citizen Lord: Edward FitzGerald, 1763–1798*. Chatto & Windus.

Turpin, John. 1990. "French Influence on Eighteenth-Century Art Education in Dublin." *Eighteenth-Century Ireland/Iris an dá chultúr* 5, pp. 105–16.

Usher, Robin. 2012. *Protestant Dublin, 1660–1760: Architecture and Iconography*. Palgrave Macmillan.

Walker, Joseph C. 1786. *Historical Memoirs of the Irish Bards*. T. Payne and Son.

Walpole, Horace. 1937. *Anecdotes of Painting in England*. Edited by Frederick W. Hilles and Philip B. Daghlian, vol. 5. Yale University Press.

Warren, Phelps. 1963. "Living with Antiques: A New York Apartment." *Antiques* 83, 3 (March).

———. 1970. *Irish Glass: The Age of Exuberance*. Faber & Faber.

Wax, Carol. 1990. *The Mezzotint: History and Technique*. Harry Abrams.

Weatherill, Lorna. 1988. *Consumer Behaviour and Material Culture in Britain, 1660–1760*. Routledge.

Webster, Charles A. 1909. *The Church Plate of the Diocese of Cork, Cloyne and Ross*. Guy and Company.

Wees, Beth Carver. 1997. *English, Irish, and Scottish Silver at the Sterling and Francine Clark Art Institute*. Hudson Hills.

Westerhof, Daniel, ed. 2010. *The Alchemy of Medicine and Print: The Edward Worth Library, Dublin*. Four Courts.

Westropp, M. S. Dudley. 1920. *Irish Glass: An Account of Glass-Making in Ireland from the Sixteenth Century to the Present Day*. H. Jenkins.

Whately, Thomas. 1770. *Observations on Modern Gardening*. John Exshaw.

Whelan, Kevin. 1995. "An Underground Gentry? Catholic Middlemen in Eighteenth-Century Ireland." *Eighteenth-Century Ireland/Iris an dá chultúr* 10, pp. 7–68.

White, Harry. 1998. *The Keeper's Recital: Music and Cultural History in Ireland, 1770–1970*. University of Notre Dame Press.

Willemson, Gitta, ed. 2000. *The Dublin Society Drawing School: Students and Award Winners, 1746–1876*. Royal Dublin Society.

Williams, William. 1881. "On the Occurrence of the Great Irish Deer, *Megaceros hibernicus*, in the Ancient Lacustrine Deposits of Ireland, with Remarks on the Probable Age of These Beds." *Geological Magazine* 8, 8 (August), pp. 354–63.

Wilson, Kathleen Curtis. 2011. *Irish People, Irish Linen*. Ohio University Press.

Worsley, Giles. 1995. *Classical Architecture in Britain: The Heroic Age*. Yale University Press.

Wynne, Michael. 1976. "An Influence on Robert Healy." *Burlington Magazine* 118, 879 (June), pp. 412–13, 415.

Young, Arthur. 1970. *A Tour in Ireland, 1776–1779*. 2 vols. 1780. Repr., Irish University Press.

———. 1906. *Travels in France during the Years 1787, 1788, 1789*. 1792. Repr., G. Bell and Sons.

Young, Edward. 1728. *Love of Fame, the Universal Passion. In Seven Characteristical Satires*. 2nd ed. S. Powell.

CONTRIBUTORS

TOBY BARNARD
Emeritus Fellow
Hertford College
University of Oxford

PAUL CAFFREY
Lecturer
National College of Art and Design, Dublin

TOM DUNNE
Emeritus Professor of History
University College Cork

ALISON FITZGERALD
Lecturer
National University of Ireland, Maynooth

LESLIE FITZPATRICK
Assistant Research Curator
European Decorative Arts
The Art Institute of Chicago

PETER FRANCIS
Independent scholar

DARCY KURONEN
Pappalardo Curator of Musical Instruments
Museum of Fine Arts, Boston

WILLIAM LAFFAN
Independent scholar

PHILIP MADDOCK
Independent scholar

SUZANNE FOLDS MCCULLAGH
Anne Vogt Fuller and Marion Titus Searle
Chair and Curator
Prints and Drawings
The Art Institute of Chicago

CHRISTOPHER MONKHOUSE
Chair and Eloise W. Martin Curator
European Decorative Arts
The Art Institute of Chicago

KEVIN V. MULLIGAN
Independent scholar

FINOLA O'KANE
Senior Lecturer
School of Architecture, Landscape and
Civil Engineering
University College, Dublin

JAMES PEILL
Curator
The Goodwood Estate

BRENDAN ROONEY
Curator of Irish Painting
National Gallery of Ireland

MARTHA TEDESCHI
Deputy Director for Art and Research
The Art Institute of Chicago

LENDERS TO THE EXHIBITION

Dr. and Mrs. Leo Ackerman

Albright-Knox Art Gallery, Buffalo

American College of Surgeons, Chicago

The Art Institute of Chicago

Neville and John Bryan

Vincent and Linda Buonanno

The Irish Art Collection of Brian P. Burns

Collection Centre Canadien d'Architecture/Canadian Centre for Architecture, Montréal

Chrysler Museum of Art, Norfolk

Cincinnati Art Museum

Colonial Williamsburg Foundation

Cooper Hewitt, Smithsonian Design Museum, Smithsonian Institution

Dallas Museum of Art

The Collection of Richard H. Driehaus, Chicago

Kathleen Durdin

Leslie B. Durst

Christine Du Boulay Ellis

Filoli: Historic House and Gardens, Woodside

Folger Shakespeare Library, Washington, D.C.

Fowler Museum at UCLA, Los Angeles

Anne and Bernard Gray

Samuel and Patricia Grober Family Collection

Charlotte Hanes

John and Judith Herdeg

Higinbotham Textile Collection

Historic New England, Boston

Hood Museum of Art, Dartmouth College, Hanover

The Huntington Library, Art Collections, and Botanical Gardens, San Marino

The John Work Garrett Library, Johns Hopkins University, Baltimore

The J. Paul Getty Museum, Villa Collection, Malibu

Tara Kelleher and Roy Zuckerberg

Kimbell Art Museum, Fort Worth

Mr. and Mrs. Jerold D. Krouse

L. Knife and Son, Inc.

The Lewis Walpole Library, Yale University, Farmington

Rolf and Magda Loeber

Loyola University Museum of Art, Chicago, Martin D'Arcy, S.J., Collection

Philip and Niamh Maddock

Peter Clayton Mark

The Metropolitan Museum of Art, New York

Minneapolis Institute of Arts

Museum of Art, Rhode Island School of Design, Providence

Museum of Fine Arts, Boston

The Museum of Fine Arts, Houston

National Gallery of Art, Washington, D.C.

National Gallery of Canada, Ottawa

The Nelson-Atkins Museum of Art, Kansas City

New Orleans Museum of Art

Norton Museum of Art, West Palm Beach

The O'Brien Collection

Philadelphia Museum of Art

Private collection (16)

John Richardson

The Rienzi Collection, Museum of Fine Arts, Houston

S Franses, London

Saint Louis Art Museum

San Antonio Museum of Art

Sarah Campbell Blaffer Foundation, Houston

Tom Shudell

Smith College Museum of Art, Northampton

Snite Museum of Art, University of Notre Dame, South Bend

Joseph Peter Spang III

Melinda and Paul Sullivan

Timken Museum of Art, the Putnam Foundation Collection, San Diego

University of Michigan Museum of Art, Ann Arbor

Winterthur Museum

Yale Center for British Art, New Haven

Yale University Art Gallery, New Haven

Yale University Collection of Musical Instruments, New Haven

Maris and Maija Zuika

INDEX

PHOTOGRAPHY CREDITS

Unless otherwise stated, all photographs of artworks appear by permission of the lenders mentioned in the captions. Every effort has been made to contact and acknowledge copyright holders for all reproductions; additional rights holders are encouraged to contact the Art Institute of Chicago. The following credits apply to all images in this catalogue for which separate acknowledgment is due.

Unless otherwise noted, all photographs of the works in the catalogue were made by the Department of Imaging at the Art Institute of Chicago, Christopher Gallagher, Director of Photography, Louis Meluso, Director of Imaging Technology, and are copyrighted by the Art Institute of Chicago.

P. 16; p. 130, fig. 1; p. 184, figs. 5–6; p. 243, fig. 188; p. 244, fig. 193; p. 245, figs. 194–96—photography by James Fennell.

P. 21, fig. 1; p. 28, fig. 14; p. 41, fig. 2; p. 50, fig. 15; p. 124, fig. 6; p. 128; p. 134, fig. 7; p. 137, fig. 12; p. 171, fig. 7; p. 208, fig. 2; p. 150, fig. 5–6; p. 237, fig. 143; p. 250, fig. 230; p. 264, fig. 306—photography by Jamie Stukenberg, Professional Graphics.

P. 22, fig. 3, 4; p. 55, fig. 23; p. 65, fig. 3; p. 80, fig. 3; p. 89, fig. 15; p. 92, fig. 21; p. 99, fig. 2; p. 103, fig. 8; p. 105, fig. 11; p. 133, fig. 6; p. 134, fig. 8; p. 154, fig. 1; p. 157, fig. 6; p. 183, fig. 4; p. 190, fig. 4, 5; p. 193; p. 195, fig. 1; p. 198, fig. 6; p. 199; p. 203, fig. 4a, 4b; p. 204, fig. 6; p. 211, fig. 6; p. 232, fig. 89; p. 236, fig. 139, 142; p. 239, fig. 150; p. 240, fig. 162, 164; p. 241, fig. 173; p. 246, fig. 206, 208; p. 251, fig. 247; p. 252, fig. 244; p. 253, fig. 245, 248, 253; p. 263, fig. 304; p. 265, fig. 326—photography by Dara McGrath.

P. 23, fig. 5—A. E. Henson/Country Life/IPC+Syndication. © IPC Media.

P. 23, fig. 6—courtesy National Gallery of Art, Washington, D.C.

P. 24, fig. 7—Country Life/© IPC Media.

P. 25, fig. 10—photography by Richard Valentia.

P. 26, fig. 11—Albright-Knox Art Gallery/Art Resource, N.Y.

P. 26, fig. 16—courtesy of the Lewis Walpole Library, Yale University.

P. 41, fig. 3; p. 84, fig. 8; p. 93, fig. 22; p. 102, fig. 5; p. 138—photography courtesy Pyms Gallery, London.

P. 43, fig. 5; p. 164, fig. 8—Bridgeman Images.

P. 44, fig. 6; p. 107, fig. 14; p. 182, fig. 2; p. 238, fig. 146; p. 259, fig. 282; p. 265, fig. 325—Images © The Metropolitan Museum of Art. Image source: Art Resource, N.Y.

P. 49, fig. 14; p. 83, fig. 7; p. 88, fig. 16; p. 91, fig. 20—Image courtesy the National Library of Ireland.

P. 53, fig. 19—photography © National Gallery of Canada.

P. 53, fig. 20; p. 140, fig. 2—photography courtesy Philip Mould & Company.

P. 54, fig. 21; p. 66, fig. 5; p. 67, fig. 6; p. 231, fig. 85—© courtesy of the Huntington Art Collections.

P. 64, fig. 1; p. 199, fig. 8—photography by Erik Gould, courtesy of the Museum of Art, Rhode Island School of Design, Providence.

P. 64, fig. 2; p. 69, fig. 10; p. 72, fig. 14; p. 120, fig. 2; p. 169, fig. 2; p. 173, fig. 9; p. 202, fig. 1, 2; p. 204, fig. 5, 7, 8; p. 215, fig. 1; p. 233, fig. 97; p. 234, fig. 119; p. 239, fig. 151; p. 240, fig. 164, 165, 166; p. 241, fig. 170, 171; p. 243, fig. 183; p. 258, fig. 251; p. 259, fig. 283; p. 260, fig. 288—photography by Tim Nightswander/IMAGING4ART.

P. 73, fig. 15—photography by Jamison Miller.

P. 74, fig. 18—by permission of the Folger Shakespeare Library.

P. 91, fig. 19—© The British Library Board, KTOP LV.

P. 103, fig. 7—© Christie's Images/Bridgeman Images.

P. 108, fig. 17 and 18—photography by Thomas R. DuBrock. Sarah Campbell Blaffer Foundation, Houston.

P. 120, fig 1; p. 162, fig. 3—photography courtesy of the National Gallery of Ireland.

P. 130, fig. 1; p. 178, fig. 5; p. 197, fig. 4—courtesy Winterthur Museum.

P. 134, fig. 8; p. 169, fig. 3; p. 170, fig. 5; p. 249, fig. 223, p. 251, fig. 233—photography by Mark Coffey.

P. 135, figs. 10 and 11; p. 150, fig. 5; p. 168, fig. 1; p. 251, cat. 234; p. 261, fig. 303—photography by Bruce White Photography.

P. 155, fig. 3—© Con Brogan, Photographic Unit National Monument Service.

P. 174—photograph by Denis Nervig. © Photograph courtesy of the Fowler Museum, UCLA.

P. 176, fig. 1; p. 244, fig. 192—photography Minneapolis Institute of Arts.

P. 176, fig. 2—photography courtesy Dallas Museum of Art.

P. 182, fig. 1—© Fitzwilliam Museum, Cambridge/Art Resource, N.Y.

P. 186; p. 253, fig. 246—photography by Peter Harholdt. Courtesy of Historic New England.

P. 188, fig. 1—© National Maritime Museum, Greenwich, London.

P. 196, fig. 3—photography by David H. Ramsey.

P. 219, fig. 7—photography © Warren Jagger, courtesy of the Museum of Art, Rhode Island School of Design, Providence.

P. 227, fig. 36; p. 230, fig. 81; p. 247, fig. 210—photography by Tom Little Photography.

P. 242, fig. 181—photography courtesy of the Newberry Library, Chicago.

P. 249, fig. 222—Yale University Art Gallery.

P. 257, fig. 275—© Jeff Dunas 2014.

FSC
www.fsc.org
MIX
Paper from responsible sources
FSC® C016245